American Folk Painters of Three Centuries

American Folk

of

Jean Lipman, Tom Armstrong, *editors*

Painters
Three Centuries

ARCH CAPE PRESS New York

in association with the

WHITNEY MUSEUM OF AMERICAN ART

For the Whitney Museum of American Art
Editors: Jean Lipman, Tom Armstrong
Curator: Jennifer Russel
Editorial director: Ruth Wolfe
Head, publications: Doris Palca
Editor of publications: Margaret Aspinwall
Consultants: Herbert W. Hemphill, Jr., Beatrix T. Rumford,
Alice Winchester

This 1988 edition is published by Arch Cape Press,
a division of dilithium Press, Ltd., distributed by
Crown Publishers, Inc., 225 Park Avenue South, New York, New York 10003,
by arrangement with Hudson Hills Press

Printed and bound in Hong Kong

Library of Congress Cataloging-in-Publication Data

American folk painters of three centuries / [edited by Jean Lipman
and Tom Armstrong]
 p. cm.
 Bibliography: p.
 Includes index.
 ISBN 0-517-66192-6
 1. Painting, American—Themes, motives. 2. Primitivism in
art—United States—Themes, motives. I. Lipman, Jean.
II. Armstrong, Tom, 1932-
ND205.5.P74A43 1988
759. 13—dc19 87-37584
 CIP

ISBN 0-517-66192-6
h g f e d c b a

Sponsor's Letter

The Chase Manhattan Bank is delighted to have the opportunity to participate in the opening exhibition of the year-long celebration of the 50th Anniversary of the founding of the Whitney Museum of American Art. We recognize the Whitney Museum as the pre-eminent museum of American art and appreciate the support and encouragement the Museum has extended to American artists throughout its history. The bank has been an enthusiastic collector of American art, and we are particularly pleased to help present this first major exhibition of the works of a selected group of great American folk painters.

For much of this century, American folk painting was of interest to only a small number of artists, collectors, and museum specialists. Folk painters were generally ignored in surveys of American art. This exhibition offers a unique opportunity to study in depth one of the most important aspects of American culture. We hope that it will not only help make the public aware of the accomplishments of these indigenous artists but also inspire more scholarship in this field. Although a substantial amount has been learned about these once anonymous figures, there is still the challenge of a great deal more research.

We are grateful to the Whitney Museum for recognizing the need for this exhibition, to the authors who contributed to the book, and to the lenders whose generosity has enabled the Museum to assemble an outstanding group of paintings.

It is always a privilege—in the truest sense of the word—to enjoy the accomplishments of creative individuals who express themselves with extraordinary imagination and talent. This is a very special exhibition and we are proud to help make it possible.

DAVID ROCKEFELLER, *Chairman of the Board*
The Chase Manhattan Bank

Contents

Preface

The cultural history of the United States has not been until recently a major concern of either educational institutions or the public. In the bicentennial year of 1976 much attention was directed to various aspects of the arts of the past two hundred years. While we were reminded of the contributions made by American artists, the prevailing attitude that our culture has been dependent upon others remained for the most part unchanged. The dominance of Europe in our heritage reinforces the tendency to consider American artistic accomplishments as secondary. The condescension and even lack of interest in the art of this country has nowhere been more apparent than in art history curricula. Until twenty-five years ago no graduate degrees in American art history were given by American universities.

At the beginning of the twentieth century a few artists and patrons, including Gertrude Vanderbilt Whitney, attempted to determine the character of the American artistic statement. This resulted in a concentrated effort to discover indigenous aspects of American culture. The American folk artist intrigued people searching for the backbone of our visual arts, but in the absence of biographical information, the folk artist became the subject of myths derived from speculation about the objects produced. The nature of the social and economic roles of the nineteenth-century folk artist in a self-conscious, ambitious nation was not adequately understood. These initial attitudes toward folk art determined the position that the folk artist has occupied in American art history. Rarely have folk artists been treated in the same way as their academic peers, as creative individuals whose art is studied along with factual information about their lives. As a result, folk art has been largely ignored as a serious aspect of American art history. This gap in the study of the visual arts in this country is being reversed by public enthusiasm, but more scholarly study and insight are needed.

Indigenous untrained painters, primarily of the eighteenth and nineteenth centuries, produced art as a specific response to the needs and enthusiasms of their contemporaries for images of themselves and their surroundings, and they created a body of work with lasting aesthetic value. Their lives and their work are a vital part of our American heritage, and it is their story that is presented for the first time in this book and the associated exhibition. Because these artists were so much a part of the social and economic history of their communities, their work is often considered chiefly for its value in documenting the history of their times. The

work may serve this purpose, but it deserves greater recognition as the expression of talented artists.

Throughout its history the Whitney Museum of American Art has helped foster public recognition of American folk art with pioneering exhibitions and publications. The first exhibition of American folk art was presented at the Whitney Studio Club by the Director, Juliana Force, in 1924. Organized by the painter Henry E. Schnakenberg, it introduced to the public forty-five examples, of which thirty-five were by anonymous artists. Standards for the judgment of quality in this field were established in *The Flowering of American Folk Art. 1776–1876*, a 1974 Whitney Museum exhibition and publication which assembled the largest collection of outstanding American folk art produced in the century of its greatest achievement. It seems particularly appropriate that the Whitney, in its fiftieth anniversary year, is presenting *American Folk Painters of Three Centuries*. This major exhibition and publication will further expand the appreciation of American folk art with a selective survey of the work of thirty-seven folk painters. It is through a sequence of exhibitions like these that the Museum reinforces its role as an educational institution.

In the past, most folk art exhibitions have either been limited to one artist or have focused on periods, regions, mediums, subject matter, or collectors. Attention has been focused on the objects, rather than on the artists and their lives and work.

In this publication and the associated exhibition, folk painters are presented as outstanding American artists in the context of a museum devoted to the history of American art. For the first time the paintings are considered as the achievements of talented, creative individuals rather than as isolated or anonymous works. This study offers the public an opportunity to learn about the lives of these individuals, as well as a chance to identify their art.

The artists included here represent the editors' choices of the best American folk painters, limited to those whose lives can be documented with some certainty and in most cases to those who have left a substantial body of work. They are grouped by century according to the period of their major activity, and arranged alphabetically within each century. The majority come from the eastern United States, where the first American colonies were founded in the seventeenth century. Folk painting in the Southwest derived from a culture vastly different from that of the East, dominated by Spanish influence and the Catholic church. By including a representative Southwestern artist, we hope to draw attention to both

parallels and contrasts in the lives and works of untrained artists from such different backgrounds. American Indian art was considered beyond the scope of this study. The smaller number of twentieth-century artists reflects the editors' belief that the quality and originality of folk painting in our era have not remained as consistent as in the eighteenth and nineteenth centuries.

The artists were selected with the advice of three consultants, each of whom is distinguished in this field: Herbert W. Hemphill, Jr., author of *Twentieth-Century American Folk Art and Artists*; Beatrix T. Rumford, Director of the Abby Aldrich Rockefeller Folk Art Center, Williamsburg, Virginia; and Alice Winchester, author, lecturer, and former editor of the magazine *Antiques*.

When the artists had been chosen, the outstanding authority on each artist was invited to contribute a chapter to this anthology. Many of the chapters in this book are based on previously published articles and books, which have been revised to reflect new information gathered by the authors and others (the original source is given at the end of each chapter). Thus research previously scattered among different publications is now available in a single volume. Other chapters were written specifically for this book. Each author has a unique style and approach to the subject; we have maintained this individual quality throughout the book. We are grateful to the authors for their help in compiling an anthology which we believe will be a substantial contribution to the literature on American folk art and a basis for further study.

This book has been planned and edited at the Museum by five people listed on the copyright page. I feel it is appropriate for me, on behalf of scholars and the public, to express our special gratitude to five of the authors who have contributed a total of seventeen essays. Four of them, Mary Black, Nina Fletcher Little, Jean Lipman, and Alice Winchester, have collectively played the most substantial role in the history of the scholarship of American folk art. It is a privilege to be a part of a publication that celebrates their combined authority on the subject. The fifth author who deserves special recognition is Sidney Janis. It was he who published the first major study of twentieth-century folk painting and expanded our knowledge to include a new group of creative artists.

The painters in this book are represented by several outstanding works, reproduced in color and referred to in the texts as colorplates. No attempt was made to cover the progression of styles throughout an artist's career: the colorplates present the artist's masterpieces. In cases where additional photographs were included to clarify the text or to provide documentary material, they are reproduced in black and white and denoted in the texts as illustrations.

Some of the works reproduced here have never before been exhibited in New York City. Owners have been extremely cooperative in joining us in this endeavor. As books and museum exhibitions of this caliber become more difficult to produce, it is the owners of works of art to whom we are increasingly indebted for their generosity. In this instance, many of the lenders represent those who first recognized the achievement of American folk artists. Both private collectors and the staffs of museums and historical societies have made an extraordinary effort to assist us because they recognized, with us, the importance of presenting these American artists in terms of the finest examples of their work.

TOM ARMSTRONG

Foreword

The catalogue for the first folk art exhibition, presented in 1924 at the Whitney Studio Club and simply titled *Early American Art*, did not include a critical essay. Although active collecting began in the 1920s, no significant appraisals of folk art or artists were published until the next decade. The following comments by outstanding collectors and scholars offer a variety of definitions of what has come to be known as American folk art.

1931
Edith Gregor Halpert contributed an article to the October 1 issue of *The Art Digest* to announce the opening of her American Folk Art Gallery. She stated that the folk art works she offered had been chosen "not because of antiquity, historical association . . . or the fame of their makers, but because of their aesthetic quality and because of their definite relation to vital elements in contemporary American art."

1932
Holger Cahill. Museum of Modern Art catalogue, *American Folk Art. The Art of the Common Man in America, 1750–1900:* "[American folk art] is the unconventional side of the American tradition in the fine arts. . . . It is a varied art, influenced from diverse sources, often frankly derivative, often fresh and original, and at its best an honest and straightforward expression of the spirit of a people."

1942
Alfred H. Barr, Jr. Foreword to Sidney Janis's *They Taught Themselves:* "[Their] independence of school or tradition . . . distinguishes these painters psychologically and genetically. . . . Their independence and isolation is revealed not only in their art but in their biographies."

1942
Sidney Janis. *They Taught Themselves:* "There are people in the world who always retain an untouched quality, a spiritual innocence, regardless of their experiences in life. . . . When these individuals paint, they rarely learn from a developed painting culture because it is far removed from their perception, and being removed, cannot touch them. Each creates in his own world. Often a surprising enterprise and courage are born of their very innocence. Not realizing the pitfalls, they are unafraid."

1949
Maxim Karolik. Museum of Fine Arts, Boston, catalogue, *M. and M. Karolik Collection of American Paintings. 1815 to 1865:* "The question I continue to ask is whether lack of technical proficiency limits the artist's ability to express his ideas. I do not believe that it does. [Among the folk painters] were a number . . . of exceptional talent. Fortunately, they had no academic training. Because of this they sometimes lacked the ability to describe, but it certainly did not hinder their ability to express."

1950
"What Is American Folk Art?" Symposium in the May issue of *Antiques.*

E. P. Richardson: "American folk art is not Americana. It is art."

Nina Fletcher Little: "American folk art is, to me, essentially the expression of the individual. . . . One of its outstanding characteristics is spontaneity. As opposed to formal art, American folk art is utterly unselfconscious."

John I. H. Baur: "American folk art might be defined, I think, as the naïve expression of a deeply felt reality by the unsophisticated American artist. . . . By 'a deeply felt reality' I would imply that our folk art is primarily realistic in intent but that it is inspired by an emotional rather than a visual realism—that it seeks the essence of a subject as the artist understands it rather than the outward form."

John A. Kouwenhoven: "The forms and techniques of this vernacular art are sensitive to the technological environment and in harmony with democratic social institutions. . . . And they carry in themselves the seeds of the future, rather than memories of a nostalgic past."

1954
May, special issue of *Art in America* devoted to "American Primitive Painting," as exemplified by the Garbisch collection.

Virgil Barker: "Their makers apparently painted [the folk pictures] about as straightforwardly as they went to church and sang hymns, and that is one reason for their present historical and spiritual authenticity."

Louis C. Jones: "One feels about the best primitive work that the artist sees his material not as an outsider but as one sharing the mood and values of his subject matter."

Frank O. Spinney: "After a century of testing the limits of representational art, the modern artist turned to his own inner world and in so doing understood that the American primitive was something more than a quaint relic of the past."

1961
Alice Winchester in the April issue of *Art in America:* "[The folk artists] who had genuine originality and creative imagination were not, probably, much concerned with the idea of expressing themselves in a new and different way; they just went ahead and did it."

1974

Herbert W. Hemphill, Jr. *Twentieth-Century American Folk Art and Artists:* "If there is any one characteristic that marks folk artists, it is that for them the restraints of academic theory are unimportant, and if encountered at all, meaningless. In effect, the vision of the folk artist is a private one, a personal universe, a world of his or her own making. There exists only the desire to create, not to compete, not necessarily to find fame (although many are not without ego and pride and do very much enjoy the pleasure of being recognized). Hence, the products of the folk art world are truly the art of the people, by the people, and for the people, and the vigorous life of this art has no limit in time."

1977

Beatrix T. Rumford in *Spinning Wheel,* July–August: "America's richest and most original source of native art is found in the work of unschooled artists with little or no exposure to such academic principles as anatomy, perspective, or the use of light and shadow. Besides pleasing the eye, the best of the carvings, paintings, and utilitarian objects created by these so-called folk artists chronicle the tastes and attitudes of common citizenry who seldom recorded ordinary experiences in their writings."

1979

Robert Bishop, "Director's Letter," *The Clarion,* Summer. "The folk arts, a great cultural heritage in America, are finally achieving their much deserved recognition. And because of research done in the last fifty years, the major artists are no longer anonymous; a whole cast of folk art characters, with known personalities and known bodies of work, are now an important part of American art history."

Having started to discuss American folk painting in the 1930s, I now, in 1980, allow myself the last word in the collection of comments I've assembled here. In my first article, "A Critical Definition of the American Primitive," published in *Art in America* in 1938, I focused on the importance of understanding the special quality of folk art:

The style of the typical American primitive is at every point based upon an essentially non-optical vision. It is a style depending upon what the artist knew rather than upon what he saw, and so the facts of physical reality were largely sifted through the mind and personality of the painter. The degree of excellence in one of these primitive paintings depends upon the clarity, energy, and coherence of the artist's mental picture rather than upon the beauty or interest actually inherent in the subject matter, and upon the artist's instinctive sense of color and design when transposing his mental pictures onto a painted surface rather than upon a technical facility for reconstructing in paint his observations of nature.... The outstanding artists, ... unhampered by any external requirements or restrictions, arrived at a power and originality and beauty which was not surpassed by the greatest of the academic American painters.

I reiterated this opinion in three of my books on the subject in 1942, 1966, and 1974. It is now more than forty years since that first article on folk painting, and I have never changed my mind. I am sure that the work of these painters was not a minor branch in the history of American art. I believe it was a central contribution to the mainstream of American culture from the first formative years of our nation to the present.

JEAN LIPMAN

18th
Century

The Beardsley Limner

active c. 1785 – c. 1800

The Beardsley Limner was one of several talented but unidentified portraitists active in New England and New York in the two decades after the Revolution. His designation derives from two of his earliest known and most ambitious portraits, those of Hezekiah and Elizabeth Davis Beardsley (colorplates). Nina Fletcher Little first grouped these and four other portraits as the work of one artist in the seminal exhibition *Little-Known Connecticut Artists, 1790–1810*, held at the Connecticut Historical Society in 1957. I subsequently attributed other portraits to the same hand in a 1972 exhibition centering on the Limner's work at the Abby Aldrich Rockefeller Folk Art Center. With the recent attribution of *Major Andrew Billings* in the William E. Wiltshire collection, the Limner's oeuvre has expanded to fifteen portraits, representing different phases of his career.

Although no clues to the artist's name have been found so far either on the paintings or in his sitters' papers, considerable information about the Beardsley Limner may be inferred from the portraits themselves and from the lives of his patrons. He seems to have been an itinerant artist, for the majority of his known subjects lived along the Boston Post Road in Massachusetts and Connecticut. The portrait of Major Billings, who lived in Poughkeepsie, indicates not only that the Limner also worked in New York State, but that other paintings from that region may yet be discovered. The apparent ages and costumes of his sitters suggest that he was active from about 1785 to the early nineteenth century. The Beardsley Limner's style, and probably his prices, appealed to the middle class. His clients were fairly prosperous but not particularly wealthy or prominent. Commissions from those patrons generally fell to artists, such as Ralph Earl, who had some European training. Earl had spent part of the Revolution in England and returned to America only in 1785. Despite his suspect allegiance, he painted many prominent Connecticut citizens during the period the Beardsley Limner was active.

The portraits reproduced here mark the apparent beginning and end of the Limner's career. Hezekiah and Elizabeth Beardsley were probably painted in the years just before their deaths in 1790. Their portraits, as well as the *Colonial Dame* at Princeton and portraits of the three Wheeler children in the National Gallery and the Little collection, represent the Limner's earliest known style. They reveal that in the 1780s he was already an accomplished artist. The Beardsleys are the Limner's largest and most impressive portraits; their unusual width required the joining of three sec-

tions of canvas each. The sitters' features, costumes, and settings were painted in detail and with a sure hand. The Limner's depictions of textures—notably of Elizabeth's hair, transparent skin, and green silk dress—are particularly beautiful. He defined all the images in these portraits with precision and often outlined them with a thin black line. X-rays of the two portraits show that once the Limner set his forms down on the canvas, he made few alterations, although some corrections are apparent in the positioning of Hezekiah's vest buttons and in the flounces of Elizabeth's cap. The artist occasionally scratched outlines directly into the underpainting, as can be seen in the arches of Elizabeth's basket; however, he did not necessarily follow the scratched lines exactly in the final painting. The arrangement of the figures and the objects around them seems fairly sophisticated. The lines that follow the table's shadow and the drape of the curtain in Hezekiah's portrait form a triangular pattern which is paralleled by the dog and curtain in Elizabeth's. When the portraits are hung side by side, these triangles form a diamond pattern which draws the images of the sitters closer together.

The Beardsley portraits are evidence of considerable artistic talent and professional skill. Nevertheless, other aspects suggest that the Limner had little training in academic painting techniques. He did not have a command of perspective, as is apparent in the lines of Hezekiah's table, which recede in different directions. He also frequently had difficulty with the perspective of his sitters' heads and shoulders. Women's portraits presented fewer problems since their forms were well hidden by the voluminous caps and dresses of the period. The artist compensated to some extent for his problems with depth by confining his sitters to a narrow, flat band of space between the picture plane and the wall directly behind them.

Limited academic experience may also be inferred from the artist's reliance on set formulas to depict his sitters' facial features, which tends to give his patrons a "family" resemblance. The most obvious of these formulas, which appear in all of the Limner's works, are thin compressed lips and symmetrical almond-shape eyes. Although he turned his sitters' heads slightly to the side, making the outline of the nose much easier to depict, he represented both eyes in the same way, without allowing for recession of the far side of the face. These simplified artistic formulas suggest a largely self-taught artist, and they are also important criteria for attributions when the paintings yield no other indication of the artist's identity.

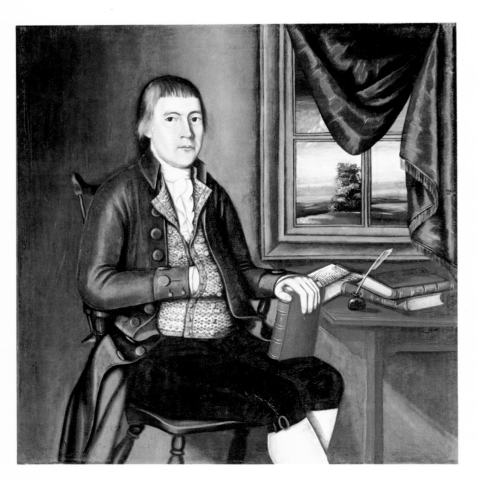 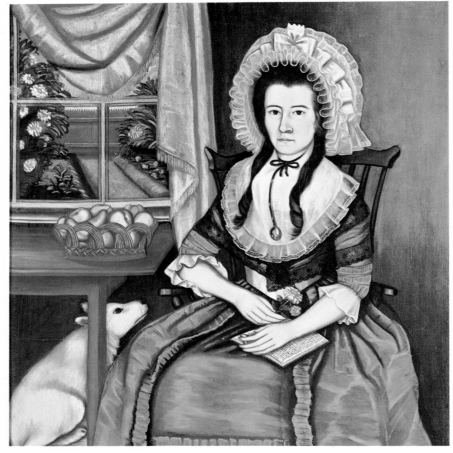

The Beardsley Limner. *Mr. and Mrs. Hezekiah Beardsley (Elizabeth Davis)*, c. 1785–90.
Oil on canvas, each 45 x 43 inches.
Yale University Art Gallery, New Haven, Connecticut;
Gift of Mrs. E. A. Giddings.

Amount brought forward £46..16..10
2 Portrait Pictures 7..10..0 7..10..0
4 Old White Chairs 4..0
1 Kitchen Table 5..0
4 Cedar Pails 2..
8 Wooden Bowls 7..6
1 Pine Washing Tub 1
1 small Sugar Box 9
3 Trays ... 3
1 Sieve ... 6

Detail of the 1790 inventory of Hezekiah Beardsley's household goods. Connecticut State Library Archives, Hartford.

As is frequently the case in late eighteenth-century New England portraits, the artist represented the Beardsleys as though in their own home. In fact, the clothing and furniture in the paintings are listed in the inventory of household goods made after the Beardsleys' deaths. The elegant silk curtains, however, do not appear in the inventory, and they were probably a fanciful addition by the artist. The portraits themselves were probably the "2 Portrait Pictures" listed with a value of £7.10.0 (illustration). This unusually specific sum may represent the amount paid the artist, and was greater than the value ascribed to "1 Cherry Desk & Book Case" listed on the inventory at £6.0.0.

Hezekiah Beardsley was a doctor and pharmacist in New Haven, Connecticut, but the book titled *Extracts*, which lies open on the table near a pen and inkstand, probably does not refer to his profession. More likely, it holds notes (extracts) that Hezekiah appears to be making from the three volumes of Gibbon's *History of the Decline and Fall of the Roman Empire*. Editions of Gibbon were imported to Connecticut in the 1780s and his ideas became a source of controversy in the local newspapers. Although books were a traditional motif in male portraits in Europe and America, the inclusion of Gibbon's volumes in this portrait probably indicated Hezekiah's desire to be regarded as an intellectual.

Elizabeth Beardsley is surrounded by traditional symbols of femininity and domesticity. Whereas Hezekiah's view from his window suggests vast distances, Elizabeth's view is strictly limited to her enclosed garden, which is a particularly attractive feature of this painting. Fruit and flowers, a dog, an open book titled *Reflections*, and a locket with her husband's portrait are her attributes. The pinks, greens, and yellows in her portrait convey a livelier impression than the somber greens and brown-grays of her husband's.

The domestic surroundings suggested in the Beardsleys' portraits were part of a broader trend in New England portraiture around the period of the Revolution. With independence, returning prosperity, and settled conditions, the middle class revived their demand for portraits. Paintings of the 1780s had simpler, more natural poses and settings than the comparatively formal portraits of the colonial period. The more realistic settings were consistent with the new claims of republican citizenship and the rejection of aristocratic pretension. Such an attitude is suggested by a report made in 1787 by the French chargé d'affaires: "The people of [Connecticut] generally have a national character not commonly found in other parts of the country. They come nearer to republican simplicity; without being rich they are all in easy circumstances." However, the domestic trend in New England portraits was probably also influenced by a similar shift in English paintings of the 1750s and 1760s.

Unlike many provincial painters who relied on a portrait formula, the Beardsley Limner continued to change his poses and develop his painting technique. In works after 1790, he departed from the precise painting style and detailed backdrops exhibited in the Beardsleys' portraits. In his depictions of Major Billings, of Harmony and Oliver Wight, and of the Dix brothers, he concentrated more on the figures of the sitters. The settings of these later portraits tend to be more generalized, often with only a landscape or a large curtain behind the figure. Brushstrokes become broader; there is more freedom in the artist's painting. This change was probably due to the Limner's exposure to more sophisticated portrait styles. While depicting the Dix brothers, he very likely would have seen the portrait of their mother, Dorothy Dix, painted about 1789 by Christian Gullager, a Danish artist active in Massachusetts. In the portrait of Jonathan Dix, the Limner seems to have imitated Gullager's more skillful shadowing and positioning of Mrs. Dix's arm and fingers. Furthermore, he painted Jonathan's brother Clarendon Dix holding a flute, a motif seen in English portraits and which also appears in Ralph Earl's painting of Philo Ruggles of 1796 (illustrations). The portrait of Major Andrew Billings reveals a more definite link to Ralph Earl's work. For this portrait the Limner borrowed Earl's characteristic setting motifs—a red draped curtain and a table covered with a green cloth. He also experimented with placing the sitter in a corner of a room with a window, as Earl frequently did, although the Limner had difficulty with the perspective of the table and the window mullions. In emulating Gullager and Earl, the Limner revealed his desire to follow the latest modes of New England society portraiture. Nevertheless, he continued to rely on his usual formulas for rendering his sitters' facial features and hands.

Little of this later style is evident in the simple setting of what may be the Limner's latest known painting, the unidentified *Little Boy in Windsor Chair* (colorplate). The child's short jacket and frilled collar suggest a date around 1800. The pose provides an amusing comparison with Hezekiah Beardsley's similar but formal pose. The little boy's childish fingers also hold a book upright, while he dreamily regards the viewer with his head resting on his other pudgy hand. The perspective of the chair is not in the least

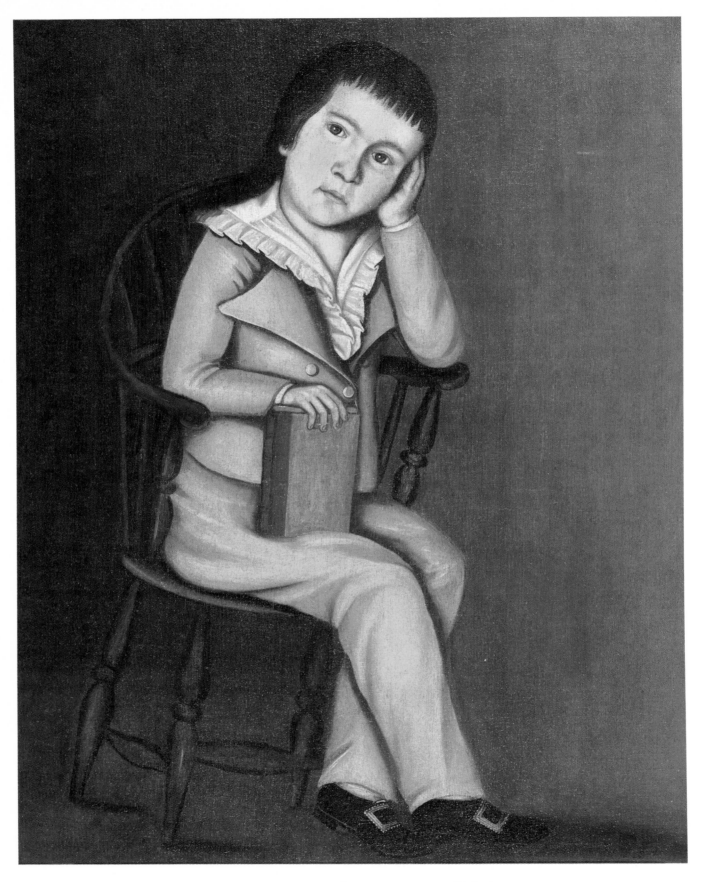

The Beardsley Limner. *Little Boy in Windsor Chair*, c. 1800. Oil on canvas, 32 x 24¾ inches. Montclair Art Museum, Montclair, New Jersey; Lang Acquisition Fund.

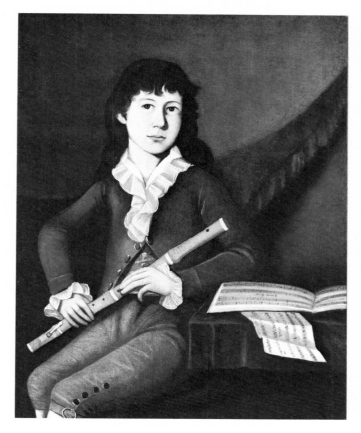 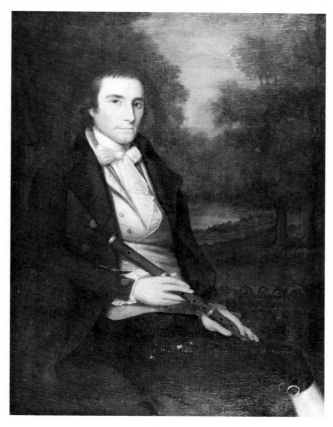

The Beardsley Limner. *Clarendon Dix*, c. 1795. Oil on canvas, 36⅛ x 28⅛ inches. Private collection.

Ralph Earl. *Philo Ruggles*, 1796. Oil on canvas, 48 x 34⅝ inches. Litchfield Historical Society, Litchfield, Connecticut.

accurate, but it is oddly effective, as its arms enclose the sitter and the apparent tilt of the seat inclines him toward the onlooker. The resulting portrait is one of the most natural and convincing images of childhood painted in the period.

The name of the Beardsley Limner may yet be found in the papers of one of his sitters. In addition to the fifteen works that have been attributed to him during the past twenty years, at least one other portrait—of an unnamed Dix brother seated in front of a window—is known but as yet unlocated. Our understanding of the Beardsley Limner is still evolving, and each new discovery increases the possibility of identifying this intriguing artist.

CHRISTINE SKEELES SCHLOSS

This chapter is based on the exhibition catalogue *The Beardsley Limner and Some Contemporaries* by Christine Skeeles Schloss. Williamsburg, Va.: Colonial Williamsburg, 1972.

Further Reading

LITTLE, NINA FLETCHER. "Little-Known Connecticut Artists, 1790–1810." *Connecticut Historical Society Bulletin*, vol. 22, no. 4 (October 1957), pp. 99–100, 114–17.

SCHLOSS, CHRISTINE SKEELES. "The Beardsley Limner." *Antiques*, vol. 103, no. 3 (March 1973), pp. 533–38. Adapted from 1972 Williamsburg catalogue.

JONES, KAREN M. "Collector's Notes." *Antiques*, vol. 113, no. 6 (June 1978), pp. 1244, 1246. Attribution of *Major Andrew Billings* to the Beardsley Limner by Christine Skeeles Schloss.

WOODWARD, RICHARD B. *American Folk Painting from the Collection of Mr. and Mrs. William E. Wiltshire III* (exhibition catalogue). Richmond: Virginia Museum, 1977, p. 19.

John Brewster, Jr.

1766–1854

The life of an itinerant painter, even under normal circumstances, was not easy 175 years ago; but if one could neither hear nor speak, the necessity of mingling with a constant flow of uncomprehending strangers must have magnified the ordinary hardships of a solitary traveler. Success in the specialized field of "face-painting" depended to a large extent on mutual agreement concerning pose, costume, size, and price. Many prospective clients might hesitate if the artist were unable to discuss these details in advance. It was possible, however, for a deaf-mute who had mastered certain basic natural signs and could communicate by means of the written word to be both independent and self-supporting.

John Brewster, Jr., was born a deaf-mute in Hampton, Connecticut, on May 30/31, 1766, a son of Dr. John Brewster and his first wife, Mary Durkee. He was the only member of his family so afflicted. Dr. Brewster was an eminent physician and a highly respected resident of Hampton Hill, and young John was reared in a cultured eighteenth-century household in company with seven brothers and sisters. His mother died when he was seventeen years old. Six years later Dr. Brewster married Ruth Avery of Brooklyn, Connecticut, and eventually four more children were added to the family.

The earliest known references to John Brewster, Jr., are in the manuscript diary of the Reverend James Cogswell of Scotland Parish, Windham, which is owned by the Connecticut Historical Society. As Dr. Brewster had been born in Scotland, Connecticut, it is not surprising to find John, Jr., accepting hospitality from the pastor of his father's boyhood home. Under the date of December 13, 1790, Reverend Cogswell made this revealing statement: "Doctr Brewster's Son, a Deaf & Dumb young man came in in the Evening, he is very Ingenious, has a Genius for painting & can write well, & converse by signs so that he may be understood in many Things, he lodged here." On February 7, 1791, occurs a second reference: "Brewster, the Deaf & D. young Man was at my House when I came Home. he tarried & dined here—he appears to have a good Disposition & an ingeneous [sic] Mind. I could converse little with Him, being not enough acquainted to understand his Signs. I pity Him—& feel thankful to God for the Exercise of my Senses." At this time Brewster was receiving instruction from the Reverend Joseph Steward, a successful self-taught portrait painter.

Several unsigned pictures by John Brewster, Jr., may be confidently dated before 1800, among them the double portrait of his father and stepmother, painted in Hampton, probably about 1795. A pair of portraits of Mr. and Mrs. James Eldredge of Brooklyn, Connecticut (colorplates), is closely allied to the painting of the senior Brewsters in pose, costume, and furnishings. The fact that Mrs. Brewster also came from Brooklyn suggests a friendly connection between the two families. The Eldredge pictures, which are dated July 5, 1795, on the letter in Mr. Eldredge's portrait, gain in dignity through the spaciousness of separate canvases. The stenciled floor or floorcloth is a decorative feature of the interiors in several of Brewster's early works.

The flesh tones in Brewster's first portraits were delicate, and the modeling subtle and restrained in comparison with his later work. His parents' pictures were painted on coarse, imported English linen which gives a pebbly surface to the finished picture. Sometimes he pieced his canvases horizontally and even used two different fabrics if it suited his convenience. Original frames vary so greatly that it would seem they were procured by the sitters, not supplied by the artist, as was often the case with other painters.

Four months after the painting of the Eldredge portraits, a family event took place that was to influence the future career of John Brewster, Jr. This was the marriage of his younger brother, Royal, to Dorcas Coffin on November 22, 1795, in the distant country parish of Buxton, Maine. Dorcas was the daughter of the Reverend Paul Coffin, pastor of the Congregational Church since 1761. Royal Brewster, following in his father's footsteps, became a physician and settled in Buxton. The young couple formally joined the Buxton church in 1796, and in 1798 they purchased their first lot of land in the community which Royal was to serve for nearly forty years. John accompanied, or soon followed, his brother and, between painting trips in Connecticut, seems to have made Buxton his permanent home.

Brewster was especially successful at painting small children, and three of his most beguiling studies are the full-length portraits of his tiny half-sisters, painted in Hampton, Connecticut, probably in 1800, and of two-year-old Francis Osborne Watts (colorplate). Francis was related through his mother to the prominent Lord family of Kennebunkport, Maine, of whom Brewster painted several handsome likenesses. As far as we know, he did not paint landscapes as such, but he did use them to good effect as backgrounds in a few of his compositions. The well-defined trees and rolling hills in the Watts picture make a charming backdrop that serves to accentuate the sturdy little figure with a bird perched on his finger. Although many of Brewster's pictures, especially the early

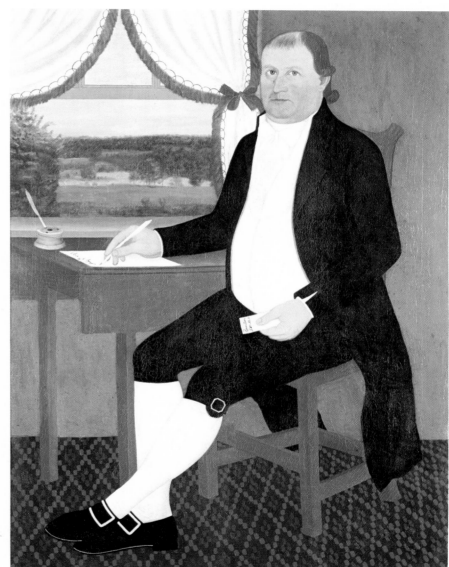

John Brewster, Jr. *Mr. and Mrs. James Eldredge (Lucy Gallup)*, 1795.
Oil on canvas, each 54 x 40½ inches.
The Connecticut Historical Society, Hartford.

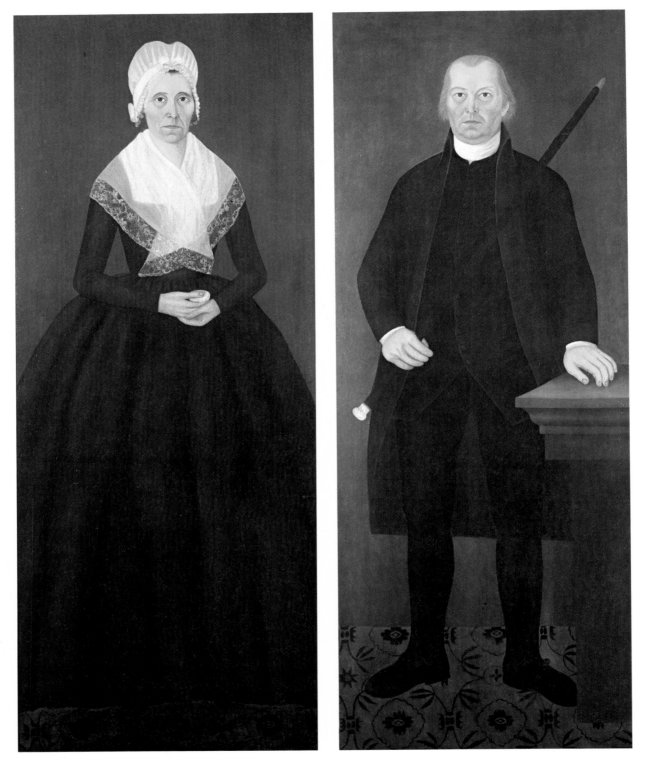

John Brewster, Jr. *Colonel and Mrs. Thomas Cutts (Elizabeth Scamman)*, c. 1795–1800.
Oil on canvas, each 74½ x 30 inches.
Dyer-York Library and Museum, Saco, Maine.

ones, were never signed, beginning with *Francis O. Watts with Bird* in 1805 he frequently penciled his name on the top stretcher.

On an early visit to Maine, Brewster painted the first two of a remarkable series of portraits of the Cutts family of Saco. Colonel Thomas Cutts was one of the most prominent merchants in Maine, and Brewster painted him and his wife, Elizabeth Scamman, life size, their somber countenances and uncompromising figures boldly outlined (colorplates). The colonel stands on a handsome floral carpet or floorcloth and holds his ivory-headed cane, which is still exhibited at the York Institute with the portrait. During the ensuing twenty years Brewster did other portraits in Saco, many of which are now in the collection of the York Institute and are believed to be younger members of the Cutts family.

During the late fall of 1801 Brewster traveled down the New England coast to the old Massachusetts town of Newburyport, where it seems likely that he had an introduction to James Prince, an influential man active in business, politics, and affairs of the church. Prince had recently purchased a handsome brick mansion on State Street, where Washington had been a guest in 1789 and where Lafayette would be entertained in 1824. Its many costly furnishings included two large Wilton carpets, India card tables, glass chandeliers, and five elegant looking glasses. In one chamber the curtains and upholstery were all yellow damask. Amid these luxurious surroundings John Brewster lived while in Newburyport, and here he painted outstanding portraits of James Prince and his four children.

The large double portrait of James and his son William Henry (colorplate) shows a letter lying on the portable desk dated *Nbpt., Novr. 24 1801*, and it is probable that the three companion Prince portraits were executed at the same time. Sarah Prince (colorplate), seated at her pianoforte, exhibits all the serene beauty that Brewster knew how to project so well on canvas. This charming portrait was painted when Sarah was about sixteen. The sheet music of "The Silver Moon," which she holds in her hand, was composed in Scotland by James Hook, and six editions were published in the United States between 1795 and 1800. This appears to be a manuscript copy of the romantic ballad, probably penned by Sarah herself. Brewster portrayed the other two Prince brothers as self-possessed and debonair young men (colorplate of James Prince, Jr.).

After completing the Prince family pictures, Brewster apparently decided to remain in Newburyport. On December 25, and again on January 22, 1802, he inserted his customary notice in the *Newburyport Herald*:

JOHN BREWSTER Portrait and Miniature Painter Respectfully informs the Ladies and Gentlemen of Newburyport, that if they wish to employ him in the line of his profession, he is at Mr. James Prince's where a Specimen of his Paintings may be seen. He flatters himself, if any will please to call, they will be pleased with the striking likeness of his, and with the reasonableness of his prices. N. B. If there is no application made to him within ten days he will leave town.

The first ten years of the nineteenth century were busy ones for Brewster, judging from the dated portraits that have survived. He painted a fine interrelated group of eleven portraits in Kennebunk and Kennebunkport and a miniature of Daniel Cleaves of Saco (illustration), which descended to the sitter's great-great-granddaughter in Kennebunk. Cleaves was born in 1771, son of a Danvers, Massachusetts, shipmaster and owner. He came to Saco in 1792, bringing five hundred dollars, which he invested successfully in real estate, and became one of the organizers of the first bank in Saco. In some of his newspaper notices Brewster advertised portraits at fifteen dollars and miniatures at five dollars. Only three miniatures have been discovered, recognizable through their similarity of technique to his larger works.

In the middle of April 1817, the Connecticut Asylum for the Education and Instruction of Deaf and Dumb Persons was formally opened in Hartford with a class of seven pupils. Among them were twelve-year-old Alice Cogswell, granddaughter of Reverend James Cogswell, and fifty-one-year-old John Brewster, Jr., the sixth pupil to be admitted. Many students at the asylum were in their teens or early twenties, and most of them were uninstructed in the rudiments of normal communication. This was not true of Brewster, who had apparently been taught to write and use signs when quite young. Moreover, he had been on his own, both professionally and financially, for many years. Most of the asylum's inmates were supported by friends, family, or the state from which they came; Brewster was one of the very few who supported themselves.

We may judge from the curriculum what Brewster hoped to learn. The asylum aimed "to impart language to its pupils, and through its instrumentality to establish social intercourse among themselves and with the rest of the world; to instruct the mind by means of signs, writing, pictures, the manual alphabet, artificial speech, and reading the lips." The first record book at the American School for the Deaf in West Hartford, as it is now called, contains the following information: "*Name*, John Brewster; *Residence*, Hampton, Conn.; *Time of admission*, Apl. 16, 1817; *Age*, 51; *Cause of deafness*, congenital; *Deaf and dumb relative*, none; *How supported*, himself; *Time under instruction*, 3 yrs.; *Remarks*, a portrait painter."

Early in 1820, Brewster returned to Saco, Maine, where he painted several additional members of the Cutts family in February and March of that year. At least ten portraits painted in 1820 and 1821 suggest a renewed enthusiasm and vigor, while greater depth and strength are apparent in his characterizations. Facial expressions became increasingly somber, and heavy shadowing more pronounced, though clarity and precision never diminished. Canvases were now fine-textured, and occasionally the gray priming applied to the fabric came through to the backs of the pictures. Throughout Brewster's life, exceptionally fine brushwork was the predominant element in his style. His rendering of facial expression was almost photographic in its intensity, and one feels that the total absence of audible communication between him and the people around him rendered him uniquely sensitive to the distinctive personality of each sitter. The latest dated examples of Brewster's

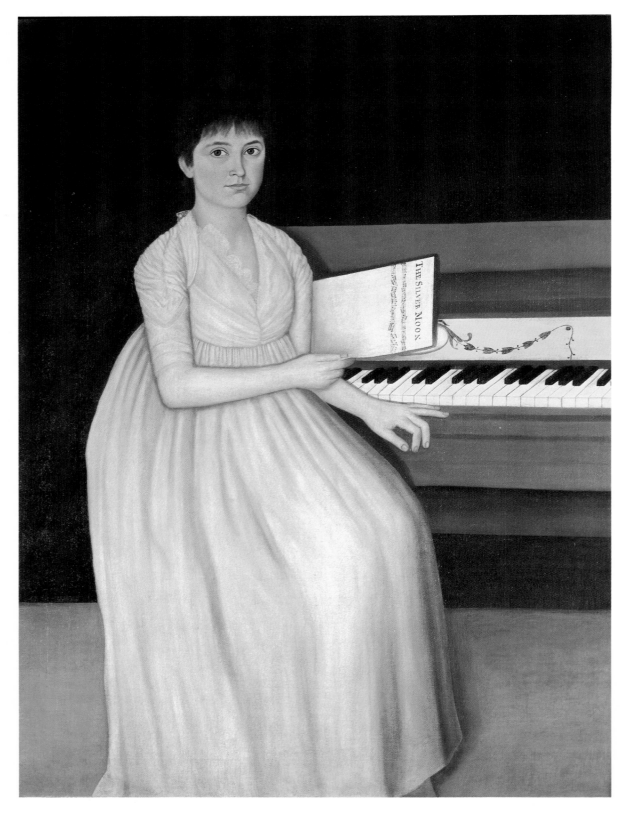

John Brewster, Jr. *Sarah Prince,* 1801. Oil on canvas, 52½ x 40 inches.
Collection of Mr. and Mrs. Jacob M. Kaplan.

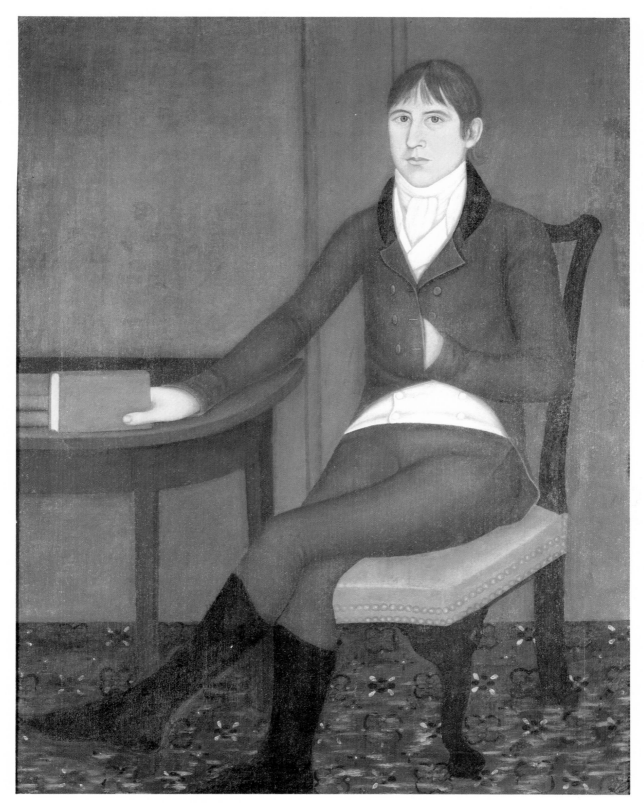

John Brewster, Jr. *James Prince, Jr.*, 1801. Oil on canvas, 52⅜ x 40 inches.
Historical Society of Old Newbury, Newburyport, Massachusetts.

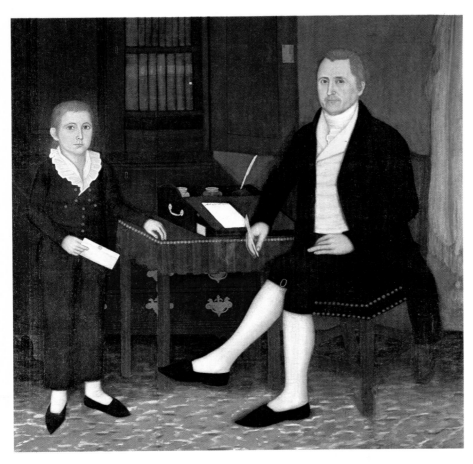

John Brewster, Jr. *James Prince and Son William Henry*, 1801.
Oil on canvas, 60⅜ x 60½ inches.
Historical Society of Old Newbury, Newburyport, Massachusetts.

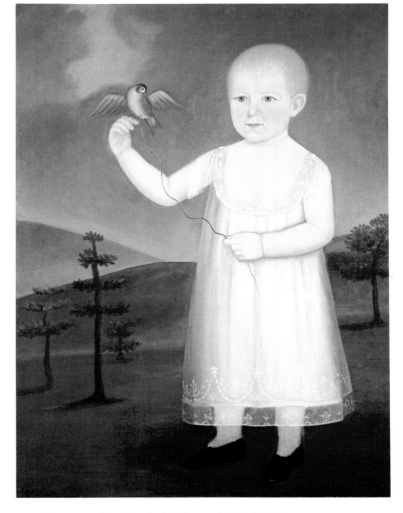

John Brewster, Jr. *Francis O. Watts with Bird*, 1805.
Oil on canvas, 35½ x 26¼ inches.
New York State Historical Association, Cooperstown.

work which I have seen are portraits of Mr. and Mrs. William Pingree of Denmark, Maine, painted in 1832, with hairdo and costumes that illustrate prevailing styles.

The deeds of York County, Maine, reveal no property registered in Buxton in John Brewster's name until 1833. Presumably he had always shared a home with his brother Royal's family. However, on March 18, 1833, Royal Brewster, Esq., for the sum of $3,500 paid by "John Brewster of Buxton, portrait painter," sold to said John eighty acres of land in Buxton "which constitutes the farm on which I now live." This was the original acreage bought by Royal in 1798, with the addition of two parcels of land purchased in 1800 and 1810. Royal died two years later, on March 20, 1835, and on July 28, 1835, John sold the same property back to the widow, Dorcas, for $1,000, thereby taking a loss of $2,500 within two years. No doubt other considerations were involved in this curious transaction, but no further elucidation appears in the county records.

Neither his father, Dr. John Brewster, at his death in 1823, nor any of the Buxton relatives felt it necessary to provide for the artist in their wills. We must assume, therefore, that Brewster was always self-supporting. Of the later years of his life we know nothing. He left no will or estate. His remains rest beside those of Dr. Royal Brewster and his children in Tory Hill Cemetery, behind the Congregational Church in Buxton Lower Corners near the square old Brewster family house that remains unchanged. A plain, rectangular headstone bears only the simple epitaph, "John Brewster Died Aug. 13, 1854 Aged 88," but his portraits are an eloquent expression of his life's accomplishment.

NINA FLETCHER LITTLE

This chapter is based on "John Brewster, Jr., 1766–1854" by Nina Fletcher Little in *Connecticut Historical Society Bulletin*, vol. 25, no. 4 (October 1960); reprinted in *Antiques*, vol. 78, no. 5 (November 1960), pp. 462–63.

Further Reading

WARREN, WILLIAM L. "John Brewster, Jr.; A Critique." *Connecticut Historical Society Bulletin*, vol. 26, no. 2 (April 1961), pp. 45–48.

John Brewster, Jr. Miniature of Daniel Cleaves of Saco, Maine, c. 1800–10. Location unknown.

Winthrop Chandler

1747–1790

Winthrop Chandler. *Self-Portrait*, c. 1789. Oil on canvas, 25¼ x 20⅝ inches. American Antiquarian Society, Worcester, Massachusetts.

The first appearance of the Chandler family in America occurred in 1637, when William and Annis Chandler settled in Roxbury, Massachusetts, with their four children. Their son John became in 1686 one of the first settlers of Woodstock, Connecticut, in company with the Gores, the Crafts, the Scarboroughs, and the Ruggles. A century later, John Chandler's great-grandson Winthrop would be closely connected with the descendants of these early Woodstock settlers. John Chandler, Jr., after a few years' residence in New London, also settled in Woodstock, where he was appointed town surveyor in 1703. His son, William, the father of Winthrop, was likewise a surveyor, but he also farmed a large acreage on the Woodstock and Thompson line. This high ridge of land, with its fine view to the east and west, was long occupied by successive generations of the family, and is still known as Chandler

Hill. Here William and his wife, Jemima Bradbury, reared a family of ten children, the youngest of whom they named for Jemima Bradbury's ancestor, Governor John Winthrop. Left a widow with a large family at the death of her husband in 1754, Mrs. Chandler managed her affairs capably, and according to the *History of Woodstock* (1926), "Her home was a colonial mansion."

Amidst the quiet solitude of Chandler Hill, Winthrop Chandler was born on April 6, 1747, and there he spent the greater part of the forty-three years of his life. Upon the death of his father, he and his eleven-year-old brother Henry were left the remaining part of the homestead after the older children had been allotted their share, "To be equally divided between them as soon as their Mother has done with it." On March 31, 1758, a court order directed that owing to the death of Henry in 1756, his share was to be divided between his heirs and his brother Winthrop, whose name is also found as a subscriber of thirty pounds to the church at East Woodstock in 1760.

In 1762, at the age when most boys were apprenticed in order to insure them both an education and a trade, he applied to the court for a guardian, as follows: "This may serve to inform that Winthrop Chandler, a minor aged about fourteen years, son to William Chandler late of Killingley, deceased, came before me and made choice of Samuel McClellan of Woodstock to be his guardian, and prays your worship to approve of the same and appoint him guardian. Attest Samuel Chandler, Justice of the Peace." In the *History of Worcester* (1862) is the statement: "He [Winthrop] studied the art of portrait painting in Boston." This interesting statement deserves further investigation. The application for a guardian indicates that Chandler must have been contemplating some course of action which necessitated such a move. Apprenticeship papers were required to be legally drawn, signed by both master and apprentice before witnesses, and to be registered with the town authorities. This may well have been the motive behind his choosing McClellan, his prosperous brother-in-law, as legal guardian at this time. Despite a careful search of many records, both in Massachusetts and Connecticut, no other evidence has been found to prove that Chandler studied in Boston or elsewhere. However, it is a fact that soon after the expiration of the usual seven-year term of apprenticeship (during which time there is no record of his whereabouts) Winthrop was in Connecticut, executing one of the most important commissions of his career, the portraits of Reverend Ebenezer Devotion and his wife. This would indicate that during the interim

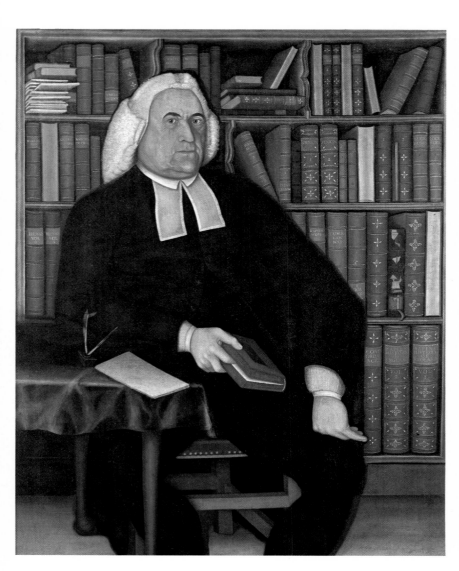

Winthrop Chandler. *Reverend and Mrs. Ebenezer Devotion (Martha Lathrop)*, 1770.
Oil on canvas, each 55 x 43¾ inches.
Brookline Historical Society, Brookline, Massachusetts.

he had received some professional training which would have entitled him to the notice of such an important personage. The diversification of Chandler's work, which also included gilding, carving, illustrating, and drafting, as well as portraiture, landscape and house painting, suggests that in some manner he attained versatility and competence in his chosen profession.

March 1, 1770, found Chandler in Woodstock, at which time he conveyed to his brother Samuel three tracts of land for the sum of seventy-eight pounds. On May 8, the Reverend Ebenezer Devotion, eminent clergyman, ardent politician, and beloved pastor of the Third Church in Windham (now Scotland), Connecticut, celebrated his fifty-sixth birthday. In honor of this occasion he and his wife, Martha Lathrop Devotion, sat for their portraits to their neighbor Winthrop Chandler, who had just turned twenty-three.

Winthrop Chandler. *Eunice Huntington Devotion*, 1772.
Oil on canvas, 52½ x 37 inches.
Lyman Allyn Museum, New London, Connecticut.

These paintings (colorplates) are the only ones so far known to me that bear the names and dates of the subjects. Expertly hand-lettered on the back of the canvas, perhaps by the artist himself, one inscription reads: *Ebenezer Devotion, natus Maii 8vo, 1714 O, S. Pictus Maii 8vo, 1770 N, S.* These portraits, the earliest by Chandler which can be definitely dated, are among his most powerful. The strong modeling of the face of the Reverend Devotion, with its piercing eyes and beetling brows, is outstanding, and although the hands display certain deficiencies of drawing—which is a definite characteristic of all of Chandler's work—they have strength and individuality. In the background stands a bookcase with gracefully shaped shelves and partitions between which one can discern the informal arrangement of a much-used library. The titles of the handsome calf-bound volumes are so clearly drawn that many of them can be recognized again in the sitter's inventory, and a few still remain with the portraits in the old Devotion House in Brookline, Massachusetts. The repeated use of books as backgrounds or accessories should be particularly noted as a distinguishing feature of many of Chandler's portraits.

Early in 1772, Chandler received his second commission from the Devotion family, this time from Judge Ebenezer, son of his previous patron. Ebenezer Devotion, Jr., was a prominent lawyer in Scotland, who in 1764 married Eunice Huntington, she being the third member of her family to marry a child of the Reverend Devotion. Eunice was painted in a gown which she later wore at a state dinner in Philadelphia during the Revolution. Her sister-in-law Martha Devotion (wife of Governor Samuel Huntington) also attended, and pieces of each of their dresses are still preserved. The full-length portrait of Eunice Devotion, holding her daughter Eunice on her lap (colorplate), has character and charm. A companion portrait of her husband is inscribed with the only date that appears on the face of any of Chandler's pictures: on a page of the Judge's ledger is found *Jany 13th, 1772*. Fortunately, most of Chandler's portraits retain their original frames. They are all very similar, usually consisting of a simple black molding, sometimes with a narrow gilt line on the inner edge.

None of the pictures at present known to me is signed with the artist's name, all previous attributions necessarily having been based on stylistic evidence or family tradition. Research, however, has brought to light the following clause contained in the will of Judge Ebenezer Devotion, drawn on November 2, 1827: "The seven *Family Pictures* painted by Chandler must be divided as justly as possible among my four surviving children." The seven pictures refer to those already mentioned and to portraits of Judge Devotion's three sons, Ebenezer, John, and Jonathan. These, therefore, provide the key for any further study of Chandler's work.

On February 17, 1772, Winthrop Chandler married Mary Gleason, the ceremony being performed by her father, the Reverend Charles Gleason of Dudley, Massachusetts. (This name has been spelled "Gleason" and "Glysson" by different members of the family. The spelling used by the person in question has been retained in each case.) Mary Gleason's mother was Bethiah Scarborough of Roxbury, Massachusetts, and her father came from Brookline,

Winthrop Chandler. *Homestead of General Timothy Ruggles*, c. 1770–75. Oil on canvas, 31½ x 62½ inches. Collection of Miss Julia T. Green.

where he had lived adjacent to the Devotions before they removed to Connecticut. In October 1772, Winthrop added to his holdings on Chandler Hill by purchasing thirty-three additional acres from his sister and brother-in-law, Mehitable and Ebenezer Crafts. Here he and his wife raised a family of five sons and two daughters during the next ten years.

The first of five deeds in which Chandler specifically designated his profession is recorded on April 1, 1774. In the conveyance from his brother Theophilus of thirty acres in Pine Swamp, he titled himself "Painter." From 1785 through 1788, however, he used the word "Limner," indicating the emphasis on portrait rather than on general painting.

During the early 1770s black clouds began to gather over the spirited New Englanders. Many families were bitterly divided in their feelings toward the coming conflict, none more so than the large Chandler connection. Theophilus Chandler moved back to Woodstock from Petersham with the comment, "There were so many Tories there." His eldest brother, the Reverend Thomas Bradbury Chandler, one of the most noted Episcopalian clergymen in the Colonies, sailed for England in 1775, not to return until ten

years later. One of Winthrop's first cousins was John Chandler, the "Honest Refugee," who departed for England never to return, while another cousin, Gardiner Chandler of Worcester, Massachusetts, professed Tory leanings which he finally disclaimed under pressure from the Committee of Correspondence. In his handsome house, which stood on Main Street in Worcester, the Tories gathered at the outbreak of the Revolution. Here, in 1773, he commissioned Winthrop to carve in pine the Royal Arms of George III over the hall fireplace. This unusual piece is executed in full relief, with the lion and unicorn supporting a quartered shield surmounted by the crowned lion.

In the summer of 1775, Chandler purchased nine acres of land in Woodstock, with house and barn, from one of his relatives, and he was still there in April of 1777 and in March of 1778. There seems to be no evidence that the artist took any active part in the Revolutionary War. He did, however, leave to posterity vigorous representations of two battle scenes, which are discussed with other of his landscape views. Two portraits that may date from about 1780 are those of his brother Samuel and Samuel's wife Anna (colorplates), who espoused the cause of their country as enthusias-

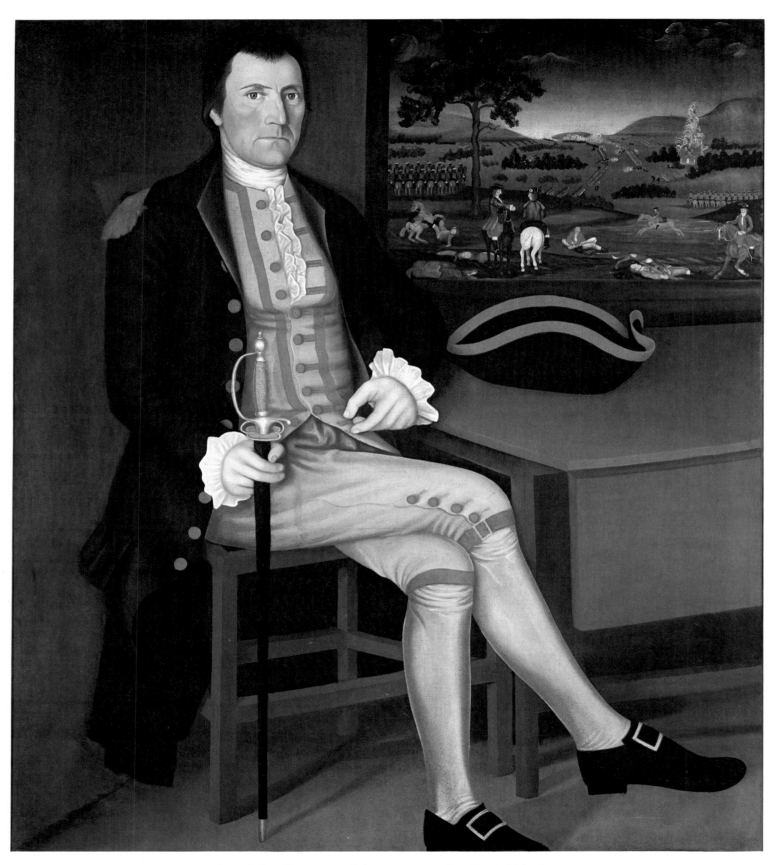

Winthrop Chandler. *Captain and Mrs. Samuel Chandler*, c. 1780. Oil on canvas, each 54¾ x 47⅞ inches.
National Gallery of Art, Washington, D.C.; Gift of Edgar William and Bernice Chrysler Garbisch.

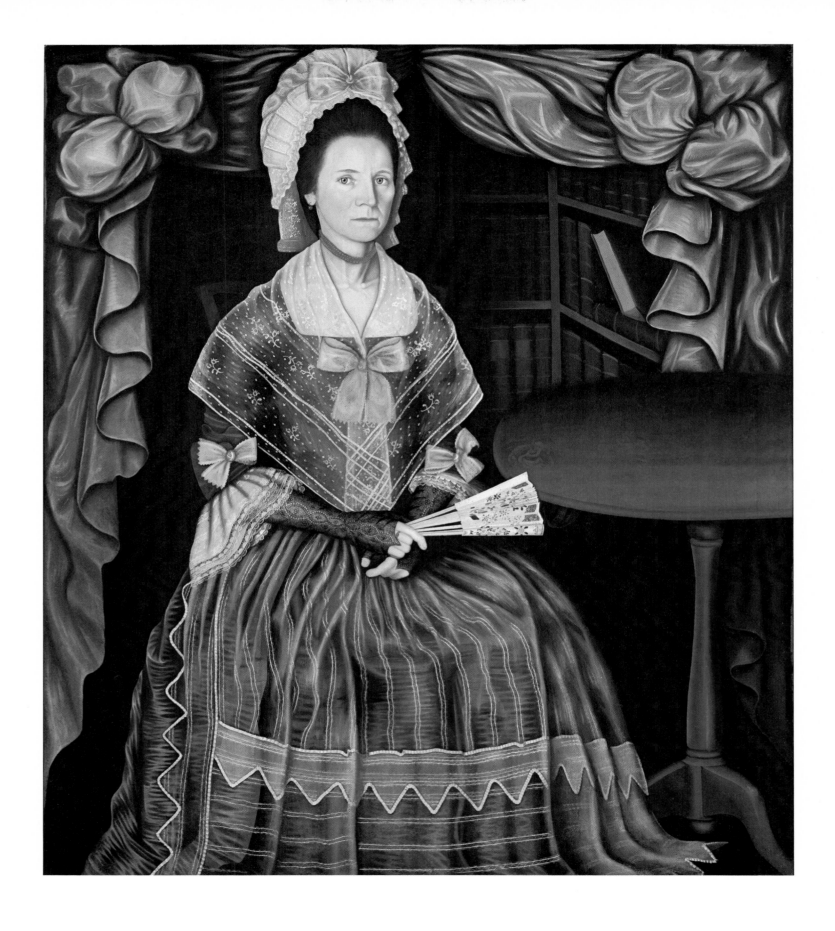

Winthrop Chandler. *Dr. William Glysson*, c. 1780–85.
Oil on canvas, 56 x 48 inches.
Ohio Historical Center, Columbus.

Winthrop Chandler. *John Paine*, c. 1786.
Oil on canvas, 32 x 29 inches.
Collection of Hamilton Child Paine and Prudence Paine Kwiecien.

tically as some of the Massachusetts Chandlers upheld the king. Samuel Chandler was placed in command of the 11th Company, 11th Regiment, in the Colony of Connecticut, and is portrayed in his captain's uniform, holding a sword with silver hilt of the type made by Jacob Hurd of Boston. With tight mouth and piercing eyes, he is one of the most striking of Chandler's figures. Anna Paine Chandler is shown with the familiar background of books, enframed by voluminous draperies similar to those in the elder Mrs. Devotion's portrait. Master John Paine (colorplate) lived as a child with his aunt, Mrs. Samuel Chandler. The little boy, with his straight back and direct gaze, is almost dwarfed by the high back of the Chippendale side chair.

Five portraits can be placed with fair certainty within the period 1780 to 1785, two of these representing Chandler's brother-in-law, Dr. William Glysson (colorplate), and his wife, Mary Kidder Glysson. The doctor, with silver-headed cane and spurs, is taking the pulse of an unseen patient who is shrouded within the privacy of a carefully curtained bed. His wife's portrait also includes their daughter, Bethiah Scarborough Glysson, born in 1775, who appears to be about five years old, giving a clue to the date of the picture. Bethiah eventually married William Pitt Putnam and traveled to Ohio in 1795, whither the portraits followed her and remain to the present day.

In 1775 occurs tangible evidence of the monetary difficulties that were to beset Chandler from this time until the end of his life. In the summer of that year an execution was entered against him by Nathaniel Blackmar of Gloucester, Providence County, Rhode Island, for the nonpayment of two pounds, seventeen shillings, and three pence. One acre of land was offered in payment, and after this had been appraised by a committee of three men (among whom was Samuel Chandler, "Attorney for the debtor") and

judged to be worth more than the debt, a settlement was accepted by the creditor. Meanwhile, Chandler continued to borrow from his relatives, not always being able to repay the loans. Notes varying from five to several hundred pounds appear in the estates of Theophilus, Gardiner, and Charles Church Chandler. One cannot help wondering if Chandler sometimes painted portraits in partial payment of his debts, as an examination of the estates of his sitters reveals not a single reference to the price paid for any of his paintings, although the paintings are specifically mentioned in a number of cases.

Perhaps in search of new fields for his talents, Chandler decided to move with his family to Worcester in the summer of 1785. He probably took up his new residence sometime before December of that year, for he sold considerable property during the summer. On December 8, in a transaction with one Calvin Chaffee, he appears for the first time as "Of Worcester." *The Chandler Family* records that he lived for a time in a rented house on Salisbury Street, but soon moved to one owned by Dr. Willard near the Common; Chandler kept a shop nearby, doing house painting as an extra means of livelihood. Here the family resided until 1789, but things did not go well for the Chandlers in Worcester. On March 29, 1786, they lost their son Charles, who died there at the age of six. He was buried from the home of his uncle Samuel Chandler in Woodstock.

No pictures can be definitely traced to the Worcester period, although Chandler's self-portrait (illustration) and that of his wife may have been done toward the end of his life, as they exhibit characteristics quite different from much of his early work. In the collection of the American Antiquarian Society, however, is a receipted bill in the artist's handwriting, dated 1788, for "Painting and gilding the vain and balls belonging to the Court House, the

laying on of 8 books of gold leaf at 2/ [shillings] per book" (illustration). This charge seems modest in comparison with that made by the firm of Rea and Johnston of Boston in the same year for gilding the weathercock on the Cambridge Meeting House, which cost Thomas Brattle six pounds, thirteen shillings.

In a further attempt to increase his funds, Chandler sold to his brother Theophilus on December 10, 1788, "30 acres in Thompson, being part of the place that Winthrop Chandler lately lived upon." In 1789, Mrs. Chandler became ill, and taking her furniture with her she returned to her parents in Dudley, where she died of tuberculosis on June 30 of that year. Chandler himself died in Woodstock on July 29, 1790, at the age of forty-three. With the breakup of the family, the children went to the homes of various relatives.

Only a passing reference has been made to the group of decorative landscapes which form one of the most interesting aspects of Winthrop Chandler's art. Probably dating before the Revolution is a view of the homestead of General Timothy Ruggles (colorplate), who was the father of Mrs. John Green, an ardent supporter of the king. This must have been painted before the general took refuge with the British in Boston in 1775, after which his large estate at Hardwick, Massachusetts, was confiscated. The details of this picture provide a starting point for the study of Chandler's views in relation to other artists' landscapes, many of which exhibit similarities of subject matter and arrangement. However, distinctive characteristics of Chandler's buildings, figures, and backgrounds are easily recognizable to the close observer of eighteenth-century landscape painting. To be particularly noted is the individual treatment of houses, always painted in bright colors, with window frames, cornices, and corner boards outlined in white, and doors in solid black. The canvas of the Ruggles homestead is crowded with figures, animals, and birds. Men and women in bright costumes and tricorn hats ride horseback or chat at the doorway. At the left two hounds are picking up the scent of a large hare disappearing in the bushes nearby. In the 1799 inventory of Dr. John Green this picture is listed and valued at thirty-three cents.

Landscapes painted on broad panels above a fireplace were to be found in many late eighteenth-century homes. Chandler did at least eight of these overmantels, of which a typical example is reproduced here (illustration). Although the majority of Chandler's overmantels were fanciful compositions, they combined familiar elements of the New England countryside with buildings and figures that suggest an acquaintance with English engravings of the period. Over the fireplace in the house that was originally the home of John Chandler in Petersham, Massachusetts, is a view said to be of the city of London. Another overmantel panel is in the house built in 1769 by General Samuel McClellan in South Woodstock, Connecticut. Here Chandler painted two shelves of books in the same manner as in his portrait backgrounds, the drawing and arrangement showing his usual care and accuracy.

Two Revolutionary battle scenes by Chandler are known, one of them supposedly a view of the Battle of Bunker Hill painted on a fireboard for Peter Chandler of Pomfret, Connecticut. Chandler's other Revolutionary scene appears in the background of the portrait of Captain Samuel Chandler, and because it is so carefully executed it deserves separate consideration with the group of larger landscapes. This perhaps represents one of the battles in which the captain took a prominent part as a company commander or it may have been included as a symbol of his military service.

Winthrop Chandler was one of the most important artisan-painters to emerge during the Revolutionary period, his uncompromising likenesses and linear compositions being little influenced by the conventional traditions of the academic English school. Like other of his New England contemporaries, Chandler combined portraiture and architectural decoration with such utilitarian pursuits as carving, gilding, and even some botanical illustrations. Although his talents were not appreciated during his lifetime, they have now secured for him a respected place in the annals of eighteenth-century American art.

NINA FLETCHER LITTLE

This chapter is based on "Winthrop Chandler" by Nina Fletcher Little in *Art in America*, vol. 35, no. 2 (April 1947), special issue.

Further Reading

FLEXNER, JAMES THOMAS. "Winthrop Chandler: An Eighteenth-Century Artisan Painter." *Magazine of Art*, vol. 40, no. 7 (November 1947), pp. 274–78.

LITTLE, NINA FLETCHER. "Recently Discovered Paintings by Winthrop Chandler." *Art in America*, vol. 36, no. 2 (April 1948), pp. 81–97.

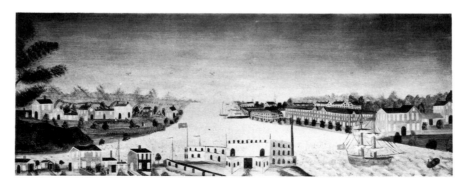

Winthrop Chandler. *Island Fort*, overmantel from the Ebenezer Waters House, West Sutton, Massachusetts, c. 1779. Oil on wood, 18 x 47½ inches. Collection of Bertram K. and Nina Fletcher Little.

Rufus Hathaway

1770–1822

The country doctor was a familiar figure throughout New England during the eighteenth and nineteenth centuries. Journals, account books, and early town histories indicate, however, that the majority of men engaged in several occupations at the same time and often followed more than one trade. The person who was able to provide almost any service for his neighbors—from building their homes and repairing their shoes to settling their estates and carving their headstones—has vanished with the modern trend toward specialization, and we do not realize that the storekeeper was sometimes a gravestone cutter or that the physician might also be a farmer and a limner.

It is said by his descendants that painting was Rufus Hathaway's first profession, and his earliest known portrait was signed with initials and dated in 1790, when he was only twenty. Several years later he arrived in Duxbury, Massachusetts, on horseback as an itinerant painter, but upon his marriage to the daughter of a prominent Duxbury merchant, Hathaway was persuaded by his father-in-law to take up medicine as offering a more secure future for himself and his family. Although all subsequent references speak of him as a physician, he continued to paint when occasion offered, and he also did wood carvings, including at least one eagle. The personal details of his life are hard to ascertain and must be pieced together from family and local traditions, and from factual data contained in deeds and probate records, which are meager at best. Fortunately his pictures survive. As the work of his hand and the expression of his creative ability they must remain his most personal memorials.

Rufus was of the seventh generation from Nicholas Hathaway of Dorchester, Massachusetts, who became one of the original purchasers of Taunton, Massachusetts, in about 1640. His son John had been born in 1629 and lived in Taunton. There followed, in direct descent, John, Ephraim, and another John, all born in Freetown, Massachusetts.

Asa, son of the last John and father of Rufus, was born in Freetown on August 1, 1744, and on September 21, 1769, was married to Mary Phillips by the Reverend Ebenezer Crane. Records of the birth of Asa's seven children are not entered, as far as I can ascertain, in Freetown, Swansea, Somerset, or Taunton, or in Bristol, Rhode Island, but it is believed that the artist was born in Freetown on May 2, 1770. In his will, dated October 18, 1816, Asa left one dollar to each of his six living children, with Rufus, the first-born, heading the list.

Some of the earliest information concerning Rufus as an artist comes by way of a pair of portraits of the Reverend Caleb and Mrs. Phebe King Turner, of which his is signed *In anno 1791, Aetatis suae 58. Rufus Hatheway, Pinx.* Reverend Turner was pastor of the church in Middleborough and Taunton Precinct from 1761 until his retirement in 1801. His picture is the first so far ascribed to Hathaway that bears his complete signature. In this instance he spelled his name with *e* instead of the usual second *a*. Mrs. Turner's "effigy," framed in a wide, marbleized bolection molding, is a compelling study that evokes the stark quality of a tombstone carving (colorplate).

From the same early period is the remarkable portrait *Lady with Pets*, dated 1790, of which the identity of the sitter is uncertain (colorplate). The choice and arrangement of symbolic elements is unlike anything known in Hathaway's later work and results in an exceptionally bold and decorative linear pattern.

On December 10, 1795, Rufus married Judith Winsor, daughter of Joshua Winsor and his first wife, Olive Thomas. The ceremony was performed in Duxbury by the local pastor, Reverend John Allyn, who became a lifelong friend of the young couple. Family tradition avers that a romantic prelude led up to this event. Mr. Winsor is said to have asked Rufus to paint portraits of two of his daughters, Lucy, who was twenty years of age, and Judith, who was then seventeen. While painting Judith the young man fell in love with her, and they were married the following December. Rufus then abandoned painting as a career to study medicine with the eminent Dr. Isaac Winslow of Marshfield. He became in later years the only physician in Duxbury.

The portraits of Judith and Lucy Winsor, with their tall hats, long curls, and black neckbands, show costumes typical of the mid-1790s. Long white gloves were a popular accessory of the day, and several of Hathaway's ladies, including Judith, are wearing them. Shipping merchants sometimes sent, along with their regular cargoes, individual consignments to be sold for the benefit of someone at home, and Joshua Winsor on one occasion sent to England a special box of fish on behalf of each of his three daughters. The "ventures" were successful and from the proceeds one of the girls bought a ring, one a pair of long white gloves in which she wished to be painted (this was presumably Judith), and one the silk for her wedding gown.

Hathaway also painted likenesses of his father-in-law and his young brother-in-law Seth Winsor. About the same time he did a

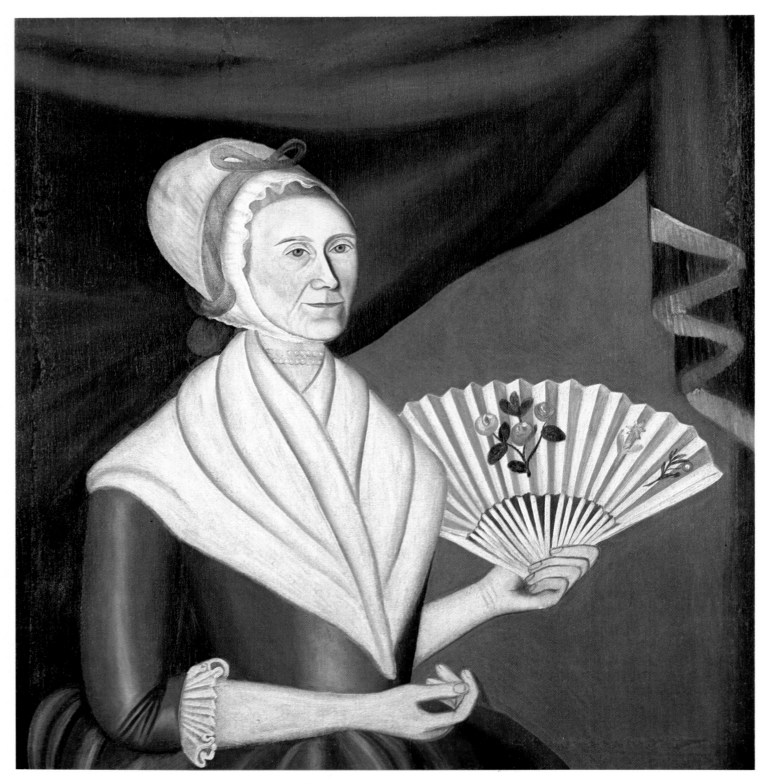

Rufus Hathaway. *Mrs. Caleb Turner (Phebe King)*, 1791. Oil on canvas, 39 x 38 inches.
Old Colony Historical Society, Taunton, Massachusetts.

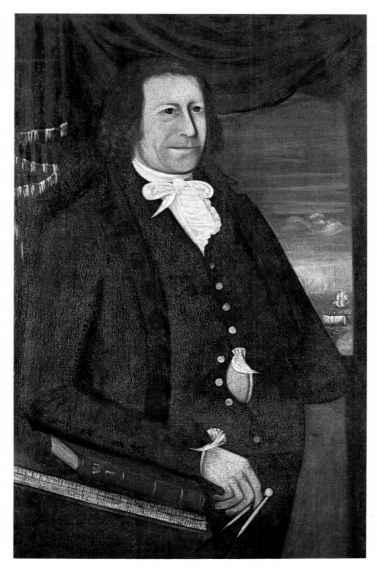

Rufus Hathaway. *Ezra Weston (King Caesar)*, c. 1793.
Oil on canvas, 38 x 25 inches.
Collection of Bertram K. and Nina Fletcher Little.

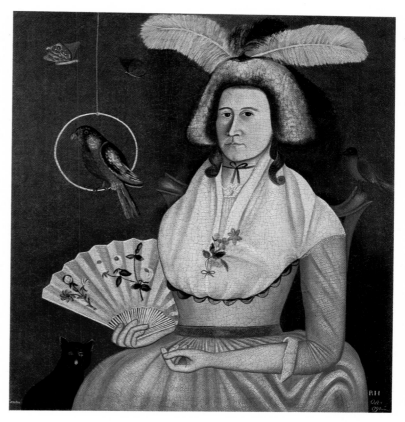

Rufus Hathaway. *Lady with Pets*, 1790.
Oil on canvas, 34¼ x 32 inches.
The Metropolitan Museum of Art, New York;
Gift of Edgar William and Bernice Chrysler Garbisch.

delightful view of the Winsor homestead, with its adjacent wharves and ships in the bay (colorplate). In the foreground we see Joshua himself carrying a bunch of keys to signify his ownership of the storerooms and warehouses which were only a part of one of the largest fishing enterprises in Duxbury.

Another famous merchant, for whom Hathaway painted ten family portraits, was Ezra Weston, or "King Caesar," as he was popularly known in the town. From 1764 until 1842 he and his son Ezra, Jr., carried on a very large shipping business, with more than one hundred vessels under their ownership at one time, which earned for them the listing by Lloyds of London as "the largest shipowners in America." They built vessels from timber grown on their own land in Duxbury, made cordage in their own ropewalks, sails in their own lofts, and anchors in their own forge. Their ships sailed to all parts of the world, provisioned with produce from the Weston farms. Hathaway has preserved for posterity the likenesses of "King Caesar" and his wife; of Mr. and Mrs. Ezra Weston, Jr., and their three children; of Mr. and Mrs. Sylvanus Sampson (daughter and son-in-law of "King Caesar") and their son, Church Sampson—three generations of one of Duxbury's most prominent families. Ezra Weston (colorplate) is portrayed holding the "gauging rod and calipers" that were valued at four dollars in his inventory, and several of his vessels are shown in the background window view. According to Hathaway's bill of 1793 (illustration), which includes this and other family pictures, the price of the portrait was one pound ten shillings, plus six shillings for painting and gilding the frame.

In 1798, Washington Street, now the main thoroughfare of Duxbury, was planned by Ezra Weston, Joshua Winsor, Seth Sprague, and Samuel Delano, who were bitterly opposed by other factions in the town. Eventually they petitioned the Court of Sessions, which upheld their case; but to complete the road, it was necessary to build a bridge over the Bluefish River, and this was also strongly opposed by a majority of citizens because of an estimated expense of three thousand dollars. After considerable agitation at a town meeting, work was begun in April of 1803 and rushed to completion by July 3. On the Fourth of July the bridge was formally opened with a parade and a sumptuous collation, which it is believed went a long way toward restoring good feeling among all concerned. The bridge was impressively decorated, and a temporary arch was erected, for the top of which Rufus Hathaway carved out of wood a large and handsome spread eagle.

Hathaway also painted miniatures, but to what extent can now only be surmised. Four examples have thus far been recorded, one of Colonel Briggs Alden of Duxbury, which appears as the frontispiece of Justin Winsor's *History of the Town of Duxbury* (1849), and a self-miniature of the artist, now lost. A third miniature is privately owned, and the fourth (illustration) is on ivory and depicts Thomas Winsor, younger brother of the artist's wife. According to an inscription on the reverse of the frame, this miniature was painted in 1797, when Thomas was seventeen years old.

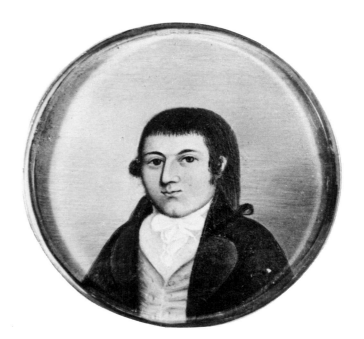

Rufus Hathaway. *Thomas Winsor*, 1797. Oil on ivory, 2⅜ inches in diameter. Collection of Bertram K. and Nina Fletcher Little.

Hathaway's bill for painting the Weston family portraits, 1793. Collection of Bertram K. and Nina Fletcher Little.

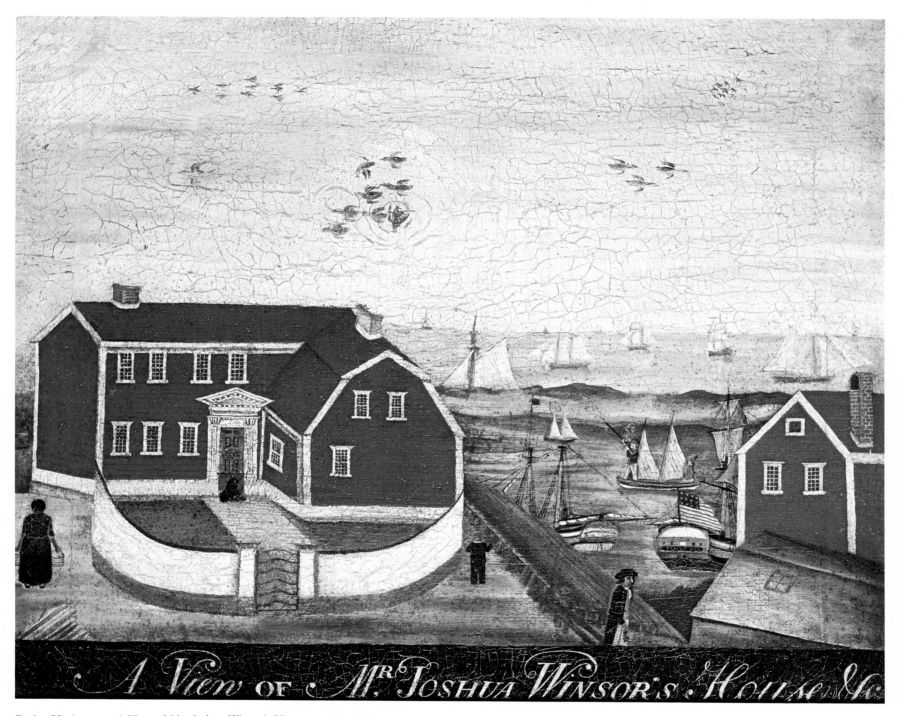

Rufus Hathaway. *A View of Mr. Joshua Winsor's House*, c. 1795. Oil on canvas, 23¼ x 27½ inches.
New England Historic Genealogical Society, Boston.

On quite a different scale is a representation of a pair of peacocks that was painted as an overmantel decoration for the old John Peterson House on Powder Point in Duxbury. This panel (illustration) was removed when the house was demolished shortly after the Civil War and was for many years installed in the home of the late Dr. Abbott Peterson in Duxbury.

Twelve children—five boys, six girls, and an infant who died—were born to Rufus and Judith Hathaway between 1796 and 1821. The house in which they lived, originally the property of Mrs. Hathaway's father, is no longer standing. On February 13, 1815, Joshua Winsor executed five most interesting and nearly identical deeds, conveying to his three daughters and two of his sons the houses in which they were then living, "in consideration of natural love, goodwill and affection." The property of each daughter was valued at two thousand dollars and consisted of houses, outbuildings, and a small parcel of land; in the case of Judith Hathaway, this amounted to one quarter of an acre.

A mark of professional recognition, and an honor which must have pleased Dr. Hathaway, came to him during the last year of his life. In 1822 he was elected an Honorary Fellow of the Massachusetts Medical Society. He died on October 13, 1822, at the age of fifty-two. His personal estate was small, totaling $416.18. Of this amount a windmill and land were assessed at $200.00, and a "shed for shaise, stable, hay loft and hogsty" were valued at $100.00. He left no will, but his inventory lists the usual appurtenances of a simple but comfortable home replete with feather beds, tables, chairs, candlestands, looking glasses, and a clock and silver watch. Of particular interest is his medical library, worth $40.00, with "family ditto [library?]" listed at $9.75; medicine and bookcase, $5.00; two pocket cases containing surgical instruments and medicine, $10.00; and a thermometer and tooth drawers at $1.00 each. References to paintings or artist's equipment are disappointingly absent, but one entry which lists "carved work and picture hangings, $4.50" is provocative. Taken in conjunction with the eagle which his granddaughter says he carved for the arch over the Bluefish River Bridge, I believe that we are safe in assuming that "carved work" indicates that he did wood carving as well as painting. "Picture hangings" may refer to the moldings for his frames, which he apparently made himself.

Rufus Hathaway is buried with other members of his family in a lot near the road in Duxbury's Mayflower Cemetery. On his stone is carved an epitaph which is thought to have been composed by himself:

Thousands of journeys night and day
I've traveled weary on my way
To heal the sick, but now I'm gone
A journey never to return

Hathaway's paintings are compelling likenesses of some of the prominent men and women who lived in Plymouth County during the last decade of the eighteenth century. Despite their wealth, they wear costumes that are simple and conservative in color. No lace or bowknots adorn the severe fichus, and jewelry is at a minimum. Rufus Hathaway's pictures mirror truthfully, one feels, the character, strength, and individuality of his sitters.

NINA FLETCHER LITTLE

This chapter is based on "Doctor Rufus Hathaway. Physician and Painter of Duxbury, Massachusetts. 1770–1822" by Nina Fletcher Little in *Art in America*, vol. 41, no. 3 (Summer 1953), special issue.

Further Reading
LITTLE, NINA FLETCHER. "Rufus Hathaway." *Art in America*, vol. 42, no. 3 (October 1954), p. 223.

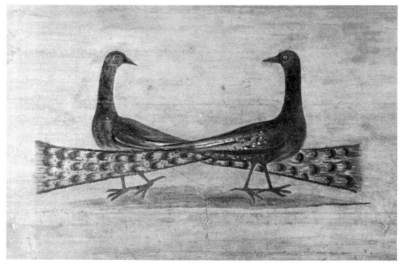

Rufus Hathaway. Overmantel for John Peterson House, Duxbury, Mass., c. 1800. Oil on wood, 30 x 57 inches. Collection of Ann P. Vose.

Pieter Vanderlyn

c. 1687–1778

In the first half of the eighteenth century there flourished for a brief generation a whole troupe of artists who worked in the vicinity of Albany in the Province of New York. At this time Albany was in every sense a metropolis, marking the dividing line between the Indians' wilderness kingdom and the land that the Dutch and English colonists had settled and cultivated. The years of greatest painting activity were encompassed by the uneasy peace between two colonial wars—Queen Anne's, which ended with the Treaty of Utrecht in 1713, and King George's, which began in 1744. Between these wars the freeholders of Albany and surrounding towns were the patrons of at least eighteen painters, who produced almost one hundred and fifty pictures known today. In many ways it was the most extraordinary flowering of the craft and profession of painting in any colonial city on this continent.

In 1967, when a seminar on the limners of the Upper Hudson was held in New York City, not one of the artists was known by name. Of the ten portrait painters, the earliest was called the *Aetatis Sue* Limner (active c. 1715–25); both he and the Wendell Limner (active c. 1734–37) were believed to have been British professionals. I attributed a third distinctive group of portraits, painted about 1730–45, to the Gansevoort Limner (so named for his subjects among the Gansevoort family) and suggested that he was Dutch or of Dutch descent.

Descendants of some of the Gansevoort Limner's subjects believed that the artist who created the pictures was Pieter Vanderlyn, who came to New York in 1718 and was the grandfather of the nineteenth-century artist John Vanderlyn. Following this local tradition, portraits of Kingston subjects owned by that town's Senate House Museum have always been recorded as the work of Pieter Vanderlyn. In Waldron Phoenix Belknap's *American Colonial Painting: Materials for a History* (1959), two portraits belonging to descendants of the sitters are illustrated, with the artist identified as Pieter Vanderlyn. The Kingston Senate House Museum's portrait of Helena Sleight is attributed by Belknap to Vanderlyn with a question mark after his name.

Doubts concerning the attribution of the Gansevoort Limner's work to Pieter Vanderlyn were raised in comparatively recent years, when several art historians suggested that Vanderlyn might be the De Peyster Limner, who worked in and around New York City about 1715–45. The styles of the De Peyster and Gansevoort groups are totally distinct, and this essay proposes that, in keeping with the Kingston traditions, Pieter Vanderlyn and the Ganse-voort Limner are one and the same; there follow some additional considerations and evidence to support this claim.

To modern eyes the sensitivity, sure skill, and careful technique of the paintings attributed to Pieter Vanderlyn overshadow the work of his contemporaries. His subjects were, for the most part, members of a prospering middle class rather than the patricians who had been the patrons of the somewhat earlier *Aetatis Sue* Limner. Many of the Albany subjects—Gansevoorts, De Wandelaers, Winnes, and Douws—were descendants of middle-class families, as were the Vroomans, Mynderses, Wynkoops, and Sleights of Kingston. Even as Vanderlyn set to work, earlier class distinctions among the Upper Hudson Dutch were being blurred by intermarriage and a common interest in preserving Dutch custom.

Neatness, simplicity, and economy of expression are qualities that characterize Vanderlyn's style. While faces and figures are two-dimensional, the artist achieved richness of expression by planning each composition as a unified design in which the face is the dominant feature. Almost all the faces are shown in three-quarter view, divided down the center from eyebrow to mouth in a curious manner that appears to be the artist's way of giving plasticity to his flat, almost Oriental style. The stilted—occasionally awkward—poses and gestures are nonetheless distinctive, and give these works a monumental repose.

Hands tend to be overly large with fingers and nails carefully articulated. The men and boys wear no wigs, and hair is wispy and fine. With one or two exceptions, dress is contemporary to the period. The women's gowns, many in a similar style and painted in a similar way, show laced bodices, muslin aprons, and soft belts with long, free ends falling over the skirts. An occasional use of a wreath or basket of flowers and a long drapery in the background hints at the influence of the mezzotint that was so obvious a feature in the design of earlier colonial portraits. There is richness and variety in the warm browns, reds, pinks, greens, and blues that the artist favors. Paint is applied with restraint and is very thin. Pattern appears in the leaves of trees painted like loops of ribbon, in vigorously or gently striped gowns, in waistcoats of delicate lace and fine fabrics, in jewels, and in the full-blown roses held by most of the women.

Twelve of the portraits have landscape backgrounds, most of them unusually interesting scenes of mountains, fleecy clouds, marshes, brooks, and rivers. The Hudson is depicted in the portrait of young Pau de Wandelaer (colorplate). It shows a typical

Pieter Vanderlyn. *Adam Winne*, 1730. Oil on canvas, 32 x 26½ inches.
The Henry Francis du Pont Winterthur Museum, Winterthur, Delaware.

Hudson River sloop; tied to it is one of the flat-bottomed bateaux used to take cargo and passengers to and from shore. The name Pau is not listed in De Wandelaer family records, but it is probably a diminutive for Pieter, oldest son of Johannes and Lysbeth Gansevoort de Wandelaer, baptized on September 20, 1713.

Fourteen of the twenty known subjects attributed to Pieter Vanderlyn are children or young men and women. Deborah Glen was seventeen in 1737, the approximate date of her portrait (colorplate). Vanderlyn probably painted her while in Glenville—named for Deborah's father Jacob Glen—near the juncture of the Mohawk and Hudson rivers. The remaining portraits of adults are evenly divided between men and women; one woman holds her infant daughter on her lap. Seven of the eight inscriptions found on these works are in the same hand, marked by even, well-formed letters and elaborate capitals. The eighth inscription, *B.V.—1720* coarsely printed on the portrait of Barent Vrooman, is almost certainly an addition transcribed by a later writer from an original inscription. (The date was probably copied incorrectly, for Vrooman, born in 1709, would have been only eleven in 1720; 1730, the earliest date on other Vanderlyn paintings, is more likely the right one for this young man's portrait.)

With the exception of two English words—*February*. on a 1733 portrait and *years* on one dated 1745—the inscriptions are in Latin and Dutch. It is the inscriptions along with a newly rediscovered document that help to establish these works as Vanderlyn's. The document, located in the course of my study, is a song—seven verses in Dutch—signed by Pieter Vanderlyn. It provides a formal and extended sampling of the artist's cursive hand and a valuable means for comparison with the inscriptions in the same hand that appear on the paintings (see illustrations).

There exists in the Kingston State House Library a manuscript biography of the painter John Vanderlyn, written by his friend and fellow townsman Robert Gosman. According to this document Vanderlyn's grandfather Pieter was born in Holland about 1687. New York records show that he was admitted to the Reformed Dutch Church in New York in 1718; it is remarked there that he was "van Curaçao." Less than two months later, banns of marriage were announced between him and Gerretjen Van den Berg of Albany; they were married a month later, on August 8, 1718, in New York City. By act of the New York Council, Vanderlyn became a naturalized citizen of the English province in June 1719.

In September 1719, their only child, Elizabeth, was baptized; between that date and June 1722, Gerretjen Van den Berg died and Pieter moved up the Hudson. On June 20, 1722, he was married to Gertruy Vas, the daughter of Petrus Vas, the dominie of the Kingston Dutch Church. In the marriage record both are listed as Kingston residents, and it is noted that they were born in Holland. Pieter and Gertruy became the parents of the first of their children, Nicholas, baptized in Kingston on December 8, 1723. (Nicholas in turn became the father of John Vanderlyn.)

The earliest accurate date on a portrait attributed to Vanderlyn is 1730, the subject being Adam Winne of Albany (colorplate). Late

Sixth and seventh verses of hymn tune "Wie Schon Leucht' Uns Der Morgenstern" with Vanderlyn's signature. The Senate House State Historic Site, Palisades Interstate Park Commission, New York State Office of Parks and Recreation.

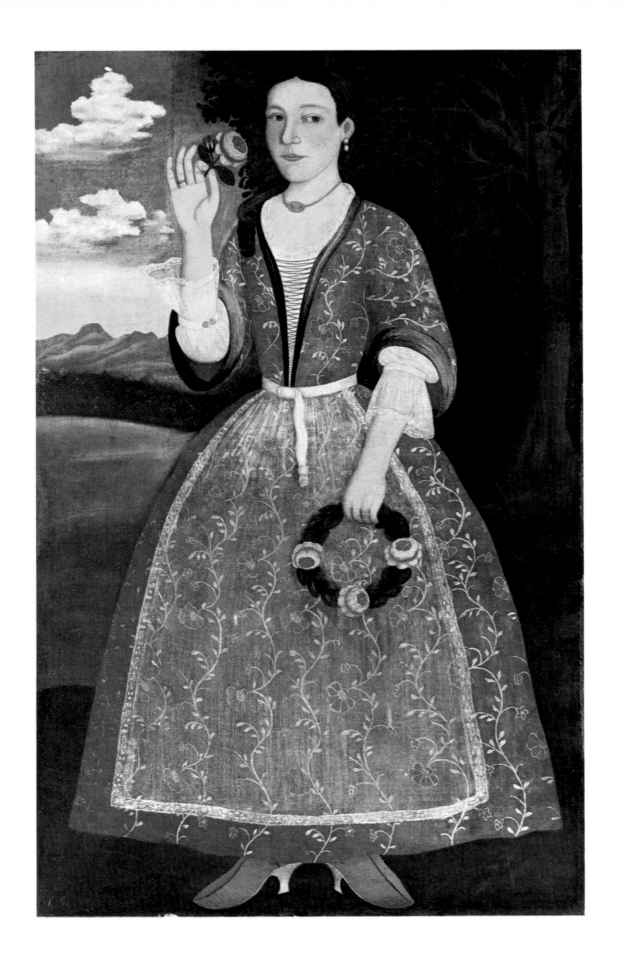

in 1730 Pieter Vanderlyn was listed as one of two firemasters in the second ward in Albany that also included in its lists the names of Leendert Gansevoort and Johannes de Wandelaer. Vanderlyn's portraits of these families and of other Albany residents—Susanna Truax and Barent Vrooman—appear to have been painted about this time.

By 1733 Vanderlyn was back in Kingston, and all but three of his identified portrait subjects in and after that year lived there or in nearby towns. Two portraits of boys—Pieter Elmendorf and his cousin Matthew Ten Eyck—are dated 1733. A portrait of Magdalena Veeder of Schenectady dates from about 1735, and about 1737 the portraits of Deborah Glen and of a girl of the Van Rensselaer family indicate his presence in the Albany area once more.

Vanderlyn was in Kingston between 1740 and 1745 and completed a portrait of Helena Sleight, dated 1745. Another of the subjects of this period was the assistant pastor of the Dutch Church, George Wilhelm Mancius. Vanderlyn's original portrait is lost, but a copy by John Vanderlyn now hangs in the entrance hall of the church. There are no known portraits in the familiar style after 1745, although Pieter himself lived until 1778, remaining in Kingston until 1777, when, as the city was burned by the British, he left it forever to trudge on foot to the house of his son Jacobus in Shawangunck.

In order to develop the story of Pieter Vanderlyn's career as a portrait painter in the Albany and Kingston areas, an explanation had to be found for John Vanderlyn's belief, stated in the Gosman biography, that Pieter was the author of the portrait of his step-mother-in-law, Elsje Rutgers Schuyler Vas. That portrait, painted in 1723, is now attributed to her kinsman Gerardus Duyckinck. Family tradition has always been that there was a companion portrait of her husband, Dominie Petrus Vas, that was lost in the Kingston fire of 1777. The likely explanation seems to be that the portrait of Petrus Vas was indeed by Pieter Vanderlyn, painted after 1723 as a companion to Gerardus Duyckinck's portrait of Mrs. Vas.

My discovery of Gerardus Duyckinck's death and burial in Kingston in the summer of 1746 sets up a direct family link between the Duyckincks of New York and Mrs. Vas, their New York-born Kingston relative, her husband—the dominie of the Dutch Church—and Pieter Vanderlyn, the dominie's son-in-law, who was also choirmaster in the Dutch Church and occasionally its acting minister.

The colonial portrait painters of the Hudson River Valley—Pieter Vanderlyn, the four Duyckincks (Evert, Gerrit, Gerardus, Evert III) of New York, John Watson, and the unidentified limners in New York City known only by their characteristic styles—influenced each other and the following generation of painters in New York, most notably Abraham Delanoy, half-cousin to the Duyckincks, and John Durand. Delanoy and Durand provide a direct connection between the Upper Hudson River Valley painters and the late eighteenth-century Connecticut folk artists who, beginning with Winthrop Chandler, became the leading producers of folk portraits in the new republic. In turn, the Connecticut painters directly influenced artists like John Brewster, Jr., J. Brown, Ammi Phillips, and Erastus Salisbury Field. It is through this link that the prolific colonial painters of America continued to inspire folk painters for a century after they themselves had disappeared from the scene.

MARY BLACK

This chapter is based on "Limners of the Upper Hudson" by Mary Black in *American Painting to 1776: A Reappraisal*. Ian Quimby, ed. Charlottesville, Va.: University of Virginia Press for Winterthur Museum, 1971, pp. 217–49.

Further Reading

HASTINGS, MRS. RUSSELL. "Pieter Vanderlyn. A Hudson River Portrait Painter." *Antiques*, vol. 42, no. 6 (December 1942), pp. 296–99.

FLEXNER, JAMES T. "Pieter Vanderlyn, come home." *Antiques*, vol. 75, no. 6 (June 1959), pp. 546–59.

BLACK, MARY. "The Gansevoort Limner." *Antiques*, vol. 96, no. 5 (November 1969), pp. 738–44.

Pieter Vanderlyn. *Deborah Glen*, c. 1737. Oil on canvas, 57½ x 35⅜ inches. Abby Aldrich Rockefeller Folk Art Center, Williamsburg, Virginia.

(continued)

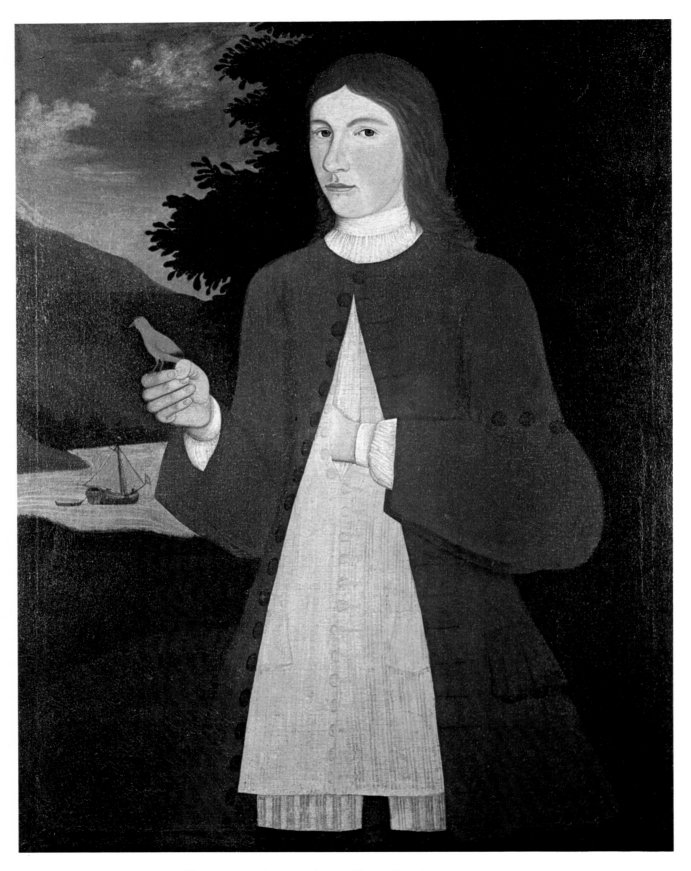

Pieter Vanderlyn. *Pau de Wandelaer*, c. 1730. Oil on canvas, 44⅞ x 35⅜ inches.
Albany Institute of History and Art; Gift of Mrs. Abraham Lansing.

19th
Century

José Rafael Aragón

c. 1795–1862

José Rafael Aragón was one of a small number of artists who lived and worked in the northern mountain and valley communities of Spanish New Mexico during the eighteenth and early nineteenth centuries. These folk artists concentrated on creating religious images for use in the village church and homes. Sculptors carved their works (*imagen de bulto*, or more simply, *bulto*) from local woods, such as cottonwood root or ponderosa pine, and covered them with gesso (*yeso*), an artists' plaster. The image was then painted with water-based pigments made from supplies found in the area or imported from Mexico. New Mexican painters preferred to work on wood panels, despite the availability of imported fabrics. The paintings (*retablos*) were first sized with gesso and then painted with the same water-based pigments used by sculptors. These techniques, as well as the subject matter, derived from the long Spanish tradition of polychromed wood. New Mexican artists often drew inspiration and compositions from religious prints imported from Mexico, but their style was unique. Freedom of drawing, boldness of line, sharp and inventive color contrasts, imaginative decorative motifs, harmony of abstract form, are hallmarks of New Mexican folk art, and few artists employed these techniques with greater verve or assurance than José Rafael Aragón.

The historical records of the church, records of births and deaths, bills needing payment, and inventories of goods owned offer a glimpse of Aragón's long and productive career. The first record of this artist is found in North America's oldest capital city, Santa Fe, on July 19, 1815, when he was married to María Josefa Lucero. Three years later he pledged a contribution to the Cofradía de Nuestra Señora del Rosario, a lay religious organization. Like most young artists, Aragón probably had financial problems, for despite his pledge he failed to pay. By 1823 he was living in the Barrio de San Francisco—apparently a woodworkers' district in Santa Fe—with his wife and children. They lived near his in-laws, some of whom were carpenters, and near another artist, the *escultor* Anastacio Casados.

In the 1823 Santa Fe census, Aragón refers to himself as an *escultor*. The natural assumption is that he was a sculptor, but during the same period this term was used in direct relation to painting by two other New Mexican painters, José Aragón (no known relation to José Rafael) and Molleno. One *retablo*, for example, bears the inscription, *Pitado* [sic] *En el Año De 1845 por El escultor Molleno* (Painted in the year 1845 by the sculptor Molleno); while another reads, in part, *Se pinto A[ve?] de Maria de 1835 en la esculteria de José Aragón* (Painted, [praise?] Mary in 1835 in the sculpture workshop of José Aragón). Obviously there is something in the work process of the New Mexican folk artist that we do not yet fully understand, making his terminology difficult to interpret.

The separate roles of the carver and the painter of the carving are well documented in both Latin American guild requirements and Spanish artistic treatises. Perhaps New Mexico was closely allied with its colonial neighbors and with Spain in that the carver and the painter of the carving were separate people working together in a specialized workshop, as the use of the term *esculteria* strongly suggests. Although New Mexico had no formal *gremios* (guilds), it seems that many occupations functioned under a loosely organized workshop system. It seems possible that in nineteenth-century New Mexico *escultor* referred to one who worked in an *esculteria*, whether he was a painter or a carver. However, we cannot eliminate the possibility that an artist like José Rafael Aragón had equal facility in painting and carving: there are sculptures that appear to be painted by the same hand and with the same pigments as the *retablos* now attributed to him.

One of Aragón's first major commissions must have been an altar screen in the Church of San Lorenzo at Picuris Pueblo near Santa Fe, painted in tempera and clearly in his style. Judging from descriptions of the church interior written by visiting Mexican prelates, the altar screen was done sometime between 1818 and 1826. Around 1835 the artist's career expanded with a move to a new home in the village of Quemado (now Cordova, New Mexico) in the Santa Cruz Valley. The artist went there to join Josefa Cordova, whom he married following the death of his first wife. At about this time he completed and signed the main altar of Quemado's Church of San Antonio de Padua (illustration).

Within the Santa Cruz Valley José Rafael Aragón found support for his growth as a master painter. The main church of Santa Cruz and the neighboring village churches provided stable patronage, and for them Aragón created monumental altar screens. These were huge frames into which individual wood panels were fitted and the whole then gessoed and painted in tempera. It appears that Aragón also supervised the creation of entire decorative schemes, including altar screens, sculpture, paintings, and decorative accessories, for churches or chapels. Aragón's reputation traveled and he with it: moving up the valley of Santa Cruz and through the mountain villages, he completed projects for just about every church in the area: Santa Cruz, El Valle, Truchas, Chimayo,

Interior of the Church of San Antonio de Padua, Cordova (formerly Quemado), New Mexico, photographed c. 1935. The main altar was signed by Aragón about 1835 and much of the statuary has been attributed to him. Courtesy of the Photo Archives of the Museum of New Mexico, Santa Fe.

essential since only handhewn lumber was available until the second half of the nineteenth century. (Aragón used sawmill lumber when it began to be produced in New Mexico, thus giving us one means of dating his later works.) There also would have been a worker in gesso who was responsible for obtaining the necessary mineral supplies for both pigments and gesso, as well as preparing the wood surfaces and mixing the needed pigments. With a dozen extant altar screens, some three hundred panel paintings, and countless sculptures attributed to Aragón, he would certainly have had one or two assistants working directly with him as painters. These helpers might have been his sons (according to baptismal and census records Aragón had twelve children and was survived at the time of his death by three of them). He would have supervised their work closely, establishing the original design scheme, offering advice as work proceeded, and stepping in to do the final finishing work. This procedure would have been especially true of altar screens; the small *retablos* would have been left more often to individual assistants and therefore exhibit the greatest variations. These many hands and multiple projects would tend to confound the identification of a consistent Aragón style.

The signed *San Calletano* offers a standard against which other paintings can be judged. It is a work of control, color, and balance, and it bears striking details which are useful in tracing the hand of the artist—the drawing of fingers, eyebrows, and ears, and the handling of special areas of shading. The same details appear with little variation in other *retablos*. While *El Alma de la Virgen* (colorplate) shares many of the characteristics of the signed panel, its overall effect is broader and bolder. *La Huida a Egipto* (colorplate) takes this freedom further still with its looseness of drawing and surprising juxtaposition of red, white, and blue.

Some paintings, however, are so far from the hallmarks of the signed example that it is difficult to conceive they could be by the same hand. Nor, in all probability, are they. Some scholars have reasoned that these strays are the work of one son, Miguel Aragón, whose presence in Quemado in 1867 has been documented. The large number of paintings that deviate from the standard suggests the existence of at least one if not more followers. The altar screens exhibit the same variations found in the *retablos*, no doubt for the same reasons. The altar screens also vary because each was created in keeping with the architectural features of a particular church, as well as the special requirements of donors and patrons.

One of Aragón's most knowledgeable and demanding patrons was Cura Don Juan de Jesús Trujillo, who served as the spiritual guide for the Roman Catholic Church in Santa Cruz from 1838 until 1869. These dates closely coincide with Aragón's career there. The artist's association with the overall decoration of the great church of Santa Cruz was long and complex, providing one of the few documented cases of commissioned work thus far unearthed from the vast church records of New Mexico.

Although today the town of Santa Cruz seems small and serene, it was once rivaled only by Santa Fe in the number of *vecinos*, or Spanish members, it had among its congregation. Cura Trujillo also oversaw religious life of residents in neighboring villages, such

Hernandez, Pojoaque. In the Taos area, too, he worked on an altar screen for the citizens of Llano Quemado.

Besides the altar screens that are signed or linked to Aragón by contemporary documents, numerous *retablos* have been attributed to him. There is, however, only one signed panel painting, that of San Calletano (colorplate). The signed works range from tight, highly controlled compositions with areas of carefully balanced abstract forms to painterly and, at times, almost sloppy compositions. Such variations have led to the practice of attributing staggering numbers of paintings as well as sculptures to this single artist. Several factors may account for this range of styles. First, Aragón had a long career. There is documentary evidence that he was active for more than forty years, from some time after his first marriage in 1815 until his death in January 1862—time enough for his style to develop and change. Furthermore, Aragón certainly ran a workshop. (On a ceiling beam in the Duran Chapel near Taos he signed himself *maestro*, indicating that he was the master, or director, of a workshop.) A speculative reconstruction of the way such a workshop functioned shows how this system of artistic production could result in works of great numbers and variety.

As a *maestro*, Aragón might have had working for him a carpenter who would hew the lumber necessary for altar screens and fit the structures into place as well as adz lumber in preparation for panel paintings and statuary. The duties of the carpenter would be

José Rafael Aragón. *El Alma de la Virgen (The Soul of the Virgin)*, c. 1840–60.
Tempera and gesso on wood, 11⅜ x 8½ inches.
Loan from the Spanish Colonial Arts Society, Inc.,
to the Museum of International Folk Art, Santa Fe, New Mexico.

José Rafael Aragón. *San Calletano (Saint Cajetan of Thienna)*, c. 1830–50.
Tempera and gesso on wood, 11 x 8 inches.
Loan from the Spanish Colonial Arts Society, Inc.,
to the Museum of International Folk Art, Santa Fe, New Mexico.

José Rafael Aragón. *La Huida a Egipto*
(The Flight into Egypt), c. 1850.
Tempera and gesso on wood, 20½ x 8⅞ inches.
Museum of International Folk Art, Santa Fe,
New Mexico; Charles D. Carroll Bequest.

as Chimayo, Truchas, and Aragón's village of Quemado, who came to the Santa Cruz Church. Understandably, the church had to be large in order to accommodate this population. Rarely has simple adobe mud been made to perform in such extraordinary ways as for this church (illustration). Surrounded by intricately textured walls, it had heavy buttresses of mud and delicate crenelations along the top near its twin towers. Many of these features have been lost or altered in the continual process of destruction and rebuilding that characterizes all adobe construction in the Southwest. Within and attached to this fortress of a church were various chapels (illustration). Typically, each chapel had an altar screen, an altar table with sculpture or other decorative objects on it, and perhaps paintings and other decorations hanging nearby. A chapel was dedicated to a saint or member of the Holy Family: all the objects within it were related to that personage and worked together to render the greatest honor possible. In creating art for the chapels of Santa Cruz and other churches, Aragón found his greatest means for expression.

In Spanish New Mexico the many costs of caring for the church, paying the salaries of sacristans and musicians, holding services and festivities, and aiding members, were frequently borne by various confraternities (*cofradías*). Annual dues were collected from members, and each confraternity was responsible for sponsoring certain events or maintaining parts of the church. It was also quite common for a confraternity to establish a chapel within the church, paying for its creation and decorations as well as its upkeep. The most active among the confraternities in Santa Cruz seemed to be the one dedicated to Nuestra Señora del Carmen. The accounts for this popular organization reveal the role that the confraternity played in the patronage of religious art. It paid for the services of the artist ("*En dos Angeles que hiso Rafael Aragón siete pesos cuatro r^s*"—"For two angels by Rafael Aragón seven pesos, four reales"); but it was Cura Trujillo who recorded the transaction and who most likely supervised the work. The "two angels" are probably the two large painted images of archangels beneath the main altar screen at Santa Cruz. Payment for these paintings was made in 1860, two years before Aragón's death.

In an 1867 inventory of property belonging to the Santa Cruz Church, a document that seems intended as a summary of his long career, Cura Trujillo specifically noted the artistic projects "made in my time." We learn that there were seven altar screens in the church (today Santa Cruz has three), but how many of these were the work of the artist José Rafael Aragón is not known. The altar screen now on the south transept in the Chapel of the Third Order of St. Francis is attributed to him, as is a panel showing Nuestra Señora del Carmen. The panel was once part of an altar screen said to have been in Santa Cruz Church. The lack of precise information about this panel is tantalizing, because Trujillo tells us that in the chapel to Nuestra Señora del Carmen there were sculptures by

Aragón for which he received payment that covered the cost of his burial.

The Cura Trujillo and Aragón were in harmony in their dedication to the service of the Divine, but the uncluttered life of devotion as it was lived in New Mexico was radically transformed after annexation by the United States. Outside elements entered Spanish New Mexican communities and challenged a centuries-old way of life. As increasing numbers of Anglo-Americans came to the new territory seeking commercial profit, the fabric of life among the insular villages of northern New Mexico was strained. In 1860, Cura Trujillo lists among the payments of the Cofradía de Nuestra Señora del Carmen: *"En tres Angeles que biso un Irlandes quinse p⁰"* ("For three angels made by an Irishman fifteen pesos"). What effect the art of the newcomers would have on the look of the church can be surmised from the Victorian Gothic decorations that invaded New Mexican structures in the late nineteenth century. José Rafael Aragón's death in 1862 marks the passage from the old to the new. With him went traditional religious art in the Santa Cruz Valley. The spell of harmony in the architecture, art, and life of Spanish New Mexico was broken.

CHRISTINE MATHER

Further Reading

CARROLL, CHARLES D. "Miguel Aragon, A Great Santero." *El Palacio*, vol. 50, no. 3 (March 1943), pp. 49–64. Works now attributed to José Rafael Aragón were first published, by this author, under the name of Miguel Aragon.

BOYD. E. *Saints and Saint Makers of New Mexico.* Santa Fe: Laboratory of Anthropology, 1946, pp. 45–53.

ESPINOSA, JOSÉ E. *Saints in the Valleys.* Albuquerque: University of New Mexico Press, 1960, pp. 67–70.

BOYD. E. *Popular Arts of Spanish New Mexico.* Santa Fe: Museum of New Mexico Press, 1974, pp. 392–407.

PIERCE, DONNA. "The Holy Trinity in the Art of Rafael Aragón: An Iconographic Study." *New Mexico Studies in the Fine Arts*, vol. 3 (1978), pp. 29–33.

Exterior and main altar of the Santa Cruz Church, photographed c. 1880–84. Courtesy of the Photo Archives of the Museum of New Mexico, Santa Fe.

James and John Bard

1815–1897 1815–1856

Although the graceful sailing vessel and the mighty ocean liner have been more attractive as subjects for most marine artists, the less imposing river steamboat and lowly towboat have not been entirely neglected. Posterity, therefore, can pay tribute to the few modest self-taught artists like James Bard of New York, whose lives were devoted to portraying these lesser craft.

As with other folk artists, James Bard made no pretense at competition with his more academic contemporaries. His self-appointed task was to depict a given vessel as faithfully as possible. Had his inability to place these vessels in realistic surroundings embarrassed him, he might have accomplished far less. As it is, he has left behind an enviable record as an American folk artist, and since his pictures faithfully describe better than words the steamboats of his day, he deserves equal credit as a marine historian.

James Bard had a twin brother, John, who collaborated with him for the first twenty years of his professional life. John Bard deserves a place in a definitive history of the Bard brothers, such as he receives in A. J. Peluso's book *J. & J. Bard: Picture Painters* (1977). For the purpose of this article, I will give John Bard only a passing glance, concentrating on his more successful brother. I refer the reader to Mr. Peluso's book for more complete biographical details on the Bard brothers, quoting here only James Bard's obituary, which appeared in the April 1, 1897, issue of *Seaboard* magazine. It is interesting that his death received notice only in a marine journal, and also that the writer was Samuel Ward Stanton, a fellow steamboat artist, historian, and friend.

Mr. James Bard, the last of New York's oldtime marine artists, died at his home in White Plains, N.Y., on Friday last, March 26, in his 82nd year. He survived his wife but a short time, she having passed away on January 5 of this year. Mr. Bard was born in 1815, in a little house overlooking the Hudson, in what was then the suburban village of Chelsea; his early home stood on the land which is now bounded by 20th and 21st streets, and 9th and 10th avenues, New York City. His twin brother, John, died in 1856. Mr. Bard leaves a daughter, Ellen, to mourn his loss, she being the youngest and only surviving member of six children. Mr. Bard made his first painting in 1827, finishing in that year a picture of the *Bellona*, the first steamboat owned by Commodore Vanderbilt, with whom he was well acquainted. From 1827 to within a few years of his death Mr. Bard made drawings of almost every steamer that was built at or owned around the port of New York, the total number of these productions being about 4,000. Probably Mr. Bard was without a parallel in the faithfulness of delineation in his drawings of vessels. His methods of work, the minuteness of detail, and the absolute truthfulness of every part of a steamboat which characterized his productions, cannot but cause wonder in these days of rapid work. His pictures were always side views, and this often made faulty perspective, yet a Bard picture will ever be held in esteem for its correctness and the beauty of drawing.

Living during the time of the days when shipbuilding at this port was the greatest of any in the country, and when myriads of beautiful river, sound and ocean craft were turned out every month, Mr. Bard with his talent, had opportunities of becoming acquainted with all of the leading shipbuilders and vessel owners in the days before the [Civil] war. He knew them all, and was held in high regard by them, and shipbuilders have said that they could lay down the plans of a boat from one of his pictures, so correct were they in their proportions. Before making his drawing, Mr. Bard would measure the boat to be pictured from end to end, and not a panel, stanchion or other part of the vessel, distinguishable from the outside, was omitted; each portion was measured and drawn to a scale.

His life work is finished, and the world is richer for it. Were it not for the pictures to be found here and there—and now fast disappearing—we would not know what beautiful specimens of steam vessel architecture our forefathers were capable of turning out. No one in his time compared with James Bard in the matter of making drawings of vessels, and his name will ever be associated with the lists of artists of this country who make a specialty of painting pictures of vessels. In the art he was the father of them all.

This tribute to James Bard is plainly indicative of a contemporary esteem. Such enthusiasm would naturally wane, however, and the memory of Bard perhaps be lost but for the fact that many of his paintings have found their way into various museums and private collections. Some 450 Bard works are known—extant, sighted, or somehow recorded. It seems difficult, therefore, to give credence to Stanton's statement that Bard paintings and drawings numbered as many as four thousand. To be sure, this could have been possible, for if James Bard had devoted fifty active years to painting and John Bard twenty years, they could have accomplished it by producing about one picture a week. Unquestionably the mortality of Bard works has been high, but four thousand still seems an inflated figure.

Early works were usually signed *J. & J. Bard*, thus indicating collaboration on the part of the two young men. More than two dozen of the presently known paintings were done by the brothers, probably the latest one being of the steamboat *Wilson G. Hunt*, dated 1849. The signature *J. Bard, Painters* on a few of the pictures also documents their working together.

In signing much of his own work, James Bard usually included his complete address as well, a practical note obviously designed to

James and John Bard. *DeWitt Clinton*, c. 1830.
Watercolor on paper, 23¾ x 36 inches.
The Mariners Museum, Newport News, Virginia.

James Bard. *Saratoga*, 1881.
Oil on canvas, 29 x 53 inches.
The New-York Historical Society.

bring more clients to his door. This serves to inform us, for instance, that after 1854 James Bard was living at 162 Perry Street, in lower Manhattan, appropriately near the downtown docks along the Hudson River. In later years, more secure in his reputation, he used his address less frequently.

Bard's pictures of vessels bear so much resemblance to mechanical drawings that it has been conjectured that he might have been a shipyard draftsman or copied draftsmen's work. We know he frequented the shipyards that constructed the vessels he painted. The dates of many of his paintings coincide with the dates of building of the vessels, and in one case he made a drawing of the *Jacob H. Vanderbilt*, the name of which was changed to *General Sedgwick* before the vessel was completed. However, there is no evidence that he was actually employed by the yards as a draftsman, and there are reasons to question the theory that he copied from working drawings. We know that he actually took measurements from the hull of the steamboat *City of Troy*. George W. Murdock, engineer on that vessel, told Edwin M. Eldredge, steamboat historian, of having held the tapeline for Bard when the latter was securing data for his drawing. Further reason to believe in the originality of Bard's work is indicated by the complete lack of a standard scale. It is evident that he established a scale for each drawing. He seems to have begun with a sketch of the ship's hull up to the main deck, choosing whatever length suited his paper, his fancy, or his client's specifications. Then he divided the length of the main deck into equal sections, based on the actual length of the vessel. Thus, if it should measure 180 feet long, he divided his drawing into eighteen equal sections. Marks along the guards, indicating this practice, may be seen in many of his drawings. One of these ten-foot sections (usually the third or fourth from the bow) was divided into ten equal spaces to give an even foot measurement; in a few instances he divided his scale into half-foot lengths.

The theory that Bard did not copy plans seems to be further substantiated by the many scratch notes that appear on his unfinished drawings (illustrations). The following are quoted from his drawing of the double-ended steam ferry *Southfield* (1882–1912):

Smoke Pipe 26 ft. long 3½ Sections/The windows are 3 ft. 9 inches long 3 lights in them/Skylight is only 20 inches from Center Back of the Pilate House/Brass rail is 4 ft. 6 in. above round skylight deck

This is obviously indicative of James Bard's meticulousness. Since it was his particular aim to produce an absolutely correct drawing, he hastened to promise correction when a mistake was discovered in any of his preliminary studies. For example, on the drawing of the ferry *Jay Gould*, built in 1868, he wrote:

This Side House is too Short by 6 ft. as the Extra Window is not made which is 16th one/There is 6 ft. more room wanting for the name place or 6 ft. more distance between the windows where the name is/The Smoke pipe is not in the right place as it is 24 ft. from its Center to the Center of Beam Frame/the other parts of the draft of Cabin stair House is right and so is the Steam Pipe and wistle also right yet I will show the pipe so as to draft on the Canvasses

James and John Bard. *Robert L. Stevens*, c. 1836.
Oil on canvas, 22 x 35½ inches.
The Mariners Museum, Newport News, Virginia.

The word "canvasses," of course, refers to the oil paintings he contemplated as the finished product. This brings us to a further consideration of Bard's procedure. We may assume that, having carefully worked up his drawing on paper, he submitted it to his client for corrections and approval, upon the receipt of which he proceeded with the painting of the final work.

Apparently Bard did his coloring in the studio and not from life, for his drawings also include copious color notes arrowed in to the actual objects to be so colored. Sometimes, however, he would write a separate paragraph for his own guidance, such as the following, quoted in part from the drawing of the towboat *Eliza Hancox*:

The Bits are green. The deck rail is flesh couler, the Fender or guard is Indian red. Blinds in Pilate House yellow. Whell [wheel] tops yellow, upper deck yellow. Working Beam is oak

Generally Bard's finished work was in oil on canvas, although sometimes he would merely color the preliminary drawing itself with watercolor or tempera. There are also drawings which have been shaded faintly with crayon.

The proud builders, captains, and owners of the vessels Bard painted were his principal clients. In some cases the client had his own name painted on the canvas. Witness the portraits of the steamboat *Thomas Hunt*, "painted for Captain A. H. Haggarty," and the Hudson River schooner *Robert Knapp*, "painted expressly for Captain James Lawson." Another Bard client was Thomas Collyer, builder of the *Henry Clay*, for whom Bard painted a steamboat portrait inscribed "Presented to Palmer Crary by Thomas Collyer, N. Y. Oct. 1, 1851." Crary was the engineer of the *Henry Clay*. The *Calhoun* painting was "Presented to Wm. Headding by his friend Albert Degroot, 1857." Peluso covers the artist's clients thoroughly in his book on the Bards.

James Bard. *Wiehawken*, 1868. Oil on canvas, 14 x 34 inches.
Museum of the City of New York; The Andrew Fletcher Collection.

The characteristics of a James Bard painting are so definite that little skill would be required to recognize one of his unsigned paintings. An avoidance of any but the simplest perspective is typical. Never did he attempt a bow or quarter view of a vessel, always picturing the craft from the broadside and, with the exception of some of the earlier works done in collaboration with his brother, invariably from the port side. Thus his boats steam from right to left. None is shown at anchor or alongside a wharf. In the case of side-wheel vessels, his most common subjects, his point of perspective was usually taken from slightly forward of the paddlebox. Anything in the ship's construction that called for perspective drawing was apparently rather difficult for him to handle convincingly. When steering wheels show through pilot house windows, they generally appear as though mounted fore and aft instead of athwartships.

The most noticeable and perhaps the most charming Bard hallmark consists of a unique stippling of the water at the ship's bow which, for want of a better term, I call the "bubbly bow." For a considerable area ahead of his vessels, the water seems to bubble like soda water. This same effervescent treatment is seen in the backwash of the paddle wheel and in the ship's wake. In some paintings depicting a rougher sea, the same style is used in handling breaking waves, although generally Bard steamboats sail placid waters.

The backgrounds usually represent river scenes, as might be expected since so many of the subjects were Hudson River craft. A typical Bard vessel stands out in vivid white, silhouetted against crude river shores, much as would a beautiful prima donna against

an amateur stage set. The masses of ill-defined trees and lofty hills are dotted occasionally with two-dimensional houses appearing as if cut out and carelessly pinned in place. Nearly all are of the same size regardless of how far away they should appear. This gives the impression that Bard worried little about the effect of his backgrounds. We might almost credit him with purposely creating neutral sets upon which splendid boats like the *Wiehawken* and the *Saratoga* (colorplates) might stand out in contrast. Or perhaps it was the unself-conscious achievement of a folk painter who, just because he was not concerned with realism of backgrounds, attained remarkable decorative design.

It is always interesting to note exceptions to the general rule. For instance, an early J. & J. Bard painting shows the steamboat *Robert L. Stevens* (colorplate) in far from usual circumstances. Instead of placidly steaming through calm waters, she is depicted as if crashing through thick ice, her frail paddle wheels effortlessly breaking rocklike chunks of ice into small bits.

Only once, as far as is known, did Bard depart from the environs of the Hudson River for his background. This was in a portrait of the steamer *Jay Cooke*, shown against what must be the island called Gibraltar in Put-in-Bay, Lake Erie. It is assumed that the mansion shown on the hillside beyond the vessel is the summer home of Jay Cooke himself, noted Philadelphia financier and owner of the steamer. We wonder whether James Bard went to Put-in-Bay to make this picture, or if he had a drawing to follow.

Twenty of Bard's known works depict sailing craft, seventeen of which are schooners; two depict the Hudson River sloop class; and one shows a race between sporting craft resembling sandbaggers.

Bard's schooners were generally small freight-carrying craft of the Hudson, though a few seem of a type to have ventured into Long Island Sound. The most notable schooner Bard recorded is the *America* of America's Cup fame. It is framed within an oval on a rectangular canvas. In most of his works with oval or arched format, Bard painted the "matted" area directly on the canvas, using dark green paint.

One of the outstanding characteristics of Bard's work is his primitive handling of the human figure. In a spirit of sympathetic good humor we can point delightedly to the strange people who man and travel on his vessels. These odd characters, whether deck hands or passengers, almost invariably wear high silk hats and long black frock coats, giving them a funereal appearance. Occasionally one chances to be normally proportioned, but the majority are grotesque caricatures of men with long bodies and short legs, and some, especially when uninhibited by a deck above, are disproportionately tall. Nearly all of them seem uncomfortable and decidedly out of place on shipboard. Of the female counterpart of these creatures, there are very few. Perhaps Bard felt strained in trying to depict human beings, and most of his later paintings and drawings show but few people, often only the man at the wheel, a lack of patronage which would hardly be appreciated by the owners. In some instances, the vessel proceeds up the river completely unattended, as if guided by remote control. And then there is the *Jay Gould*, a double-ended ferryboat, undecided as to which way to go, with a quartermaster at each wheel, one in a top hat, and the other in a derby.

Two late Bard works are of the steamer *Saugerties*. With pardonable pride and charming simplicity the artist signed one of these paintings, *J. Bard, N. Y. 1890. 75 years*. In the year 1893, four years before his death, he produced his last extant work, a drawing of the *Westchester* done apparently at the request of Samuel Ward Stanton, his good friend and obituarist.

HAROLD S. SNIFFEN

This chapter is based on an essay by Harold S. Sniffen written for the exhibition catalogue *James and John Bard: Painters of Steamboat Portraits* with checklist of works by Alexander Crosby Brown, Newport News, Va.: Mariners Museum, 1949; reprinted in *Art in America*, vol. 37, no. 2 (April 1949), pp. 51–78, and in *Primitive Painters in America. 1750–1950*, Jean Lipman and Alice Winchester, eds., 1950; reprint ed., Freeport, N.Y.: Books for Libraries Press, 1971, pp. 121–31.

Further Reading

SNIFFEN, HAROLD S. "James and John Bard: New Discoveries." *Art in America*, vol. 42, no. 3 (October 1954), p. 222.

LIPMAN, JEAN. "J. & J. Bard, Picture Painters." *New York Times* (Westchester County weekend ed.), June 5, 1977; reprinted in *The Clarion* (Museum of American Folk Art, N.Y.), Summer 1977, pp. 32–34.

PELUSO, A. J., JR. *J. & J. Bard: Picture Painters*. New York: Hudson River Press, 1977.

Detail of James Bard's drawing of the steamboat *Brilliant*, 1868, with color notes and corrections. The Mariners Museum, Newport News, Virginia.

Detail of James Bard's drawing of the steamboat *Shady Side*, 1873. The Mariners Museum, Newport News, Virginia.

Hannah Cohoon. *The Tree of Light or Blazing Tree*, 1845.
Ink and tempera on paper, 18⅛ x 22¼ inches.
Shaker Community, Inc., Hancock Shaker Village, Hancock, Massachusetts.

Hannah Cohoon

1788–1864

One evening in the 1930s, Faith and Edward Deming Andrews were sitting in the retiring room of the old Brick Dwelling in the Shaker community of Hancock, Massachusetts, talking with their friend Sister Alice Smith. "I have something to show you which I have kept secret since I was a child of eight," she told them, taking out a large, carefully wrapped scroll. In her memoirs Faith Andrews recalls:

What we saw was the first of these mysterious paintings which we have come to call "inspirationals.". . . When we had recovered from our amazement Alice told us this story. When she was a little girl helping in the kitchen, she noticed that an eldress, during the spring cleaning season, was putting under the fuel log in the bake oven a roll of papers with many colored and pen-and-ink designs. There were floral and arboreal symbols and various decorations which had no meaning to her, but which she instinctively realized had charm. She begged the eldress to let her have them, and when the request was granted she took the bundle to her own room, adding them to other things which she had collected. . . .

Showing this one painting to us, Sister Alice confessed, was to be a test. If we found it "amusing" or a subject for idle curiosity, she had made up her mind to destroy it along with the others she hinted at possessing. She felt that if we, as world's people she was beginning to trust, failed to perceive any beauty or intrinsic meaning in them, they should never go out into the world.

Reassured by the Andrewses' enthusiasm, Sister Alice entrusted them with her pictures—some twenty of them—which she had rescued in 1892 from Eldress Mary Frances Hall, whose passion for cleaning drawers and closets resulted in the destruction of scores of Hancock documents. Although the Andrewses were deeply immersed in the study of Shaker history, music, furniture, and crafts, they had not suspected the existence of a pictorial art in this ascetic religious sect. They included the pictures in the first major Shaker exhibition, which they organized for the Whitney Museum in 1935. Eventually they sold them to the Hancock Shaker Village, a public museum founded in 1960, after the few surviving Hancock Shakers decided to close their community.

Since the 1930s about one hundred Shaker pictures have been rediscovered. They are included in the checklist accompanying the Andrewses' *Visions of the Heavenly Sphere*, published in 1969. This was the only major work on Shaker religious art until ten years later, when June Sprigg, curator of collections at Hancock Shaker Village, published her studies in *The Gift of Inspiration*, a catalogue for an exhibition held in New York City.

Scholars have puzzled over the meaning and purpose of Shaker art. As Edward Deming Andrews pointed out, the Millennial Laws regulating Shaker conduct forbade the display of pictures. The Shakers kept meticulous records about almost everything, but they were silent about these pictures, evidence of an ambivalent attitude toward beautiful but "useless" objects. The copious inscriptions on the pictures themselves reveal that they are visions and messages from "the spirit world." From her analysis of these inscriptions, Sprigg concluded that almost all the works were presented as tokens of love to respected older members of the community, perhaps in an effort to render the creations more acceptable. Evidently they were put away and never displayed, for the paper and colors remain remarkably bright and unfaded, showing how nineteenth-century watercolors must have looked when new.

Most of the pictures seem to have originated in the three oldest Shaker communities, Watervliet and New Lebanon, New York, and Hancock, Massachusetts, in the 1840s and 1850s. The earliest were the mysterious "sacred sheets" in which monochromatic, abstract calligraphy is arranged in neat, geometric patterns. Next came what have been called the valentines of the Shaker world—cut-out heart and leaf shapes, usually on colored paper, with inscriptions and occasionally small drawings. Finally, there were the large watercolor and ink pictures like those Sister Alice had revealed to the Andrewses. These fall into what might be called two "schools." The paintings made at New Lebanon are complex compositions crowded with naïvely drawn doves, crowns, trumpets, and other symbolic motifs interspersed with inscriptions, whereas those from Hancock are simpler in design, larger in scale, and more dramatic.

Four Hancock paintings have become the best known visual images associated with the Shakers (colorplates). They feature a dominant central image and a limited range of strong colors, producing an immediate visual impact. They bear fluent, vividly written descriptions of the exact time, place, and circumstances of their creation and, most important, they are signed. Out of the whole body of Shaker pictorial art, only a few works carry any indication of the identity of the artists, and none is signed so boldly, and with such obvious pride of authorship, as these four by Hannah Cohoon.

The artist was born Hannah Harrison on February 1, 1788, in Williamstown, Massachusetts, which was then a frontier village, a scant generation removed from the wilderness. She descended from old New England stock; both sides of her family came from England and were established in Connecticut by the 1650s. Her

grandfather Titus Harrison was one of the first permanent settlers of Williamstown. According to *Origins in Williamstown* (1894), Titus came from Litchfield, Connecticut, sometime in the 1750s bringing his wife, Anna (who could not write), a large family, "and much personal enterprise." He soon amassed substantial landholdings along the Green River where he established the town's first gristmill and built a handsome gambrel-roofed dwelling house. His sons served in a Berkshire County regiment during the American Revolution, and two of them, Noah and Almond, married the Bacon cousins Huldah and Jerusha, from nearby Lanesborough. The Bacons were a numerous clan who had come to western Massachusetts from Middletown, Connecticut.

Arthur Latham Perry, the author of *Origins in Williamstown*, was personally acquainted with descendants of both the Harrisons and the Bacons. He relates that "Noah Harrison and his wife, Huldah, brought up a family of children on Water Street who did credit in life to their parents and grandparents." Noah died at the age of thirty in 1789, leaving Huldah with three small daughters: Lois, five; Polly, four; and eighteen-month-old Hannah. There is evidence that the widow Huldah remained in Williamstown and remarried after a few years. Hannah grew up in a comfortable, respected family, and obviously received a good education, judging from her accomplished prose style and unusually beautiful, flourished penmanship. It is interesting that Perry writes in detail about the elder Harrison girls and the local men they married, but never mentions Hannah. Could it be that she was not considered a credit to her family by reason of her marriage or subsequent conversion to Shakerism?

Research has failed to uncover any record of Hannah Harrison Cohoon's marriage or the birth of her children. All that is known is that on March 19, 1817, at twenty-nine years of age, she entered the Shaker community at Hancock, about twenty miles southwest of her birthplace. With her she brought a five-year-old son, Harrison, and a daughter, Mariah, aged three. We can only speculate on her motives for joining the Shakers: a quest for personal salvation, escape from an unhappy marriage, or security for herself and her young children after her husband died or perhaps deserted them? Whatever her reasons, she stayed and six years later, on April 3, 1823, signed the Shaker covenant, giving her services and property to the community. In accordance with Shaker usage, she was called Sister Hannah.

The Shakers founded the most successful and enduring of the experimental communes that sprang up across America in the early decades of the new Republic. They traced their beginnings to an obscure group of English dissenters known derisively as the Shaking Quakers. In 1774 eight of them had emigrated to America with their charismatic leader, Mother Ann Lee, and settled at Watervliet, near Albany, New York. The waves of religious revival that periodically swept rural America brought many converts. At its peak the United Society of Believers in Christ's Second Appearing—the Shakers' official name—numbered some six thousand in nineteen communities in New York, the New England states, Kentucky, and Ohio.

Hancock was the third oldest Shaker community, organized in 1790. When Hannah Cohoon arrived, she found a thriving self-sufficient village surrounded by woodlands, fields, orchards, and gardens set amidst the picturesque Berkshire Hills. In addition to farming and operating numerous mills, including a woolen cloth factory, the Hancock Shakers supported themselves by the sale of garden seeds, herbs and medicines, and the manufacture of farm implements, hats, boxes, chairs, baskets, and brooms. The men and women of the community were organized into "families," which replaced their worldly ties of blood and marriage. They lived under the same roof, in separate quarters, and labor was divided along conventional lines, with men doing the farming and heavy work and women performing domestic tasks. At every level, however, governance of the community was divided equally between the sexes, in keeping with Mother Ann's belief in a dual godhead in which God the Father coexisted with Holy Mother Wisdom, a female deity. Within the confines of their ascetic life, Shaker women probably had more freedom and exercised more power than any other women of their time.

The community at Hancock reached its height in 1829, when a total population of 247 was grouped in six families. The Church Family, in which Hannah Cohoon lived, was the highest order, composed of those who had confessed their sins and signed the covenant. They had a satellite family nearby, in the North House, where Mariah Cohoon is recorded as living in 1829. Children were placed in girls' or boys' orders, under the supervision of specially appointed "caretakers." Not until they were adults could they become Shakers. According to the 1829 records, Harrison Cohoon was at this time in the "2nd Order of the Church," meaning that he was spiritually prepared to enter the highest order. He did so the following year, when at the age of eighteen he signed the covenant.

About this time there began a slow decline in all the Shaker communities, especially among male members and the young. The stream of converts slackened, and the ranks were thinned by numerous defections. Among the "apostates," as the Shakers called them, were Hannah Cohoon's children. Harrison left Hancock in July 1836, returned the following February, and went into the world again, this time forever, on June 19, 1838. Mariah probably left around the same time and eventually married a man named Ward. It is surprising to find that she returned to Hancock at the age of sixty-seven and lived there until her death in 1899.

In addition to their difficulties in making and keeping converts, the Shakers also experienced a demoralizing sense of loss occasioned by the deaths of the revered "first witnesses," men and women who had actually known Mother Ann or her immediate successors. In what seems to have been a spontaneous effort to restore morale, a remarkable revival began in the summer of 1837, when a group of young girls at Watervliet were seized by trances in which they sang, whirled, heard voices, and saw visions of "the spirit land." Such phenomena had been common in Mother Ann's day; now they quickly spread from Watervliet to the other Shaker communities. At first Shaker leaders were alarmed, but they soon recognized and encouraged the "manifestations" as a means of re-

Hannah Cohoon. *The Tree of Life*, 1854.
Ink and tempera on paper, 18 1/8 x 23 1/4 inches.
Shaker Community, Inc.,
Hancock Shaker Village, Hancock, Massachusetts.

Hannah Cohoon. *A Bower of Mulberry Trees*, 1854.
Ink and tempera on paper, 18 1/2 x 23 inches.
Shaker Community, Inc.,
Hancock Shaker Village, Hancock, Massachusetts.

kindling the spiritual fervor of the early days. Individuals who were particularly prone to mystical experiences were appointed to act as "instruments," or mediums, through whom messages from God, Mother Ann, and departed Shakers were delivered, often in impassioned sermons during worship services. The instruments also received "spiritual gifts" in the form of songs, dances, and paintings or drawings, which they sincerely believed had supernatural origins.

The revival, known as the "Era of Manifestations" or "Mother Ann's Work," reached its peak in 1842. Shaker communities were given new names; they closed their public meetings (which had become something of a tourist attraction) and instituted new forms of worship. Anonymous Shaker scribes kept detailed accounts of tumultuous open-air celebrations held in each community. In June 1842, at Hancock, now called the City of Peace, a holy meeting ground was cleared on North Mountain, renamed Mount Sinai. Early on the Fourth of July, the entire community marched up the mountainside, two abreast and singing in unison. They were led by the chief instruments, the elders and eldresses, and a band of singers. At the meeting ground they experienced seizures, visions, speaking in strange languages. Elaborate pantomimes were enacted in which they received imaginary "spiritual gifts"—crowns, bejeweled ornaments, brightly colored garments, exotic fruits, and wine. (Edward Deming Andrews surmised that these luxuries were an unconscious compensation for the self-denial of the Shakers' daily lives.) After much singing, dancing, and a great feast (also imaginary), they marched back to the village. At Hancock the mountain feasts were held each spring and fall for over a decade.

Hannah Cohoon was undoubtedly a participant in all these events, and it was in this atmosphere of mystical excitement that she made the first of her known drawings. On October 9, 1845, three weeks to the day after the autumn feast, she painted her vision of *The Tree of Light or Blazing Tree* (colorplate), and inscribed it with an account of her experience. It is worthwhile to quote this and all the commentaries on her drawings, which are barely legible in reproductions, for they are the most direct evidence that remains of the personality and methods of the artist.

The Tree of Light or Blazing Tree. Oct. 9th 1845.
The bright silver color'd blaze streaming from the edges of each green leaf, resembles so many bright torches. N. B. I saw the whole Tree as the Angel held it before me as distinctly as I ever saw a natural tree. I felt very cautious when I took hold of it lest the blaze should touch my hand.
Seen and received by Hannah Cohoon in the City of Peace Sabbath Oct. 9th 10th hour A.M. 1845, drawn and painted by the same hand.

According to Shaker documents of the revival era, it was often the case that one person received the "gift" of a song, vision, or message, while another recorded it in written or pictorial form. Hannah Cohoon obviously wanted it clearly understood that she was both the visionary and the artist. This sense of self, along with the act of signing her paintings, hint at a strong, perhaps intractable personality that conflicted with the Shaker ideal of individual submission to the community. John Harlow Ott, director of Hancock Shaker Village, has found indications that Sister Hannah did not fit comfortably into the Shaker way of life. According to an 1831 chart of the Hancock Meeting House, her place was in the fifth row; even her teenage daughter was two rows ahead of her. For a mature woman who had been a member of the community for more than a decade, this was a surprising distance from the honored front row, indicating perhaps some official disapproval of her conduct or attitude.

The artist's individuality comes through in her choice of mediums and her improvisational technique. Whereas other Shaker paintings are tightly rendered in transparent inks and delicate watercolors, Hannah Cohoon's paintings are done in a thick, opaque paint, sometimes applied in layers and—on the tree trunks—roughly scratched to give a textured effect. In another unconventional gesture, she coated the leaves with a thin varnish, causing them to shine. She rendered the "silver color'd blaze" streaming from each leaf in tremulous red lines. The juxtaposition of red and green, combined with the rhythmic arrangement of shining leaves and swirling branches, creates a dazzling optical approximation of the blazing fire of her vision.

The source of Hannah Cohoon's imagery is found in Shaker theology and history. The Tree of Life is for the Shakers what the Cross is to other Christians, an instantly recognizable and emotionally charged symbol of their faith. While the Shakers were still a small and persecuted sect in England, the Tree of Life had appeared to James Whittaker, one of Mother Ann's disciples (and her successor), calling them to the New World:

I saw a vision of America, and I saw a large tree, and every leaf thereof shone with such brightness, as made it appear like a burning torch, representing the Church of Christ, which will yet be established in this land.

The Tree of Life became a symbol of the unity of the Shaker Church: just as each leaf and branch is part of the tree, so was each Believer a part of the body of Christ. Many Shaker songs are about the Tree of Life, and trees appear frequently in Shaker paintings.

The surviving Hancock pictures suggest that there were at least two artists other than Hannah Cohoon working there. In 1844, the year before her first painting, Elder Joseph Wicker, the leading instrument at Hancock, made a large bannerlike painting of a tree surmounted by geometric arrangements of inscriptions in an indecipherable language. Though rather dull as a work of art, this cryptic picture is interesting because it is one of the few done by a male Shaker and the only one by an important spiritual leader.

One is tempted to suggest that Wicker established the Tree of Life as a motif that Hannah Cohoon picked up and developed. Although there is a gap of nine years between her first painting and *The Tree of Life* of 1854 (colorplate), they are sufficiently alike to suggest that she might have done a whole series, since destroyed, of variations on this favorite Shaker theme. Cohoon's paintings were followed by a more stylized and delicately colored Tree of Life se-

Hannah Cohoon. *Basket of Apples*, 1856. Ink and tempera on paper, 10⅛ x 8⅛ inches.
Shaker Community, Inc., Hancock Shaker Village, Hancock, Massachusetts.

ries that began in 1855 and ended in 1859. These paintings are unsigned, but they have been tentatively attributed to Polly Collins, who also authored a manuscript of "inspired writings."

Like her first painting, Hannah Cohoon's *Tree of Life* bears an eloquent and precise inscription:

City of Peace Monday July, 3rd 1854. I received a draft of a beautiful Tree pencil'd on a large sheet of white paper bearing ripe fruit. I saw it plainly; it looked very singular and curious to me. I have since learned that this tree grows in the Spirit Land. Afterwards the spirit shew'd me plainly the branches, leaves and fruit, painted or drawn upon paper. The leaves were check'd or cross'd and the same colors you see here. I entreated Mother Ann to tell me the name of this tree: which she did Oct. 1st 4th hour P.M. by moving the hand of a medium to write twice over Your Tree is the Tree of Life. Seen and painted by, Hannah Cohoon.

On the reverse, in a corner, she added a biographical note, "Aged 66." June Sprigg points out that in *The Tree of Life* and in *A Bower of Mulberry Trees*, done the same year, Hannah states that her designs appeared to her as completed drawings on large sheets of paper. The spirit even returned to give her a drawing lesson, showing three painted leaves, "so that I might know how to paint them more correctly."

A Bower of Mulberry Trees (colorplate) is Hannah Cohoon's most complex composition, and has the lengthiest inscription, written in curving lines that repeat the arch of the trees:

Sept. 13th 1854. Blessed Mother Ann came into meeting we had a very powerful meeting and I saw a beautiful great bower four square on the ground; the trees met together overhead as you will preceive by the representation; it was painted upon a large white sheet and held up over the brethrens heads, I saw it very distinctly. Afterward the spirit presented to my view three leaves painted, belonging to the bower which was shown me in meeting so that I might know how to paint them more correctly. The long white table standing under the bower stood at the left hand close by the side of the trees with cakes knives etc. upon it; I saw Elder Ebenezer Bishop and Elder Nathaniel Deming take off their hats go into the bower then to the table ate standing up. Then thence they went to the spring just beyond the square to the right hand and drank keeping off their hats, untill they got fully out of the bower. N. B. The ground was cover'd with beautiful short green grass; I saw the small trees bearing the fruit of Paradise very plainly, there was much ripe fruit on them which was very smooth and of a lively deep green color, the size of our largest english cherries. (They appeared to shine) The spirits said they were green when ripe, each berry appeared to grow separately close to the limbs— Afterwards I saw many brethren sitting upon long benches in the bower. Seen and painted in the City of Peace by Hannah Cohoon.
A Bower of Mulberry Trees
See 2nd Samuel. 5th 24th. v. Chron. 14th and 15 v.

She is obviously picturing the setting for the feasts held in earlier years on Mount Sinai. A long Shaker table like those used in their dining rooms is set for the spiritual feast, and naïve representations of doves—symbols of hope and glad tidings—fly overhead and perch in the bower. The elders to whom she refers were beloved leaders of the Hancock and New Lebanon communities who had died a few years earlier.

The Old Testament references at the end of the inscription are virtually identical passages which describe how God advised David in a maneuver against the Philistines: "And let it be, when thou hearest the sound of a going in the tops of the mulberry trees, that then thou shalt listen thyself: for then shall the Lord go out before thee, to smite the host of the Philistines." June Sprigg suggests that this biblical text was probably the subject of a sermon Hannah Cohoon heard preached at Hancock. In the 1850s the warring theme was prevalent among the Shakers, who "warred" against the temptations of the world, just as the ancient Hebrews struggled against the evil Philistines.

Such is the power of Hannah Cohoon's designs that it seems unlikely she had no previous artistic experience or that the four extant paintings are the only ones she ever made. Watercolor painting was something of a fad in the early nineteenth century, and Cohoon may have painted as a young woman. A more probable school for her talents, however, was the needlework training given every young girl of her time.

Many Shaker drawings, especially those from New Lebanon, are reminiscent of New England samplers. A more obvious design source for Hannah Cohoon's great single-image paintings is the appliquéd quilt. In the late eighteenth century a popular quilt design was a large Tree of Life, sometimes cut out of imported English or Indian textiles and appliquéd to the quilt top as the centerpiece. In *The Tree of Life* the leaves look as though they have been cut out of a green-and-black checked fabric, as for an appliqué. The great green and red balls have a three-dimensional look, like a quilt embellished with embroidered French knots or the padded work (trapunto) used to make fruits and flowers literally stand out from the quilt top.

Basket of Apples (colorplate) is Hannah Cohoon's last known work. Its smaller size and loose brushwork make it seem more intimate than the others, and it is perhaps the most imaginative in concept. It presents what is in effect an X-ray vision of a basket, as though one side had been cut away to reveal four neat rows of mysteriously suspended fruit. Only someone familiar with basket construction could have presented this abstract rendering of the in-and-out weaving of a splint basket; perhaps one of Sister Hannah's work assignments at Hancock was basket making.

The inscription is written in a clear and beautiful hand, despite the artist's sixty-eight years:

Sabbath. P.M. June 29th 1856. I saw Judith Collins bringing a little basket full of beautiful apples for the Ministry, from Brother Calvin Harlow and Mother Sarah Harrison. It is their blessing and the chain around the pail represents the combination of their blessing. I noticed in particular as she brought them to me the ends of the stems looked fresh as though they were just picked by the stems and set into the basket one by one. Seen and painted in the City of Peace. by Hannah Cohoon.

Judith Collins was one of the chief female instruments at Hancock, and she had died the previous July at the age of fifty. It was she who had directed the Hancock Shakers to the holy meeting ground on Mount Sinai and had led the marches up the mountainside. Polly Collins, believed to be the other "Tree of Life artist" at Hancock, was her older sister. As members of the Church Family and fellow visionists, the Collins sisters and Hannah Cohoon may well have been close friends. In this rather complicated vision, the artist sees her recently deceased friend bringing a gift from the long-dead founders of the Hancock community, Calvin Harlow and Sarah Harrison. The gift is intended for the Ministry, the two men and two women who directed the Hancock community, and it was to be presented to them by Sister Hannah, which she did in the form of this painting.

At the top is a verse: *Come, come my beloved/ And sympathize with me/ Receive the little basket/ And the blessing so free.* This may be an example of a song by Hannah Cohoon, for the artist also had the gift of song. This discovery was made by Daniel W. Patterson, professor of folklore at the University of North Carolina, in the course of his study of Shaker music. He found four tunes by "H. Cohoon" scattered through the pages of a songbook scribed at Hancock (illustration). He classifies them as wordless "laboring songs," sung with syllables like *lo-dodle lo do-lum* as accompaniments to the dances and marches performed in meeting when the Believers "labored for a gift" from God.

No other painting or record of Hannah Cohoon appears until January 7, 1864, when she died at Hancock a few weeks short of her seventy-sixth birthday. She is buried in the Church Family cemetery.

The religion that nurtured and inspired this artist is fading into history. Today there are fewer than a dozen covenanted Shaker sisters living. They sometimes express dismay that their religion has come to be identified almost exclusively with the spare and elegant furniture and handicrafts so appealing to modern tastes. "Who wants to be remembered as a stick of furniture?" one Sister has complained. The paintings of Hannah Cohoon bear the impress of the Shaker spirit. More vividly than anything else made by Shaker hands, they embody the ecstatic mysticism of a vanishing faith.

RUTH WOLFE

Further Reading

ANDREWS, EDWARD D. "Shaker Inspirational Drawings." *Antiques*, vol. 48, no. 6 (December 1945), pp. 338–41.

ANDREWS, EDWARD DEMING, AND ANDREWS, FAITH. *Visions of the Heavenly Sphere. A Study in Shaker Religious Art*. Checklist by Susan Terdiman. Charlottesville, Va.: University of Virginia Press for Winterthur Museum, 1969.

The Gift of Inspiration. Religious Art of the Shakers (exhibition catalogue). Introduction by Eugene M. Dodd. Hancock, Mass.: Hancock Shaker Village, 1970.

ANDREWS, EDWARD DEMING, AND ANDREWS, FAITH. *Fruits of the Shaker Tree of Life. Memoirs of Fifty Years of Collecting and Research*. Stockbridge, Mass.: Berkshire Traveller, 1975.

The Gift of Inspiration. Shaker and American Folk Art (exhibition catalogue). Preface by Nina Fletcher Little; introduction by June Sprigg. New York: Hirschl & Adler, 1979.

Page from a Shaker hymnal with a song by Hannah Cohoon. Library of Congress, Washington, D. C.

Joseph H. Davis

active c. 1832– c. 1838

In the 1830s an itinerant "portrait grinder" who signed himself JOSEPH H. DAVIS, LEFT-HAND PAINTER traveled the roads of Maine and New Hampshire, leaving behind dozens of brilliant watercolor portraits. Many of these portraits are still cherished by the sitters' descendants, for without benefit of glamour or grandeur they make rural New Englanders look like the Founding Fathers' dream—a comfortable and literate citizenry, serene and God-fearing. Husband and wife always face each other, the perfect picture of amity and self-respect. Children are sedate when alone and affectionate when with their parents. Even pets are on their best behavior.

The tenor of Davis's work is remarkably even, so that we know a Davis when we see one. But what we know about the man himself is regrettably little. Dozens of Davis families lived in the part of New England where he worked, including a distressingly long list of Josephs and even several Joseph H. Davises. Many years ago Frank O. Spinney spent long hours in the local genealogical and documentary collections, trying to pin down the real JOSEPH H. DAVIS, LEFT-HAND PAINTER. The most interesting possibility he found was the legendary Pine Hill Joe Davis of Newfield, Maine. A century after his death, people in Newfield still remembered Pine Hill Joe as a "farmer and incurable wanderer who was always dabbling in paints."

Spinney's identification, though still a hypothesis, has a foundation in two kinds of evidence. The primary source of information is the painter himself, who often inscribed a caption across the lower margin of his portraits, giving the names of the sitters, where the picture was painted, and when. He occasionally added birth dates and, on a few rare occasions, a poem or extra calligraphic flourishes. Other evidence is documentary, gathered first by Spinney and later amplified by many contributors.

The earliest pictures by Joseph H. Davis, Left-Hand Painter, were indeed painted near Pine Hill Joe's home of Newfield. Thereafter, the artist's itinerary expanded year by year, so that he eventually covered an area from Wakefield, Maine, on the north, to Epping (and possibly Manchester), New Hampshire, on the south; from Berwick, Maine, on the east, to Concord, New Hampshire, on the west.

With Davis's identity still uncertain and his time and place of work well-documented, two interwoven questions remain: What was the nature of his style, and how did his skills evolve? Concentrating on a polished performance within a limited repertoire, Davis shows himself to be an artisan, rather than a creative innovator. His subject matter was limited: the bulk of his output is portraiture and the only other works which can be confidently ascribed to him are the calligraphic pieces (such as family registers) done in his distinctive lettering style. It can also be said that Davis was a man of limited imagination. Every element in his work can be found in the common fund of images available to country painters. All of them used silhouettes, instruction manuals, advertisements, and a scattering of academic paintings as resource material, but few used them with such spirit and charm.

Davis could have learned his craft from studying other artists, either as a student or through copying. This seems most likely when his work is compared with the early work of J. Evans, whose portraits were hanging in towns that Davis visited in the early 1830s. The portrait of the Furber children (colorplate) is an example of that Evans-like style. Much of the paper is left unpainted; the profiles are drawn with a pale pencil; and the color scheme is a delicate combination of salmon pink, daffodil yellow, and turquoise.

From this early style, which may or may not be related to Evans, Davis's work steadily blossomed into the bright and emphatic style of 1836–37. His characteristic formats, however, had crystallized by 1833. His couples or family groups are a primitive version of the conversation piece, that decorous format for disposing families in a congenial and flattering milieu. He used another format for single standing figures and yet another for the rarer seated figures. Individualization, variation, and free invention on these themes were confined to details and accessories. Even when he was most inventive, Davis never strayed from the canon of polite household effects, nor from nineteenth-century middle-class taste.

Davis was ever the producer of popular merchandise: he found a formula that pleased his clientele, then practiced it to become a local success. Despite the vagaries of time and fashion, at least 160 watercolors survive from a career of less than a decade. Davis rarely painted only one picture when he visited a town. He usually painted several members of the same family, and sometimes he made return visits. Davis painted in Strafford, New Hampshire, for the first time in 1834, again in 1835 and 1836, leaving at least 24 pictures recording a total of 44 citizens.

Tabulating only the captioned pictures, Davis was primarily a painter of families. More than a third of his works portray members of an immediate family together in one watercolor; a large proportion of the single-figure portraits are of people closely re-

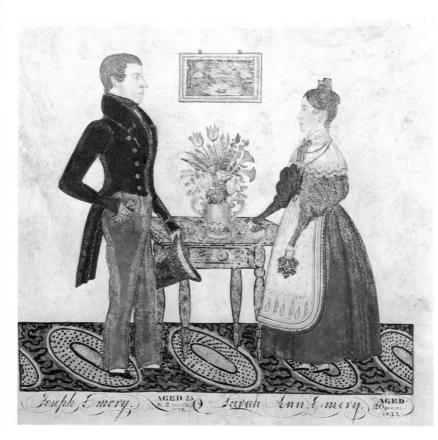

lated to each other. The portrait of Joseph and Sarah Emery (colorplate) has a companion piece, a portrait of Sarah's parents. The Caverly family holds the record: twelve Caverlys distributed in five pictures.

Few itinerant artists were concerned with exploring personality, and Davis is no exception. He was much more interested in the symbols of middle-class respectability. If there is a gentleman in the picture, he is dressed in black and often wears a vest or top hat. If there is a woman, Davis gives her a bouquet of flowers, a bonnet or formal hairdo, and usually an apron. Almost every table displays a Bible, sometimes assertively alone, sometimes as the centerpiece of a group of smaller untitled books. Numerically, books are Davis's favorite accessory. Most of the tiny hands hold even tinier books—perhaps volumes of poetry or prayers, both commonly bound in miniature sizes, both symbols of refinement. Did Davis use them to disguise his inability to draw hands convincingly?

In addition to the tabletop arrangements, Davis used hand-held objects to tell us about the sitter's social role. There are conventional props, such as knitting for elderly women and toys for children, but the most interesting are the most personal ones. Several men are shown with the tools of their trade, such as a whip for a coachman or a drum for a major. During the nineteenth century, when newspapers were more openly partisan than they are today, one could tell a man's politics or religion by the newspaper he

Joseph H. Davis. *Emery Family*, 1834.
Watercolor on paper, 14½ x 14½ inches.
New York State Historical Association, Cooperstown.

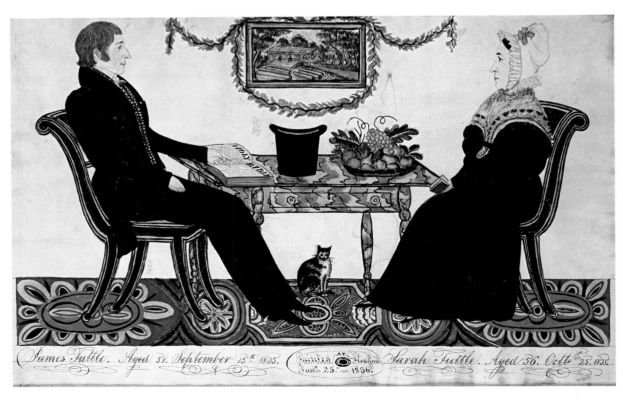

Joseph H. Davis. *James and Sarah Tuttle*, 1836.
Watercolor on paper, 9½ x 14½ inches.
The New-York Historical Society.

read. Many of Davis's gentlemen hold newspapers with quite legible logos; a Free Will Baptist reads *The Morning Star*, published by that sect; two Andrew Jackson supporters look at front-page pictures of their hero.

One of Davis's trademarks is a framed picture, hung above a painted table and festooned with ropes of greenery. Usually the picture is a standard romantic view, such as a lake and castle or a fisherman and grazing sheep, but sometimes it is an overt personal reference, representing the sitter's home or business. The James Tuttles of Strafford, New Hampshire, are seated beneath a picture of Mr. Tuttle's sawmill (colorplate), while other family groups may have portraits of ancestors or a political figure. In one of the Caverly pictures, three different devices are used to focus on the family house: a picture of it hangs on the wall, a diagram of it is on the table, and the three-year-old son hands his father a builder's rule.

None of the elements of Davis's format commands as much attention as the carpet. Brilliantly colored and patterned, it seems to stand straight up under the tiny feet with a stylistic bravado unmatched by any other part of these pictures. Davis's floors (whether they are carpets or floors painted to imitate carpets) derive from the ingrain rugs first imported from England, then manufactured in New England in the 1820s. Many folk artists used them, but none so consistently and insistently as Davis. Pattern runs riot, drawing attention from the sitters' bland faces, turning

Joseph H. Davis's portrait of John F. Demeritt showing the tools of a writing master. Collection of Bertram K. and Nina Fletcher Little.

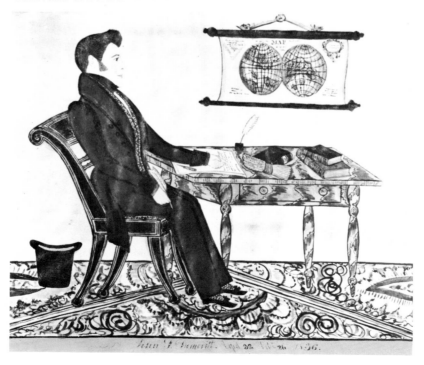

what is supposed to be a portrait into a flowered, grained, striped, dotted, and embroidered kaleidoscope of ornamentation. The pictures with the finest and most brilliant carpets are usually the surest and strongest pictures in every respect. The sitters are well drawn; few hesitations interrupt the firm outlines of their faces and hands. Colors are rich and laid on in smooth, even strokes. Crisp and graceful, without a trace of underdrawing, these pictures are the work of a virtuoso.

Although all the portrait accessories are interesting for the information they provide about the sitters or their period, they do little to advance our knowledge of the artist himself. One portrait, and one class of accessories, however, may be an exception. Far more frequently than any other folk artist of his time, Davis uses letters and writing materials as props. In the portrait of the schoolteacher John F. Demeritt (illustration) they take a central and telling role. All of the ingredients are at hand—unsharpened and sharpened quills, inkpot, and knife—arranged as a left-handed person would use them. (We know that Davis was left-handed, but we do not know about Demeritt.) This particular display, and the frequent appearance of similar materials, prompt intriguing questions: Was Davis an itinerant writing master as well as an itinerant artist? Is he here displaying his own expertise as well as Demeritt's?

The combination of skills would have been a convenience, rather than a surprise, to Davis's clients. During the nineteenth century, rural schooling was erratic in location, frequency, and quality. Schoolmasters were supposed to teach handwriting, a socially and commercially valuable skill, but their own writing usually left much to be desired. Students often had to wait for the visits of an itinerant writing master and make do with poor copybooks at other times. If Davis did teach writing, he would have received higher fees and more perquisites than he did as an artist. If he did both, it would have meant no change of materials, scale, tools, or potential customers. The strongest argument for the supposition that he practiced both trades is the handwriting displayed in his captions. No American artist wrote a more beautiful hand and no other artist made it so prominent a feature of his work. Like his painting, Davis's writing is an idiosyncratic combination of elements drawn from widely available sources. His basic letter formation follows the "Italian Hand" propounded in the popular writing manuals of Allison Wrifford of Hopkinton, New Hampshire. Even the fanciful flourishes are based on Wrifford's rather stodgy suggestions.

Two examples of Davis's nonpictorial work which have recently come to light in private collections—a family register and a birth certificate—are reminiscent of the commercial advertising of the period. Both the register and the certificate are written primarily in Roman capitals, partly in Wrifford-style script, then embellished with the same colorful range of ornament that decorated signs, labels, posters, circus wagons, and other products of American typographic design.

If Davis was a master of two trades, why not others? Did he give up painting in 1837 or 1838 and become the Joseph H. Davis who bought twenty-eight pounds of nails from Clark & Scruton in

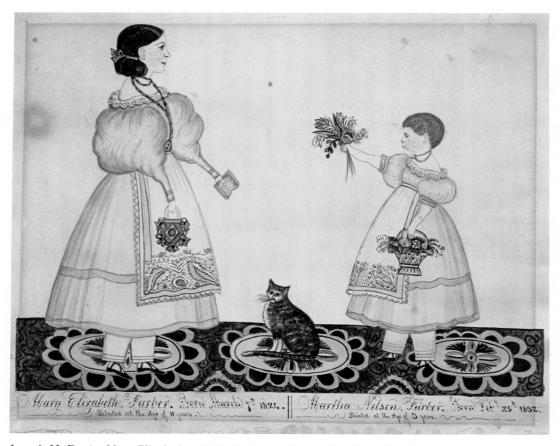

Joseph H. Davis. *Mary Elizabeth and Martha Nelson Furber: Two Little New Englanders*, 1832–33.
Watercolor on paper, 9¹⁄₁₆ x 11¹⁵⁄₁₆ inches.
Museum of Art, Rhode Island School of Design, Providence; Museum Works of Art Fund.

Farmington, New Hampshire, in 1844? Was he a carpenter or cabinetmaker? His chairs and tables are striking "portraits" of contemporaneous country furniture, though more fanciful than most.

Davis's love of decoration shows particularly in two types of single-figure portraits. The first type is the single standing female, in which the ruffles, aprons, hairdos, reticules, and jewelry are often more engrossing than the face. The second is the group of fifteen pictures in which decorated corners, borders, and draperies all but overwhelm the nominal subject of the portrait. Similar designs are found on countless images and antiques from this period. Did Davis make patterns for stencils or embroidery? What else did he do?

The artist's story is still punctuated with too many question marks. Joseph H. Davis found a popular formula, painted enough so that more than 160 works have survived for nearly a century and a half, and was proud enough to sign 5 of them. His productivity increased until 1836 and 1837, then he suddenly stopped. Why?

Someday, perhaps, a birth record or generously annotated picture will come to light, revealing at last the true identity of the Left-Hand Painter.

ESTHER SPARKS

Further Reading

SPINNEY, FRANK O. "Joseph H. Davis, New Hampshire Artist of the 1830s." *Antiques*, vol. 44, no. 4 (October 1943), pp. 177–80.

———. "The Method of Joseph H. Davis." *Antiques*, vol. 46, no. 2 (August 1944), p. 73.

———. "Joseph H. Davis" in *Primitive Painters in America. 1750–1950*, Jean Lipman and Alice Winchester, eds., 1950; reprint ed., Freeport, N.Y.: Books for Libraries Press, 1971, pp. 97–105.

LITTLE, NINA FLETCHER. "New Light on Joseph H. Davis, 'Left-Hand Painter.'" *Antiques*, vol. 98, no. 5 (November 1970), pp. 754–57.

SPARKS, ESTHER. "Joseph H. Davis" in *Three New England Watercolor Painters* (exhibition catalogue) by Gail and Norbert H. Savage and Esther Sparks. Chicago: Art Institute, 1974, pp. 7–9, 22–41.

James Sanford Ellsworth

1802/03–1874

From about 1835 until 1855 the itinerant painter James Sanford Ellsworth painted miniature watercolor profiles of New England squires, their ladies, and their children. He portrayed them with candid realism in stiff and awkward poses, sometimes perched on fantastic chairs that are invariably airborne on vaporous clouds. Behind their heads he painted similar stylized clouds suggesting the halos that presumably awaited these pious people in some Puritan heaven.

Ellsworth was born somewhere in Connecticut between 1802 and 1803, according to a letter dated August 28, 1861, to the governor of New York, in which he says that he is "fifty-eight years of age" and "from my native state of Connecticut." His mother is recorded as transferring from the First Church, Hartford, to West Hartland Second Church in 1805, and there James S. and a brother, William R., the "children of John and Huldah Ellsworth," were baptized on July 26, 1807. A sister, Julia, was baptized on September 8, 1809. Their mother returned to First Church, Hartford, in 1810, and was still a member there in 1816. On May 23, 1830, when Ellsworth was married to Mary Ann Driggs by Samuel Spring of North Church, Hartford, the couple was listed as "both of Hartford." A son, William Ledyard Ellsworth, was born on November 15, 1829, and baptized in Christ Church, Hartford, on April 12, 1835. Ellsworth's marriage, which according to these statistics was somewhat tardy, ended in divorce on January 17, 1839, his wife alleging desertion in 1833.

Apparently Ellsworth and his wife had another son who is listed as Edward E. in a genealogy provided by an Ellsworth descendant, Mrs. Alfred A. Siebert. This son's birth was unconfirmed until 1975, when Barbara Luck, research associate at the Abby Aldrich Rockefeller Folk Art Center, found a Midwife's Record published in the *Connecticut Historical Society Bulletin* (October 1968) which listed the birth on April 8, 1831, of a "son, to James Elsworth [sic] trumble St. [sic]," Hartford. Further verification of Mrs. Siebert's genealogy has come from my discovery, in the Springfield, Massachusetts, census of 1860 of a family of Ellsworths, "residents in a Boarding House," including "Edward Ellsworth, 30 male, born Conn. Baggage Master."

Some colorful but unsubstantiated legends about James S. Ellsworth were recorded by H. W. French in *Art and Artists in Connecticut* (1879). He claimed to know, or have corresponded with, all the artists included in his book, but his failure to record any sources invites considerable skepticism regarding his account of Ellsworth: that "too much Shakespeare made him mad," a condition of mind allegedly aggravated by his unhappy marriage; that "he left without warning for the West" and later "appeared in Connecticut, a weather-beaten wanderer, followed by an old dog, which, he said, was his only friend on earth"; and that "he died in an almshouse in Pittsburgh in 1874." A diligent search of city, county, state, as well as newspaper records, has failed to produce confirmation of even this last assertion.

At the present time 263 miniatures by Ellsworth have been documented, providing evidence of the peripatetic Yankee's wanderings through Massachusetts, Connecticut, and New York. There is also evidence that he ventured farther afield. In his letter to the governor of New York, Ellsworth writes of his travels through Pennsylvania, New York State, and "to the edge of Ohio," complaining that he had been shot at by a mob which apparently suspected him of Confederate leanings. A signed oil portrait of Mrs. William Henry Harrison, with preservation instructions inscribed above his signature, is dated May 1, 1843. If painted from life, this and the portrait of her husband would have been begun in Ohio several years earlier, before Harrison's brief 1841 term as president. Though Ellsworth certainly painted during his travels, the largest number of his miniatures come from eastern Connecticut and western Massachusetts and date between 1845 and 1850. If Ellsworth practiced some other trade, such as farming, peddling, or house painting, no record of it has been found. It is tempting to suggest that he worked at upholstery. That would account for his preoccupation with various chairs and sofas in different colors and styles, found in more than half of his curious miniatures.

A word should be added about Ellsworth's oils, which are interesting and competent but do not possess the distinctive characteristics of his miniatures. There are eight presently known and well authenticated, six of them bearing his signature. The sitters are conventionally posed, with simple backgrounds. They are of ordinary size, except for the copy, commissioned by Daniel Wadsworth, of a Gilbert Stuart portrait of George Washington; the copy now hangs in the Old State House, Hartford, and is 98 by 60 inches. Besides the oil portraits of the Harrisons, there is one portraying a "Mrs. Cable" and four of unidentified persons.

Frederic Fairchild Sherman, who in 1923 was the first to publish and admire Ellsworth's miniatures, believed him to be self-taught, and there is, to date, no evidence to the contrary. Except for his treatment of hands and occasionally chairs, Ellsworth displayed re-

markable talent, especially in conveying character in portraits. Faces are skillfully modeled to reveal structure. The color of eyes and the shape of brows are expertly represented, and the likenesses are presumably very accurate, even uncompromisingly so, as some portraits of plain, homely, and even toothless sitters clearly show.

Hair styles and dress provide documentation of actual country fashions of the period. Though there is some similarity in the style of the clothes, there is no hint of a stock pattern used indiscriminately for different sitters. The evidence is convincing that each costume is the sitter's own "Sunday best." It is noteworthy that for all his realism, Ellsworth never portrayed a sitter holding or wearing eyeglasses.

Hands obviously posed a problem for Ellsworth. Many of his people appear to be sitting on them, the arm vanishing with the figure at the waist or inside the chair arm just below the elbow. Sometimes he showed the hands folded, while in other portraits the sitter holds some object—a book, flower, fan, handkerchief, love birds, or in one case a nail, the product of a family foundry.

All but seven of Ellsworth's miniatures are profiles, leading some to suggest that he might have begun as a silhouette cutter. Of the full-face miniatures, only two portray the entire figure.

To appreciate the individual style that Ellsworth brought to his miniature watercolor portraits, one must examine his amusing inventions: cloverleaf clouds supporting his sitters, with similar but often paler clouds against which he projects their faces in profile; fanciful chairs in which many sitters are perched; and the placing of the subject with less space in front of the figure than behind it, adding to the appearance of levitation which the clouds also convey. Ellsworth used these conventions consistently but with ingenious variations.

His scalloped clouds support almost all of the sitters so that, though only some are chairborne, almost all are airborne. The cloud provides an illusion of depth as well as an artificial base for the small portrait. Men generally emerge from these clouds at the waist, women at the hips. The chairs, whimsical, unreal, and never completely represented, materialize only partially out of the clouds which support them. They occur in six basic patterns and a variety of colors. All are upholstered and appear to have natural, stained, or painted wood frames. It seems that Ellsworth must have considered these chairs a kind of trademark, for he left unsigned the great majority of miniatures that feature chairs.

The pair of miniatures of a middle-aged lady and gentleman (colorplate) exhibit all the characteristics of Ellsworth's paintings. They are his usual size, 2⅞ by 2½ inches each, and painted in watercolor on thin paper. The distinguished gentleman and his wife are well portrayed. Each sits in a stylized chair of green upholstery with yellow frame, supported by aureoles, their profiles painted against similar aureoles. The original double frame is an example of the type most commonly used by Ellsworth: a narrow, half-inch wood veneer, fitted with blown glass, secured at the back with glazier's points, and finished off with a wire ring at the top for hanging.

A variant of his more characteristic style is the portrait of the lady said to be of the Folts family of Albany, New York (colorplate). This miniature is an example of the larger size painted by Ellsworth. It is 4½ by 3½ inches; the paper is thin and pink; and there is a painted oval around the subject. The signature, in printed letters—*Ellsworth-Painter.*—is centered below the portrait outside the oval. Clouds with many lobes encircle the hips and frame the head. There is no chair. The special features of this portrait are the excellence of the facial delineation, the clarity of the colors, and the able three-dimensional representation of the head and figure.

The miniature *Jennie Post of Guilford, Connecticut* (colorplate) is the smaller size used by Ellsworth, 2½ x 2 inches. The dark background, which is one of only three recorded, precludes any signature on the face of the painting, so it is found on the back and varies only slightly from that on the Folts lady: *J. S. Ellsworth Painter.* The frame is not original, and it should also be reported that an examination of both the vital records and the church records of Guilford, Connecticut, failed to confirm that any Jennie Post

Three of the thirteen signatures Ellsworth used on his paintings.

was living there at the time when this miniature was probably painted. The beauty of this portrait is in the facial expression and extraordinary poise of this lady, made singularly clear by the elimination of all background, thus emphasizing her exquisite profile, her white lace collar and cap, and the "good book" held close against her folded arms. The whole is a subtle study in black and white, the perfect portrait of a serene and dignified New Englander.

Ellsworth painted at least sixty-four children. Representing this group of portraits is *Elizabeth Bushnell* (colorplate), identified by the former owner, her niece, who provided information that Elizabeth was born in 1843, and that her portrait and one of her sister, Cornelia, were painted in Westbrook, Connecticut, at the request of their mother. She wished to send the children's pictures to her husband, who had followed the gold rush to California. The date would presumably be about 1851, when Elizabeth was eight, Cornelia six. Originally, the miniatures were left unframed to facilitate their consignment to the mails. Elizabeth's portrait shows her as an attractive child with rosy cheeks and artfully groomed hair set in stiff curls at her forehead and tied with a red bow at her neck. Meticulously dressed in a bright red dress, a picture book in hand, she sits in an unreal chair with green upholstery on a yellow frame, different in design from those already described. The chair is supported by vaporous clouds, which also appear in a three-lobed form behind her head.

Christina Johnson (colorplate) is one of a group of miniatures

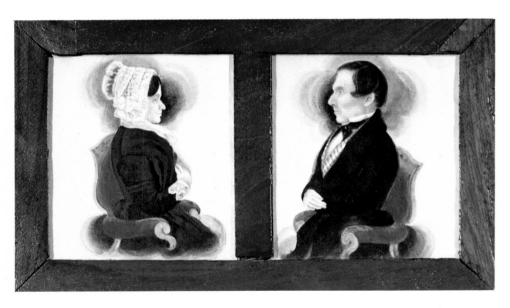

James Sanford Ellsworth. *Lady and Gentleman*, c. 1840–45. Watercolor on paper, each 2⅞ x 2½ inches (framed together). Collection of Mrs. Samuel L. Meulendyke.

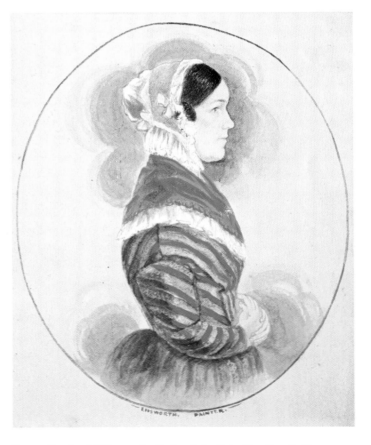

James Sanford Ellsworth. *Lady of the Folts Family of Albany*, c. 1845–50. Watercolor on paper, 4½ x 3½ inches. New York State Historical Association, Cooperstown.

James Sanford Ellsworth.
Jennie Post of Guilford, Connecticut, c. 1835.
Watercolor on paper, 2½ x 2 inches.
New York State Historical Association,
Cooperstown.

James Sanford Ellsworth.
Elizabeth Bushnell, c. 1851.
Watercolor on paper, 3³⁄₁₆ x 2³⁄₈ inches.
Collection of Mrs. Cornelia H. McLean.

James Sanford Ellsworth. *Christina Johnson*, 1853.
Watercolor on embossed paper
(valentine envelope), 3¹⁄₁₆ x 2⁹⁄₁₆ inches.
Connecticut Valley Historical Museum,
Springfield, Massachusetts.

painted on embossed paper or envelopes used for valentines. This type of paper, first introduced in America about 1840, must have appealed to Ellsworth as a decorative support for his miniatures. The former owner, a descendant, identified Christina, together with her parents and two brothers, as the Jehiel Johnsons, farmers, of Bozrah, Connecticut. He had been told that Christina's beads were coral and her dress with sprigs of rosebuds was "of delaine"; that the artist painted "in exchange for his room and board"; and that he "used wild flowers to produce the colors for his paints." Christina sits in a chair similar to Elizabeth Bushnell's but upholstered in red. One brother's miniature is signed *Ja. S. Ellsworth, Portrait Painter* and dated *Jan. 1853*, with *age 11 years*. Christina's bears an inscription, probably by another hand, *Taken by James S. Ellsworth, Jan. 29, 1853, Age 6 years*. The original frame, another type sometimes provided by the artist, is made of soft, patterned brass which folds over the glass, the portrait, and its backing. This type of frame was also used for daguerreotype cases beginning about 1850.

Ellsworth had thirteen different signatures; three typical examples are illustrated. He sometimes used initials only, and almost any combination of initials and name with or without *Painter*, sometimes in print, sometimes in script, or a combination of the

two. He signed his oils *James* [or *Jas.*] *S. Ellsworth, Portrait Painter*, with a calligraphic flourish; the same signature is occasionally found on his miniatures.

The miniatures reproduced here serve to illustrate some of the successful variations that Ellsworth developed within the framework of his unique style, which combines meticulous realism in portraiture with imaginative design in its presentation.

LUCY B. MITCHELL

This chapter is based on the exhibition catalogue *The Paintings of James Sanford Ellsworth, Itinerant Folk Artist, 1802–1873* by Lucy B. Mitchell. Williamsburg, Va.: Colonial Williamsburg, 1974. Includes extensive bibliography.

Further Reading

SHERMAN, FREDERIC FAIRCHILD. "Miniature by J. S. Ellsworth." *Art in America*, vol. 11, no. 6 (June 1923), pp. 208–13.

———. *James Sanford Ellsworth*. New York: privately printed, 1926; reprinted in *Primitive Painters in America. 1750–1950*, Jean Lipman and Alice Winchester, eds., 1950; reprint ed., Freeport, N.Y.: Books for Libraries Press, 1971, pp. 67–71.

MITCHELL, LUCY B. "James Sanford Ellsworth: American Miniature Painter." *Art in America*, vol. 41, no. 4 (Autumn 1953), pp. 147–84.

Erastus Salisbury Field

1805–1900

Erastus Salisbury Field at ninety-three.

Erastus Field and his twin, Salome, named after their parents, were born on May 19, 1805, in Leverett, Massachusetts. Leverett is a small hill town on the first rise east of the fertile Connecticut Valley. At the first census in 1790, eighty-six houses sheltered eighty-seven families, and most of them—Ashleys, Balls, Hubbards, and Fields—were close relatives. New York was three days off, Boston two, and only a few of Leverett's inhabitants had ventured to either city. In his whole life Field would never go more than two hundred miles from home.

Corn huskings, sugaring-off parties, stolen first-of-the-year swims in brooks and ponds—to all these pleasures of a New England childhood Erastus added a growing ease in sketching portraits of his relatives. His parents apparently encouraged him and provided him with paints with which he experimented on scraps of cardboard. Even though these first attempts were halting ones, they were in demand in a society that wanted a record of its citizens and their ancestors.

In 1824 Field took the momentous step of traveling to New York to study with the young artist Samuel F. B. Morse. Years later Field himself told a Massachusetts newspaperman the circumstances. The reporter wrote, "When a mere lad he developed a love for painting in oils which became so pronounced as he advanced in years his parents considered it wise to place their son under the instruction of some noted artist."

Morse had established himself in New York in a studio at 96 Broadway and, for the first time, was enjoying some success in his vocation. Just before Christmas in 1824, he noted: "I have everything very comfortable at my rooms. My two pupils, Mr. Agate and Mr. Field, are very tractable and very useful."

Over all competitors Morse won the prized commission of painting for the City of New York a portrait of the hero Lafayette, who had returned to America, landing at Castle Garden in the Battery on Saturday morning, August 14, 1824. To nineteen-year-old Erastus the coming of the general to "Professor Morse's" studio was unforgettable, and much later he recorded it in paint.

In February of 1825, Morse's young wife died suddenly in New Haven, and the tragedy marked the end of that phase of Field's painting career. He probably returned to Leverett in the early spring, for the portrait of his grandmother Elizabeth Billings Ashley (colorplate) dates from about that time. It is a powerful expression with broad, smooth planes of complexion and cloth. The old lady's deep-sunk eyes stare wisely toward eternity in this, her last year. A clear bright accent to the somber palette is the red chair in which she sits, and Field's quick and sometimes casual method is revealed in three blotches of the same red daubed as though by accident against the background.

Late in August 1826, Field took to the road with his paints and canvases and by mid-September was in Charlton, just southwest of Worcester. The next year he crossed back and forth across the central part of Massachusetts. In Worcester he painted the smooth and vapid likeness of young Biel Le Doyt, the only signed and dated portrait yet discovered from Field's early period. Nothing more is known of his wanderings until June of 1828, when the only letter remaining from his youth was written to his father from Hudson, New York. His great-aunt Sarah Dickinson lived there and probably helped him in "the prospect of retaining business." Field reported that those who had seen his portraits "think they are good likenesses."

All the portraits of this period show unmistakable and characteristic difficulties in making hands and figures look real: waists are

Erastus Salisbury Field. *Elizabeth Billings Ashley*, c. 1825.
Oil on canvas, 24¼ x 22¼ inches.
Museum of Fine Arts, Springfield, Massachusetts;
The Morgan Wesson Memorial Collection.

Erastus Salisbury Field. *Miss Margaret Gilmore*, c. 1845.
Oil on canvas, 54 x 34 inches.
Museum of Fine Arts, Boston; Bequest of Maxim Karolik.

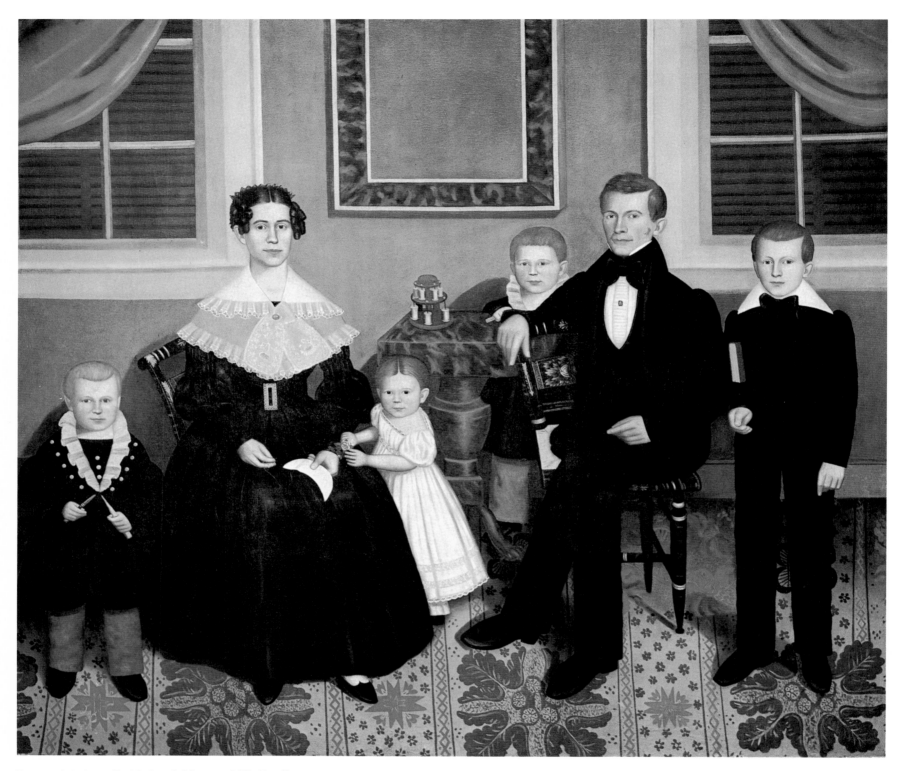

Erastus Salisbury Field. *Joseph Moore and His Family*, 1839.
Oil on canvas, 82¾ x 93¼ inches.
Museum of Fine Arts, Boston; M. and M. Karolik Collection.

too short, shoulders too narrow, arms too long. But there is dash, color, and style in each. A red chair, with arms ending in curlicues like brown snail shells, appears often. Fine fabrics, jewels, and curls are prominent. The boldly scaled figures fill the canvases.

On December 29, 1831, Field married Phebe Gilmur, daughter of David and Mary Moore Gilmur, in the beautiful old Congregational meetinghouse of Ware, Massachusetts. The young people lived briefly in Hartford, where Erastus had worked before, but Henrietta, their first and only child, was born in Monson, twelve miles south of Ware, on November 6, 1832.

The nation's economy was building up to the financial panic of 1837, and prices in general were low. Field, however, was prospering. Records of prices paid for his portraits range from five dollars in 1830 to four for large portraits and a dollar fifty for smaller ones of children in 1837–38. When one considers that a room and supper at a Massachusetts tavern cost twenty-five cents, one can see that he was doing very well indeed. The usual portrait took him only a day to complete, as shown by the likenesses of the Reverend and Mrs. Frederick Marsh of Winchester Center, Connecticut, dated 16 and 17 April, 1833. In this little town, and in nearby Winsted and Torrington, he painted thirty or more portraits during a two-month period.

Relations and friends in the Connecticut Valley spread the word of their talented cousin and townsman. Family names of Massachusetts subjects are found among later Connecticut subjects; maiden names of Connecticut ladies are sometimes the last names of Massachusetts sitters. An interwoven family pattern among Field's clients emerges.

In about 1833 Mr. and Mrs. Charles Backus Jones of Monson, Massachusetts, became the painter's subjects. A change in style is apparent in the portraits of the Joneses—a growing softness, an assurance with his brush quite different from the crystal-hard edges of the portraits of about 1830. The new style shows romantic visions of handsome young men and beautiful young women.

The early 1830s must have been a happy and prosperous time for the painter. Having applied on home ground the lessons learned in Morse's studio, he was now learning on his own and experimenting with new and varied effects. His method was extremely quick, competent, and workmanlike. Apparently he stretched his own canvases, priming them with a base coat of warm light gray that occasionally shows through to the back of canvases that have not been relined. Around 1835 Field painted several striking full-length portraits of children standing on boldly patterned carpets; these illustrate the expressive shorthand style that he had developed. Backgrounds are shaded from dark to light neutral tints in billowing cloud effects. The children all have elfin ears and small two-knuckled fingers. Their faces are shaded and highlighted in pointillist applications of gray and pink. Patterns in lace and embroidered muslin are expressed in designs of black dots.

Plumtrees, close by Sunderland, Massachusetts, was named by Zachariah Crocker and Caleb Hubbard, its first settlers, after the wild fruit trees in bloom when first they saw this lovely region.

Field's aunt was Caleb Hubbard's second wife, and the painter journeyed now to this small settlement on the Connecticut River.

In the 1830s Field and Ammi Phillips must have crossed paths frequently, both working in western Massachusetts and Connecticut towns. Each man surely knew the other's style; it is interesting to see the same pose of hand and arm in both artists' compositions. At least once, the painters portrayed members of the same family, Field painting the Fylers of Winsted in 1833, and Phillips recording the likeness of his cousin Jane Kinney Fyler in 1838.

Field's production before the mid-thirties included a handful of great portraits and a number of quickly drawn likenesses of minor importance. After returning to Leverett on Christmas of 1836, his work showed mastery of oil portraiture. The draftsmanship is crisp, the painting fresh and incisive. The portraits dating from 1836 to 1840 are the best and most even performances that Field was to achieve.

Some time before May 1838, Field did the first of his portraits of a Petersham, Massachusetts, family—Jeremiah and Dorcas Gallond and their daughter and son-in-law, Louisa and Nathaniel Cook. Louisa, mother of two small children, was fragile and wan; Field shows her delicacy in the last months of her life. Another Gallond daughter, Clarissa, was married to Nathaniel Cook's brother William, and the following year Field posed her at a window overlooking an unidentified river landscape.

For Field, 1839 was the year of a painting trip as far north as Brattleboro, Vermont, and a move with his family to the home of his wife's parents on Pleasant Street in Ware, Massachusetts. Across the street in a comfortable frame house lived Joseph Moore from Windham, Maine—hatmaker in winter and itinerant dentist in the summer—with his wife, two children, and two orphans. It is not known if Moore was related to Field's mother-in-law, Mary Moore Gilmur, but his wife was Almira Gallond of Petersham, sister of Louisa and Clarissa. The orphans were Louisa Cook's children. In the Moores' parlor Field painted a landmark of nineteenth-century American painting, a portrait of the Moores and the Cook children, who appear in gorgeous array on a wonderfully exuberant carpet (colorplate). It is believed that the figures from left to right represent George Francis Moore, Mrs. Moore, Louisa Ellen Cook—two years old—Frederick Cook, Mr. Moore, and Joseph Lauriston Moore. Although she is gentler-faced and smaller-featured, Mrs. Moore strongly resembles Clarissa's portrait and wears precisely the same comb, collar, gown, pin, and belt buckle.

There is no way of knowing the reasons for Field's next move. Leaving Massachusetts, he traveled by stage and steamboat to New York City, where "Erastus Field, portrait painter" is listed in the 1841–42 city directory at 58 Carmine Street in Greenwich Village, within sight of Trinity Church cemetery. In the *New York Directory* for 1842–43, Field—now an "artist"—was still at Carmine Street. During the summer of 1843, he moved uptown a few blocks to 68 Bank Street, a square building on the corner of Hudson Street facing Abingdon Square. His name fails to appear in the 1844–45 directory, but there is evidence that his works were exhib-

ited at the 1845 fair of the American Institute of the City of New York. His wife, listed as Mrs. Field of 151 Hammond Street, entered "one painting"; George Sherwood and Mrs. Tuck, living half a block from Field's first New York address, entered two paintings and one drawing. (Art entries in the fair indicated ownership rather than creation, and all these may well have been Field's work.) Another oil painting was the entry of "M. Gillmur," who was probably Phebe Field's niece (her brother David Gilmore was living near the Fields in New York in 1845). There is a full-length portrait by Field of a young girl in blue, posed with a book and cat, holding a fan, and wearing red shoes (colorplate). The costume, furnishings, and warm brown base coat date the painting to the 1840s. The subject is identified as Miss Margaret Gilmore of Ware, Massachusetts; it hardly seems that the "M. Gillmur" fair entry of 1845 could be any painting but this one.

In the 1847 fair, Phebe entered "one picture" and Erastus "one landscape oil painting." The change in subject should be noted, for landscapes and history pieces began to replace portraits as Field's chief endeavor, explaining the change in his directory listing from "portrait painter" to "artist."

According to a news article early in this century, based on material supplied by his daughter and other relations, Field was called home to Massachusetts in 1848 "to conduct his father's farm." The same article states that he remained in Sunderland "some four years in the practice of his art." That is all. No painting can be dated to this period with the single exception of a lost portrait of four-year-old Edwin D. Marsh of Amherst.

At forty-three, the artist had just passed the summit of his powers as a portrait painter. The same year Field began his great portrait of the Moore family, Samuel Morse had returned from Paris with Daguerre's invention. Smaller and cheaper than the painted portrait, the daguerreotype soon became the permanent record that society demanded. It is ironic that Field's talents were to be replaced by the photographs introduced by his old teacher. With typical flexibility and good humor he seems to have adapted to the change and set about making a new vocation for himself.

In 1854 Field took a studio on the top floor of the Cross Block in Palmer, Massachusetts. Here he filled a number of commissions for local residents, but their portraits were quite different from the looming giants who dominated his canvases before 1850. Somewhere—probably in New York—he had learned the use of the camera, and he now followed Morse's precept, "to accumulate for my studio models for my canvases." He posed and photographed his subjects, then enlarged the results on canvas in color.

On August 14, 1859, Phebe Field died of "paralysis of the brain." Husband and daughter returned to Plumtrees, where Field purchased some land. There he dug a hole in the hillside and constructed a two-room studio, scarcely more than a shack. He now compensated for his lack of worldly wealth by painting big exotic pictures of great buildings in foreign lands. Eventually the walls of the shack were lined with paintings from floor to ceiling—all of them landscapes or genre scenes with religious or historic themes.

The Garden of Eden was a subject Field painted at least twice.

The versions are similar and were probably done within a few weeks of each other; the smaller of the two has a brilliant blue-and-gold trompe l'oeil frame (colorplate). Field combined ideas from a number of illustrations, creating compositions of naïveté and charm that outshine their technical limitations. The paintings of John Martin of London were reproduced in a number of English and American Bibles, and it may have been one of his versions of *The Temptation* that Field adopted. The landscape, and especially the trees and mountains, are taken directly from Martin's vocabulary. Thomas Cole's *Garden of Eden*, also based on Martin's themes, is the direct source for the large exotic plants at left and right foreground of Field's versions of the subject.

The exotic architecture and perspective in John Martin's *Plagues of Egypt* seem to have been the inspiration for some of Field's paintings on this theme as well. Apparently the series was intended for the walls of the North Amherst Church, of which Field was a member, but several paintings once owned by the church are now lost. Four remaining ones were found in this century, laid out on the second floor of a shed behind a cousin's house in Plumtrees. *Burial of the First Born* (colorplate) shows the grandiose architecture that Field chose as the background for his themes from the Bible. This experiment may have led to the major project that Field undertook for the nation's centennial. The coming anniversary might have seemed a fitting occasion for an idea he had long contemplated—a huge historical painting that would be the crowning effort of his career.

To modern eyes the resulting *Historical Monument of the American Republic* (illustration) is superior in every way to the genre scenes of Turkish slaves and homely country incident that were shown at the Centennial Exposition in Philadelphia. But if the *Monument* was on view there at all, it was only in the form of Edward Bierstadt's small photoengraving. Each facade of each level of the monument's many towers portrays an episode in American history, the central tower being devoted to Lincoln and the Civil War. Field wrote a "descriptive catalogue" for the painting and this was published in Amherst in the centennial year. In 1933 the *Monument* was found rolled up in the attic of the former home of Field's nephew, and in the 1940s it was rescued by a grandniece from ignominious storage in a shed behind a pigsty in Plumtrees.

A portrait of the artist as an old man can be drawn from the accounts of men and women who knew him when they were boys and girls at Plumtrees. At recess, the schoolchildren would climb the hill to the studio and sit enthralled at the artist's description of the works lining the walls, which included an eighty-foot panorama of an imaginary voyage around the world, *Christ's Temptations in the Wilderness* (now lost), *The Plagues* series, and *The Last Supper*. In 1898 he journeyed to Springfield, where he sat to A. C. Moore at Gill's Art Building for a photograph (illustration); he looked like Rip Van Winkle waking from his long nap. He cast his vote in the state election just before his ninety-fifth birthday in 1900, as one would expect this Yankee to do. He was the oldest man in Franklin County. On Saturday, the 28th day of June, 1900, he died.

Erastus Salisbury Field. *The Garden of Eden*, c. 1865.
Oil on canvas, 35 x 41¼ inches.
The Shelburne Museum, Shelburne, Vermont.

Field's paintings are windows that reveal the character, taste, and look of his region in nineteenth-century America. Even more important, the little man sitting at his easel before his patron of the moment preserved each Yankee subject just as he saw him, emotionally, spiritually, and aesthetically. It is a good legacy.

MARY BLACK

This chapter was originally prepared by Mary Black as the story line for *Erastus Salisbury Field*, 1966 (33 min.), a film produced by Arthur Smith, director, Audiovisual Department, Colonial Williamsburg; Mary Black, assistant producer.

Further Reading

FIELD, ERASTUS S. *Descriptive Catalogue of the Historical Monument of the American Republic*. Amherst, Mass.: H. H. McCloud, 1876.

DODS, AGNES M. "Erastus Salisbury Field (1805–1900). A New England Folk Artist." *Old Time New England*, vol. 33, no. 2 (October 1942), pp. 26–32.

ROBINSON, FREDERICK B. "Erastus Salisbury Field." *Art in America*, vol. 30, no. 4 (October, 1942), pp. 244–53; reprinted in *Primitive Painters in America. 1750–1950*. Jean Lipman and Alice Winchester, eds., 1950; reprint ed., Freeport, N.Y.: Books for Libraries Press, 1971, pp. 72–79.

DODS, AGNES M. "A Check List of Portraits and Paintings by Erastus Salisbury Field." *Art in America*, vol. 32, no. 1 (January 1944), pp. 32–40.

[BLACK, MARY C.] *Erastus Salisbury Field, 1805–1900*. Williamsburg, Va.: Abby Aldrich Rockefeller Folk Art Collection, 1963.

BLACK, MARY C. "Erastus Salisbury Field and the Sources of His Inspiration." *Antiques*, vol. 83, no. 2 (February 1963), pp. 201–6.

DODS, AGNES M., AND FRENCH, REGINALD. "Erastus Salisbury Field, 1805–1900." *Connecticut Historical Society Bulletin*, vol. 28, no. 4 (October 1963), pp. 97–144.

BLACK, MARY. "Rediscovery: Erastus Salisbury Field." *Art in America*, vol. 54, no. 1 (January–February 1966), pp. 49–56. Adapted from the 1966 Colonial Williamsburg film *Erastus Salisbury Field*.

Erastus Salisbury Field. *Burial of the First Born*, c. 1865–70.
Oil on canvas, 33¼ x 39¼ inches.
Museum of Fine Arts, Springfield, Massachusetts; The Morgan Wesson Memorial Collection.

Erastus Salisbury Field. *Historical Monument of the American Republic* (detail), 1876.
Oil on canvas, 115 x 159 inches.
Museum of Fine Arts, Springfield, Massachusetts; The Morgan Wesson Memorial Collection.

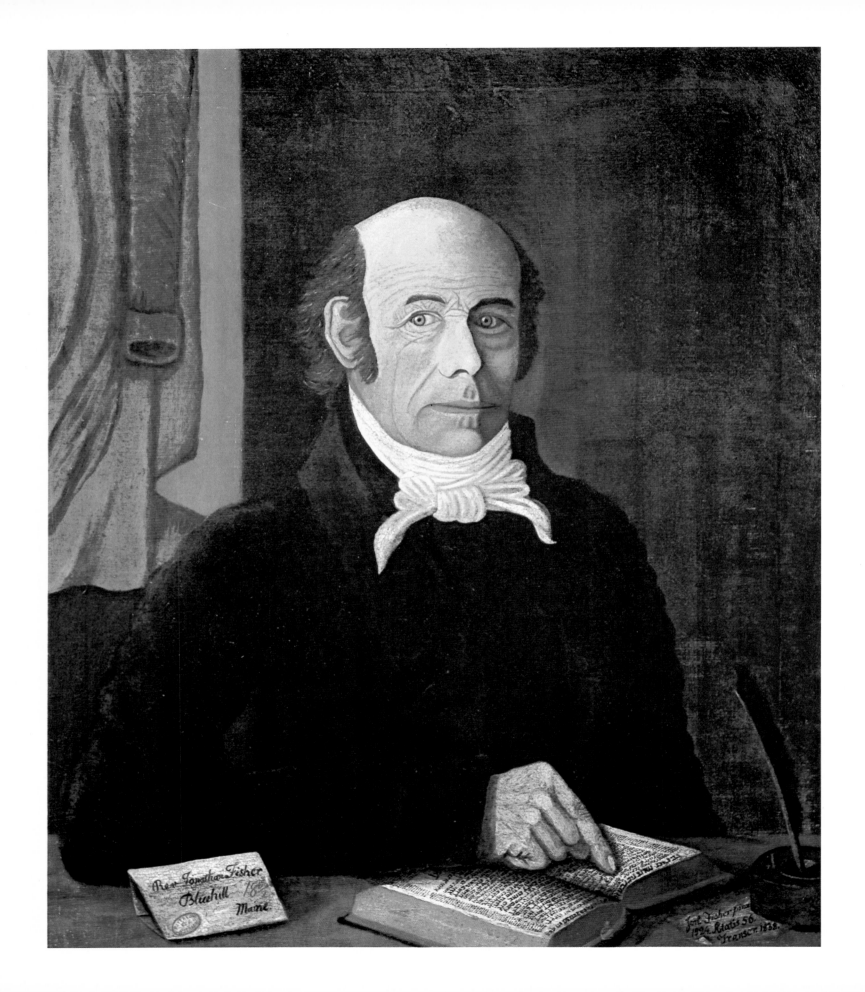

Jonathan Fisher

1768–1847

At the age of fifty-six, the Reverend Jonathan Fisher sat before a mirror in his house in Blue Hill, Maine, and painted a picture of himself. It shows him seated at his table with his finger on an open copy of the Bible in Hebrew; beside the book are his inkwell and quills, and papers inscribed with his name and address, his age, and the date. Fisher wrote in his journal that he painted his portrait between April 19 and April 28, 1824, working on it every day except Sunday, and that it was "not so good as I should have wished." Soon afterward he made a second attempt, a copy of the first. Then nearly fifteen years later he made two more copies, so that each of his daughters might have one.

By profession Fisher was a clergyman, not a painter: for forty-one years he was minister of the Blue Hill Congregational Church. But by temperament he was an artist, a poet, and a naturalist; and by necessity he was a craftsman, teacher, architect, surveyor, inventor, and more besides, for he always had to make contrivance do the work of money, as one of his daughters said.

Fisher made pictures all his life. His oeuvre, if that is not too pompous a word for it, consists of drawings in ink and pencil, paintings in watercolor and in oil, and engravings on wood, and it shows him to have been uncommonly versatile and prolific. A few of his paintings are owned by descendants or institutions, but most of Fisher's surviving work in all mediums is now in two permanent collections in Maine, one in his house at Blue Hill, maintained by the Jonathan Fisher Memorial, the other at the William A. Farnsworth Library and Art Museum at Rockland. These collections also preserve Fisher's paint box and his engraving tools, many of his wood blocks with the drawings he made for them, and copies of the books he wrote and illustrated, as well as furniture, tools, and many other things he made and used.

Fisher documented his life and work with remarkable completeness. For over fifty years he faithfully kept a journal recording daily events and a diary devoted to his spiritual concerns; he also wrote sketches of his life and kept his accounts to the penny. He usually titled, signed, and dated his pictures. He invented a form of shorthand which he called his philosophical alphabet, and in it he made copies of countless letters, sermons, and memoranda. These records are also preserved in Maine. They tell much more about Fisher than can be learned about most country people of his time.

Jonathan Fisher was born October 7, 1768, at New Braintree, Massachusetts, the eldest son of Jonathan and Katharine Avery Fisher. Nine years later his father died while serving in the Continental Army, and his mother had to break up housekeeping and distribute her seven children among relatives. Jonathan went to live with his uncle Joseph Avery, minister of the Congregational Church at Holden, Massachusetts.

When the boy was not busy with chores around the house and farm, his uncle gave him lessons in Latin, Greek, and theology, and for a few weeks each year he went to school. In 1788, after two or three years of studying "in great earnestness," as he wrote later, Jonathan was admitted to Harvard, where he had to work to pay his way. He graduated in 1792 and spent another three years as a divinity student.

During the summers of 1794 and 1795 Fisher served the Congregational Church at Blue Hill, and in 1796 he became its first permanent pastor—indeed, the first settled minister east of the Penobscot River. Blue Hill, a fishing and farming village clinging to the rocky Maine coast, had been incorporated as a town only seven years before, and the surrounding region was still wilderness. Settlers had built mills, docks, and a few substantial houses, and cleared enough land for farms and pastures. In 1792 they had raised the meetinghouse; work on the interior went on for some years, and Fisher painted and numbered the pews in 1799.

Soon after moving to Blue Hill, Fisher married Dolly Battle of Dedham, the town near Boston where his forebears and hers had lived since the mid-1600s and where he frequently went to visit relatives. The couple lived at first in a little house that in 1814 became the ell of a larger dwelling which Fisher planned with great care and ingenuity. Characteristically, he kept a detailed record of his designs and of the progress and costs of construction. The ell has since been changed, but the 1814 structure still stands as Fisher built it, and is now on the National Register of Historic Places.

In this simple two-story, hip-roofed parsonage Fisher and his wife raised their family of nine children. "The walls of his dwelling," a visitor wrote, "were ornamented with paintings, the work of his own hands." Built into the woodwork is a typical Fisher contrivance, a clock that he made during college vacations in Dedham. In 1817 he moved the clock to Blue Hill, where he painted a new dial, decorating it with floral scrolls and mottoes in five languages, and added an ingenious alarm mechanism made of an old wineglass. The clock ran for another fifty years.

Fisher raised crops and livestock to feed his family and made his own farm implements and household utensils. He made surveying instruments and with them laid out roads in Blue Hill and mapped

Jonathan Fisher. *Self-Portrait*, 1838 (after 1824 original). Oil on canvas, 31¼ x 27 inches. Collection of Mrs. Robert L. Fisher.

Jonathan Fisher. *Navigation. The Mariner's Compass* from *Mathematics*, 1791. Ink and watercolor on paper. Jonathan Fisher Memorial, Inc., Blue Hill, Maine.

the surrounding regions. To make money he fashioned and sold all sorts of useful objects, from buttons to sleighs and pumps. He made his own furniture, including a study table which he could convert into a workbench so that, as a friend said, he could pass in a moment from head work to hand work.

He believed in the virtue of labor and the value of learning. He mastered Hebrew, Greek, Latin, and French, and understood the Penobscot Indian language. He was a great reader, not only of theological writings and the classics but also of the modern English poets. He had an aptitude for mathematics and a passion for natural history. And he engaged in the social and moral issues of his time, such as the abolition of slavery, the temperance movement, and the rights of American Indians.

Parson Fisher's spiritual influence was strong and far-reaching. Besides preaching literally thousands of sermons, he visited the sick and troubled, taught children and founded schools, officiated at baptisms, marriages, and funerals, kept a record of all local births and deaths, and performed a variety of other ministerial duties. Year in, year out, he covered hundreds of miles "through the forest" as a missionary to outlying settlements and to the Indians—and he did all his traveling on foot. Sharing his learning and his intellectual interests, he broadened the horizons of his remote village and contributed in every way to its cultural dignity. In 1837

he retired, and he died in Blue Hill in his seventy-ninth year on September 22, 1847.

Fisher's student years at Harvard had opened up new worlds to him—the worlds of science and mathematics, literature and art—and these enriched all the rest of his life. Among his earliest artistic efforts was a "perspective view" of Harvard's Hollis Hall which he made in 1791; it is preserved with other students' "mathematical theses" in the Harvard Archives. This was probably the first of a dozen or more watercolor views of Harvard which Fisher painted.

During his college years Fisher drew scores of little watercolor sketches of other subjects, which are preserved in volumes that he bound in leather. One notebook, which he titled *Mathematics*, consists of college work in the form of solutions to problems in trigonometry, surveying, and navigation, with diagrams and decorations carefully drawn in ink and often colored. Many pages are illuminated with what he called "flowers and sprigs" in watercolor, or embellished with calligraphic scrolls (see illustration). Another notebook contains sketches of animals, birds, flowers, fruits, shells, and insects. Fisher copied some of these from books but drew others from his own observation, as when he sketched the great black horsefly "drawn to full size from the life."

Similar sketches are scattered through a small notebook titled *Varietas*, which also contains bits of useful information copied from the *Christian Mirror* and other sources, such as: "Recipes. To secure Cabbage plants from worms. To make bad butter good." There are instructions for mending china, drying furs, and grafting apple trees. One page gives "Receipts for those who paint in water colors" which Fisher copied verbatim from *The Artists Assistant in Drawing, &c...*, a little book first published in London about 1760 and reissued again and again in "improved" editions. It was no doubt from a similar book that Fisher learned to paint his flowers and sprigs.

Many of the early sketches are childishly inept, for Fisher was just teaching himself to draw. He received no training beyond the mechanical drawing required for his college courses and the self-

Jonathan Fisher. *Mastiff* from *Scripture Animals*, 1834. Wood engraving. Courtesy of the Jonathan Fisher Memorial, Inc., Blue Hill, Maine.

Jonathan Fisher. *The Latter Harvest*, 1804.
Oil on canvas, 20 x 26½ inches.
William A. Farnsworth Library and Art Museum, Rockland, Maine.

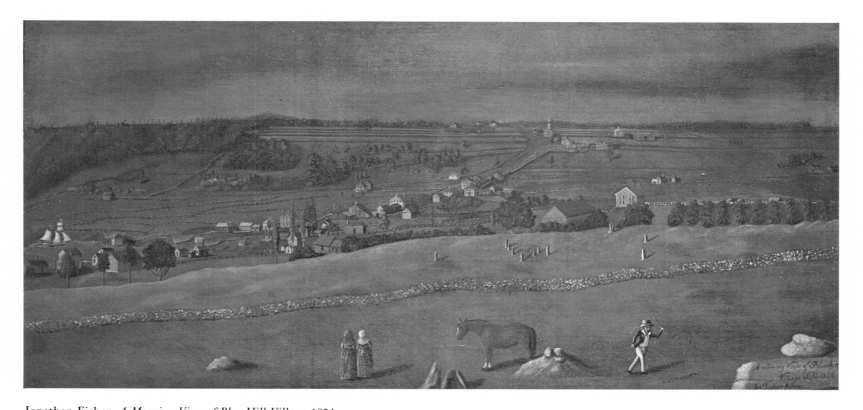

Jonathan Fisher. *A Morning View of Blue Hill Village*, 1824.
Oil on canvas, 25½ x 52 inches.
William A. Farnsworth Library and Art Museum, Rockland, Maine.

applied instruction he derived from the few available "how-to" books. For him, as for many of his contemporaries, copying printed pictures was the most important means of learning, if not the only one.

The year before he left Cambridge, Fisher discovered a new source of material, and with its aid produced more complex and finished pictures. In the Harvard library he found the three-volume work by the English naturalist George Edwards, *Gleanings of Natural History, exhibiting figures of quadrupeds, birds, insects, plants, &c...*, (London, 1758–64). From the hand-colored engravings that fill these tomes, Fisher copied in watercolor twenty pictures of exotic animals and birds, and bound them in a leather-covered album of full folio size. He duplicated Edwards's pages as exactly as he could, with the picture large at the top and two columns of descriptive text below, one in English, the other in French—except that Fisher wrote the English version in his own shorthand. He even inscribed Edwards's name and book title and usually his own name as well, with the date, 1795. These lively, well-designed plates afforded him excellent practice in drawing and coloring, with subjects that especially appealed to him.

In Blue Hill, Fisher's work became more mature and more varied, though he continued to make watercolor sketches of natural subjects, now more often inscribed "drawn from life" or "from nature." About 1798 he began to produce paintings in oil on canvas or on board. Nearly twenty-five of these are recorded, all in frames he made himself. They range from portraits and views to still life and nature studies, with a few religious, allegorical, and literary subjects copied from prints. Two are dated 1847, the year of his death.

The most important of Fisher's oils, artistically and historically, are his self-portrait and his view of Blue Hill (colorplates). Of the former, Oliver W. Larkin wrote in his *Art and Life in America* (1960): "When Fisher limned his own portrait, he revealed the whole man.... The shading of the head gives it a startling and solid reality against the dark background; and on this firm structure Fisher has traced every wrinkle and crease which age and character produce. One can believe that these eyes missed nothing in the world around him; that this strong hand could carve wood and metal; that this forefinger could stab the consciences of his parishioners."

A few months after his self-portrait, Fisher painted the large panorama on which he wrote *A morning View of Bluehill/Village. Sept. 1824/Jon. Fisher pinx.* He showed his parish as he knew it, its single road climbing from the harbor to his church. Houses and barns are clustered along the road, the wide fields beyond them marked off with fences and dotted with tree stumps, and not far off is the forest where leaves are taking on their autumn colors. In the foreground, near a horse and two women in sunbonnets, a man raises a stick to strike a snake. More than a pleasing scene, the picture is a poignant document of an outlying seacoast village in the early nineteenth century.

The best of Fisher's numerous still-life pictures is *The Latter Harvest* (colorplate), a composition of vegetables and apples prob-

ably from his own farm. His original oils also include several views of Dedham, a picture of a recumbent red cow in a hilly green landscape, and a colorful composition of four birds in a habitat setting *Drawn from nature* in 1820.

Fisher's most innovative work, technically, was his engraving on wood. He began investigating this medium in Dedham in the summer of 1793. In July he wrote in his journal, "Worked on the farm; engraved on boxwood, began a small printing press." Early in August he noted, "Worked some on the farm. Finished my printing press; engraved a little and struck off a number of prints from boxwood cuts."

He was inspired by the work of the English engraver Thomas Bewick, whose *General History of Quadrupeds*, illustrated with cuts, became popular in America in the late 1700s; the Harvard library acquired a copy in 1793. Bewick's technique, known as white-line engraving, was first used successfully in this country by Dr. Alexander Anderson, who became one of the leading practitioners of this exacting art. Anderson had begun experimenting with it in the summer of 1793, when he was a young medical student in New York. By a striking coincidence, in the same summer the young divinity student Jonathan Fisher was experimenting independently in the same way.

Three years later Fisher turned his new skill to commercial use by engraving a "headpiece" for a Dedham newspaper; he recorded that in payment he received "the life of Thomas Paine." In 1807 he began work on *The Youth's Primer*, a book of his verses illustrated by twenty-eight of his wood engravings; it was published in Boston in 1817. He wrote and illustrated three other books for children, which appeared during the following ten years, and he made numerous cuts for broadsides and other purposes.

When he was sixty-six years old, Fisher's magnum opus appeared: *Scripture Animals, or Natural History of the Living Creatures Named in the Bible, Written Especially for Youth*, published in Portland in 1834. He had worked on it for nearly fifteen years. In this one volume Fisher brought together his passion for natural history, his love of making pictures and writing verses, his concern for moral uprightness, and his interest in instructing the young. He engraved for it more than 140 wood blocks of animals, reptiles, birds, and insects mentioned in the Bible, and arranged them alphabetically, from Adder to Wolf (illustration). With each cut he gave biblical references to the creature, information about its species and habits, and often a moral comment in prose or verse. For the title page he engraved a hilly landscape filled with beasts and birds, in the center of which a profile portrait of himself is outlined by the branches of trees. In the introduction to the book Fisher wrote, "As respects the cuts, a few of them are from nature but most of them are copied [from Bewick, Edwards, and others]. I have engraved them myself, and having had no instruction in the art, and but little practice, I can lay claim to no elegance in their appearance."

Fisher's work with both burin and brush shows great honesty, a strong feeling for pattern and line, and often genuine force. He strove for simple realism and that is what he achieved. He was like

many other American amateur artists of his day in that he was self-taught. He prepared his own materials and made his own tools, and his very lack of training and sophistication helped to give his work individuality. He was more painstaking than imaginative and for him, as for others, making pictures was more a craft than an art. Unlike most others, however, he learned to work in several mediums. And he practiced his skill purely for his own pleasure: he rarely sold a picture.

The art of Jonathan Fisher is the personal expression of a versatile Yankee—the New England country version of the universal man. Inventive, capable, industrious, full of intellectual curiosity, he was ready to try his hand at anything. Within his own small sphere he exercised his abundant faculties to know, and enjoy, the world around him.

ALICE WINCHESTER

This chapter is based on *Versatile Yankee: The Art of Jonathan Fisher* by Alice Winchester. Princeton, N.J.: Pyne Press, 1973.

Further Reading

FISHER, JONATHAN. *Scripture Animals*, 1834; reprint ed., Princeton, N.J.: Pyne Press, 1972.

BYRNE, JANET S. "An American Pioneer Amateur." *Princeton University Library Chronicle*, vol. 6, no. 4 (June 1945), pp. 153–70.

CHASE, MARY ELLEN. *Jonathan Fisher, Maine Parson, 1768–1847.* New York: Macmillan, 1948; reprint ed., Blue Hill, Me.: Jonathan Fisher Memorial, Inc., 1978.

The Arts and Crafts of the Versatile Parson Jonathan Fisher 1768–1847 (exhibition catalogue). Rockland, Me.: William A. Farnsworth Library and Art Museum, 1967.

WINCHESTER, ALICE. "Rediscovery: Parson Jonathan Fisher." *Art in America*, vol. 58, no. 6 (November–December 1970), pp. 92–99.

———. "Versatile Yankee: The Art of Jonathan Fisher 1768–1847. An Antiques Book Preview." *Antiques*, vol. 104, no. 4 (October 1973), pp. 658–64.

ADAMS, PRISCILLA B. "Jonathan Fisher" in *Versatility—Yankee Style* (exhibition catalogue). Rockland, Me.: William A. Farnsworth Library and Art Museum, 1977, pp. 9–14, 29–30.

Edward Hicks

1780–1849

Thomas Hicks. Portrait of Edward Hicks, 1838. Oil on canvas, 27¼ x 22⅛ inches. Abby Aldrich Rockefeller Folk Art Center, Williamsburg, Virginia.

The career of Edward Hicks is a study in contrasts. He was both an artist and a Quaker preacher, which is a contradiction in terms. A master of color and symbolism, he painted for a clientele that muted all colors and rejected every visual symbol. And though his many *Peaceable Kingdoms* have marked him an apostle of peace, he was, in fact, one of the most contentious of Quakers. No one knew this better than he. In his diary he confessed, "My poor zig-zag nature predisposes me to extremes."

He came by his divided nature honestly, for he entered the world in a season of conflict. The Revolutionary War was well advanced when, on April 4, 1780, this son of Isaac and Catherine Hicks was born at what is now Langhorne, Bucks County, Pennsylvania. Within eighteen months he was motherless, and the war had swept away the family fortune. Happily, his father put him in

the care of Elizabeth Twining, a gentle Quakeress who raised him with the same love she would have given a son of her own. At the age of thirteen—an age when, in the eighteenth century, boys started their vocational training—he left her sheltered household for the rough life of a coachmaker's apprentice, where long days of hard work alternated with holidays spent in city taverns. "About the twentieth year of my age," he tells us in his *Memoirs*, "a terrible storm of sickness overtook me whilst on a frolic in the city of Philadelphia." He was cured by what he believed to be divine intervention, and was overcome with remorse. After a period of uncertainty, he gave up dancing and singing, adopted the "plain language" of the Quakers, and having joined the Society of Friends in 1803, later in the same year married his Quaker sweetheart, Sarah Worstall. They lived in Milford (now Hulmeville), Pennsylvania, where Hicks was the junior partner of a coachmaker. In 1811 he moved his family to Newtown, then the county seat of Bucks County, and resided there for the rest of his life.

To support a wife and growing family, Hicks augmented his coach work by painting household objects such as chairs, tables, and fire buckets, and, as the years went on, trade and tavern signs. From signboards he acquired certain archaic conventions, including the bold outlines, decorative borders, and lettered banners that he used in his own early work. As for subject matter, signcraft provided two specific legacies: the various emblems of the craft guilds, preserved on trade signs; and the vivid colors and stylized animals of medieval heraldry, which lingered on tavern boards into the late eighteenth century. Most important, signcraft taught Hicks how to handle pictorial space and to draw figures. By 1818 we find in his shop ledger such entries as "To two landscape paintings, $30." He could use the extra money, since by this time he had become a Friends minister, for which he received no pay.

Just what did it mean to be a Quaker preacher in the early nineteenth century? Unlike most pastors, he had no sermons to prepare, for all speaking was spontaneous, nor were there any sacraments to administer. The Friends minister was chosen solely because he—or she—had demonstrated a more than usual receptivity to the Holy Spirit, or the Light Within, as George Fox, the founder of Quakerism, had expressed it. As a Friends minister Hicks was expected to serve as a channel for the Spirit, and when inwardly prompted, to give it utterance in his own meeting. He was also expected to carry his message to other Friends meetings and to the world at large, if so bidden by the inner voice.

Such a call came to Hicks in 1819. He was already afflicted with

Above, below, where'er the astonished eye
Turns to behold, new opening wonders lie,

With uproar hideous first the *Falls* appear,
The stunning tumult thundering on the ear.

This great o'erwhelming work of awful Time
In all its dread magnificence sublime,

Rises on our view, amid a crashing roar
That bids us kneel, and Time's great God adore.

The Falls of Niagara

18 25

Edward Hicks. *The Falls of Niagara*, 1825. Oil on canvas, 31½ x 38 inches.
The Metropolitan Museum of Art, New York; Gift of Edgar William and Bernice Chrysler Garbisch.

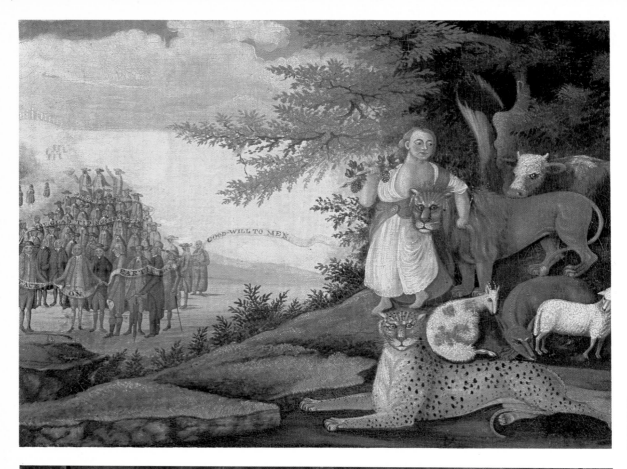

Edward Hicks. *Peaceable Kingdom*, c. 1827.
Oil on canvas, 17⅞ x 23¾ inches.
Friends Historical Library of Swarthmore College,
Swarthmore, Pennsylvania.

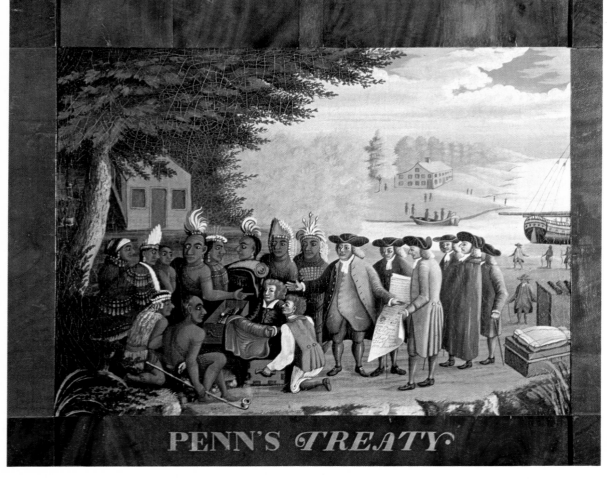

PENN'S *TREATY*

Edward Hicks. *Penn's Treaty with the Indians*, c. 1830–35.
Oil on canvas, 17⅝ x 23¾ inches.
Abby Aldrich Rockefeller Folk Art Center,
Williamsburg, Virginia.

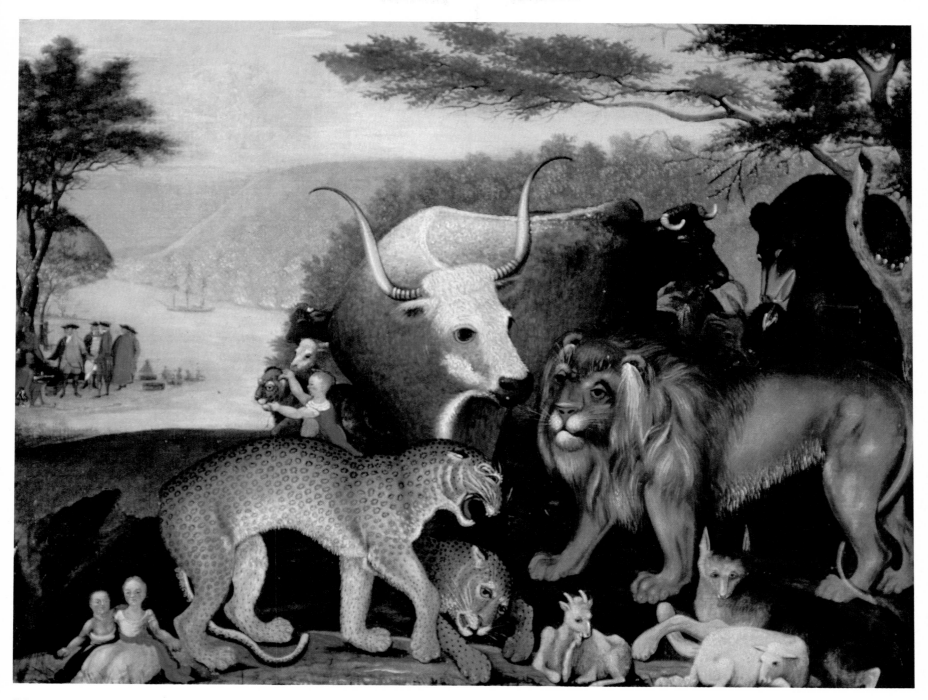

Edward Hicks. *The Peaceable Kingdom*, 1844. Oil on canvas, 24 x 31¼ inches.
Abby Aldrich Rockefeller Folk Art Center, Williamsburg, Virginia.

symptoms of tuberculosis, then known as consumption. "In these journeys," he wrote, "I rode near 3,000 miles on horseback, which I am disposed to believe was the cause of changing my complaint from pulmonary consumption to chronic cough." It is hard to see how three thousand miles on horseback in the dead of winter, preaching in drafty halls and traveling through frontier districts laid waste with yellow fever, could cure such a disease. Yet it is a matter of record that he survived the experience by thirty years.

A stop at Niagara Falls inspired the landscape now owned by the Metropolitan Museum (colorplate). Though the motivation came from his trip, the composition was borrowed. His model was a vignette from an 1822 map by Henry S. Tanner, a discovery made by James Ayres, director of the John Judkyn Memorial in Bath, England. Tanner had presented the Falls side by side with the Natural Bridge of Virginia, the two wonders separated in his map only by a large oak tree. Hicks converted this into an effective design by removing the bridge and adding a decorative border which combined verses from Alexander Wilson's poem "The Foresters" with corner blocks bearing the title and date, *The Falls of Niagara 1825.*

Hicks faithfully retained certain details from the map, such as the four uniquely North American animals: eagle, moose, beaver, and rattlesnake. The crosshatching on the beaver's tail is a convention of signcraft added by Hicks; hatters' signs often carried a beaver with tail so rendered, accompanied by a small tricorne to further advertise the product (illustration). The most dramatic of the creatures is the rattlesnake, coiled to strike. During the struggle for American independence it had become a symbol of resistance to foreign oppression, a concept which must have appealed to the artist who, though he had been born into a Tory family, was an ardent patriot.

Motifs used on hatters' signs, from *A History of Signboards* by Jacob Larwood and John Camden Hotten (London, 1866). Courtesy of the Free Library of Philadelphia.

Hicks is best known for his *Peaceable Kingdoms*, approximately sixty of which survive. These form a sequence in which the details constantly dissolve and regroup but, like the colored fragments in a nineteenth-century kaleidoscope, never exactly repeat themselves. It was probably around 1820 that he painted his first. As Alice Ford has told us in her biography of the artist, he acquired the composition from an engraved illustration of a painting by the English academician Richard Westall. Titled *The Peaceable Kingdom of the Branch*, it illustrates Isaiah's prophecy of a world at peace under the reign of the Messiah: "The wolf also shall dwell with the lamb, and the leopard shall lie down with the kid; and the calf and the young lion and the fatling together; and a little child shall lead them" (Isaiah 11:6).

Westall's picture appeared in many Bibles in use at the time. It shows a child embracing a lion, surrounded by the other animals of the prophecy. Over the child's shoulder is the branch, Isaiah's metaphor for the Messiah. Westall made it a grapevine, a Christian symbol of the Redemption, thus identifying the Messiah of the Old Testament with the Christ of the New Testament. To this arrangement Hicks added a vignette of Penn's Treaty, the meeting on the banks of the Delaware River where William Penn paid the Indians for the land of Pennsylvania. The painter saw in this occasion a practical realization of the peaceable kingdom on earth.

In the late 1820s, however, Hicks's canvases reflected the impact of a bitter conflict within the Society of Friends. It was centered in the person of his cousin Elias Hicks. This Long Island patriarch was the most controversial figure in the history of Quakerism. A speaker of extraordinary power, he placed such emphasis on the Light Within that he appeared to exclude the authority of the Bible and the Atonement of Christ. In so doing he provoked issues that were theological, social, and economic. For in this period the city Quakers felt the pressures of the popular revivalism around them in a way their more isolated country cousins did not. It was from the country communities that the followers of Elias were largely drawn, and it was upon these country men and their preachers that the Quaker Elders of Philadelphia sought to impose the tenets of orthodoxy. The tension reached its climax in April of 1827 when the Hicksite party, including the painter, withdrew from Philadelphia Yearly Meeting.

In the *Peaceable Kingdom* owned by Swarthmore College (colorplate), we see a kingdom in conflict. The composition is divided: to the right is the Westall nucleus; to the left, instead of the usual Penn's Treaty, a mountain of drably dressed Quakers support a banner inscribed: *Behold I bring you glad tidings of great joy. Peace on earth and good-will to men.* But instead of peace and good will, the canvas is laden with hostility—in the faces of the carnivorous animals, the erosions of the landscape, and the cleft trunk of the tree. At the foot of the Quaker mountain is Elias Hicks, painted after a well-known silhouette. He is hatless and wears the riding boots of the traveling minister. A limp handkerchief droops from his hand in token of his arduous preaching, which often left him drenched with perspiration.

The title "Peaceable Kingdom with Quakers Bearing Banners"

has been applied to this type of composition. It was Mary Black who first perceived in such works the aftermath of the Quaker controversy, while Dr. Frederick B. Tolles, formerly head of the Friends Historical Library, Swarthmore College, discovered their specific inspiration in a poem by a fellow Quaker, Samuel Johnson of Buckingham, Pennsylvania, titled, "To Edward Hicks on his proposition for painting an Historical piece commemorative of the progress of religious Liberty." The composition of these paintings closely follows the text of the poem, where, for example, we learn that the banner proceeding from Christ and his Apostles on the mountain top represents Christian liberty. It is supported by Protestant Reformers before encircling a trio of early Quakers—Robert Barclay, with book in hand, Penn, and Fox—and then descends among a nameless multitude until it reaches the base of the pyramid, which is occupied by Elias and his followers—with one possible exception. It has been suggested that the central figure in this bottom row is George Washington.

The painter had three great heroes: Elias Hicks, George Washington, and William Penn, all of whom found their way in one form or another into his pictures. But his favorite was Penn, who not only dealt fairly with the Indians but also gave to his English and Welsh colonists an unprecedented degree of civil and religious liberty.

Although the Treaty scene is absent from the Swarthmore *Kingdom*, Hicks soon began to devote whole canvases to the subject, drawing for inspiration on Benjamin West's famous work *William Penn's Treaty with the Indians*. Hicks never saw the original, which did not arrive in America until after his death, but copied the 1775 engraving by John Hall, a print that adorned the walls of innumerable Quaker households both in England and in the Delaware Valley. As in many engravings, the composition is reversed, which accounts for the reversal in all Hicks's adaptations. The artist also

used background details from two engravings in John Fanning Watson's 1830 *Annals of Philadelphia*.

One of Hicks's earliest *Treaties* is the version now at Williamsburg (colorplate), which is typical in size and in the veneered frame made in the artist's shop either by the master himself or by his assistant, Edward Trego. The rich reds and blues of the canvas have a medieval look inherited from the sign painter's tradition, which is also evident in the emphasis on profile and the disproportionate size of the signatures on the scroll.

The signatures show a casual disregard for historical fact. The names, except those of Penn and his deputy, William Markham, belong to men who were not on this side of the Atlantic in 1682 when, according to tradition, the treaty with the Indians was made. Thomas Janney, for example, arrived the following year; we wonder if he is mentioned here because a descendant of the same name was a Newtown acquaintance, later appointed by the painter as an administrator of his will.

In the 1830s a transformation took place in the *Peaceable Kingdoms*. Hicks created a new composition dominated by a seated lion, which later in the decade became a lion standing in profile, poses drawn from the artist's sign-painting experience. He also shifted Westall's child to the background and removed the grape branch, presumably because it was too orthodox an emblem to continue after the Hicksite/Orthodox schism of 1827. But the most striking change was the host of new figures crowding the canvas. Not only did Penn's Treaty return in expanded form, but where Westall had used only the child and animals from Isaiah 11:6,

Lion passant guardant, from *English Heraldry*, by
Charles Boutell (London, 1907).

Edward Hicks. *Noah's Ark*, 1846.
Oil on canvas, 26½ x 30½ inches.
Philadelphia Museum of Art;
Bequest of Mr. and Mrs. William M. Elkins.

Edward Hicks. *The Residence of David Twining, 1787,*
c. 1845–48. Oil on canvas, 26½ x 31½ inches.
Abby Aldrich Rockefeller Folk Art Center,
Williamsburg, Virginia.

Hicks now added all the creatures from the remaining verses (7–9) of the prophecy:

And the cow and the bear shall feed; their young ones shall lie down together; and the lion shall eat straw like the ox.

And the sucking child shall play on the hole of the asp, and the weaned child shall put his hand on the cockatrice's den.

They shall not hurt nor destroy in all my holy mountain: for the earth shall be full of the knowledge of the Lord, as the waters cover the sea.

On September 23, 1844, a *Peaceable Kingdom* (colorplate) was delivered to Joseph Watson of Middletown Township, Bucks County, who had commissioned it for his new house on the Bristol-Newtown Road. An accompanying note from the artist called it one of his best, stated the price as $21.75, including payment of $1.75 to Edward Trego for a frame, and concluded with his characteristic "butterfly" signature (illustration).

Here we see a composition totally different from that of the Swarthmore *Peaceable Kingdom*. Where that was divided, the 1844 canvas is magnificently centered in a triangle consisting of leopard, lion, and ox. The Penn's Treaty scene has returned to its accustomed spot. And the leopard—instead of a heraldic creature, decorative but static—has become powerful and dynamic as it arches over its mate.

To understand this work we must understand the symbolism. In a sermon at Goose Creek Meeting, Loudon County, Virginia, in 1837, the artist-preacher stated that every human being is born with the savage disposition of the wolf, the leopard, the bear, or the lion. If left unchecked, these passions must destroy one another, but if the individual yields self-will to the Divine Will, he or she can be reborn into the gentle spirit of the lamb, the kid, the cow, and the ox. This denial of self was the goal of Quaker quietism. It is typified by the patient ox, and negatively, by his opposite, the lion. We suspect that in the lion Hicks saw willful, contentious Quaker leaders like himself.

The ox/lion symbolism finds an echo in the Westall child, now withdrawn to the middle distance, who is trying to yoke "the young lion, the calf, and the fatling together" with a tasseled cord. This yoking process also implies submission to the Divine Will— but with a difference: the cord not only binds; it also unites, suggesting the hope of reconciliation among nature's creatures.

In the spring of 1846 Hicks painted *Noah's Ark* (colorplate) for Dr. Joseph Parrish, Jr., son of his old friend and personal physician. Inscribed on the reverse is the quotation from Genesis 7:15: *And they went in unto Noah in the Ark, two and two of all flesh, wherein is the breath of life.* The source was an 1844 lithograph by Nathaniel Currier. To it the painter added crossed tree trunks and a thunderous arch of storm cloud, and transformed the lion from a simpering Victorian into the stately *lion passant guardant* of medieval heraldry—a late relic of the signcraft tradition (illustration). But the ultimate magic was Hicks's placement of the white mare in front of the black stallion, so that her beauty could shine forth unobstructed.

Although executed in a period of deep sorrow, following the death of his favorite granddaughter, this is a work of wondrous serenity. Like Hicks's many *Kingdoms*, it is a sermon in salvation, wherein opposing elements meet in ordered harmony as the animals, wild and domestic, male and female, march into the promised refuge of the Ark. Years earlier, as a preacher, Hicks had pleaded, "Come you away to Christ of whom Noah was the antitype, and here find rest for your souls."

A love of the maternal pursued Hicks all his motherless days, but it was not until late in life that he celebrated it in his nostalgic masterpiece, *The Residence of David Twining* (colorplate). In this lost paradise of his childhood, we see seven-year-old Edward with his foster parents: Elizabeth Twining in cap and kerchief, her Bible on her knee, and her husband David in broadbrim hat and the drab coat of a plain Friend. Beulah, youngest of the Twining daughters, stands in the farmhouse doorway, while sister Mary, already mounted, waits for her husband to swing into his saddle. As in all the farmscapes, the composition is Hicks's own invention. The pose of the horses comes from Thomas Sully's *Washington at the Passage of the Delaware*, and was used by Hicks in his versions of that work. But here the question of sources is unimportant: this haunting vista into the agrarian world of the eighteenth century was Hicks's own.

Though he was shaky on historical facts, the painter had a gift for capturing the mood of an age which can be fully appreciated by comparing the Twining canvas with his farmscape for James Cornell (colorplate). The Twining and Cornell holdings lay within a few miles of each other, and their masters were alike in their ability to manage a large domain. But Twining in his Quaker broadbrim is a colonial farmer of the 1700s; whereas Cornell in his 1840s hat is part of an expanding new America which rejoices in the threshing machine, locomotives, and agricultural competitions, as witnessed by the inscription on the canvas: *An Indian summer view of the Farm & Stock of James C. Cornell of Northampton Bucks County Pennsylvania. That took the Premium in the Agricultural society. October the 12, 1848.* The artist senses the new mood and portrays it, but adds a dimension beyond time in the white mare that nuzzles her foal, and the barn that rides the golden landscape like an ark on the flood.

Edward Hicks died on August 23, 1849. In retrospect we see him as a supreme folk artist, but not a typical one. While most of his fellow folk artists were little-known or anonymous figures, Hicks, through his preaching and published sermons, was known to thousands. More significantly, he was unique in respect to the evolutionary character of his work. Although his painting retained primitive elements to the last, its progress from early signboard to late farmscape represents an enlargement of vision and technical maturation usually seen only in the masters of academic art.

ELEANORE PRICE MATHER

(continued)

Edward Hicks. *The Cornell Farm*, 1848. Oil on canvas, 36¾ x 49 inches.
National Gallery of Art, Washington, D.C.; Gift of Edgar William and Bernice Chrysler Garbisch.

Further Reading

HICKS, EDWARD. *Sermons Delivered by Elias Hicks and Edward Hicks in Friends Meetings, New York. In 5th Month, 1825.* Taken in shorthand by L. H. Clark and M. T. C. Gould. New York, 1825.

HICKS, EDWARD. *Memoirs of the Life and Religious Labors of Edward Hicks, Late of Newtown, Bucks County, Pennsylvania. Written by Himself.* Philadelphia: Merrihew & Thompson, 1851.

"Hicks Called Greatest in America by Léger." *Art Digest*, vol. 6, no. 6 (December 15, 1931), p. 13.

DRESSER, LOUISA. "The Peaceable Kingdom." *Worcester Museum Bulletin*, vol. 25, no. 1 (April 1934), pp. 25–30. Reprinted in *Design*, vol. 37, no. 6 (December 1935), pp. 6–7.

BYE, ARTHUR EDWIN. "Edward Hicks, Painter Preacher." *Antiques*, vol. 29, no. 1 (January 1936), pp. 13–16; reprinted in *Primitive Painters in America. 1750–1950*, Jean Lipman and Alice Winchester, eds., 1950; reprint ed., Freeport, N.Y.: Books for Libraries Press, 1971, pp. 39–49.

LIPMAN, JEAN. "Peaceable Kingdoms by Three Pennsylvania Primitives." *American Collector*, vol. 14, no. 7 (August 1945), pp. 6–7.

PRICE, FREDERICK NEWLIN. *Edward Hicks, 1780–1849.* Swarthmore, Pa.: Benjamin West Society, Swarthmore College, 1945.

KEES, ANN. "The Peaceable Painter." *Antiques*, vol. 52, no. 4 (October 1947), p. 254.

HELD, JULIUS. "Edward Hicks and the Tradition." *The Art Quarterly*, vol. 14, no. 2 (Summer 1951), pp. 120–36.

FORD, ALICE. *Edward Hicks, Painter of the Peaceable Kingdom*, 1952; reprint ed., Millwood, N.Y.: Kraus, 1973. The standard biography, with many good early references.

McCOUBREY, JOHN W. "Three Paintings by Edward Hicks." *Yale University Art Gallery Bulletin*, vol. 25, no. 2 (October 1959), pp. 16–21.

BLACK, MARY C. *Edward Hicks 1780–1849, a Special Exhibition Devoted to His Life and Work* (exhibition catalogue). Introduction and chronology by Alice Ford. Williamsburg, Va.: Abby Aldrich Rockefeller Folk Art Collection, 1960.

———. "& a Little Child Shall Lead Them." *Arts in Virginia*, vol. 1, no. 1 (Autumn 1960), pp. 22–29.

FORD, ALICE. "The Publication of Edward Hicks's *Memoirs*." *Bulletin Friends Historical Association*, vol. 50, no. 1 (Spring 1961), pp. 4–11.

TOLLES, FREDERICK B. "The Primitive Painter as Poet. . . ." *Bulletin Friends Historical Association*, vol. 50, no. 1 (Spring 1961), pp. 12–30.

MARSAL, SONIA. "Edward Hicks. Quaker Painter." *Américas*, vol. 17, no. 12 (December 1965), pp. 5–14.

ARKUS, LEON ANTHONY. "Edward Hicks. 1780–1849" in *Three Self-Taught Pennsylvania Artists: Hicks, Kane, Pippin* (exhibition catalogue). Pittsburgh: Museum of Art, Carnegie Institute, 1966, n.p.

WINSTON, GEORGE P. "The Wolf Did With the Lambkin Dwell." *Pennsylvania History*, vol. 33, no. 3 (July 1966), pp. 261–73.

BREY, JANE W. T. *A Quaker Saga*. Philadelphia: Dorrance, 1967, pp. 79–88.

MATHER, ELEANORE PRICE. *Edward Hicks, Primitive Quaker*. Wallingford, Pa.: Pendle Hill, 1970.

———. *Edward Hicks. A Peaceable Season.* Princeton, N. J.: Pyne Press, 1973.

PULLINGER, EDNA S. *A Dream of Peace. Edward Hicks of Newtown.* Philadelphia: Dorrance, 1973.

MATHER, ELEANORE PRICE. "The Inward Kingdom of Edward Hicks." *Quaker History*, vol. 62, no. 1 (Spring 1973), pp. 3–13.

———. "A Quaker Icon." *The Art Quarterly*, vol. 36, nos. 1/2 (Spring/Summer 1973), pp. 84–99. Reprinted as *Edward Hicks: A Gentle Spirit* (exhibition catalogue). New York: Andrew Crispo Gallery, 1975.

PARRY, ELLWOOD. "Edward Hicks and a Quaker Iconography." *Arts Magazine*, vol. 49, no. 10 (June 1975), pp. 92–94.

WERNER, ALFRED. "Edward Hicks Preacher and Painter." *Art and Artists*, vol. 10, no. 5 (August 1975), pp. 26–31.

DERFNER, PHYLLIS. "Edward Hicks. Practical Primitivism and the 'Inner Light.'" *Art in America*, vol. 63, no. 5 (September/October 1975), pp. 76–79.

BLACK, MARY C. "Three Folk Artists and Their Description of Pennsylvania" in *1976 University Hospital Antiques Show*. Philadelphia: University of Pennsylvania Hospital, 1976.

AYRES, JAMES E. "Edward Hicks and His Sources," *Antiques*, vol. 109, no. 2 (February 1976), pp. 366–68.

KARLINS, N. F. "Peaceable Kingdom Themes in American Folk Painting." *Antiques*, vol. 109, no. 4 (April 1976), pp. 738–41.

MATHER, ELEANORE PRICE. "The Peaceable Kingdom." *Early American Life*, vol. 7, no. 6 (December 1976), pp. 20–23, 52–53.

MATHER, ELEANORE PRICE, AND MILLER, DOROTHY C. Catalogue raisonné of Hicks's *Peaceable Kingdoms*. In preparation.

Joseph H. Hidley

1830–1872

Joseph H. Hidley, 1860s. Courtesy of the Abby Aldrich Rockefeller Folk Art Center, Williamsburg, Virginia.

In Poestenkill, a village approximately ten miles east of Troy, New York, Joseph Henry Hidley, house painter, carpenter, taxidermist, and handyman, painted some of the most personal views of rural life produced in nineteenth-century America.

Hidley was born on March 22, 1830, on Hidley Road in the town of Greenbush (now North Greenbush), Rensselaer County, New York. The son of George and Hannah Simmons Hidley, he was the only survivor of four children when his father died in 1834, just before Joseph's fourth birthday. Young Hidley spent the next seven years with his uncle Philip I. Simmons and his maternal grandparents, Christian and Patience Simmons, in the nearby town of Sand Lake, which had been settled in 1770 and would be incorporated in 1848 as Poestenkill (a combination of *posten* and *kill*, two Dutch words meaning "puffing or foaming creek"). In 1841, he returned to Hidley Road to live with his grandfather Michael Hidley and

his aunt and uncle John and Christine Hidley. He lived with his mother, who had remarried, from 1844 until 1850, when his stepfather, William W. Coonradt, died and his mother moved to be with relatives in Monroe County, New York. Hidley, then twenty, remained in Poestenkill, where he lived until his death from consumption in 1872.

Hidley's family were descendants of German Lutherans, refugees from the Rhenish Palatinate who settled in the Hudson Valley in the early 1700s, joining descendants of the earliest Lutherans, who had come with the Dutch West India Company almost a century earlier. Descendants of the Palatinate settlers entered the Manor of Rensselaerwyck, which included the area of Poestenkill, between 1745 and 1765. Among them was a distant cousin of Joseph, John Heidley (an alternate spelling of the surname), who came to Greenbush from Germantown, New York. A Lutheran congregation was formed in West Sand Lake in 1776, and in 1832 representatives from this group paid John Heidley and his wife one dollar for a parcel of land which became the site of the Lutheran Church that occupies a prominent position in Hidley's views of the town (see *Poestenkill: Summer*, colorplate). Directly to the left of the church is the home where Joseph Hidley moved with his wife, Caroline Danforth, a native of Poestenkill, several years after they were married on her sixteenth birthday, September 18, 1853. They had six children, of whom only three survived infancy.

Poestenkill was known primarily for several mills along the creek that gave the town its name; among them were the mills that provided lumber for the New York Central Railroad. The Poestenkill census taken on June 23, 1870, lists Joseph H. Hidley as a house painter with real estate valued at $600 and a personal estate valued at $200. This information, recorded two years before his death, reveals his meager circumstances. From the shed behind his home, Hidley conducted his house painting business and worked at assembling decorative arrangements of dried flowers and stuffed birds and producing his paintings. The Lutheran Church next door paid him twenty-five dollars a year to perform the duties of sexton. Caroline Hidley died in 1870 at the age of thirty-three; when Joseph died two years later, the Hidley children were separated. One daughter was placed in a foster home near East Schodak, New York; the other daughter and a son were sent to live with relatives in Chicago.

Hidley left little more than his paintings, which for the next seventy years would be known only in the area of Poestenkill. There

are at least eight surviving townscapes—four of Poestenkill, two of nearby Glass Lake, one of West Sand Lake—and two unidentified rural scenes. In addition, his work includes fireboards and decorative paintings for underwindow panels in homes in the area as well as a few undistinguished portraits of his family and of residents of Poestenkill. The backs of three of his canvases are marked *R L G Drake, Artists Depot, Troy, N.Y.*, a drug store which advertised artists' supplies from 1850 to 1865.

Hidley's works were introduced to the modern public in 1941 at the Carnegie Institute in Pittsburgh. Three townscapes and a Noah's Ark scene were included in the exhibition, *American Provincial Paintings from the Collection of J. Stuart Halladay and Herrel George Thomas*, proprietors of The 1750 House, an antiques shop in Sheffield, Massachusetts, who began collecting folk art about 1927. Confusion concerning the artist's name, which continued for a number of years, developed from the catalogue attribution, Joseph H. Headley, taken from the stretcher of one of the paintings, which is inscribed *Village of West Sand Lake painted by Headley*. In correspondence between the Carnegie Institute and Halladay-Thomas, the artist's name was also spelled Hedley. In the 1940s the collection traveled to several other museums, including the Whitney, and during this tour the artist's name was also spelled Hadley.

In January 1947, Janet R. MacFarlane published an article in *New York History* titled "Hedley, Headley, or Hidley, Painter" in which she related that Mrs. Emmaline Hunt had visited the New York State Historical Association in Cooperstown and identified photographs of paintings in the Halladay-Thomas Collection as the work of her father, Joseph H. Hidley, who had died when she was seven. (Emmaline was the Hidley child who had remained in the East after her father's death.) The Halladay-Thomas Collection, including the Hidleys, was acquired by the Abby Aldrich Rockefeller Folk Art Collection in 1958; the most important representation of Hidley's work is now at Williamsburg.

During his lifetime Joseph Hidley's art apparently provided him with little more than the dollar a day plus room and board he allegedly earned painting *Noah's Ark* (colorplate). The panel on which this scene is painted originally concealed the dining room fireplace in a farmhouse built in 1865 by Paul Springer in Brunswick, New York. This is the strongest of approximately thirty known landscapes and still lifes that Hidley painted on panels for at least nine residences in the neighboring areas of Brunswick, Troy, and Poestenkill. All these works appear to derive from illustrations in European view books, and one of the landscape views has been identified by Warren F. Broderick as an adaptation of a print by William H. Bartlett, a British artist whose landscape drawings of American and European scenes were reproduced by English engravers and widely distributed at that time. In three of the nine residences the works have different signatures, each followed by the word *painter*: the initials J. H. H., the name Hidley, and the full name with the alternate spelling, Joseph H. Heidley. The use of the word *painter* in the signature shows an effort to establish the artist's professional status.

Joseph H. Hidley. *Noah's Ark*, c. 1865.
Oil on wood, 25¾ x 26¾ inches.
Abby Aldrich Rockefeller Folk Art Center, Williamsburg, Virginia.

Noah's Ark has several unusual features in its representation of the subject. The door of the ark has been placed in the bow instead of in the side of the vessel as specified in Genesis. The animals are shown in a frieze across the foreground in a manner similar to that used by Nathaniel Currier, whose work became the source for a painting of the same subject by Edward Hicks. Hidley, however, has included Noah, his wife, and three sons in the left foreground, an unusual addition.

Hidley's most distinguished paintings are the four scenes of Poestenkill, all painted on wood panels. The earliest, dated May 10, 1862, owned by the New York State Historical Association, shows the town from the east and is painted from a natural elevation, Snake Hill. The other three depict the town from the west: *Poestenkill: Winter*, *Poestenkill: Summer* (colorplates), and a similar but apparently later summer version now owned by the Metropolitan Museum. These townscapes, painted from an imaginary elevated viewpoint, show the residents engaged in their daily tasks. There is no better description of life in Poestenkill as Hidley painted it than that published by Jean Lipman in *American Collector* in 1947:

Joseph H. Hidley. *Poestenkill, New York: Summer*, between 1865 and 1872. Oil on wood, 20 x 29¾ inches. Abby Aldrich Rockefeller Folk Art Center, Williamsburg, Virginia.

In the view of *Poestenkill: Winter* one-horse sleighs are moving briskly down side streets. A horse-drawn wagon on runners is pulled up in front of the hotel and another is seen going down the road. Another horse, unharnessed, is tethered in front of what appears to be a shop in the foreground, while nearby, two wagons retaining their wheels are stuck in the snow. A man at the left is rolling a wagon wheel toward the side of his house and wheels lean up against this house and the shop just mentioned. Apparently a heavy snow has just fallen, requiring a change to runners. In the companion view, *Poestenkill: Summer*, the same wagons, now on wheels, are seen again, this time carrying loads of hay and wood. The men are in shirt sleeves instead of topcoats and cows graze behind the houses.

To provide a comprehensive record of the town, Hidley painted both figures and architecture in an abstracted arrangement of space ordered by rows of fences and lines of trees, with an unnatu-

ral pervasive light that creates no shadows. Horizontal patterns of scalloped clouds reflect the glow of the landscape.

As his work developed during the 1860s, Hidley seems to have realized that in order to record as much as possible of the plan of the town, he would have to work from an imaginary aerial viewpoint. In the three scenes of Poestenkill from the west, the point of view becomes progressively higher.

Hidley also did a drawing for a lithograph of Poestenkill, a winter scene with the same composition as the two summer views. Published by G. W. Lewis of Albany, a printer active between 1861 and 1867, this lithograph depicts the town from a low viewpoint and may derive from an early unknown painting. Sketches on the back of *Poestenkill: Summer* (Abby Aldrich Rockefeller Folk Art Center), including one of the Lutheran Church in reverse, in-

Joseph H. Hidley. *Poestenkill, New York: Winter*, between 1865 and 1872.
Oil on wood, 18¾ x 25⅜ inches.
Abby Aldrich Rockefeller Folk Art Center, Williamsburg, Virginia.

dicate that this panel probably served as Hidley's working surface when preparing the reverse drawing needed for the lithograph.

Hidley's only consistent effort to represent the shadows produced by natural sunlight occurs in the lithograph, suggesting two possible explanations. Either it is a later work, executed when he was becoming more technically sophisticated; or it derives from an early work—indicated by the low point of view—and the lithographer instructed him to use shadows to make the scene appear more natural than the painting from which it was derived.

The dates of the Poestenkill paintings and the lithograph can be established from *A History of the Evangelical Lutheran Church* (1958). The records state that a chapel was dedicated on November 16, 1832, and that "in all probability there was no spire or belfry." This chapel, on the site of the present church, was demolished in the second week of April 1865 to provide a site for a larger church. On December 21, 1865, a new church with a belfry tower and spire, seen on the right in *Poestenkill: Winter*, was dedicated. An inscription on the lower right border of this painting reads: *J. H. H. Fe 18 18[?]8*. The obscured numeral must be a six (1868), since all the paintings showing this church with tower and spire would have to date between its dedication in 1865 and Hidley's death in 1872.

Hidley appears to have had not only a feeling for the activity of his town but also a desire to record events and their effect on the topography over a period of time. These topographical changes help establish the chronology of the paintings. The grove of pine trees in the field to the left and rear of the Lutheran Church in *Poestenkill: Winter* has been partially chopped down in the lithograph, and becomes smaller in the later summer scene, until only stumps remain in the final summer painting. Other trees become larger in subsequent paintings, and wood piles are consumed. The shed and house at the southwest corner of the crossroads are the blacksmith's shop and house: they are shown as separate structures in the earlier winter scene, later to be joined. Hidley recorded other telling details: some houses have white facades and red sides, indicating that more expensive white paint was used only on the public side.

The buildings in Hidley's paintings of Poestenkill are still recognizable today, particularly the Lutheran Church. The plan of the town which Hidley presented is confirmed by an aerial photograph. A comparison of the photograph with Hidley's paintings reveals that he brought forward the far end of the facade of each building along the main road so as to depict the arrangement of doors and windows as completely and accurately as possible. Each house is also presented in a separate perspective.

The manner in which Hidley creates a sense of light is directly related to his method of painting. In most of his works, he prepared the panel or support with a ground coat of light cream color. He then sketched his composition in pencil and covered it in translucent layers of thin paint. The light ground unifies the colors of the overpainting and gives a brilliant quality to the thin surfaces. He represented objects with controlled, short brushstrokes which follow the natural volumes of the forms. It is Hidley's intuitive understanding of how to use paint and how to establish a structural order in his compositions that gives his paintings their quality as works of art.

On the north edge of Hillside Cemetery in Poestenkill there is a fallen marker which indicates that Joseph H. Hidley died on September 28, 1872. His wife is buried next to him with their three children who died in infancy. In his short life, Hidley translated his acute awareness of his surroundings into a permanent record of his times. There is no indication that he received training as an artist, but his work transcends the conventional academic principles of painting. His paintings are a testimony to an artist whose talent is now recognized, long after a life of few rewards.

TOM ARMSTRONG

Further Reading

MACFARLANE, JANET R. "Hedley, Headley or Hidley, Painter." *New York History*, vol. 28, no. 1 (January 1947), pp. 74–75.

LIPMAN, JEAN. "Joseph Hidley (1830–1872): His New York Townscapes." *American Collector*, vol. 16, no. 5 (June 1947), pp. 10–11. Reprinted in *Primitive Painters in America. 1750–1950*, Jean Lipman and Alice Winchester, eds., New York, 1950; reprint ed., Freeport, N.Y.: Books for Libraries Press, 1971, pp. 132–38.

BRODERICK, WARREN F., ed. *Brunswick . . . A Pictorial History*. Brunswick, N.Y.: Brunswick Historical Society, 1978, pp. 84–103.

Charles C. Hofmann

1821–1882

Three almshouses along the Schuylkill River in Pennsylvania were the refuge and only known home for the nineteenth-century itinerant artist Charles C. Hofmann. He regularly committed himself to almshouses when drinking, and he painted views of these institutions for members of their administrative staffs, the politically appointed county board of directors, and local tradesmen. Originally hung in parlors with pride, the paintings were later moved to attics and given to historical societies, as the heirs of the first owners chose to dimiss family associations with the local poorhouse. Virtually nothing was known of Hofmann until the *Paupers' Registers* of the Berks County Almshouse in Reading were discovered in 1968 in Berks Heim, the successor organization, in connection with my search for Hofmann's identity. The meticulous hand-written records provide the few known facts about the strange life of this remarkable painter who came to the United States in 1860 at the age of thirty-nine.

The origin of the Berks County Almshouse as a social institution is described in the *History of Berks County* by Morton L. Montgomery (1886):

The poor people of the county were provided for by "overseers" till the passage of an act of Assembly, on March 29, 1824 . . . whereby the county commissioners were authorized to levy a tax for the purpose of purchasing land and erecting thereon and furnishing necessary buildings for their employment and support. . . . [On May 30, 1824, the directors] purchased the "Brown farm," formerly known as the "Angelica farm," in Cumru township (owned and occupied during the Revolution by General Thomas Mifflin), three miles from Reading, situated on the Lancaster road, and containing 417 ¼ acres, for the consideration of $16,690, and proceeded to erect upon it a commodious building to accommodate the poor people of the county. This building was finished in 1825. It has since been known as the "Main Building." Other improvements were subsequently made upon the premises, prominent among them being the "Insane Building," erected in 1837 and 1843, and the "Hospital," in 1871 to 1874.

Between 1872 and Hofmann's death in 1882, six entries in the *Paupers' Registers*, beginning with the first on October 26, 1872, provide the only record of his life:

Sex, male; *Color*, white; *If committed, by whom*, self; *Place of Settlement*, none; *Nativity*, Europe; *Time in United States*, 12 years; *At What Port Landed*, New York; *Occupation*, painter; *Civil Condition*, was never married; *Habits*, intemperate; *Education*, could write name; *Physical Condition*, able-bodied; *Classification*, sane; *Cause of Pauperism*, intemperance.

Though Hofmann's death certificate states that he was born in Germany, the exact place of his birth remains unknown and the reasons he came to America can only be surmised. By the middle of the nineteenth century, the growth of industry in Germany was disrupting the traditional economic and social structure. Artisans once protected by the guild system were unable to compete with factory products. Perhaps Hofmann, discouraged by this fact, began drinking and was dismissed from his guild. Like many Germans who arrived in the United States at that time, Hofmann settled in Pennsylvania.

An unsigned, undated watercolor (Collection of Edgar William and Bernice Chrysler Garbisch) of the Northampton County Almshouse, established in 1837, can be attributed to Hofmann. If he was traveling to Berks County from New York City, he could have passed through Northampton County. The obvious difficulty with perspective and the emphasis on genre incidents associate this watercolor with Hofmann's earliest work.

By 1865, Hofmann had reached Reading, where in April of that year he painted two watercolor views of the Berks County Almshouse. One, depicting the complex from the front, is titled along the lower border, *View of the Almshouse, Hospital, Lunatic-Asylum and Agricultur-Buildings of Berks-County, Pennsylvania.*, and inscribed in the lower right, *C. C. Hofmann/ aufgenommen am 12ten April/1865; Jacob Conrad, Steward,/and/Salome Conrad, Matrone,/ 25ten November 1852* (colorplate). This work, which does not include the large hospital building erected between 1871 and 1874, documents the years of service of the matron and steward of the institution, who may be the couple standing in the road at the lower left. The stone building next to them, which would have been their home as administrators of the almshouse, is still standing.

In a companion picture dated five days later, April 17, 1865, the almshouse complex is depicted from another viewpoint, indicated by the inscription *Aufgenommen von Sud-West* (taken from the Southwest), with Reading in the distance. The word "lithograph" appears after Hofmann's name; this, together with his skill in rendering minute detail, indicates that Hofmann may have been accustomed to preparing his drawings for graphic reproduction, although no prints derived from these works have been found. These two compositions established the pattern for the series of Berks County Almshouse paintings that followed. Of ten known views, including the two watercolors, seven are from the front and three from the southwest.

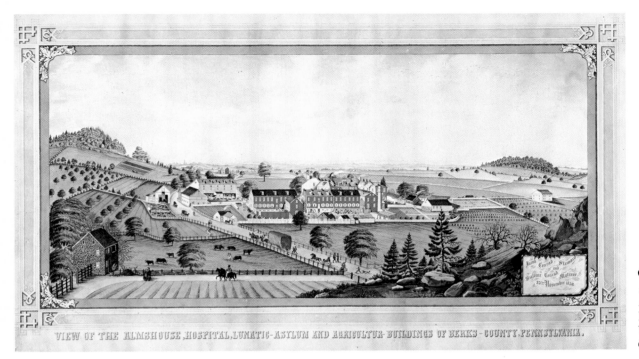

Charles C. Hofmann. *View of the Almshouse, Hospital, Lunatic-Asylum and Agricultur-Buildings of Berks-County, Pennsylvania.*, 1865.
Ink and watercolor on paper, 23⅝ x 40⅝ inches.
Whitney Museum of American Art, New York;
Gift of Edgar William and Bernice Chrysler Garbisch.

Charles C. Hofmann. *View of Henry Z. Van Reed's Farm*, 1872.
Oil on canvas, 39 x 54½ inches. Abby Aldrich Rockefeller Folk Art Center, Williamsburg, Virginia.

Nothing is known of Hofmann's activities between 1865 and 1872, when he painted Henry Z. Van Reed's farm and paper mill in Lower Heidelberg Township (colorplate). The mill had been founded by Van Reed's grandfather and namesake and had been developed into a successful business, now the Federal Paper Company, by his father, Charles. Hofmann's landscape, which is signed and dated October 5, 1872, depicts Van Reed at the lower left talking with his drover, who has just arrived from Reading with a six-mule wagon loaded with bales of rags used to make paper. When the late James G. Pennypacker, auctioneer in Reading, purchased this painting from a Van Reed descendant, he was told that it was painted for five dollars plus one quart of whisky. Henry Z. Van Reed is reported to have commissioned Hofmann to paint four additional views, one for each of his children. For these the artist reportedly received five dollars apiece plus a cumulative number of quarts of whisky, so that for the last version he received four quarts.

During this period, county atlases were popular publications in which the depiction of a residence or business could be arranged for a fee. In the 1876 *Illustrated Historical Atlas of Berks County, Penna.*, there is a view of the Van Reed farm and paper mill (illustration), which is very similar to Hofmann's composition. It is doubtful that Hofmann provided the drawing, but the atlas artist probably used the Hofmann painting hanging in the Van Reed house as his source. The railroad and steam locomotive were added in the atlas print as part of an unrealized scheme promoted by the Van Reeds to construct a railroad line from their paper mill to Sinking Spring.

"View of Henry Z. Van Reed's Fair Papermill..." from the *Illustrated Historical Atlas of Berks County, Penna.* (Reading, Pa., 1876). Courtesy of the Abby Aldrich Rockefeller Folk Art Center, Williamsburg, Virginia.

In at least two instances a relationship exists between the dates of Hofmann's paintings (presumably the time he received payment and could purchase whisky) and the dates he committed himself to the Berks County Almshouse. On October 26, 1872, twenty-one days after the date inscribed on the only two extant versions of Van Reed's farm, Hofmann committed himself and the cause of his pauperism is listed as "intemperance." A view of the Berks County Almshouse dated September 15, 1873, is followed four days later by an entry indicating that he was admitted.

It seems evident from the small number of landscapes Hofmann painted in the vicinity of Reading that commissions for this type of work were more difficult to obtain than views of almshouses which he could sell to people associated with the institutions. The same year he painted the Van Reed farm and paper mill, he also painted a view (now owned by the National Gallery in Washington) of the Benjamin Reber Farm. Only three other landscapes are known, and these were painted for John B. Knorr, a cabinetmaker and undertaker in Wernersville, not far from the Berks County Almshouse. As clerk of the almshouse, Knorr was no doubt well acquainted with Hofmann, and in 1879 the artist painted *Wernersville, Hains Church,* and *My Home* for him. These pictures still remain in the Knorr home, purchased by the present owner from Knorr's son.

Between 1870 and 1880, the Schuylkill River and Canal served as the main route for transporting coal from the mines in Pottsville to Philadelphia. During this same period the river established Hofmann's route, as he visited the Schuylkill County Almshouse in Pottsville, the Berks County Almshouse farther down river in Reading, and the Montgomery County Almshouse in Norristown, fifteen miles west of Philadelphia. From the inscriptions on Hofmann's views of these institutions, which are dated by month and year, it is evident that they were painted between early spring and late fall, when the river and canal were open.

In each of these three almshouses Hofmann could find food and shelter as a transient, and sell his paintings to the people who managed and serviced the institutions. An 1878 painting of the Berks County Almshouse was originally owned by Jacob Hartgen, the almshouse baker. An 1874 view of the Montgomery County Almshouse was originally owned by Jacob Wisler, listed in a cartouche at the bottom of the painting as second steward of the almshouse (colorplate). This, Hofmann's earliest known painting of the Montgomery County Almshouse, is dated March 12, 1874, three days after the Schuylkill Canal opened for the season. It is the only view with a rowboat on the river, a spirited genre incident reminiscent of details in Hofmann's earlier compositions. In another version, a bearded man is seated on the bank of the river wearing a wide-brimmed hat and drinking from his bottle; this figure appears in many other paintings and is probably a self-portrait.

The three known views of the Montgomery County Almshouse, built between 1870 and 1872 to house four hundred paupers, are Hofmann's most contrived manipulations of reality. The almshouse complex, so prominently reflected in the Schuylkill River, is actually at such a distance from the water that a mirror image is

physically impossible, as can be seen from a 1970 aerial photograph of the site (illustration). Unnatural as it may be, the reflected image is the means used by the artist to make the almshouse dominate his composition. There are no competing reflections; leafy trees are mysteriously reflected without foliage, and boats have no reflections at all.

No records have been found to indicate that Hofmann was ever registered at the Schuylkill County Almshouse, although he painted at least four versions of it. These, like all known views of the Montgomery County Almshouse, are in oil on canvas. The earliest is dated 1876 and is owned by Rest Haven, the successor organization. The second version is also dated 1876, and two others, one of which is now lost, are dated 1881, the year before Hofmann died (see colorplate). A view of this almshouse was included in *County Atlas of Schuylkill County, Pennsylvania* published in 1875, a year before the earliest of Hofmann's known paintings of the institution. The compositions are very similar, and in this instance the atlas may have served as Hofmann's source.

It is clear that the Berks County Almshouse was the shelter to which Hofmann most often returned. In addition to the watercolors of 1865, there are dated views of this almshouse painted in 1872, 1873, 1877, and 1878. The early views are rectangular, but beginning with the one dated September 15, 1873, the almshouse complex is depicted in a central oval area. After 1877 the artist

switched from a canvas support to rectangular sheets of zinc-coated tin, which he reputedly found in the wagon shop of the Berks County Almshouse; the paint shop supplied him with oil paints. In the 1870s paintings, Hofmann's viewpoint becomes progressively higher and closer to the almshouse, and as a result, the buildings become larger. Although all the scenes are filled with people, vehicles, and animals, the later versions tend to become standardized, without the emphasis on genre details and incidents that enliven the earlier works.

Hofmann's most stylized, accomplished work is best illustrated in a series of three paintings of the Berks County Almshouse dated 1878 (see colorplate). He presents the almshouse complex in a large central oval and divides the surrounding area into separate vignettes showing the important buildings and the graveyard. The central area is bounded by a decorative ribbon motif surmounted by the State Seal of Pennsylvania, highlighted with gold paint. Hofmann has raised his viewpoint in order to reduce the overlapping of buildings and to present the plan of the complex as clearly as possible. The functions of the buildings are indicated in the line drawing (illustration). Foliage, which had obscured buildings in earlier versions, has been thinned out or removed. Objects repeated in the composition, such as fence rails, windows, and rows of cabbage, are painted in a stylized, repetitive manner. Trees, grass, and other images that depend on color and tone to suggest

Above
Charles C. Hofmann. *View of the Schuylkill County Almshouse Property, at the Year 1881,* 1881.
Oil on canvas, 30 x 42 inches.
Collection of Willem J. Vander Hooven.

Opposite left
Charles C. Hofmann. *Montgomery County Almshouse, Pa.,* 1874.
Oil on canvas, 29½ x 41¼ inches.
Historical Society of Montgomery County, Norristown, Pennsylvania.

Opposite right
The Charles Johnson Home, formerly the Montgomery County Almshouse,
with the Schuylkill River in the foreground, 1970.
The main building of the original almshouse stands to the left of the modern multistory building.
Courtesy of the Abby Aldrich Rockefeller Folk Art Center, Williamsburg, Virginia.

form and depth, have been painted with layers of flat colors, light superimposed on dark, in patterns resembling stenciled designs.

Hofmann rarely graded colors from light to dark, a characteristic that distinguishes his work from that of John Rasmussen, a house painter from Reading who entered the Berks County Almshouse as a vagrant during the last three years of Hofmann's life. Rasmussen, who painted a few landscapes, portraits, baptismal certificates, and still lifes, also produced at least six known views of the almshouse, all based on Hofmann's 1878 composition. Rasmussen, whose work remains consistent and shows none of the development evident in Hofmann's paintings, pursued the same clients as Hofmann. One of Rasmussen's almshouse views was painted for one of Hofmann's best customers, John B. Knorr.

There are no known paintings that can be attributed to Rasmussen after 1886, when he became too ill with rheumatism to paint. In 1892, three years before Rasmussen died, Louis Mader, the third "almshouse painter," was admitted to the Berks County Almshouse for intemperance. He subsequently painted a number of views also based on Hofmann's 1878 composition, but in a markedly less skilled manner. All known works by Rasmussen and Mader are painted on tin.

Hofmann left an accurate visual record of the architecture of the institutions that housed the destitute in his time. It is difficult, however, to reconcile his brilliantly lit landscapes with the vicissitudes of his personal life and with what is known of conditions in the almshouses. The "Causes of Pauperism," recorded in the Registers of the Berks County Almshouse for inmates as young as fifteen, include insanity, homelessness, blindness, and inability to support oneself.

By all accounts, the almshouses were terrible places. The stench of the Berks County Almshouse reportedly could be smelled from a considerable distance. A turn-of-the-century commentary on the Montgomery County Almshouse, published in the *Ambler Gazette*

of Norristown, stated, "as a matter of fact, nobody, except tramps, wants to go to the Almshouse. It is a matter of dread, instead of desire." But this is not how Hofmann portrayed the almshouses. His radiant scenes show people going about their tasks in a landscape of plentiful vegetation, healthy animals, and brightly painted buildings.

The artist did, however, comment on the differences between life inside and life outside. His views of the Berks County Almshouse are from outside the walls, at a point along the road just before the registration shed. He presented not only the sturdy structures that sheltered him but also well-defined characters with animated features traveling along the road, possibly representing staff members and local residents who were his patrons. Inside the walls, however, the inmates, who numbered 613 in 1878, are indistinct, painted with shadowy notations of the brush as diminutive, anonymous figures. Their existence seems unimportant in comparison with the handsome, carefully drawn buildings. By painting a spotless world of sunshine and order, the artist-inmate has shown life at the almshouses as he, or his clients, wanted it to be remembered, rather than as it was.

Hofmann was committed to the Berks County Almshouse for the last time with a broken arm on November 2, 1881. It was there that he died of dropsy on Wednesday, March 1, 1882, at the age of sixty-one. He was buried in an unmarked grave in the paupers' graveyard on the hill behind the hospital building.

TOM ARMSTRONG

Further Reading

ARMSTRONG, THOMAS N., III. *Pennsylvania Almshouse Painters* (exhibition brochure). Williamsburg, Va.: Colonial Williamsburg, 1968. Discusses Hofmann, Rasmussen, and Mader.

———. "God Bless the Home of the Poor." *Historical Review of Berks County*, vol. 35, no. 3 (Summer 1970), pp. 86–90, 116.

Key to buildings in Charles C. Hofmann's *Berks County Almshouse*, 1878: main hospital (1); female section, main hospital (2); male section, main hospital (3); administration (4); kitchen (5); paint shop (6); wagon shop (7); power house (8); school (9); gardens (10); cabinet shop (11); slaughterhouse (12); smokehouse (13); bakery (14); greenhouse (15); laundry (16); root cellar (17); confinement, less violent (18); asylum (19); confinement yards (20); wheelwright (21); blacksmith (22); laundry hanging yard (23); cow barn (24); mule stable (25); wagon shed (26); apple orchard (27); first potters' field (28); carriage shop (29); tenant house, no. 1 (30); chapel (31); laundry (32); ice house, morgue below (33); tenant house, no. 3 (34); kitchen, supplying springs, reservoir (35); grain barn (36); tenant house, no. 2 (37); cemetery (38). Drawing by Jaime Ortega.

Charles C. Hofmann. *View of the Buildings and Surroundings of the Berks County Almshouse*, 1878. Oil on zinc-coated tin, 31¾ x 39 inches. Historical Society of Berks County, Reading, Pennsylvania.

Jurgan Frederick Huge

1809–1878

About forty years ago a large marine watercolor, *Bunkerhill*, came to my attention. Although it was fully signed and dated, the artist's name, J. F. Huge, meant nothing to me—or anyone else. Nevertheless, the picture impressed me, then as now, as the single most exciting American ship painting I had seen.

I discovered that the Mariner's Museum in Newport News, Virginia, which owns nine paintings and two lithographs of Huge's marines, had no biographical information on the artist. A March 20, 1938, article by Mary Darlington Taylor, antiques editor of the *Bridgeport* (Connecticut) *Sunday Post*, recorded the few known facts about his life in a review of a small exhibition at the Bridgeport Public Library; four paintings by Huge were reproduced and two others mentioned in the article. The only other account of Huge as a painter was found in a paragraph in a small, privately printed book titled *Space*, by Julian H. Sterling, published in 1904 by the Marigold-Foster Printing Company in Bridgeport.

My chain-letter request for information about other Huge paintings eventually turned up fifty examples. The purpose of my "rediscovery" booklet, published by the Archives of American Art, and the exhibition based on it, held in 1973 at the South Street Seaport Museum in New York, was to record all the information I had compiled about Huge's life and to list and illustrate as much of his work as possible.

Jurgen Friedrich Huge was born in Hamburg, Germany, in 1809. He must have come to America as a very young man; by 1830 he was married to Miss Mary Shelton, daughter of Silas Shelton, a substantial citizen of Bridgeport, Connecticut. (She was born in 1809, the same year as Huge.) Huge soon began to use only the initial of his first name, and changed Friedrich to Fredrick and then to Frederick; he probably anglicized his name at the time of his marriage. His first name is spelled Jurgan in the Bridgeport directories; and it was recalled by a few old-time Bridgeporters and several members of the Huge family that originally his last name was pronounced with a hard "g" as if spelled Hooga and that late in his life he occasionally signed his name with an accent on the final "e" and pronounced it as if spelled Hewgay. (His tomb is inscribed *J. F. Hugè*.) This would have been a surprising pretension to French elegance on the part of the former German immigrant and long-time New Englander (and the accent is reversed from the correct French); it was more likely an attempt to reinstate the original hard "g" of his family name. (A copy of Huge's painting *Bridgeport City Reservoir* was signed in 1872 by one L. Hugé, obviously a relative who used the accent correctly.) Huge used his full name, Jurgan Frederick Huge, instead of the usual initials in his directory listing for 1872. As the change was made shortly after his wife's death, one might surmise that she, a Connecticut Yankee, preferred to minimize her husband's "foreignness"—but that he did not. It is interesting to find that at this time, too, Huge made a nostalgic picture titled *View on the Rhine*.

The Huges had a son, George, who died at the age of twenty-two, and three daughters: Mary Burritt (1837–1892), who never married; Sarah Elizabeth, who married John Nason, a painter, had no children, and died in 1902; and Frances Harriet, the youngest (1848–1913), who was always called Rose by her father. She married George Richardson and had one child, Anne, who remained single. When the girls were still small, Huge sent to Germany for his mother, Anna M. Huge, who lived with them in North Bridgeport until she died at the age of seventy-six in 1859. A brother, Peter Henry Huge, born about 1800 in Germany, had also emigrated to America, where he became a ship's captain. His descendants say that both he and J. Frederick were sea captains, that as young seamen in Germany they worked their way over to America and from

Jurgan Frederick Huge. *New-York Ballance Drydock*, 1877. Watercolor on paper, 23½ x 35 inches. Collection of Mr. and Mrs. Jacob M. Kaplan.

NEW YORK BALLANCE DRY DOCK.

then on led successful lives at sea and later found new vocations. This might account for Frederick's early interest in and technical knowledge of ships—even for his career as a ship painter. L. Hugé, whoever he was, must have come over to settle in Bridgeport with or near the Huges; he was evidently a technically accomplished artist.

Huge's name first appears in the Bridgeport directory for 1862, though he is known to have lived there since 1830; he is listed as "J. F. Huge, grocer; house near Crossley Mills." He must have been active as a professional artist well before 1838, when he painted the *Bunkerhill*, and when his painting of the steamer *Newhaven* was reproduced in a lithograph—sign of an established reputation. He dated marines and landscapes from 1838 through 1878, the year of his death, and some of them were reproduced in lithographs, but it is clear from the listings that art was a sideline until the last few years of his life. From 1862 through 1868–69 the listing is unchanged, but in 1869–70 Huge described himself as "Grocer and artist, North Avenue near Woolen Mills." (Around 1839 Huge had painted a large watercolor of this textile mill, which had been built in the early 1830s.) After that the grocery business was evidently second to his art career; in 1871–72 he is listed as "Huge, Jurgan Frederick, landscape and marine artist, groceries, &c., North Bridgeport, house Pequonnock near Woolen Mills." From then on he is described as "Teacher in drawing and painting, landscape and marine artist." In the 1872–74 directories his daughter Sarah Elizabeth is also listed as a teacher of drawing and painting, and in the 1889–90 directory his daughter Mary Burritt is described as a "crayon artist." The girls were also musical, as was their father, and Sarah Elizabeth was an accomplished pianist as well as a painter.

Huge's wife, Mary, died in 1869, and his favorite daughter, Rose, was married the same year to George Richardson, who had just become superintendent of the Bridgeport Hydraulic Company. (It was Rose who had the impressive monument erected for her father in Mountain Grove Cemetery in Bridgeport about twenty-five years after his death.) George was the son of a wealthy mason-contractor, Joseph Richardson, builder of the original Bridgeport Water Works and the Church of the Nativity; later George became president of the Bridgeport Hydraulic Company and of the Bridgeport Steamboat Company. The Huge and Richardson families were obviously well acquainted before the marriage; in 1861, Huge had painted the Water Works, with Joseph Richardson and his wife driving by; both families lived on North Avenue, just a few doors apart, and both belonged to the Church of the Nativity. (Huge had formerly belonged to St. John's Church; the Church of the Nativity was one house away from his, which may have had something to do with the change.)

The Richardsons' daughter, Anne, was born after her grandfather's death. Though she could add nothing to the scanty record of her grandfather's life when Mary Darlington Taylor researched the *Bridgeport Sunday Post* article, Miss Richardson had kept a number of his paintings in her house in Ridgefield, Connecticut, and several of these were loaned to the Bridgeport Library exhibition.

After her death the estate was sold at auction, but the house, in accordance with Miss Richardson's strange order, was destroyed. Auctioned with a dozen-odd paintings, all since resold, were her grandfather's pencil sketchbook (most likely one of several) and a daguerreotype showing two men and two women; possibly one was Huge and the women two of his daughters. The sketchbook and daguerreotype, now lost, were bought with the group of paintings at the auction by Rockwell Gardiner, a Connecticut antiques dealer. As Huge was a professional artist, we may assume that the paintings that came to his granddaughter were among those he had not been able to sell; among them were some of the most attractive marines and the great *New-York Ballance Drydock*.

There exists an old account of early times in Bridgeport, Connecticut, written by Julian H. Sterling, a descendant of the Legrand Sterling family whose house became one of Huge's subjects. He described a fascinating facet of Huge's activity as a painter:

Near the factory [the Woolen Mills Huge had painted] was the village store, of which Mr. Huge was proprietor. He was an artist as well as a store keeper and amused himself by painting marine views and war pictures. He got up a fancy wagon inside of which were representations of the battle of Buena Vista, the taking of the City of Mexico by General Winfield Scott, and other fights which were taking place at that time [1846–48] in Mexico, and on general training day, or the Fourth of July, or whenever there was a public gathering, Mr. Huge would appear with his wagon views and for a penny the boys were permitted to look through the peep holes and see the glories within.

None of these battle scenes has been found, but Huge's landscapes and marines add up to a vivid and extraordinarily exact record of the people, costumes, vehicles, stores, streets, houses, lighthouses, and especially the ships, of nineteenth-century America. The individual works, the best ones, are much more than remarkable records: they are fascinating landscapes and seascapes painted with a marvelous combination of delicacy and strength, clarity and verve. These pictures are not realistic in an academic sense; they are composite scenes composed of more elements than would meet the eye at any given moment, with details shown more sharply than they could be seen from any single viewpoint. Huge planned his compositions to present as many of the elements that interested him—and his clients—as possible. The style of the paintings suggests that young Huge had had some training as an artist, possibly as a sign painter, in Germany; his decorative lettering, precisionist technique, and genre interests relate to many of the Pennsylvania German primitives. In Connecticut he became a versatile, prolific, and sensitive artist. His typical large watercolors with pen-and-ink details—running to three feet or more in length—are among the most impressive early works in this medium.

Huge painted almost every kind of ship—steamboats, transatlantic schooners, clippers, barks, frigates, even towboats—and each one seems to have been scrutinized for its special character. *Bunkerhill* (colorplate) is one of Huge's earliest ship paintings, done in 1838. The fact that it and other early watercolors are inscribed

Jurgan Frederick Huge. *Residence of Legrand Sterling*, 1846.
Watercolor on paper, 24 x 34 inches.
P. T. Barnum Museum, Bridgeport, Connecticut.

Jurgan Frederick Huge. *Bunkerhill*, 1838.
Watercolor on paper, 19 x 32 inches.
The Mariners Museum, Newport News, Virginia.

Drawn & Painted by J. Frederick Huge is significant, for these precise paintings were intended to be colored drawings. The *Bunkerhill*, a walking-beam side-wheeler with twin stacks, was built in Connecticut and undoubtedly Huge painted it there, probably in Bridgeport. The steamboat is recorded in every detail, but with equal interest on the part of the artist in the potentials of stylized design. The smoke and waves, flag and pennant, even the groups of people are transformed into exciting patterns.

New-York Ballance Drydock (colorplate) was painted in 1877, just one year before the artist's death, and is a virtual anthology of Huge's previous work. In this composition he portrayed not one but several minutely detailed ships with a lively waterfront view. All the signs are legibly lettered: the number of the East River Drydock offices (*241 South St.*); the names of the docked German ship (*Hamburg*) and the steam ferry in the background (*Williamsburg*); the route of the horse-drawn trolley (*White Hall & Central Park*). The ship in the drydock is the bark *Ocean King*, which Huge had portrayed at sea in another watercolor, now owned by his great-nephew Donald S. Huge. The *Ocean King* was built in 1874 at Kennebunk, Maine, by Captain N. L. Thompson and in 1877 was owned by J. Henry Sears & Co. in Boston. She was the second four-masted American-built square-rigged vessel, following after the *Great Republic*.

Huge's townscapes often featured a single building in its setting. *Residence of Legrand Sterling* (colorplate) was painted in 1846 and is a precise record of an impressive house on the corner of Chapel and Main streets in Bridgeport. Like several other fine Bridgeport houses painted at about the same time, every detail in this watercolor is exact. Anything could be accurately reconstructed from this picture—wrought-iron and picket fences, a horse's harness or a coachman's uniform, ladies' dresses and parasols, even jewelry.

Years later, in 1876, Huge painted *Burroughs* (colorplate), an important Bridgeport commercial establishment at the corner of John and Main streets. Completed in 1872, the building became the Burroughs Library in 1888, was demolished in 1927, and was replaced by the present public library. The city's life and look are fully sampled in Huge's carefully composed street scene, and no detail is lost in his sharp watercolor-and-ink rendering of the elaborate facade and pavements, the shop windows, and even the shoppers inside, the horse-drawn streetcar, carriages, horseman, people of all ages. The pair of ladies in the foreground, handsomely dressed in purple, emerald-green, and white, holding parasols at identical angles as they step forward in unison, would have made a splendid painting by themselves. This watercolor, done two years before the artist's death, is not in any basic way different in style from those he painted in his youth. The interest in detail and design, the precisionist drawing and clear color, the elaborately lettered titles and fine script signatures, all remained amazingly constant throughout Huge's long career as an artist. It is interesting to compare his delicate, flattened, linear presentation of the Burroughs Building with its actual heavy architecture as seen in the photograph (illustration) taken in 1883, just seven years after the painting was made. The striking difference between the way Huge's chosen subjects—ships and buildings—actually looked and the way he painted them is the key to his masterful style.

JEAN LIPMAN

This chapter is based on *Rediscovery: Jurgan Frederick Huge* by Jean Lipman. New York: Archives of American Art, Smithsonian Institution, 1973.

Further Reading

"When Bridgeport Was Beautiful: A Portfolio of Paintings by J. F. Huge." *American Heritage*, vol. 25, no. 4 (June 1974), pp. 16–31.

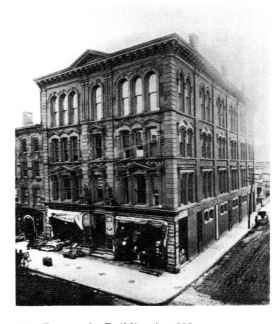

The Burroughs Building in 1883.

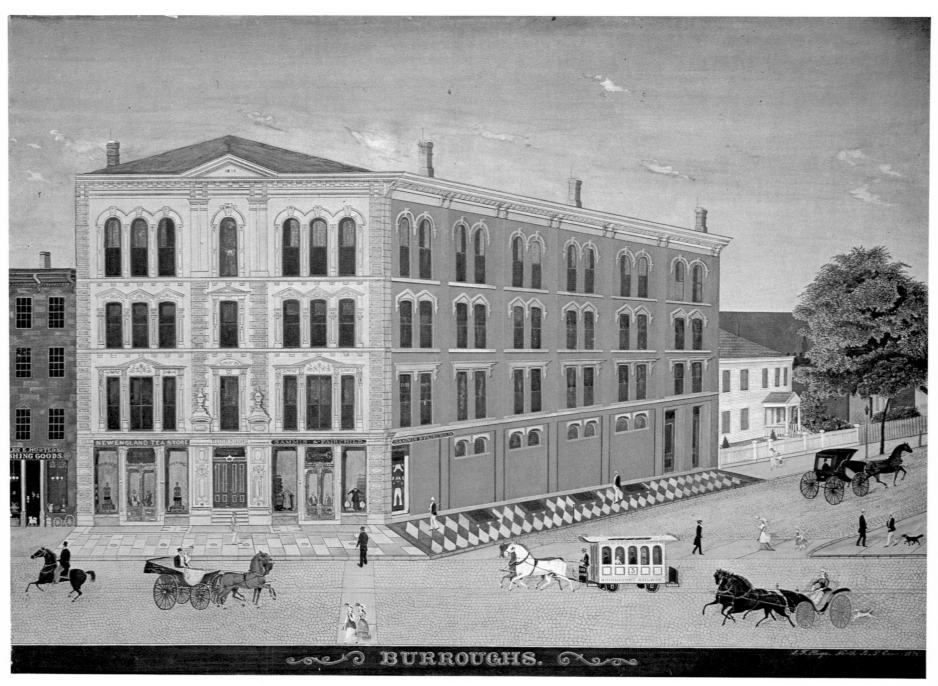

Jurgan Frederick Huge. *Burroughs*, 1876. Watercolor, ink, and gilt on paper, 29¼ x 39½ inches.
Bridgeport Public Library, Bridgeport, Connecticut.

Jacob Maentel. *Young Mr. Faul*, c. 1835–40. Watercolor on paper, 15¾ x 11 inches. Private collection.

Jacob Maentel

1763?–1863

The account that follows is the story of a search that began in Posey County, Indiana, and ended in York, Pennsylvania. In 1841, among the substantial class of German settlers who had moved from Pennsylvania to New Harmony, Indiana, was Jacob Maentel, a farmer fond of painting. For at least a part of his time there, Maentel lived in a house built by members of the Rappite sect, who in 1815 had founded a utopian community at New Harmony. Maentel's grandson remembers seeing watercolors and pigment mortars and pestles belonging to his grandfather in the attic of the house, which is now a museum restored by the Society of Colonial Dames.

Jacob Maentel may have lived in New Harmony on and off before 1841. The obituary of his daughter Louisa (alternately listing her birthplace as Baltimore and Pennsylvania) mentions her arrival in Posey County with her parents in 1836. According to a modern note on file in the Workingmen's Institute in New Harmony, Jacob had started with his family for Texas when illness forced them to stop with friends in New Harmony. He went on to seek his fortune, but his fortune lay in Indiana and back in Pennsylvania, and he remained in these states rather than forging on to an uncertain future in Texas.

Jacob Maentel's descendants have supplied the information that he was born in Kassel, Germany, in 1763. If this is so, he would have lived to the age of one hundred, for the Workingmen's Institute records Maentel's death date as 1863. (It seems curious that neither the records nor his descendants noted this remarkable longevity, so perhaps the birth date is incorrect.) According to the family history, Maentel married Catherine Gutt of Alsace and was educated as a physician before coming to America. Tradition has it that he was also a secretary to Napoleon. His "fondness for painting," remarked on by his family, is confirmed by several Indiana portraits. There, in June of 1841, he painted, signed, and dated a watercolor portrait of Jonathan Jaques of Poseyville standing on a pier against a green, hilly background, with a full-rigged ship in the foreground (illustration). He inscribed a religious text in English in the lower margin of the composition. In the companion portrait, Jaques's wife, Rebecca, aged seventy-nine, sits on a green-painted Windsor chair in an interior setting (illustration). The wall behind her has a stenciled pattern, and a plaid rag rug graces the floor. A Bible with a legible English text lies open on her wide chair arm.

Two double portraits of Indiana fathers and their children in landscape settings also date from about 1841 and can safely be attributed to Jacob Maentel. These are in the collection of the Workingmen's Institute. Early in the 1840s another New Harmony family, the Coopers, had their portraits painted; these are now owned by their descendants. The Coopers, English-born emigrants to Indiana, recorded the artist as one John Mantle, a soldier of Napoleon. The artist who painted the Coopers and the other Indiana portraits of the 1840s is beyond question Jacob Maentel. Soldier or secretary to Napoleon, farmer or pioneer, the real craft and vocation of this man was that of watercolor artist.

Six of the Indiana subjects are shown in landscapes with houses and rail fences, and with distinctive painting of foliage. The Jaques and Cooper interiors are quite similar; chairs, tables, and a desk are all shown tipped, so that the details of graining and the objects on them can be seen. The furniture and the people cast strange, small shadows, and the opaque windowpanes are given form by shading and countershading of the frames. All the portraits are individual and distinctive expressions of a charming style.

To learn more of the painter, the first clues to investigate were the statements that Maentel had come to Indiana from somewhere in Pennsylvania, and that his daughter had been born there or in Baltimore. In the Baltimore city directories for 1807 and for 1808 are identical entries: "Mattell, _____. Portrait painter, 46 south, street." The dates are more than a quarter-century earlier than the Indiana records. Could this be Jacob Maentel of New Harmony?

One of Maentel's descendants lists among his relations the Faul family of Robinson, Illinois; four unsigned and undated portraits of the Fauls are marked as Maentel's by his distinctive style. According to notes given by the original owners, the family lived in Lancaster in York County, Pennsylvania, and the portraits date to the late 1830s. Here, at last, was a clue suggesting a Pennsylvania area where Jacob Maentel might have worked. The Faul pictures, especially those with outdoor settings, provide a stylistic link between Indiana and Pennsylvania. In *Young Mr. Faul* (colorplate) the subject dominates the scene, his frontier prosperity indicated by the tiny horse and miniature log house in the background.

Now the trail appeared to lead back to Pennsylvania and to Lancaster and the counties surrounding it. Were earlier paintings done there by Jacob Maentel? I wrote to Colonel Edgar William and Bernice Chrysler Garbisch (former owners of the Faul pictures)

Jacob Maentel. *Jonathan and Rebecca Jaques*, 1841. Watercolor on paper, $17^5/_8$ x $11^1/_4$ and $17^3/_4$ x $11^3/_8$ inches. Abby Aldrich Rockefeller Folk Art Center, Williamsburg, Virginia.

and promptly received a letter and a photograph of a small blond boy's portrait. He stands, facing the viewer, in a green-blue hilly landscape dotted with trees in the familiar style of Maentel's Indiana portraits. A shadow is cast by the slight figure, the kind seen in the Faul, Cooper, and Jaques portraits. The inscription in German identifies the boy as Johannes Zartmann of Jackson Township, Lebanon County, Pennsylvania, and records that Johannes was born in May 1827, and painted in November 1828, *von Jacob Mäntel*.

Most important, the style of the portrait was a tantalizing echo, not only of Jacob Maentel's work in Indiana, but of something else. The colors, the trees and bushes, the foliage, the big hat the boy holds, the grassy mound, the delicate outlining of hands and gentle delineation of features—I had seen all these before, but not associated with Jacob Maentel. I suddenly knew that if the little figure had been shown in profile and not full-face, it would be one of a hundred or more important watercolor portraits commonly identified by American art historians as being of the "Stettinius-type." But here was the Stettinius-type (except for the figure's stance) firmly and boldly signed by "Jacob Mäntel."

The first place to look for Stettinius-type portraits was in the Historical Society of York County, where an exhibition of paint-

ings attributed to him was held in the late 1940s. Some twenty years before that, two full-length profile portraits of nineteenth-century residents of Hanover, Pennsylvania, had been deposited at the society. They are enchanting watercolor portrayals of John L. Hinkle and his wife, Catharine Wentz Hinkle, shown against a landscape with typical Pennsylvania stone houses, barns, and rail fences. The donor of the portraits not only identified the subjects, but also stated that the artist was Samuel Endredi Stettinius, an emigrant from Germany who arrived in Pennsylvania late in the eighteenth century. From this small beginning, a legend grew. In the 1940s a large number of Pennsylvania portraits were attributed to Stettinius on the basis of their similarity to the Hinkle portraits.

The details of Stettinius's life are well known to his descendants. In 1791, at the age of twenty-three, he and his young wife emigrated from Upper Silesia to Hanover in York County, Pennsylvania. There he became a printer and newspaper publisher. By 1800 he was in the District of Columbia, where the federal census lists him as a resident. In Washington he first ran a bookstore and later dealt in real estate. There, in 1809, he became a naturalized citizen of the United States, with his profession listed as merchant. On a visit to Baltimore in August 1813, Samuel Stettinius died. Forty-

Jacob Maentel. *General Schumacker and His Daughter*, c. 1812.
Watercolor on paper, 14⅞ x 10⅛ and 14½ x 9½ inches.
Collection of Edgar William and Bernice Chrysler Garbisch.

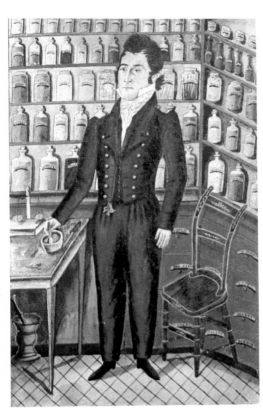

Jacob Maentel. *Mr. and Mrs. Christian Bucher of Schaefferstown,
Pennsylvania*, c. 1830–35. Gouache and watercolor on paper,
17¼ x 11 and 17 x 10⁷⁄₁₆ inches. Private collection.

Jacob Maentel. *Portrait of a Family*, c. 1825.
Watercolor on paper, 17½ x 23 inches.
The Henry Francis du Pont Winterthur Museum,
Winterthur, Delaware.

five years later his body was returned to Washington. A stone was erected over the grave giving the death date as 1815, two years later than the actual event.

Nothing in Samuel Endredi Stettinius's busy life indicates that he ever took brush in hand to paint the iconic Pennsylvania watercolor likenesses that have been attributed to him. Furthermore, the date of the earliest of this group of portraits is about 1800, the year Stettinius moved from Pennsylvania to Washington, and the greatest number are after 1813, the year of his death.

If Stettinius was not the artist, could it have been Jacob Maentel, first identified in Indiana and later traced back to Lancaster and Lebanon County? In order to establish Maentel as the painter, connecting links had to be found between the full-face subjects dating from 1828 to 1841 and the earlier profile subjects most closely associated with the Stettinius type.

With *Johannes Zartmann* as the Pennsylvania key, and with the Indiana subjects for further confirmation, it is possible to assign a dozen or more interior and exterior full-face Pennsylvania portraits in leading collections to Maentel's hand. The delineation of facial features, Maentel's unusual inscriptions and biblical quotations, and his unique method of painting trees, shadows, and interiors widen still further the range and number of nineteenth-century portraits attributable to him.

The German script seen in the portrait of *General Schumacker's Daughter* (colorplate) appears to be in the same hand as the signed inscription on *Johannes Zartmann*, and *Boy with Rooster* (colorplate) is the profile counterpart of that painting. Allowing for changes in decorating taste, the portraits of Christian Bucher and his wife and the *Portrait of a Family* (colorplates) are set in rooms with architectural details quite similar to those in the later portraits of members of the Faul and Jaques families.

General Schumacker, seen against a landscape with a battle in progress (colorplate), and the portrait of his daughter in a quiet interior are the masterpieces of Maentel's early career. This pair lead in style through *Boy with Rooster* to the *Portrait of a Family* and to the other Pennsylvania portraits complete with interiors and landscapes.

Again and again, from about 1800 to the mid-1840s, details occur and recur in both Pennsylvania and Indiana portraits: faces and forms sketched in ink or with a very fine brush, in profile or full-face; rosebushes, green umbrellas, biblical inscriptions, big top hats, embroidered muslins, inkwells, wainscoted rooms. All these details lead directly to Jacob Maentel, the signer of the key pictures *Johannes Zartmann* of Pennsylvania and *Jonathan Jaques* of Poseyville, Indiana, as the painter of the Stettinius-type portraits.

In identifying the artist as Jacob Maentel, there are still two unsolved mysteries. First, why were the Hinkle portraits assigned to Stettinius? There is no apparent reason, but, as in most unreasonable but firm attributions, there is usually a germ of truth. It seems almost certain that Maentel and Stettinius knew each other; they may even have been related. Both were emigrants from Germany to York County in the last decade of the eighteenth century. Maentel seems to have worked for two years in Baltimore, where

Stettinius died; Stettinius's daughter Rachel named the third of her four children James Mantell—perhaps in honor of Jacob Maentel, then a resident of New Harmony.

The second mystery is that there is no mention of Jacob Maentel by name in any of the transcribed records of York County deeds, wills, tax lists, births, or baptisms. Surely if he worked in and about that county from around 1800 (the probable date of his earliest work) until the mid- to late 1830s, there ought to be some mention of his name or of his children. His daughter, Louisa, it will be remembered, was born in Baltimore or Pennsylvania in 1820.

I finally completed the search of the transcribed records at the Historical Society of York County. Three big notebooks of drawings by Lewis Miller, carpenter and amateur artist, are stored in a vault there, and I thought that I would look at the portraits to see if Miller had painted any of the same subjects as Maentel. He had, and they are there to be compared with Maentel's work.

But the discovery that led me to exclaim aloud, disturbing the peaceful library, was the finding of two Miller portraits dated 1816, both identified as *Jacob Maentel* (illustrations). The men are in profile; they are similarly dressed and each holds a long-stemmed pipe in his hand. One, *Jacob Maentel, Confectioner*, is a quick watercolor sketch of a man who appears somewhat older than the other, whose portrait is more carefully drawn. The two may possibly be portraits of the same person, but it seems more likely that the con-

Left
Lewis Miller. *Jacob Maentel, Confectioner*, 1816, from *The Chronicle of York*. The Historical Society of York County, York, Pennsylvania.

Right
Lewis Miller. *Jacob Maentel*, 1816, from *Portraits of Yorkers*. The Historical Society of York County, York, Pennsylvania.

Jacob Maentel. *John and Caterina Bickel of Jonestown, Pennsylvania*, c. 1820–25.
Gouache and watercolor on paper, 17¼ x 11 and 17 x 10⁷⁄₁₆ inches.
Private collection.

fectioner is the father of the Jacob whose occupation is not mentioned. Which of the two is the artist?

Miller dated both portraits 1816, a year almost at the midpoint of Jacob Maentel's greatest productivity as an artist. It is unlikely that he would be labeled as a maker of bonbons when he was—like Miller—an artist. The date of the earliest known Maentel portrait (judging from the costumes of the subjects) is about 1800. This portrait, *Schoolmaster and Boys*, has an odd, amateur quality that has always been puzzling. As a youthful, halting attempt at portraiture, the unfinished look of the schoolmaster's face makes good sense. For these reasons, it seems likely that the artist, Jacob Maentel, whose name and work were known both in Pennsylvania and in Indiana, is the younger of the two men in Lewis Miller's portraits, and it is to his hand that the body of work is here attributed.

Maentel's career as a watercolor portraitist is unique. For more than forty years he recorded the faces, interests, occupations, and houses of his neighbors and friends, presenting not only a precious glimpse of that culture but pictures done with elegance and style as well.

Since 1965, when I first published this tale, approximately fifty rediscovered or reattributed Maentel portraits have come to light, including a signed profile which confirmed his authorship of the early Pennsylvania profiles formerly attributed to Stettinius. As Louisa Dresser, former curator of the Worcester Art Museum, said to me early in my career as a folk art historian, "If you are right, almost every rediscovery will serve to confirm your theory." Yet so much was luck. In *Fraktur-Writings or Illuminated Manuscripts of the Pennsylvania Germans* (1961), Donald Shelley successfully identified the style but misread Maentel's signature (a name recorded contemporaneously in at least three ways) as Maensel. Stettinius was thought to be the artist—through the Hinkle association—well into the 1960s. To this day, I do not really know if Lewis Miller's drawings are of two different Jacob Maentels. If it is the younger who is the artist, the birth date of 1763 is obviously for a man older than this man appears to be. All of which is by way of saying, if you are right, every rediscovery will confirm the theory, but there is, it seems to me, always one more fact to discover and to confirm.

MARY BLACK

This chapter is based on "A Folk Art Whodunit" by Mary C. Black in *Art in America*, vol. 53, no. 3 (June 1965), pp. 96–105.

Jacob Maentel. *Boy with Rooster*, c. 1815.
Watercolor on paper, 7⅞ x 5¾ inches.
The Henry Francis du Pont Winterthur Museum,
Winterthur, Delaware.

Lewis Miller

1796–1882

Self-portrait of Lewis Miller playing the bassoon, 1829, from *The Chronicle of York*. The Historical Society of York County, York, Pennsylvania.

Lewis Miller, an inquisitive Pennsylvania-German carpenter, depicted nineteenth-century America, its citizens humble and great, its historic moments, its varied landscapes. The rich pictorial content of his work, its historical coverage, and the vivacity of his detailed everyday scenes, make him a unique chronicler of life in America. Miller's talents and accomplishments extended beyond those of folk artist and master carpenter. An inveterate traveler, perceptive reporter, raconteur, writer of poetry and prose, he was well versed in music, dancing, religion, and was even a philosopher of sorts.

In 1886 his friend and fellow poet Henry Fisher publicly called attention to Miller's exceptional talents in an illustrated biographical essay. Miller did not come to public attention again until the late 1930s and 1940s, when a number of historians published black-and-white illustrations of his works. In 1955 *Life* magazine (no doubt recognizing in Miller an early counterpart of its own on-the-spot reporting) printed in full color a double-page spread appropriately titled "Lively Views of Crafts and Creature Comforts." *Life* correctly pointed out that the United States in which Miller lived "was just beginning its great transition from a nation of farmers and craftsmen to a nation of factories and mechanized power. Miller's drawings show what the country was like at the start of that change."

In 1966 the unique career of Lewis Miller, the folk artist, was fully illuminated for the first time in the monograph *Lewis Miller: Sketches and Chronicles*, published by the Historical Society of York County, for which I wrote the biographical text. Here, also for the first time, 160 typical pages from the society's collection of Miller's watercolor sketchbooks were reproduced in their original size and full color, along with a detailed index to make the contents of the illustrations readily accessible to students of American history. Even this expanded volume could only partially represent the full scale of his vast work.

For more than half a century, from 1810 until 1865, Miller recorded the life of his community in York, Pennsylvania. *The Chronicle of York* (colorplates) contains 2000 drawings; a portfolio, *Portraits of Yorkers*, immortalizes 350 of his fellow citizens, many of them dated and identified by trade or profession, and pictured in characteristic pose and costume. In the 1840s he produced a number of much larger watercolors, related to his early *Chronicle* subjects but somewhat broader in style (colorplate). Miller also kept sketchbooks of his travels to New York City and Virginia, as well as his Grand Tour of Europe (colorplate), and compiled an illustrated *General History of War*. He became fascinated with what he called "ancient" history and allegorical subjects, and some 300 more sketches were inspired by favored antique sources. Almost until the year of his death, Miller repeated with little variation certain favorite scenes, as in the manuscript of York scenes now owned by the New-York Historical Society.

A carpenter by trade, Miller obviously possessed great natural talent, not limited to portraiture, landscape, or genre, but also able to support his abilities as a story-teller and reporter. Any lack of

formal artistic training was more than made up for by his gifts as a pictorial raconteur. Humor, pathos, irony, cynicism, tragedy, and a sense of historic drama are so neatly put together in his work that the viewer unconsciously becomes an integral part of the scene.

Miller's history of the nineteenth century is all the more convincing as a "documentary" because it is intertwined with the artist's own autobiography, as he tells us on the title page of *The Chronicle of York*:

All of this Pictures Containing in this Book, Search and Examin[e] them. the[y] are true Sketches, I myself being there upon the places and Spot and put down what happened. And was close by of the Greatest number. Saw the whole Scene Enacted before my Eyes.... I See all is Vanity in this Knowing world.

The great majority of Miller's scenes are indeed based on first-hand observation, but there are instances, especially in his depictions of historic events, where he relied on prints, published accounts, or occasionally hearsay.

Miller was proud of his work as a carpenter, and he also took an intense interest in the tools and workmanship of other craftsmen. Among the pages of his *Chronicle* are lively scenes of his fellow craftsmen that fully document their tools, their products, and the milieu in which they worked.

Lewis Miller. *In Side of the Old Lutheran Church in 1800, York, Pa.*, from *The Chronicle of York*, c. 1820.
Ink and watercolor on paper, 9¾ x 7½ inches.
The Historical Society of York County, York, Pennsylvania.

Lewis Miller, *Little Tom Thumb in the New Courthouse, May 28, 1849*, from *The Chronicle of York*, 1849.
Ink and watercolor on paper, 9¾ x 7½ inches.
The Historical Society of York County, York, Pennsylvania.

Lewis Miller. *The P. A. & S. Small Store in Center Square, York*, c. 1846.
Ink and watercolor on paper, 18 x 22⅞ inches.
The Historical Society of York County, York, Pennsylvania.

Lewis Miller. *A View of Speyer* from *Foreign Travels*, 1840–41.
Ink and watercolor on paper, 9¾ x 7½ inches.
The Historical Society of York County, York, Pennsylvania.

Miller not only crams his pages with innumerable homely and fascinating details of everyday life in York, but he also records public events of historic significance for the community: bitter political campaigns, the Court of Quarter Sessions and the Court of Common Pleas in 1801, the Liberty Tree at York in 1812, the laying of the cornerstones of several churches, militiamen encamped on York Commons in 1814, hydrant water conveyed through wooden pipes in 1816, Tom Thumb's visit to York in 1849, and many other incidents.

His coverage of national events is equally comprehensive and extends from the funeral procession for President Washington in 1799 to the assassination of President Lincoln in 1865. He records for us such momentous events as General Lafayette's visit to York in 1825, a campaign parade for Henry Clay in 1844, the California Company leaving York in 1849, a funeral procession for General Zachary Taylor on August 10, 1850, soldiers in Camp Scott at York in 1861, the surrender of York to the Rebels on June 28, 1863, and a "Grand Review of the Army [of the Republic] in the City of Washington, May 24th, 1865."

Miller's pictorial re-enactment of historical scenes and events re-sembles nothing more closely than the continuously moving "panorama" paintings which used to be exhibited nightly in small-town lyceums and town halls across our nation, with the aid of numerous flickering kerosene lamps and accompanied by a lecturer or interpreter (usually the artist). Here Lewis Miller himself explains the action with extensive inscriptions in English, German, or Latin, and introduces secondary themes in which he appears as a philosopher, poet, and songster.

Miller was born in York, Pennsylvania, in 1796, the tenth child of well-educated parents. His father, Johann Ludwig Müller of Schwäbisch-Hall, Württemberg, and his mother, Katharina Rothenberger of Heidelberg, set out for the New World in 1771, soon after their marriage, sailing from Rotterdam to England and thence from Cowes to Philadelphia aboard the ship *Minerva*. After spending their early years in Philadelphia, they moved about 1780 to Montgomery County and then between 1784 and 1787 to York, where they spent the rest of their lives and where the birth of their eighth son, Lewis, was recorded in the register of Christ Lutheran Church on May 3, 1796.

His father served as schoolmaster of the German Lutheran Paro-

chial School. There is no doubt that the elder Miller's literary and classical education had a profound influence upon young Lewis who, after completing school under his father, was apprenticed to an elder brother, John, to learn the "art and mystery of house-carpentering."

His youthful curiosity and desire to travel soon spurred Miller into frequent jaunts to remote rural locations around York during the 1810s and 1820s, and to the cities of Lancaster (1822) and Baltimore (1837). Finally, in 1840–41, he took the Grand Tour of Europe accompanied by two friends, Dr. Alexander Small and Henry Hertzog. The pictorial record of this journey begins with a sketch of Miller and his friends standing on the dock in New York just prior to sailing for Liverpool. Crossing from London to Holland, he took the trip up the Rhine to Mainz and Strasburg, and ultimately visited "all the chief towns and cities of Germany, Switzerland, Austria, Bohemia, France, Italy, and Poland." He sketched them in his travel books, along with innumerable romantic and picturesque European landscapes, and filled the margins with endless historical notes. This trip to the principal countries of Europe introduced Miller to a new field of subject matter, as a result of which historical scenes, views of ancient cities, castles, and occasional mythological themes replaced hometown subjects. Although he again took up carpentry after his return to York in the autumn of 1841, Miller's new interest in "ancient" history and his concern over past wars prompted him to continue his research and ultimately to produce a volume of sketches entitled *A General History of War, written 1851.*

Following his return from the Grand Tour, Miller resumed his travels in this country, frequently in the company of his nephew Charles A. Miller. Wherever he went, Miller produced manuscripts and sketchbooks. In October 1842, he journeyed to New York City, Brooklyn, Long Island, Hoboken, up the Hudson River, and, in 1847, to Princeton, New Jersey. He visited New York City again, not only in 1859, when he spent the winter there and sketched many scenes, but also in 1864, when he returned and made fifty-six drawings for his *Guide to Central Park*, now owned by the Henry Ford Museum. Miller illustrated all the gardens, statuary, paths, summerhouses, ponds, and both sides of each bridge in the park, and carefully listed all the varieties of trees he saw there.

He spent most of the last thirty years of his life in Virginia, where once more he delineated every place he visited in a number of sketchbooks. These include *Landscapes in the State of Virginia, 1853*, a volume of more than 80 drawings that was recently given to the Abby Aldrich Rockefeller Folk Art Center in Williamsburg. From the period of 1856–57 are an album of 114 drawings belonging to the Virginia Historical Society in Richmond and a portfolio of 12 scenes which was exhibited at the F.A.R. Gallery, New York, in 1951. These Virginia sketchbook-diaries contain romantic views of the countryside and scenes of rural life. They also focus for the first time on Miller's careful study of botanical and zoological subjects, an interest that is further documented in his 1864 *Guide to Central Park*.

It is interesting that Miller placed no great emphasis on Civil War subjects or events in his Virginia sketchbooks. Perhaps his experiences were too poignant to be recorded; after all, Miller had relatives and friends on both sides of the battle lines. In the tradition of the true reporter that he was, Miller carefully depicted his occasional war subjects in a totally factual manner, thereby avoiding editorializing or interpretation.

As early as 1844 and continuing down to the 1870s, Miller made an increasing number of visits to his three brothers and other relatives in Virginia, a pattern interrupted from 1859 to 1867 by the Civil War. Still later, in the mid-1870s, he made his home in Christiansburg, Virginia, with one of his nieces, Emmeline Craig, sister of the Charles A. Miller with whom he traveled to New York in 1842, and widow of John Craig, killed in the battle of Chancellorsville in 1863. Thereafter, Lewis Miller returned to York, Pennsylvania, only occasionally, his last trip being presumably in 1879–80.

It was during this last return to York that his friend Henry Fisher presented Miller with a copy of his latest book, *'S Alt Marik-Haus (The Old Market House)*, which the artist promptly filled with color sketches and inscribed "maid by Lewis Miller in 1880 April 13." From the numerous drawings here, many of them repeating earlier subjects, we glimpse the great pleasure afforded him by his return to scenes of his youth.

Following his return from York to Christiansburg, Miller's health began to fail, as we learn from a letter of August 17, 1882: "I write these lines to you, perhaps it will be the last few lines . . . give my Respects to all friends that know me. . . ." He died on September 15, 1882, a bachelor, in his eighty-seventh year, and was buried in the Craig family graveyard in Christiansburg.

During almost seventy active working years, Lewis Miller employed a wide variety of materials, but throughout he maintained surprising consistency and homogeneity of style. Perhaps it was precisely because he had no formal art instruction that he was able to develop such an individualistic style. His earlier, more controlled technique lends itself admirably to the historical subject matter he was portraying. This was slightly modified in the 1840s and 1850s, during his middle years, to achieve more atmospheric effects both in his sketchy landscapes and in his fractur manuscript writings, whereas in his later years he adopted a much broader, mature watercolor style involving more brush and less pen work.

In his earlier works Miller handled perspective in a free, but somewhat archaic, manner to bring his action or situation, no matter how large its scale, down to the size of his page. Differences of scale on facing or adjoining pages did not bother him. As he matured, however, landscape perspective, buildings, human figures, began to fall into a more realistic relationship. Indeed, architectural students will find Miller's keen interest in both exterior and interior building design a rich treasury of the "house-carpentering" of his day. Log, half-timber, fieldstone, and brick houses of the period are depicted with a sure sense of realism, as are innumerable public buildings and bridges and the famous European castles which impressed him so forcibly on his Grand Tour.

In Miller's early *Chronicle of York* period, he usually used paper with a faint bluish or grayish cast, while in the later periods it tends to be more cream or yellowish. Often he worked on ruled paper, simply ignoring the repetitive lines. While his notebooks were frequently of 9¾ by 7½-inch size, he would seize upon whatever was at hand, even the back of an English railway timetable, an advertisement for a dictionary, or a bill of lading. In his notebooks, he was inclined to use every inch of open space, filling in empty corners and margins with additional drawings or descriptive information.

In rural Pennsylvania, Miller's was the generation of change from German to American ways. Pennsylvania German was still spoken within the family circle and High German in church and in the courts, but in public the English language gradually began to take over, along with the customs and mode of dress found in the rest of the country. This assimilation is reflected in Pennsylvania-German arts—architecture, furniture, pewter, pottery, and fracturs (illuminated manuscripts). The erratic phonetic spellings in Miller's manuscripts parallel those found in fractur birth certificates, written partly in English throughout the Pennsylvania-German counties during the first half of the nineteenth century. Similarities to fracturs may also be seen in the layout of Miller's pages, many of which begin with capitals and main title lines in fractur writing. Miller occupies a unique position in Pennsylvania-German folk art in that he fills the gap between the decorative and frequently balanced fractur forms of the late eighteenth and early nineteenth century and the genre painting which came later.

No study of Lewis Miller and his works would be complete without some reference to his ability as a sculptor. Outstanding among the limited number of examples that have been identified is the woodcarving from the doorway of his father's house, and his own birthplace, on South Duke Street. This dynamic and vigorously designed pediment with human heads, animals, and birds is crisply carved in pseudo-medieval style (illustration). A mantel-piece and some other examples of carved architectural woodwork presumably by Miller have also been found.

During his long life Miller produced a body of work of extraordinary size and content. He did not limit himself to his own locale; rather, an insatiable curiosity led him to explore and record other parts of America, and Europe as well. His classical education gave him a historical perspective that is reflected in his unusually wide range of subject matter. A decidedly uncommon man, Lewis Miller was an uncommon folk artist as well.

DONALD A. SHELLEY

Further Reading

FISHER, HENRY L. *An Historical Sketch of the Pennsylvania Germans, Their Ancestry, Character, Manners, Customs, Dialect, Etc.*, 1885. Reprinted in John Gibson, *History of York County, Pennsylvania.* Chicago: F. A. Battey, 1886.

BARBA, PRESTON, AND BARBA, ELEANOR. "Lewis Miller, Pennsylvania German Folk Artist." Pennsylvania German Folklore Society *Publications*, vol. 4 (1939), pp. 1–40.

WECHSLER, HERMAN J. *The Virginia Journey of Lewis Miller, 1856–57* (exhibition catalogue). New York: F.A.R. Gallery, 1951.

"Lively Views of Crafts and Creature Comforts." *Life*, vol. 39, no. 3 (July 18, 1955), pp. 60–61. Reprinted in *America's Arts and Skills.* New York: Dutton for *Life*, 1957.

"The Primitive and the Park." *American Heritage*, vol. 6, no. 6 (October 1955), pp. 52–55.

SHELLEY, DONALD A. *Lewis Miller: Sketches and Chronicles.* York, Pa.: The Historical Society of York County, 1966. Includes comprehensive bibliography.

DAVIDSON, MARSHALL B. *The American Heritage History of Colonial Antiques.* New York: American Heritage, 1967. Important discussion of Miller, pp. 312–15.

"Lewis Miller, Folk Artist." *Journal of the Roanoke* [Virginia] *Historical Society*, vol. 6, no. 1 (Summer 1969), pp. 1–7.

BISHOP, ROBERT. "Lewis Miller's 'Guide to Central Park.'" *The Herald* (Greenfield Village & Henry Ford Museum, Dearborn, Mich.), vol. 6, no. 2 (Spring 1977), pp. 1–57.

Pediment carved by Lewis Miller for the door of his birthplace. The Historical Society of York County, York, Pennsylvania.

Noah North

1809–1880

The portrait painter Noah North was born in Alexander, New York, in 1809, and worked in upstate New York, in Ohio, and perhaps in Kentucky throughout the mid-nineteenth century. Rooted in the strong traditions of western New England, North's family, like so many others, carried their cultural baggage westward to New York. The migration both helps explain the heritage that shaped his work and obscures the specific associations that influenced the young painter. Noah North's grandfather Martin North (1734–1806), a wheelwright in Litchfield, Connecticut, fathered four children by his first wife, and one, Noah, Sr., the painter's father, by his second wife, Mary Agard. In 1808, Noah, Sr., and his wife, Olive Hungerford, left Connecticut with their two children, Thetis and Launcelot (Lot), for western New York. The Norths settled in the wilderness of Alexander, where they purchased land on the Dodgeson Road from the Holland Land Company, which had begun extensive sales in 1800 from offices in nearby Batavia.

Noah, born on June 27, 1809, was the third of eight children. According to a local history written by a grandson, Safford E. North, Noah, Sr., was a farmer actively involved in his community and earned the reputation of a "man of superior attainments who personally attended to the education of his children, fitting several of them to be teachers." His participation in the establishment of the first public library in Genesee County at Alexander in 1811 is evidence of an interest in civic and cultural affairs. Following service in the War of 1812, he maintained his farm until his death on September 28, 1824. He had "engaged in so many cases of public trust that on his death a special town meeting was called" in his memory. That the family probably remained in Alexander after this date is presumed because Mary Agard North, the painter's grandmother, died there in 1825.

While information about the Norths' life during the following years is scanty, one major event in the area, the William Morgan affair in Batavia, affected them directly. The mysterious disappearance of Morgan in 1826, after he attempted to expose the secrets of Freemasonry, was blamed on the Masons. Several of them were tried for Morgan's alleged murder and were convicted of being parties to the conspiracy. Intense feelings of resentment toward the Masons persisted, and the issue soon became politicized. In the early 1830s Noah North, Jr., became involved in the anti-Masonic movement. A report of a convention of democratic, anti-Masonic young men of the County of Genesee published in the Batavia *Republican Advocate* on October 30, 1832, lists young North as a dele-

gate and special committee member from Alexander. The convention "enthusiastically" supported the anti-Masonic candidates for president, vice-president, and governor. Only twenty-three and continuing his father's tradition of civic involvement, North had already attained a measure of local recognition that might prove useful to an aspiring painter.

The specific influences that prompted North to begin painting remain obscure, though one account suggests that at least one person, Van Rensselaer Hawkins, gave art lessons in Alexander. In 1834, William Lawrence Utley traveled from his home in Newbury, Ohio, to visit his mother's brother, Merrill Squires, in Alexander. There he met "a celebrated artist," Hawkins, who gave him painting lessons for the next three or four years. No contemporary references mention Hawkins as a painter (he is listed as a merchant and postmaster), and his art instruction was probably informal. Only a few years older than Utley and sharing similar interests, North may also have profited from Hawkins's tutelage.

North appears to have used a numbering system for some of his portraits; to date, five have been found inscribed with the numbers 11, 15, 18, 39, and 40, respectively. All five are dated. The earliest of these, No. 11, depicts Dewit Clinton Fargo of Alexander in a posthumous portrait dated July 7, 1833. At least nine paintings can be ascribed with some certainty to the years 1833 and 1834, when North was working in Alexander. Portraying his neighbors, from young children to adults, the paintings display a compositional format that was to remain characteristic of his work. Single figures or mothers holding babies, often seated in stenciled chairs, stand out distinctly from muted brown or gray backgrounds. The charming double portrait of Gracie Beardsley Jefferson Jackman and her daughter (colorplate) illustrates the assured technique that North had developed. The features of the sitters are sharply delineated, and facial modeling is accomplished through the use of grayed flesh tones. The ears are oversized with prominent C-shape inner curves; the fingers are long and narrow with blunt nails; bits of lace, ribbon, and jewelry are minutely detailed; bright touches of color in face and clothing contrast with the darker backgrounds.

There are some similarities between North's work and that of the eastern New York and Connecticut painter Ammi Phillips (1788–1865). One of the most obvious is their frequent use of a Hitchcock-type stenciled chair. In many of the paintings the sitter's arm rests on the top rail, exposing only a small portion of the chair's decoration. The portraits painted by Phillips during his

Kent period, in which figures stand out with clarity against dark backgrounds and details are vividly depicted, seem most like North's work. The intriguing possibility that the two may have known each other is supported by a number of facts. Both North's mother, Olive Hungerford North, and Phillips's parents were from Colebrook, Connecticut, and died in Colebrook, Ohio. Ammi's brother Halsey married Olive's sister, Sally Hungerford. In 1842 Ammi Phillips painted a cousin of the sisters, Nancy Hungerford. While no evidence exists that Phillips traveled to western New York or that North went east, the Erie Canal, which opened in 1825, made such journeys relatively easy. Further research may establish a direct relationship between the two.

In 1834 the market for North's work spread beyond Alexander. In Holley, New York, an Erie Canal village well to the north in neighboring Orleans County, he painted portraits of Sarah Angelina Sweet Darrow and her mother-in-law Eunice Eggleston Darrow Spafford (colorplate), both signed in 1834 and numbered 39 and 40, respectively. Perhaps North's sister Olive, who died in Holley the next year, had introduced him to the village. Eunice's portrait, certainly one of North's most striking, is unusual because the decoration on the chair has actually been stenciled with gold powders. A remarkable woman, Mrs. Spafford outlived two husbands, raising several of their children by previous marriages plus nine of her own while continuing to manage the family farms.

By 1835, North had moved farther afield and was working in the vicinity of Rochester, New York. Five residents of Scottsville, including Pierrepont Edward Lacey, his mother, and his younger sister Eliza, had their portraits painted at this time. Pierrepont's portrait, nearly full-size, is as ambitious as any known work by North (colorplate). Solid and sturdy, the young boy, clad in a green suit and bright red shoes, looks candidly out to the viewer, bolstered by the protection of his huge dog. A number of other portraits dating from this period evidence North's ability to deal with a variety of subjects—men, women, and children—with assurance and vigorous individuality. *Boy Holding Dog* is typical of these depictions; the child's features are clearly delineated and stand out from the dark background (colorplate).

By 1836, North had moved farther west, taking up residence in Ohio City, Ohio (now part of Cleveland), on the west bank of the Cuyahoga River. This area of Ohio, originally claimed by Connecticut and controlled by the Connecticut Land Company, was settled in the late eighteenth century by men like North's father, who had left the rocky New England soil for better prospects. With the completion of the Ohio Canal in 1832, linking the Ohio River with Lake Erie, the importance of the region escalated rapidly. By 1836–37, activity reached its peak, with rampant land speculation and extensive construction projects on both sides of the river. In 1839 alone the Ohio Canal carried 19,962 passengers to Cleveland and Ohio City. Quite probably the attraction of grand new opportunities in these booming towns lured North to Ohio.

North first submitted ads to the *Ohio City Argus* on May 26, 1836, with a more elaborate notice beginning in the paper's August 25th issue: "Portrait Painting / N. North will pursue his profession in this place for a short time. Ladies and Gentlemen are respectfully invited to call at his room and examine specimens of his work. Room over the Brick Store opposite the Columbus block." He is listed in the *Directory of Cleveland and Ohio City 1837–38* as a portrait painter, residing at the Ohio City Exchange, a hotel described as "the finest building west of Albany, a magnificent brick building of five stories, crowned with a noble dome and having splendid balconies in front, supported by pillars of the Ionic Order."

Other than his ads and the directory listing, no records of North's Ohio sojourn have come to light. He presumably left Ohio City and headed south; Rhea Mansfield Knittle, an Ohio researcher working in the 1930s, apparently found North's advertisements in Cincinnati and Kentucky newspapers, but her notes have been lost. No portraits which can conclusively be attributed to North have emerged from his Ohio adventures. It appears that the blossoming artist did not find the success he anticipated in the West.

By 1841, North had returned to New York State where, in Darien, he married his neighbor Ann C. Williams, the daughter of Thorp and Clarissa Williams. By April 1842, when they had their first child, Mary Ann, the Norths had moved to Mount Morris, Livingston County, New York. Three years later, on March 14, 1845, their second and last child and only son, Volney, was born. North's interest in politics surfaced again in Mount Morris in January 1844, when he signed a petition inviting the Whigs of Livingston County to a meeting to organize a Henry Clay Club. In both 1845 and 1846 he ran for and was elected assessor on the Whig town ticket.

By March 19, 1844, advertisements reading "NOAH NORTH Carriage, Sign, House and Ornamental Painter" began appearing in the *Livingston County Whig* on a regular basis (illustration). The inclusion of ornamental work in the advertisement is interesting. Obviously a painter in a rural area required diverse skills to earn a livelihood. By 1848, North had formed a partnership with another artist, Alexander McLean, and their advertisement in the *Livingston County Whig* of January 18 reads: "NORTH & McLEAN. HOUSE, SIGN, and CARRIAGE PAINTERS, Paper Hangers and Glaziers.—Shop on Chapel street, three doors below the Methodist Church, (up stairs,) Mount Morris." The 1850 census listed North as a portrait painter living with his wife, two children, and his wife's fifteen-year-old niece, Caroline G. Williams, who was "attending school." While no signed portraits have been found corresponding to this period in North's life, there are several paintings dating from these years which can be attributed to him. In the *Western New York State Business Directory 1850–51* "North and M'Lane" are listed under "Painters—House, Sign, and Fancy." Sometime in the late 1850s, the Norths returned to Darien, where they apparently lived with Ann's father on the Bennett Road and turned to farming. With them lived "Clarissa North," born in 1855, the illegitimate daughter of Caroline Williams whom the Norths presumably adopted. In Darien, North served as a justice of the peace for ten years.

In February 1869, Ann's father died at age eighty-nine and in May the Norths sold the Darien property and bought land in

Noah North. *Pierrepont Edward Lacey and His Dog, Gun,* c. 1835–36. Oil on canvas, 42 x 30 inches. Memorial Art Gallery of the University of Rochester; Gift of Mr. and Mrs. Robert Dunn.

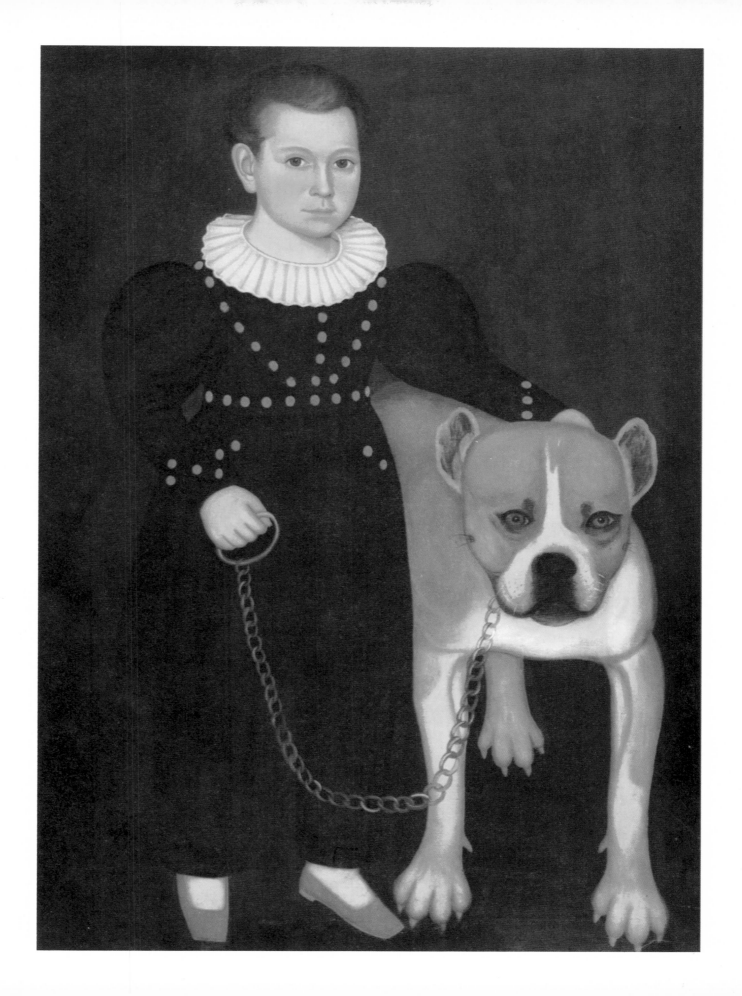

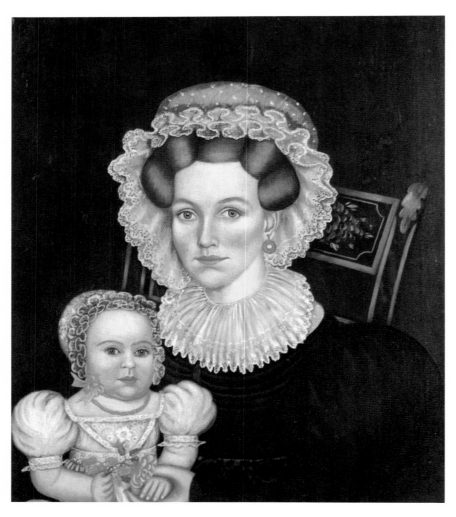

Noah North. *Gracie Beardsley Jefferson Jackman and Her Daughter*, c. 1833–34.
Oil on wood, 28 x 23½ inches.
Flint Institute of Arts, Flint, Michigan;
Gift of Edgar William and Bernice Chrysler Garbisch.

Below left
Noah North. *Eunice Eggleston Darrow Spafford*, 1834.
Oil on wood, 27½ x 23⅜ inches.
The Shelburne Museum, Shelburne, Vermont.

Below right
Noah North. *Boy Holding Dog*, c. 1835.
Oil on wood, 20¾ x 17½ inches.
Abby Aldrich Rockefeller Folk Art Center, Williamsburg, Virginia.

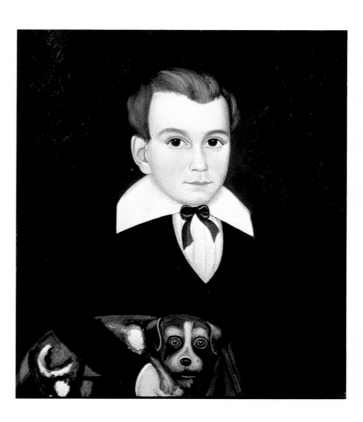

nearby Attica for seven thousand dollars. Four days later they moved to the larger city. The 1870 federal census listed North living with his wife Ann, two children, and Clarissa. F. W. Beers's *Illustrated History of Wyoming County, New York* (1880) describes North as a "farmer, manufacturer of lumber, painter, and teacher who served on the board of education." In 1872 Ann died, and North buried her in Darien in the Williams family plot in Maple Hill Cemetery. The following year Volney died at age twenty-eight and was buried near his mother. Possibly needing money, North sold two pieces of his Attica land in 1872 and 1874. In March 1875, Mary Ann died at age thirty-three, and, like her mother and brother, was returned to Darien. The following year North married his late wife's sister Caroline.

The last four years of North's life were financially troubled. Records indicate that he sold most of his remaining Attica property in small parcels and disposed of his second wife's holdings in the nearby town of Arcade. It is not known whether North still painted; no work from this period has been discovered. North still enjoyed a measure of public esteem from his continuing involvement in community affairs. He served on the Attica Board of Education in 1878–79, and at the time of his death in Attica on June 15, 1880, he was vice-president of the Genesee County Pioneer Association. The *Batavia Daily News*, Tuesday evening, June 15, 1880, stated:

Mr. Noah North, of Attica, died very suddenly this morning at his home in that village. He was born in the town of Alexander in June, 1809, and was therefore 70 years of age. Mr. North has always been a resident of Genesee County, with the exception of a few years residence at Mt. Morris and 10 years in Attica. Deceased was a brother of J. A. North, of Alexander, and uncle to S. E. North of this village.

As no paintings by North dating after the 1840s have yet been found, it appears that the demand for his work had diminished. Most of his patrons seem to have commissioned their portraits during the 1830s, when North had relatively little competition and no familial responsibilities to hamper travel to the neighboring counties. Surely the advent of photography cut into his market, as did other portraitists working in the area. The diversity of his jobs in his later years and frequent sales of land may indicate new interests and difficult times. Neither his obituary nor the family history written by Safford North makes much of his career as a painter. Nevertheless, Noah North's precise depictions of western New York's newly prosperous citizens bespeak a talent that for too long went unnoticed.

NANCY C. MULLER AND JACQUELYN OAK

This chapter is based on "Noah North (1809–1880)" by Nancy C. Muller and Jacquelyn Oak in *Antiques*, vol. 112, no. 5 (November 1977), pp. 939–45.

NORTH & McLEAN,
HOUSE, SIGN, and CARRIAGE PAIN-
TERS, Paper Hangers and Glaziers. —
Shop on Chapel street, three doors below the
Methodist Church, (up stairs,) Mount Morris.
Jan. 18, tf.

Advertisement in *Livingston County Whig*,
Mount Morris, New York; first appeared on
January 18, 1848.

NOAH NORTH,
Carriage, Sign, House and Ornamental Paint-
er—Shop on Chapel street, two doors below
the Methodist Church. mar19

Advertisement in *Livingston County Whig*,
Mount Morris, New York; first appeared on
March 19, 1844, and ran for the next two years.

Sheldon Peck

1797–1868

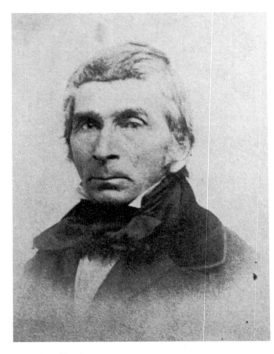

Sheldon Peck, c. 1838.

Peck's earliest known portraits, of members of his family, appear to have been painted about 1820. These include a double portrait of his parents in which the brushwork is surprisingly painterly, quite unlike his later work. He painted on wood panels, using dark, somber colors and plain backgrounds against which the subjects are portrayed from the waist up. Thus Peck avoided the anatomical challenges of a full-figure portrait. By the time of his marriage to Harriet Corey (1806–1887) of Bridport, Vermont, on September 15, 1824, the artist's distinctive style had begun to show in the piercing eyes, prominent brow, and immobile expression of his sitters. Peck treated their features as simple planes rendered by flat areas of color. He elaborated on coiffures and costumes by painting in curls, lace-trimmed collars and bonnets, and gold buttons; eventually he added background draperies and a painted chair to his repertory of props. It was in this early period that Peck introduced a decorative motif that reappears throughout his work in one form or another—a long brushstroke flanked by two shorter ones, like the print of a rabbit's foot. This kind of brushwork was commonly used in the nineteenth century for decorating all sorts of utilitarian objects, from tinware to furniture. Like many other itinerant painters, Peck most likely did ornamental work in addition to portraits—as indicated by his later advertisements.

Sheldon and Harriet Peck were in Burlington, Vermont, in 1827 when their second child, Charles, was born. He later became a landscape painter, photographer, and founding member of the Chicago Academy of Design. There are no records to indicate that Peck bought property in Burlington, suggesting that the family did not stay there long. From Vermont they probably traveled down Lake Champlain and the Hudson River and west along the Mohawk River and the Erie Canal. The canal had opened in 1825 and made westward travel by boat cheaper than overland travel along the toll roads.

In September 1828, Peck paid ninety dollars for a quarter-acre of land near the center of a booming canal town called Jordan in Onondaga County, New York. Census records for Jordan and nearby towns suggest that Vermont friends and relatives of the Pecks may also have settled in the area about the same time. Judge William Cooper of Cooperstown, New York, writing in 1810, described the western counties of New York as "chiefly peopled from the New England states, where the people are civil, well informed, and very sagacious." By the time the Pecks made their home there, Onondaga County was fairly well settled and prosperous, with local government already established.

Sheldon Peck's ancestors settled in America in 1635 and were among the founders of New Haven Colony. His father, Jacob Peck, a farmer and blacksmith who had fought in the Revolution, was one of the first settlers in Cornwall, Vermont, to which he and his wife, Elizabeth, moved from Litchfield, Connecticut, in the winter of 1787. Sheldon Peck was born in Cornwall on August 26, 1797, the ninth of eleven children. He was probably self-taught, for no record exists of his having studied with an established artist. He may, however, have had access to art instruction books in the library of the Cornwall Young Gentleman's Society, a cultural and educational institution founded in 1804.

Peck did not sign his paintings, most of which lay largely unnoticed in attics and cellars for nearly a century. However, from works attributed to him and other paintings still owned by descendants, one can discern his distinctive style and three stages of his development as an artist. These coincide with his early years in Vermont, his sojourn in New York State, and his final years in Illinois.

Sheldon Peck. *Mr. S. Vaughan*, c. 1845. Oil on canvas, 34³⁄₄ x 30⁷⁄₈ inches.
Illinois State Museum Collection, Springfield.

During his New York period, Peck continued to paint half- and three-quarter-length portraits on wood panels, but sometimes in brighter colors and with generally more detailed settings than in the Vermont paintings. There are often swags of drapery at the corners, painted furniture, Bibles and other books, bowls of fruit, and an occasional landscape in the background. The Bible and the drapery at the corners were particularly popular artistic conventions at the time, and Peck's use of them suggests that he had observed the work of other artists.

Peck prospered while in New York State. By 1835 he was able to buy a fifty-acre parcel of land outside the village of Jordan for $1,500. Then, in August 1836, Peck sold his house and all his land and left Jordan. An announcement by the town physician dated October 1, 1836, in the *Onondaga Standard* of November 9, 1836, may explain the family's abrupt departure:

Be it known to all people, that one Sheldon Peck, and Harriet his wife, not having the fear of God before their eyes, being instigated by the devil, have with malice aforethought most wickedly and maliciously hired, flattered, bribed or persuaded my wife Emeline, to leave me without just cause or provocation. It is supposed that said Peck has carried her to some part of the state of Illinois. This is therefore to forbid all persons harboring or trusting my wife Emeline, for I will pay no debts of her contracting. Hezekiah Gunn

The wording of the newspaper entry and the alleged responsibility of both Pecks brings to mind the possible influence of the Mormon practice of polygamy. Joseph Smith had founded the Church of Jesus Christ of Latter-day Saints in Onondaga County, near Jordan, in 1830. However, neither family tradition nor church records indicate that the Pecks were Mormons, and as Emeline Gunn is not listed in any Illinois census entries for the Pecks, it seems she did not join their household permanently.

The Pecks traveled to Chicago but apparently did not stay very long. According to his descendants, Sheldon Peck bought property near Washington and State streets in what was by then a bustling and growing city. However, with the Panic of 1837, largely resulting from wild land speculation, there was probably little demand for portraits in Chicago. Perhaps this is why Peck reverted to his plain Vermont style, simplifying so that he could minimize his prices and thus attract customers. All Peck's Illinois portraits are painted on canvas, not on wood panels as the Vermont and New York pictures are.

Family tradition has it that Peck traded his land in Chicago for a team of horses to move his family and furnishings to the part of Babcock's Grove that is now known as Lombard, twenty miles west of Chicago. Here the Pecks are said to have lived in a covered wagon for two years while Peck built the house in which his descendants still live today.

Sheldon Peck became a farmer and a community leader in Babcock's Grove. Eventually his family numbered ten children (two others died in infancy). He started the town's first school in his house and paid the teacher's salary himself. In the 1840 census he was listed as "employed in agriculture," and it was not until the 1850 census that he gave his profession as portrait painter. That census also shows that he was one of the wealthiest landowners in the region. According to family accounts, he was an abolitionist and his house was a stop on the Underground Railroad used by escaping slaves.

After the summer farming season, Peck traveled and painted. On trips to Aurora he produced a number of portraits in what is clearly his most powerful and distinctive style. These Illinois-period pictures have full-length figures, often in groups, and are painted in startlingly bright colors. The portraits reproduced here were all painted in Aurora around 1845 and portray members of the Crane and Vaughan families (colorplates). In the double portraits, the subjects are shown in room settings, with Peck's standard props of the period: chairs, a table covered with a cloth, books, or vases with bouquets that invariably include roses. In an attempt to give three-dimensionality to the settings, Peck painted diagonally slanting floor boards. The portrait of Mr. and Mrs. William Vaughan has its original frame, which was painted in simulated mahogany veneer, undoubtedly by Peck, for his other portraits have similarly grained trompe l'oeil frames painted directly on the canvas.

When Peck painted David Crane and his wife Catharine Stolp Crane, who had come to Aurora in 1834 from Poultneyville, New York, they were apparently so pleased that they had him make a portrait of Mr. Crane's mother and their daughter Jennette. The paintings are almost the same size and have virtually identical trompe l'oeil frames. In the home where *Anna Gould Crane and Granddaughter Jennette* was found, an entry appears in the family Bible stating that Peck painted the portrait on a linen sheet owned by the family, made his own stretcher, and was given a cow in exchange for his services. Jennette holds a rose, painted with the peculiar circular brushstrokes and dots in the center that are found in all Peck's roses. Jennette's bright yellow dress is patterned with Peck's distinctive rabbit-foot motif, which can also be found on Mr. and Mrs. Vaughan's painted chairs.

By using brighter colors, larger canvases, and trompe l'oeil frames, Peck was clearly offering effects that his patrons could not get in the quick, accurate, and inexpensive daguerreotypes which had been introduced to America in 1839. By the 1850s, however, the competition proved too much, and Peck, like countless other itinerant portraitists, was obliged to explore new avenues for his painting. In 1854 and 1855, he had a studio at 71 Lake Street in Chicago, where he advertised himself as "decorative painter," perhaps painting chairs and other furniture. In the 1860 census for Lombard, Peck, then sixty-three years old, gave his profession simply as "artist." Family tradition relates that he traveled to St. Louis to do medical drawings for colleges there, but research has failed to substantiate this. His son Charles, however, was an artist and photographer listed in the St. Louis directories between 1860 and 1866. Sheldon Peck died of pneumonia on March 19, 1868. His estate in Lombard comprised 175 acres of land valued at $9,000, including a

Sheldon Peck. *Mr. and Mrs. William Vaughan*, c. 1845.
Oil on canvas, 30 x 34 inches.
Barenholtz Collection.

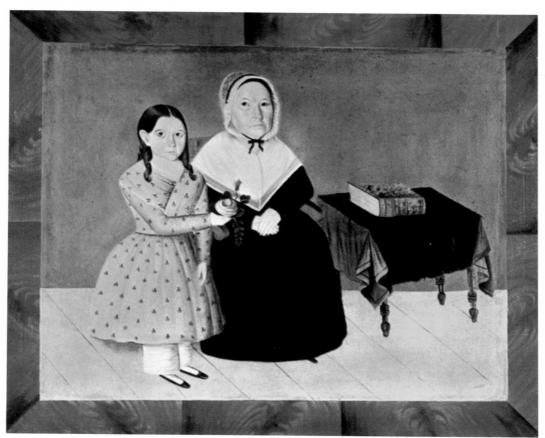

Sheldon Peck. *Anna Gould Crane and
Granddaughter Jennette*, c. 1845.
Oil on canvas, 35½ x 45½ inches.
Collection of Peter H. Tillou.

large farm well stocked with seventy-seven sheep, two horses, three cows, five hogs, and farming tools.

Peck's earliest portraits show a potential for painting in the academic tradition, with emphasis on brushwork and careful modeling. As his career progressed, he appears to have consciously chosen to paint in a simple style that would appeal to relatively unsophisticated patrons. Unlike many American artists, who flocked to the cities to compete for the patronage of wealthy merchants and manufacturers, Peck chose his style and went to the frontier where he found people to appreciate it.

MARIANNE E. BALAZS

This chapter is based on "Sheldon Peck" by Marianne E. Balazs in *Antiques*, vol. 109, no. 2 (August 1975), pp. 273–84. Reprinted as *Sheldon Peck* (exhibition catalogue). New York: Whitney Museum of American Art, 1975.

Sheldon Peck. *David Crane and Catharine Stolp Crane*, c. 1845. Oil on canvas, 35¾ x 43¾ inches. Collection of Mr. and Mrs. William E. Wiltshire, III.

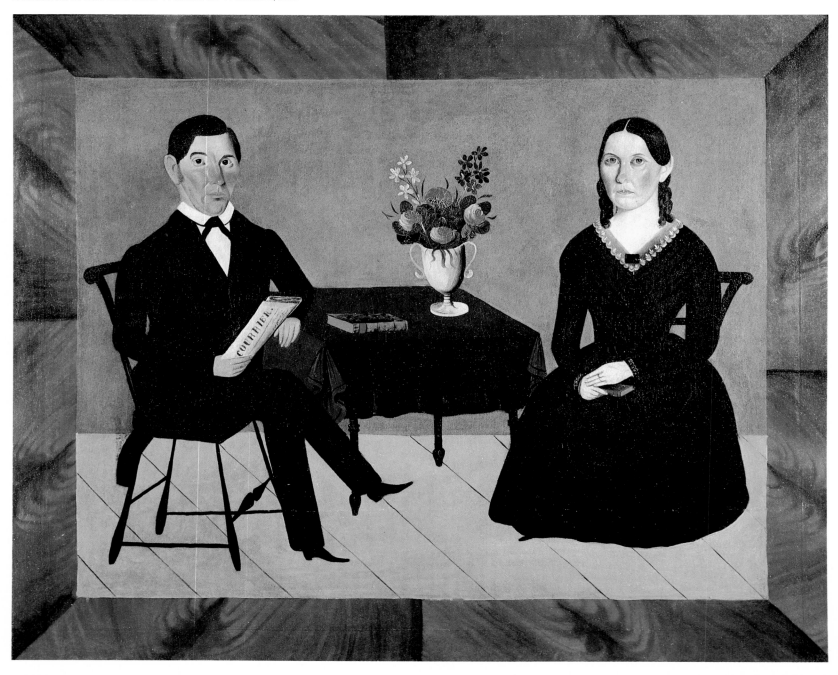

Ammi Phillips

1788–1865

Within the past ten years, portraits by the nineteenth-century folk painter Ammi Phillips have become some of the most sought after paintings in the folk-art field. That fact is remarkable when one considers that before 1960 his name was familiar to only a handful of art historians. Although Phillips's output was originally thought to be quite small, he is now known to have been one of the most prolific and important of American folk artists.

Credit for the artist's rediscovery goes to Lawrence B. and Barbara C. Holdridge of Owings Mills, Maryland, who in 1958 bought a portrait of a young man, *George Sunderland*, signed by an artist then unknown to them. They began collecting data to establish the artist's identity; by 1965 they had enough information to organize the first Phillips exhibition, at the Connecticut Historical Society in Hartford. At that time the Holdridges knew of 219 works by the artist. Three years later, when a large selection of Phillips's paintings was exhibited at the Museum of American Folk Art in New York, the Holdridges and I were able to account for 90 additional portraits. Another small Phillips exhibition was held at New York's Washburn Gallery in 1976. Today, from Phillips's fifty-year record as a portrait painter, we know about 500 works that may confidently be attributed to his hand. Having rediscovered almost double the number ascribed to him in his first one-man exhibition—many of the subjects members of large families—it is a certainty that more works exist, unknown or unidentified. Demonstrating this is the recent discovery by James Parrish of an 1809–13 diary titled *Adversaria* kept by Dr. Samuel Barstow, physician and innkeeper of Great Barrington, Massachusetts. Barstow lists five family portraits done by Ammi Phillips in 1811 that remain unidentified or unlocated: small profile views of Dr. and Mrs. Barstow, full-length portraits of "Mama and Charles," and "Oliver, halfway down."

The Holdridges' search for traces of Phillips led them on a twenty-year quest through western New England and eastern New York to areas where the painter was known to have worked. Their travels took them from stately homes along the Hudson to a retired milkman's tiny house in the Berkshires. In locating paintings related to their first purchase, *George Sunderland*, it became clear to them that two groups of paintings formerly attributed to artists identified only as the Border Limner and the Kent Limner were actually by Phillips. In solving this decades-old puzzle, overwhelming evidence was found not only in signed and dated portraits but also in receipts, diaries, letters, newspaper advertisements, land transactions, journals, birth and marriage records, estate inventories, and gravestone inscriptions. These documents, proving that Phillips was actually present in the communities where the portraits were painted, finally convinced me that the Holdridges' theory, at first an incredible one, was true, and that this prolific painter, working in an orderly progression of styles, was responsible for both the Border Limner and the Kent Limner portraits.

In 1924, a number of portraits owned by local families were displayed in a small antiques show in Kent, Connecticut; the unknown artist came to be known as the Kent Limner. His work, dating to the 1830s, is characterized by forward-leaning women in dark dresses, their pale faces surrounded by embroidered muslin collars and bonnets against muted backgrounds. In the style of the Kent Limner but painted at Clermont, New York, in 1834, are portraits of the Ten Broecks, which are recorded in the family genealogy as the work of Ammi Phillips. Through the Ten Broeck portraits, related in style to the signed Sunderland portrait they owned, the Holdridges were able to identify the formerly mysterious limner of Kent as Ammi Phillips. *The Ten Broeck Twins*, an unusual double portrait of Jacob Wessel and William Henry Ten Broeck, and the delightful *Girl in Red with Her Cat and Dog* (colorplates) are fine examples of Phillips's works in his Kent style.

In the 1940s and 1950s Agnes Halsey Jones isolated a group of early nineteenth-century portraits as the work of one person, whom she named the Border Limner because the unknown painter's subjects lived on both sides of the New York- and Massachusetts-Connecticut state lines. The known work of the Border Limner dates between 1812 and 1818. These figures of men, women, and children are set in awkward positions in powerful three-quarter or full-length portraits and are painted in pearly gray and pastel tones.

It was to see a number of paintings in this style that the Holdridges first came to Williamsburg in 1958. There, as the director and curator of the Abby Aldrich Rockefeller Folk Art Collection, I joined their search. We looked together at their identification of Phillips in his Kent period and then turned to the Rockefeller Collection paintings attributed to the Border Limner, whom they already associated with Ammi Phillips. Despite their demonstrations of similarities between the groups of paintings, I

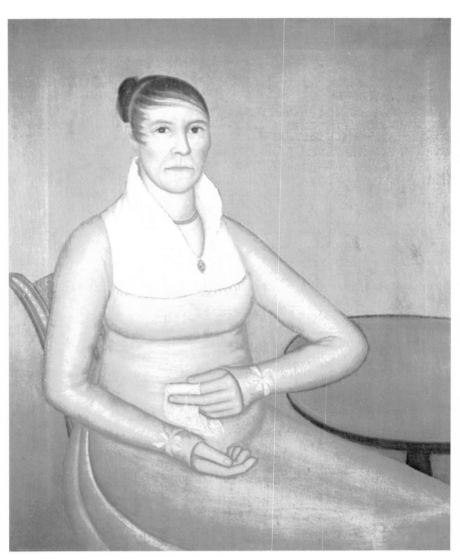 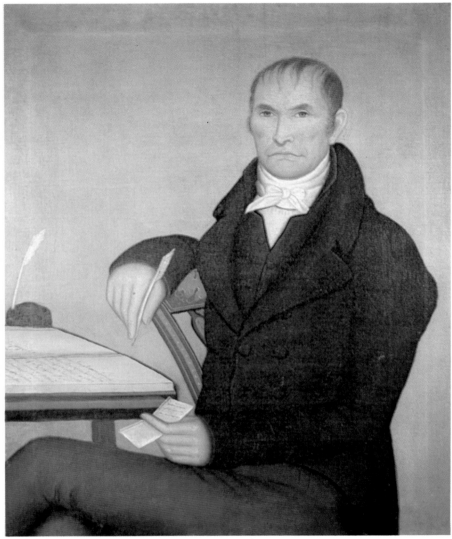

Ammi Phillips. *Colonel and Mrs. Joseph Dorr*, c. 1814–16.
Oil on canvas, each 40 x 33 inches.
Collection of Bertram K. and Nina Fletcher Little.

Ammi Phillips. *Harriet Leavens*, c. 1815.
Oil on canvas, 56¼ x 27 inches.
Fogg Art Museum, Harvard University, Cambridge, Massachusetts.

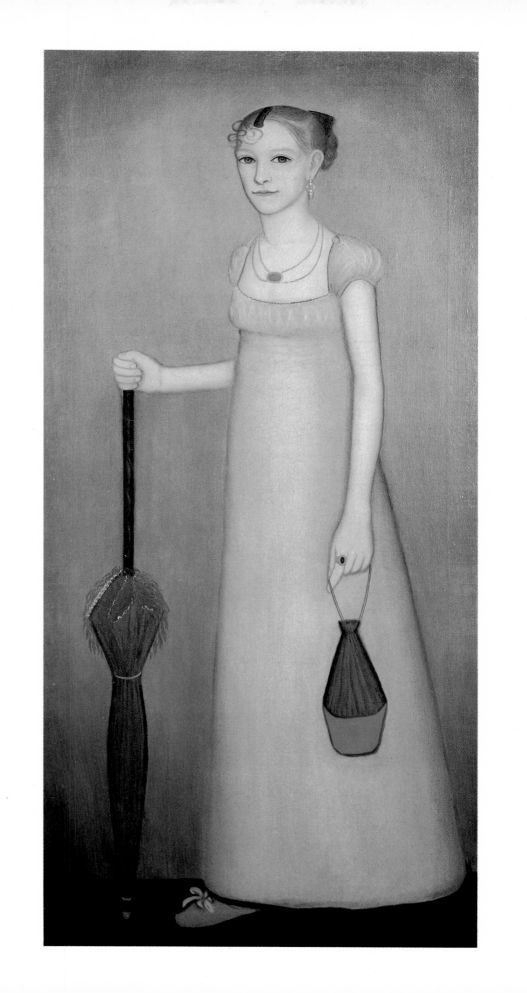

could not readily accept their hypothesis. In response to my doubts, the Holdridges intensified their search. In 1960 we went together to the Berkshires to visit the area where Phillips had died in 1865—the little town of Curtisville, now called Interlaken, Massachusetts. As the result of that weekend visit we uncovered fourteen additional portraits of the Kent period and two signed 1811 portraits of Berkshire County residents, Chloe Allis Judson and Gideon Smith, the latter proving the Holdridges' theory that Ammi Phillips and the Border Limner were one.

A pair of 1820 portraits, signed and dated by Ammi Phillips, added perspective to the end of his Border period. More signed portraits came to light, establishing his style between the Border and Kent periods, while others confirmed his style from the late 1830s to two years before his death in 1865.

Ammi Phillips was born in Colebrook, in the northwest corner of Connecticut, on April 24, 1788. (According to a descendant, his unusual given name was pronounced Am-eye.) Phillips's earliest known portraits, of Berkshire County residents, were painted when he was just twenty-three. In 1813 he married Laura Brockway of Schodack, New York; his delicate portraits date to just before this event and he continued to paint in this style until about 1820. During these years Phillips worked in eastern New York, western Massachusetts, and Connecticut. Dating to this period are many winsome portraits of children, including the elegant portrait of Harriet Leavens of Lansingburg, New York (colorplate). Painted about 1815, it is one of seven full-length paintings of children from the same general eastern New York area, all done by Phillips within a two-year period. The Leavens portrait is strikingly similar to the likeness of Laura Hall of Cheshire, Massachusetts, by J. Brown, an artist known only through the signature that appears on a few paintings of Massachusetts subjects done in the early years of the nineteenth century. Phillips must have seen the earlier portrait of Laura Hall, and he might even have had an actual acquaintance with the artist as well as with his work.

Beginning about 1820, Phillips's palette became more somber and his subjects less romantic and more realistic in appearance. In this transitional period from 1820 until about 1829 he used poses and designs similar to those of the Albany painter Ezra Ames. No documented evidence exists to show that the two ever met, but Phillips's home base at this time was Troy, and surely he saw the work of this prolific artist in towns along the Upper Hudson.

In 1830 Phillips's wife died in Rhinebeck, where they had purchased land the year before, and was buried in the Dutch Reform graveyard there. In less than six months the artist married Jane Ann Caulkins. At twenty-two she was twenty years younger than her husband; it was she, apparently, who took over care of the painter's five children by Laura Brockway. Four children were born of Phillips's second marriage as he continued to work as a portrait painter in New York State and New England. He moved from town to town but remained within a limited rural society. His clients were relations, neighbors, friends, and their families and acquaintances. Toward the end of his life, in about 1860, Phillips and his family returned to western Massachusetts, and he continued

his career as a portrait painter in the area where it had begun half a century before; it was there that he died on July 11, 1865.

By any standard Phillips was the most prolific and inventive American country portrait painter of the nineteenth century. The influences on his early style appear to have come from the last of the great generation of eighteenth-century Connecticut painters who raised folk art from craft to art. The portraits by eighteenth-century limners that he saw in houses along the Hudson Valley may have inspired some of the poses seen in his portraits of children. Phillips was himself an influence on Erastus Salisbury Field, who worked a territory slightly east of and, in part, overlapping that of the older painter.

Phillips is the perfect example of the self-taught artist who experimented to find solutions to his own painting problems. For him, figures presented difficulties from first to last. In his Border period he made his limitations work for him, and the lumpy coats, gangling limbs, huge hands, wooden arms—even the tables tilted at odd angles—are all part of well-composed and powerful portraits. Later he glossed over problems of anatomy by using flat, dark-colored backgrounds and dark dresses and suits; he rarely experimented with the rounding of facial planes.

The best of Phillips's portraits present a splendid country nobility. Figures are set in stylized poses against plain backgrounds; occasionally a profession or interest is indicated in book, newspaper, or detail; a table cover or chair will often be defined with some care, but for the most part the artist emphasized the faces, enhancing them with elaborate costumes.

In the Border period Phillips employed a remarkably subtle palette, with sophisticated pastel hues in backgrounds and women's dresses. His concern for delineating character is emphasized in the stylized but sensitive treatment of Colonel and Mrs. Joseph Dorr, prominent residents of Hoosick Falls, New York (colorplates). Their portraits of about 1814–16 conform to Phillips's lifelong pattern of painting closely related family members. He also painted portraits of Joseph's brother, Dr. Russell Dorr, his wife, and several of their children.

The Kent period lasted roughly a decade, from 1829 to 1838. In this style, *Blond Boy with Primer, Peach, and Dog* (colorplate) has both aesthetic and genealogical ties with another great Phillips painting of the Kent period, the full-length double portrait of Mrs. Ostrander and her son Titus (colorplate), painted about 1838. *Blond Boy with Primer, Peach, and Dog* descended for at least three generations in the Smith family of Greene County in which many blood and marriage ties may be found to the Ostrander family.

While other portrait painters stumbled and fell before the challenges presented by the camera, Phillips painted on. It was only in his last years that the camera had an effect on his painting; he finally employed photographs as his guide and model in the late 1850s and early 1860s. It is tempting to think of Phillips as a poor, struggling country craftsman, but the image is faulty. In his old age, his life was certainly a simple one, but more often than not his galleries were the great houses of the Hudson and Housatonic valleys. As the artist John Vanderlyn wrote in an 1825 letter en-

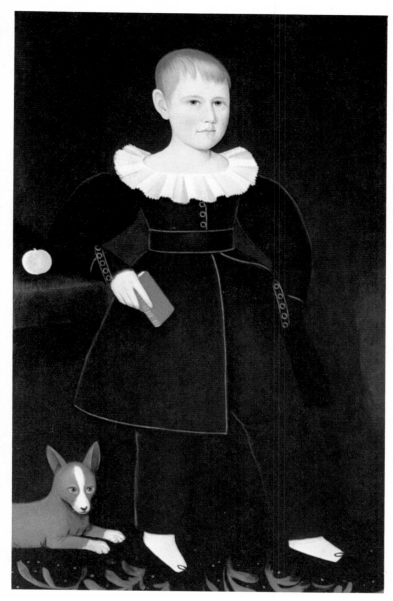

Ammi Phillips. *Blond Boy with Primer, Peach, and Dog*, c. 1838.
Oil on canvas, 48⅜ x 30 inches.
Collection of Mr. and Mrs. Jacob M. Kaplan.

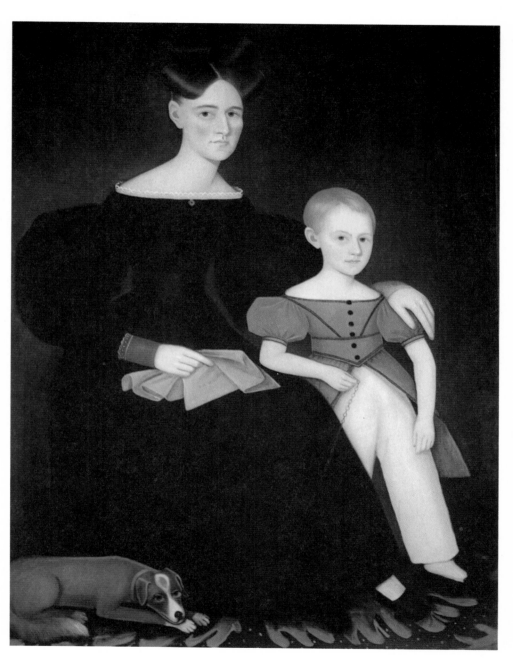

Ammi Phillips. *Mrs. Stephen Nottingham Ostrander
(Rachel Ann Maria Overbagh) and Son Titus*, c. 1838.
Oil on canvas, 58 x 44 inches.
Collection of Mr. and Mrs. Jacob M. Kaplan.

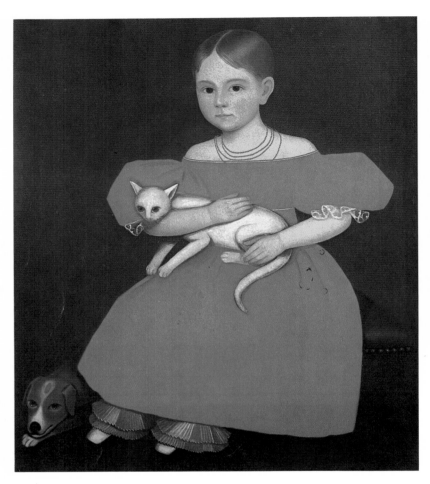

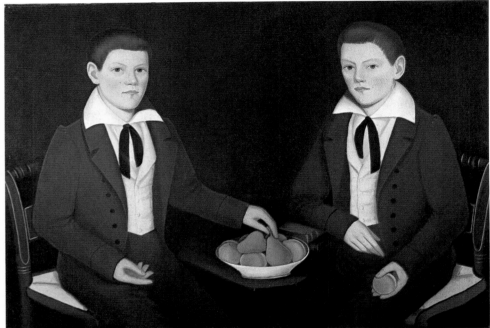

Ammi Phillips. *The Ten Broeck Twins*, c. 1832.
Oil on canvas, 33 x 50 inches.
Private collection, photograph courtesy of Carl Black—Art Research.

Ammi Phillips. *Girl in Red with Her Cat and Dog*, 1834–36.
Oil on canvas, 31½ x 27½ inches.
Private collection.

couraging his nephew to become a portrait painter, "Indeed, moving about the country as Phillips did and probably still does, must be an agreeable way of passing one's time."

MARY BLACK

This chapter is based on "The Search for Ammi Phillips" by Mary Black in *Art News*, vol. 75, no. 4 (April 1976), pp. 86–89.

Further Reading

HOLDRIDGE, BARBARA, AND HOLDRIDGE, LARRY. "Ammi Phillips." *Art in America*, vol. 48, no. 2 (Summer 1960), pp. 98–103.

————. "Ammi Phillips, Limner Extraordinary." *Antiques*, vol. 53, no. 6 (December 1961), pp. 558–63.

————. "Ammi Phillips. 1788–1865." *Connecticut Historical Society Bulletin*, vol. 30, no. 4 (October 1965), special issue.

Ammi Phillips. Portrait Painter 1788–1865. Introduction by Mary Black; catalogue by Barbara C. and Lawrence B. Holdridge. New York: Clarkson N. Potter, 1968.

BLACK, MARY. *Ammi Phillips. 1788–1865* (exhibition catalogue). New York: Washburn Gallery, 1976.

BLACKBURN, RODERIC H., AND PIWONKA, RUTH. *Ammi Phillips in Columbia County* (exhibition catalogue). Kinderhook, N.Y.: Columbia County Historical Society, 1977.

Eunice Pinney

1770–1849

Eunice Pinney is the earliest American primitive watercolorist whose life and work have been recorded, and her product, scarcely typical of her times, stands out from the body of nineteenth-century watercolors as a unique and original performance. Much early nineteenth-century watercolor painting, done by inexperienced schoolgirls, so charms us with its quaintness that we overlook the tentative, wobbly drawing, the stereotyped themes and designs. Eunice Pinney's work, although no more sophisticated, is entirely different. A mature woman when she began to paint, she was endowed with a robust originality and a flair for design which she developed into a vigorous and varied amateur art.

From what we can reconstruct of her background and life, Eunice Pinney seems to have been a well-born, well-educated, capable, and influential woman. She was a descendant of Matthew Griswold, who in 1639 came from Kenilworth, England, to Windsor, Connecticut. He in turn belonged to a family settled in Warwickshire for twelve generations prior to 1619. He is recorded as a man of true worth and piety, of superior education for the times, and an active participant in the affairs of the Colony.

Eunice Pinney was the daughter of highly respected and wealthy parents and the sister of the well-known Episcopal bishop, Alexander Viets Griswold. *The Memoir of the Life of Rt. Rev. Alexander Viets Griswold*, published in 1844 by John S. Stone, mentions various members of the family and describes Eunice Pinney as "a woman of uncommonly extensive reading" and "zealously instrumental in the first organization of our church, in that Diocese, and in the election of its first Bishop." Stone also remarks that Eunice Viets (Eunice Pinney's mother) was a pious woman of remarkable intelligence and uncommon energy, and that her marriage to Elisha Griswold "brought together two of the most considerable families and estates in the town."

Elisha was known in his community as "a man of quiet good sense, and remarkably homekeeping habits." The eight children were, we are told, "a family of various talent." Two of the boys, Alexander Viets and Samuel, entered the ministry. Two others, Roger and Elisha, were "intuitively ingenious mechanics"; their ingenuity "was in fact too versatile—they ran the race of too many other inventive geniuses of New England, and lived poor, because, in the homely phrase, 'they had too many irons in the fire.'" The children were trained from their first years to develop "abiding habits of industry" and were taught always to do something useful "in moments which would otherwise run to waste." This early

training, and the fact that the favorite amusement of the children was acting in plays performed for the neighborhood, may have some bearing on Eunice's ambitious artistic output and on the sense of drama inherent in her watercolors.

The chief facts of Eunice Pinney's life are as follows: she was born in 1770 in Simsbury, Connecticut, and died in 1849, probably in Simsbury. She married Oliver Holcombe of Granby (b. 1769), who in his twenties was drowned fording a stream on his way from Connecticut to Ohio. By him she had two children, Oliver Hector and Sophia Holcombe (Phelps). In 1797 she married Butler Pinney of Windsor (1766–1850). In 1844 she is mentioned as living in Simsbury, so it may be assumed that the Pinneys had remained in Simsbury after the marriage or had moved from Windsor to Simsbury sometime prior to that date. By her second marriage she had three children, Norman, who grew up to become a clergyman, Viets Griswold, who died as a youth, and Emeline Minerva (Bright), who before her marriage was a painting teacher.

Some of Eunice Pinney's personal belongings and letters, among them a few written to her daughter Emeline when the latter was away teaching school in Virginia, are preserved by various of her descendants. These letters have a very religious tone and also some tendency toward verse—in one to Emeline for instance: "And now good night for I have a dismal light. Write soon I pray and come you home without delay." The aspect of these letters which most interests us is that on the backs of several of them are finished watercolors intended for Emeline to use as models for her scholars.

As all the signed watercolors are inscribed *Eunice Pinney* and the only accurately datable ones range from 1809 to 1826, it may be assumed that the artist began to engage actively in her hobby of watercolor painting sometime after her second marriage and that most of her work was done in Windsor or Simsbury, Connecticut. Her painting was not the work of a schoolgirl but of a mature woman—a fact which might indeed have been deduced from the paintings themselves. If, as we believe, her work as a watercolorist was largely done in the first three decades of the 1800s, she was between the ages of thirty and sixty. This fact is more significant than it may appear. Eunice Pinney's firm, solid, robust watercolors could only have come from the hand of a vigorous artist in the prime of life. Her designs are sturdily, architecturally balanced in plan—foursquare is the word that comes to mind; the figures are stocky, the contours bold, the colors full-bodied. Her numerous pencil sketches for various portions of the finished pieces reveal

Eunice Pinney. *Two Women*, c. 1815.
Watercolor on paper, 11 x 14⅜ inches.
New York State Historical Association, Cooperstown.

Eunice Pinney. *Children Playing*, c. 1813.
Watercolor on paper, 7¹³⁄₁₆ x 9⅝ inches.
Abby Aldrich Rockefeller Folk Art Center,
Williamsburg, Virginia.

Eunice Pinney. *Undedicated Memorial*, c. 1815.
Watercolor on paper, 18½ x 15¾ inches.
New York State Historical Association, Cooperstown.

Eunice Pinney. *Masonic Memorial*, 1809.
Watercolor on paper, 13½ x 11½ inches.
Collection of Howard and Jean Lipman.

her sure-handed draftsmanship and show the careful preliminaries which entered into the production of her watercolors.

Eunice Pinney's style might be compared to that of a contemporary English illustrator, Thomas Rowlandson, for it seems not only mature in its vigor but actually more masculine than feminine, in the traditional sense. Her manner of painting and even the costuming of her figures belong to the late 1700s, which is easily explained by the fact that a number of her watercolors were based on eighteenth-century English prints. Eunice Pinney's formative period, her schooling, the development of her habits of thought and work, were entirely of the eighteenth century. By the year 1800, she was thirty years old; she had been married twice and had three children. It is scarcely stretching the point to consider her an eighteenth-century person who worked in the early nineteenth century. This explains some of the differences between her painting and that of her younger contemporaries who were, actually, of a different generation.

The great majority of the early American lady watercolorists were active in the second rather than in the first quarter of the

nineteenth century. Eunice Pinney painted before theorem pictures had become a fad, and she was educated before the popular art instruction books and painting recipes were part of every schoolgirl's equipment. This at least partly accounts for the freedom of manner and theme in her watercolors, which is evidenced by their bold style, the variety of the compositions, and the range of subject matter. Pinney was an extraordinarily prolific and versatile amateur. Her watercolors provide examples of genre, landscape, memorials, figure pieces, allegorical, historical, religious, and literary subjects, and even include birth registers, a village scene, and a painting of Old Newgate Prison.

Many of her allegorical, historical, and literary pieces were adapted from eighteenth-century English engravings, but Pinney cannot be considered a copyist. *The Cotters Saturday Night* (colorplate), dramatically illustrating the twelfth stanza of Robert Burns's poem, was inspired by an English aquatint, but the reduced detail and strengthened line translated the print source into Pinney's bold pictorial language. A gray watercolor wash sets off the row of sturdy figures lightly colored in a rainbow of pastel

shades, and attention is focused on the faces by the intensity of the various expressions.

The genre scenes are strikingly individual. For *Children Playing* (colorplate), the artist compacted a lively mix of boys and girls into a tight oval, but she kept the action—and her design—briskly swirling with the staccato rhythm of heads and hats. *Two Women* (colorplate) was first reproduced on the cover of *Antiques* magazine for May 1932, and the editor, Homer Eaton Keyes, wrote about it as the work of an artist who, "quite untrained, guided by instinct rather than by rule," produced a masterpiece—a monumentally designed New England tableau full of dramatic implication.

Pinney's flair for original design may again be seen at a glance in her memorial pictures, which vary enormously in composition, content, and coloring—and this in spite of the tendency of the times to standardize such pieces. The *Masonic Memorial* (colorplate) was painted in memory of the Reverend Ambrose Todd (1764–1809), rector of the Episcopal Church in Simsbury. The lines inscribed on the face of the watercolor are no doubt an expression of the artist's versifying tendencies:

> Death cant disjoin whom Christ hath joined in love
> Love leads to Death and Death to life above
> In Heavens a happyer place frail thing despise
> Live well to gain in future life the prize
>
> Oh spotless soul look down below
> Our unfeignd sorrow see
> God gave us strength to bear our wo
> To bear the loss of thee.

The large *Undedicated Memorial* (colorplate) has an unusual feature in the pinpricking of the women's dresses, which gives the sleeves, bodices, folds, and ruffles actual bulk and texture. The small scale of the woman at the right is an interesting but puzzling detail. Is she perhaps a less important relative and so portrayed in diminutive scale? More likely, her size is dictated purely by the requirements of the compact design.

Beneath all the variety of the artist's subjects is a basic core of style that remains constant and clearly definable. The Pinney watercolors could never have remained anonymously scattered. Even if her name had not been known, her paintings would have been recognized as the work of a single artist, for each example is clearly stamped with the hallmarks of her style. At the heart of this style are a breadth and solidity which are the exact opposite of the schoolgirl paintings of the early nineteenth century. Typically, that work is adolescent in its sensibility, with willowy figures, delicate drawing, pale coloring, and designs often timidly askew. In striking contrast, Eunice Pinney's paintings are distinguished by a versatile, dramatic, and infallibly sound sense of design. In estimating her rank as an American folk painter, we need not limit our comparisons of her work to her immediate contemporaries, to the members of her sex, or even to the watercolorists. Only a few were as bold draftsmen, as able composers in line and color.

JEAN LIPMAN

This chapter is based on "Eunice Pinney, An Early Connecticut Watercolorist" by Jean Lipman in *The Art Quarterly*, vol. 6, no. 3 (Summer 1943), pp. 213–21; reprinted in *Primitive Painters in America. 1750–1950*, Jean Lipman and Alice Winchester, eds., 1950; reprint ed., Freeport, N.Y.: Books for Libraries Press, 1971, pp. 22–30.

Further Reading

LUCK, BARBARA ROSS. "Eunice Pinney: New Perspectives." Unpublished paper. Williamsburg, Va.: Abby Aldrich Rockefeller Folk Art Center.

THE COTTERS SATURDAY NIGHT

Eunice Pinney. *The Cotters Saturday Night*, c. 1815.
Watercolor on paper, 12⅛ x 14⅝ inches.
National Gallery of Art, Washington, D. C.;
Gift of Edgar William and Bernice Chrysler Garbisch.

Rufus Porter

1792–1884

Rufus Porter, about eighty years old. Courtesy
Smithsonian Institution, Washington, D.C.

The name of Rufus Porter was virtually unknown when I began to research his life around 1940, and details of his amazing career had never been published or publicized, although he was one of our great New Englanders. It seemed important to reconstruct his life because he pioneered and made outstanding contributions in the field of American art, and in science and journalism as well.

Porter's life reads like a composite tale of the times, a personal embodiment of the era of itinerant adventure, of young invention, of scientific, industrial, and artistic enterprise. We see a New England farmer's son and shoemaker's apprentice becoming a traveling artist, founding *Scientific American* magazine, planning a "horseless carriage" and an airship (illustration) designed to travel at a hundred miles an hour. In no other time or place than nineteenth-century America could such a life have been led.

Rufus Porter's place in American art history is that of our chief early mural painter and one of our outstanding native artists. As a

portrait painter he was the first to conceive of the large-scale production of quick, cheap portraits for the people; as a landscape painter he was the first to realize the popular possibilities of the everyday American scene. From the perspective of the twentieth century his homespun art and art instruction emerge as highly significant facets of his many-sided career, and as enduring contributions to American cultural history.

Rufus Porter was born in West Boxford, Massachusetts, on May 1, 1792, the son of a prosperous farmer who moved with his wife and seven children to Maine in 1801. Young Rufus's higher education consisted of six months spent in the Fryeburg Academy in Maine at the age of twelve. For the next two years he lived as a farmer and amateur fiddler. According to an obituary account in *Scientific American*, his family decided when he was fifteen years old that "it would be best for him not to fiddle any longer" but to settle down to something solid and useful, and so apprenticed him to his older brother, a shoemaker. Soon, however, Rufus gave up this trade and began his itinerant career by walking to Portland, where he spent three years playing the fife for military companies and the violin for dancing parties. He then became, successively, a house and sign painter, a painter of gunboats, sleighs, and drums, a drummer, and a teacher of drumming and drum painting. In 1814 he was, briefly, a member of the Portland Light Infantry. Next he taught school, built wind-driven grist mills, copyrighted a music instruction book, moved from Portland to New Haven, and began his career of portrait painting. Shortly after that we find him, as "Professor Porter," running a dancing school. There are no records of his activity for the years from 1817 to 1819, but according to an elderly resident of West Boxford, Porter joined the crew of a ship on a trading voyage to the northwest coast and Hawaii. She remembered seeing letters written by Porter in which he described the people and scenery of the Hawaiian Islands.

Having begun a nomadic life in his teens, Porter remained a wanderer till his last years. He married Eunice Twombly in 1815, and ten children were born of this marriage. After his wife died in 1848, he remarried in 1849 and fathered six more children, but Porter rarely stayed at home for any length of time. The *Porter Genealogy*, published in 1878 when Rufus was eighty-six years old, notes: "Mr. Porter writes that he has good health, and walked seventeen miles." At this date he is recorded as a resident of New Haven, but he had not yet settled down and is found two years later in Bristol, Connecticut. He was still traveling in 1884, when during a

CORRECT LIKENESSES,
TAKEN WITH ELEGANCE AND DESPATCH BY
RUFUS PORTER.

Prices as follows—
Common Profile's cut double, - - $.0 20
Side views painted in full colours, - - ′00
Front views, - - - - - - - 3 00
Miniatures painted on Ivory, - - - 8 00
☞ *Those who request it will be waited on, at their respective places of residence.*

Porter's advertising handbill, early 1800s; the blotted price for "side views" is probably one dollar. American Antiquarian Society, Worcester, Massachusetts.

AN AERIAL STEAMER, OR
FLYING SHIP.

INVENTED BY
RUFUS PORTER.
Original Editor of the "New-York Mechanic," "Scientific American," and "Scientific Mechanic."

W. GREER, PRINTER, WASHINGTON, D. C. 1850.

Porter's 1850 pamphlet promoting a "flying ship." Minnesota Historical Society, St. Paul.

visit to a son in West Haven he was suddenly taken ill and died on August 13, in his ninety-third year.

Excepting his Hawaiian adventure, Porter worked steadily at the trade of itinerant artist from 1815 to around 1840. During that time he traveled throughout New England and as far south as Virginia. A versatile and productive artist, he devoted himself to the large-scale production of inexpensive portraits and murals for rural homes and country hostels. A generation before Currier and Ives had become printmakers to the American people, Porter had established a mobile one-man factory for original portraiture and interior decoration. In 1820, to speed up portrait production, he planned and constructed a camera obscura with which he could make portraits in fifteen minutes. The silhouette of the sitter was focused on a sheet of paper, the outline then sketched and rapidly filled in. These portraits, priced at twenty cents, were in great demand and sold briskly. According to his advertising handbill (illustration), Porter also produced full-face and profile watercolor portraits and ivory miniatures. A great many of the profile portraits, sensitively drawn and delicately colored, have been identified in the last few years based on comparison with the one pair reproduced in my 1968 book, *Rufus Porter, Yankee Pioneer* (illustration). A notice which Porter placed in the *Haverhill* (Massachusetts) *Gazette* for March 31, April 7, and April 14, 1821, to advertise his watercolor portraits reads:

PAINTING

The subscriber respectfully informs the Ladies and Gentlemen of Haverhill and its vicinity, that he continues to paint correct likenesses in full Colours for two Dollars at his room at Mr. Brown's Tavern, where he will remain two or three Days longer.

(No Likeness, No Pay.)

Those who request it will be waited on at their respective places of abode.

Haverhill, Mar. 31, 1821 Rufus Porter

In 1825 Porter published a book called *Curious Arts*, an art instruction manual primarily designed to give the amateur public quick and easy recipes for various types of art work. Included in this book is a section on "Landscape Painting on Walls of Rooms" —and in the following years Porter devoted himself chiefly to mural painting. His frescoes were executed in large scale on dry plaster walls in a combination of freehand painting and stenciling, some in full color, others in monochrome, the foliage occasionally stamped in with a cork stopper instead of painted with a brush. These methods, as well as stencil work, had long been used for decorating plaster, woodwork, and furniture, but Rufus Porter was the first to popularize them for landscape painting. His rapid technique and stock stencils reveal the inventive Yankee introducing time- and labor-saving devices and mass-production methods for art as he did for industry. His simple murals provided a popular substitute for the elaborate, imported scenic wallpapers that were fashionable at the time, and though somewhat related to wallpaper designs, Porter's scenes always have a fresh, native flavor (see colorplates).

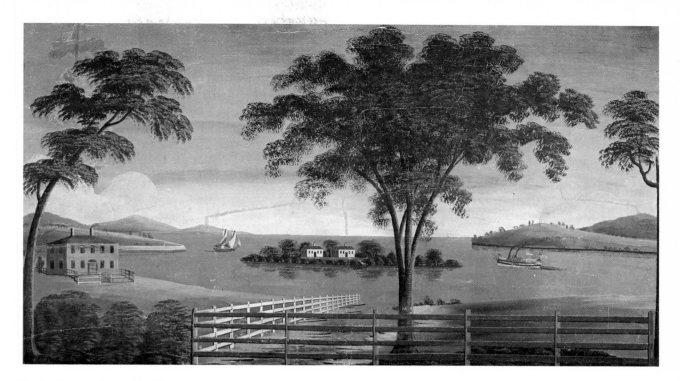

Rufus Porter. *Steamship Victory*, 1838.
From the Dr. Francis Howe House in Westwood, Massachusetts. Fresco, 75 x 96 inches.
Private collection.

Rufus Porter. *Landscape*, 1838.
From the Dr. Francis Howe House in Westwood, Massachusetts. Fresco, 72 x 96 inches.
Private collection.

A mural signed *R. Porter* in the Dr. Francis Howe House in Westwood, Massachusetts, was recorded by E. B. Allen in a 1922 *Art in America* article on New England frescoes. Starting with this, I researched and published the full story of Rufus Porter's amazing career in my 1968 book, recording 160 houses in rural Massachusetts, New Hampshire, Vermont, and Maine decorated with wall paintings executed by Porter, often with the help of assistants. These included his son Stephen Twombly Porter, his nephew Jonathan D. Poor, and several others. Always eager to instruct, Porter was quite literally a "master" of mural painting with a "school" of pupils. Since publication of my book, dozens more Porter murals have been brought to my attention, and it is safe to assume that a great many others remain undiscovered or were destroyed during the past hundred years. The Howe House murals (colorplates) were saved when the house was torn down, and they are now privately owned.

Attributing the frescoes presents few difficulties, since the Porter and Porter-school murals are distinguished by typical style and content. Their most obvious characteristics are their large scale, clear, bright colors, and bold design and execution. The three most frequently recurring scenes are harbor views much like Portland harbor as seen from Munjoy Hill, with houses, ships, and islands, mountains in the distance, and large "feather-duster" elm trees and small shrubs in the immediate foreground; mountain-climbing or hunting scenes used for stairway decorations; and farm-village scenes, most often used for overmantel frescoes, with buildings, fields, fences, roads, and again the large elms and small stylized shrubs in the foreground. The trees invariably occupy almost the entire height of the painted wall and establish the first plane of the picture. Other earmarks of his murals include billowing round clouds, clear reflections of objects in water, sharp shading of the darkened sides of houses and trees, and the use of stencils for many details, including houses and boats. Occasional exotic details such as tropical trees and vines, possibly based on recollections of Hawaiian scenery, are also characteristic. Examples of mantelpieces, overmantel panels, and fireboards (see illustration) decorated with similar painted landscapes have recently been attributed to Porter or his assistants. In a number of the houses with walls painted by Porter, he evidently also decorated the woodwork.

In a series of articles published in 1845 in the first volume of *Scientific American*, Porter discussed the mural painter's approach to his art. Here we find him enthusiastically recommending, for subject matter, American farm scenery; for style, deliberate abstraction. This was indeed a revolutionary combination for a mid-nineteenth-century artist to have advanced.

There can be no scenery found in the world which presents a more gay and lively appearance in a painting, than an American farm, on a swell of land, and with various colored fields well arranged.... In finishing up landscape scenery, it is neither necessary nor expedient, in all cases, to imitate nature. There are a great variety of beautiful designs, which are easily and quickly produced with the brush, and which excel nature itself in picturesque brilliancy, and richly embellish the work though not in perfect imitation of anything.

Rufus Porter's outstanding trait was his total independence of the more conventional ideas and fashions of his day. He felt himself free to live, to think, and to paint as he wished. This accounts both for the bold originality of his ideas as an inventor and for his free approach to the art of painting. Oblivious to academic realism, he developed a personal, deliberately abstract style, with unconventional designs and color schemes which he rendered in rapid, bold brushwork.

During the years of Porter's work as an itinerant artist he actively practiced a subsidiary profession—that of inventor. Porter's inventions were generally directed toward saving time and labor, and his liking for the itinerant life apparently caused him to specialize in devices that would improve means of locomotion. He visualized the possibilities and drew up plans for an automobile, an elevated train, and a passenger plane. After he had designed a "flying ship" and exhibited machine-driven working models that were flown in New York, Boston, and Washington (the largest model was twenty-two feet long), Porter published in 1849, neatly timed for the gold rush, a book called *Aerial Navigation, the Practicability of Traveling Pleasantly and Safely from New York to California in Three Days*. Porter tried, unsuccessfully, to promote his invention. He first offered, in *Mechanics' Magazine*, half of his patent claims to any company or person who would build a full-scale model. He subsequently stated in the *New York Mechanic* that he would accept ten percent of the profits if anyone would promote his invention. He next petitioned the Senate for an appropriation to enable him to demonstrate the practicability of his airship. Then, in 1852, he formed the Aerial Navigation Company which issued stock at five dollars a share, and as late as 1873 he is recorded as still soliciting shares. Rufus Porter never flew, but he was the first man in the world to plan and try out the possibilities of a power-driven passenger plane.

Porter also concentrated on developing portable mechanisms,

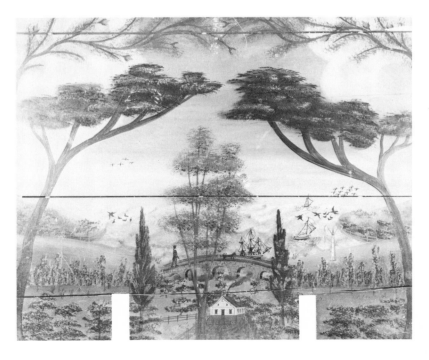

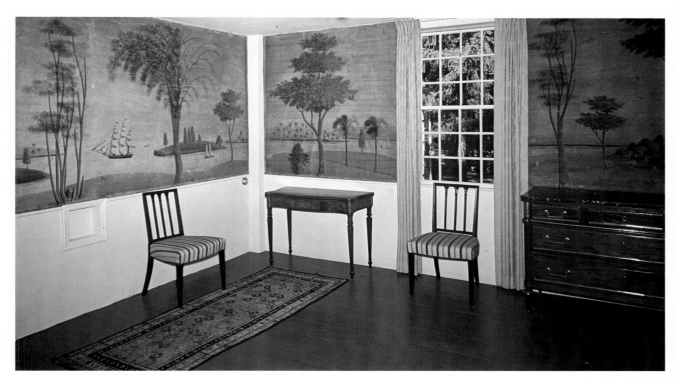

Rufus Porter. Frescoes in the Holsaert House,
in Hancock, New Hampshire, c. 1825–30.

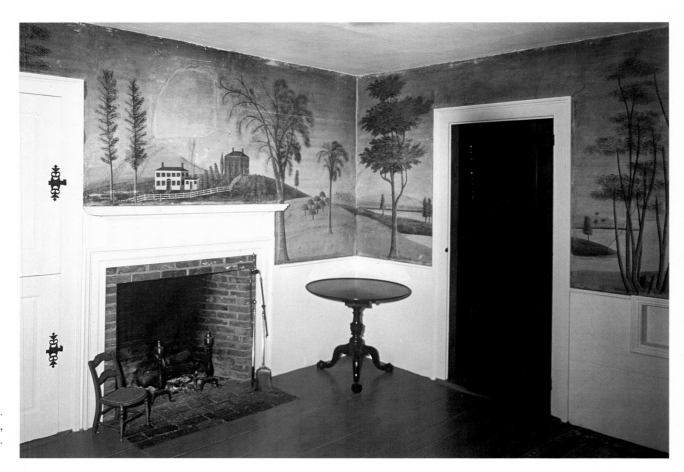

Opposite
Rufus Porter. Fireboard from the James T.
Garvin House, Greenfield, New Hampshire,
c. 1825. Oil on wood, 30½ x 36½ inches.
Collection of Mr. and Mrs. Samuel Shaer.

and "portable" is prominent in the newspaper titles of his published inventions. We find plans for "Porter's Portable Horse Power," a portable fence and portable boat, a pocket chair, and even a car for moving houses. There was nothing stodgy or static in Porter's scheme of things. A forward-looking devotee of variety, change, and speed, his life, art, writings, and inventions are entirely consistent; all typify the changing trends of his times and predict to an amazing degree the tempo of twentieth-century life.

Although Rufus Porter made detailed mechanical drawings and models for quite a number of machines that have been mass-produced in the twentieth century, he was a visionary rather than a practical inventor. His lack of fame in his (and our) time came about primarily because his art activities were carried on with almost total anonymity and because he drew up and sold the majority of his inventions without patenting them. A brilliant artist and inventor, Porter was an ineffectual businessman who never successfully merchandised or profited by his inventions. It is interesting to find that he sold one of his inventions, the revolving rifle, to Samuel Colt for one hundred dollars; the revolver Colt developed became famous but its inventor did not.

Throughout his life Porter was interested not only in doing but also in teaching. He had the instincts of the leader, the promoter, and sought at every turn to propagate the ideas and skills which he developed. During his career as an artist he was an active teacher, publishing a popular art primer, writing series of articles on the art of painting, and working with a small "school" of pupils who learned and practiced his methods of mural painting.

In the early 1840s Porter's quarter-century career as an itinerant landscape and portrait painter in rural New England had come to an end, and he began a new life in New York City as a journalist. As a magazine editor and pamphleteer, Rufus Porter sought to instruct and lead public opinion. The several scientific journals which he founded and edited covered everything from education to politics. In the 1840s he published and edited the *New York Mechanic*, *American Mechanic*, and *Scientific American*. The latter, which he founded in 1845, was one of the most important journals of its time, as it is today. Porter's journals, representing the interests of mechanics and farmers, were boldly independent and progressive. Porter was a freethinker and a severe critic of organized churches; the religious articles that he wrote and published in his latter days can only be termed revolutionary. As journalist and commentator on his times, Rufus Porter strengthened the ideals of freedom, equality, and progress in the young democracy in which he had played so varied and active a part.

JEAN LIPMAN

This chapter is based on "Rufus Porter. Yankee Wall Painter" by Jean Lipman in *Art in America*, vol. 38, no. 3 (October 1950), pp. 133–200; reprinted in *Primitive Painters in America. 1750–1950*, Jean Lipman and Alice Winchester, eds., 1950; reprint ed., Freeport, N.Y.: Books for Libraries Press, 1971, pp. 57–66.

Further Reading

LIPMAN, JEAN. *Rufus Porter, Yankee Pioneer.* New York: Clarkson N. Potter, 1969; revised ed., in association with The Hudson River Museum, 1980.

Other

"Rufus Porter, a Scientific American." Color filmstrip, 20 min. *Scientific American*, 1976.

Rufus Porter. *Mehitable and John Tyler*, 1819. Watercolor and ink on paper, each 3½ x 5 inches. Collection of Mrs. Stuart C. Hurlbert.

Asahel Powers

1813–1843

The itinerant painter Asahel Powers first came to public attention in the spring of 1958, when the Miller Art Center (now the Springfield Art and Historical Society) in Springfield, Vermont, held an unusually interesting exhibit of local family portraits. Included were pictures by the Vermont artists Horace Bundy, Zedekiah Belknap, and Aaron Dean Fletcher, as well as others by unknown artists. In addition, three groups of colorful, eye-catching portraits were shown which, despite slight differences in style, appeared to be by an individual named Asahel Powers. There were four paintings of the Chase family, three of which were signed with the artist's name and dated 1832. In the second group, dated 1833, four pictures were inscribed but not signed. The third group of portraits bore no written identification.

A local tradition that another Asahel Powers, the artist's grandfather, painted some of the pictures, has proved to be an unlikely supposition. Detailed biographical data on this branch of the Powers family in Vermont is virtually nonexistent, although *The Powers Family* (1884), compiled by Amos H. Powers, traces their descent as follows: (1) the immigrant ancestor Walter Powers (1639–1708) settled in a section of Concord, Massachusetts, that is now a part of Littleton; (2) Daniel (1669–?) lived on the westerly side of Littleton; (3) Jerathmeel (1718–?), a lieutenant in the French and Indian War, lived in Leicester, Vermont, and later in Seneca, New York; (4) Asahel (1759–1841), born in Shirley, Massachusetts, married Eleanor Bragg in 1781, and lived his adult life in Springfield, Vermont. Incidentally, Hiram Powers (the famous nineteenth-century sculptor) was descended from Thomas, another son of Walter Powers, so he and Asahel were distant cousins.

Asahel had a son and a grandson of the same name. Asahel, Jr. (1789–1845), married Sophia Lynde in 1812, and their son Asahel L. (Lynde), the artist, was born in Springfield on February 28, 1813. The designation "portrait painter" appears after his name in the family genealogy. No property deeds are listed in Springfield under the name of Asahel L. Powers and there are no probate records for either him or his father, which would appear to confirm the fact that both of them died elsewhere. Asahel L. probably began the career of traveling artist early in life. The portraits attributed to him indicate that he had begun painting by the time he was eighteen and moved about Vermont, Massachusetts, and New Hampshire, returning regularly to Springfield during the 1830s.

The earliest pictures by Powers form an extraordinary unsigned group of nine portraits depicting the interrelated Cobb-Harris families of Windham, Vermont. Seemingly dating to 1831, they are still in the possession of descendants. The sitters gaze directly at the viewer and are framed by unique curtained backdrops as they pose stiffly in yellow-painted Windsor chairs. These two-dimensional figures epitomize the artist's ability to convey personality by means of striking linear patterns of color and design. Four additional portraits employ the same curious background device.

In 1832 Powers signed and dated several portraits of the Jonathan Chase family of Springfield, and probably in the same year painted Charles Mortimer French (colorplate) and a lady who is believed to have been the boy's mother; both were executed on wood panels, as were all of the artist's earlier works. The hand-lettered inscription (illustration) on the back of the boy's portrait reads: *Charles Mortimer French/ taken at 6 years old./ Asahel Powers./ Painter.* Charles is seated in a yellow-painted side chair, his feet resting on a wood stool, with his squeak toy on a child-size table beside him. This is one of Powers's most beguiling compositions despite the heavy impasto on the face and the long, clawlike fingers which bespeak the inexperience of the artist.

The Chase and French portraits are arresting, not only for their richness of colorful detail, which is found in all of Powers's work, but even more for the strength of facial delineation. The heavy shadowing of the features, the absence of modeling and highlights, and an obvious unfamiliarity with the elements of anatomy and perspective are notable attributes of Powers's earliest and most powerful style.

Apart from their content, the inscriptions painted on the Chase and French pictures are important for comparative purposes. A superficial study of the lettering proves that even in this homogeneous group the artist combined several styles of penmanship, and later he was to change again. The Charles Mortimer French inscription appears in a copybook hand, including the signature with its rounded letters and large, flourishing capitals. The signatures on the Chase portraits are more angular and "crabbed"—less bold and free.

Two unsigned portraits of Mr. and Mrs. J. B. Sheldon epitomize Powers's style in 1833–34 (colorplates). Although still hampered by technical limitations, these pictures exhibit the marked flair for individuality that was to be an outstanding element in Powers's work throughout his brief career. On the back of Mrs. Sheldon's portrait is an inscription, not in the artist's hand, which identifies the sitter as being from Unionville, Ohio. One branch of the Shel-

don family is known to have lived in Vermont; since Powers did not travel west until later, it seems probable that the Sheldons were painted in Vermont and then moved to Ohio, taking their portraits with them.

Most folk artists delighted in painting costume details, and Powers, with his strong sense of decorative design, was no exception. Mrs. Sheldon's portrait best exemplifies the trimmings of eyelet embroidery he sometimes depicted by scraping the top paint when wet to reveal a dark layer beneath. At other times he embellished white surfaces with tiny circles or round black dots. As years went by, he used other types of brushwork to decorate caps, collars, and shawls. Powers was innovative, imaginative, and experimental. He continually tried new background and color effects, and his compositions show a definite progression toward a more accomplished style for which he was evidently striving. From the outset he used unusual and interesting accessories in his portraits, among others, a painted box, an initialed purse, a beaded bag, a stack of coins, a hearing trumpet, a concertina, and an artist's palette. Some of the backgrounds that enlivened his work consisted of looped drapery, strange curtain effects, painted paneling, traditional columns, and secretary desks. Although Powers was not the only artist to appreciate the ornamental qualities of nineteenth-century painted furniture, he used various types to good advantage in many of his compositions. He also used upholstered armchairs and even an early eighteenth-century banister-back chair that must have been an heirloom in the sitter's family.

In 1834 or 1835, Powers painted seven portraits of the Jacob Farrar family of Worcester, Massachusetts: Jacob and Achsah Fisk Farrar, two sons, two daughters, and a lady who is believed to be Mrs. Farrar's sister Allethenia Fisk. This group of pictures illustrates the gradual development in style and competence that was becoming apparent in Powers's work during the mid-1830s. While Mrs. Sheldon's image projects a flat, linear silhouette, Mrs. Farrar's face and figure (colorplate) exhibit a semblance of three-dimensional technique. The upholstered armchair, colorful drapery, and elaborate costume accessories all bespeak the artist's growing awareness of decorative detail. Also in this period, canvas backing began to supplant the heavy wood panels used in earlier years, suggesting that Powers was traveling farther afield and finding canvas lighter and more convenient to transport.

A portrait of Daniel Griswold of Springfield bears the following identification on the reverse: *painted by/ Powers. & Rice/August 1.st 1835*. Griswold's features exhibit Powers's familiar characteristics. In fact, the gray hair and pushed-up spectacles are virtually a repeat of those in the portrait of Jacob Farrar. With the exception of the capital letters, the writing used in the inscription is quite different from that observed in the early 1830s. It exhibits, however, the calligraphy that was to become associated with the signature *A. L. Powers* during the ensuing five years. Use of initials rather than the full name was generally favored by country artists during the late 1830s, including the itinerants Z. Belknap and H. Bundy, contemporaries of Powers, who were both working in and about Springfield at this time.

Who was "Rice" and what connection was there between him and Asahel Powers? It has been said that the two young men were working together in a local coach factory and that Rice may have made the frame which is nailed to the picture panel. If so, no record of such a factory has been found. Perhaps Powers and Rice combined in a joint painting effort; in any case the collaboration seems to have been of short duration.

Over the middle and late 1830s Powers's style moved gradually away from the extremely naïve manner of his earliest work. Whether he gained new facility from apprenticeship, experience, or observation of other artists' techniques remains obscure. A curious signed sketch on cardboard in the collection of the Shelburne Museum was surely a copy made for study purposes, while several trial drawings appear on the reverse of one of his portraits.

Except for the sequence of Vermont pictures, which apparently terminated in 1839, no additional information about Powers himself came readily to light. The date and place of his death (as well as that of his father) were unknown, making further biographical research frustrating. At this point an inquiry to the National Archives in Washington relative to any applications for federal aid filed under names of dependents of Asahel Powers brought gratifying results. Sophia Lynde Powers (mother of Asahel L.) applied for a land bounty in 1850, and a pension in 1871, on account of her

Inscription on the reverse of *Charles Mortimer French*. Courtesy of the New York State Historical Association, Cooperstown.

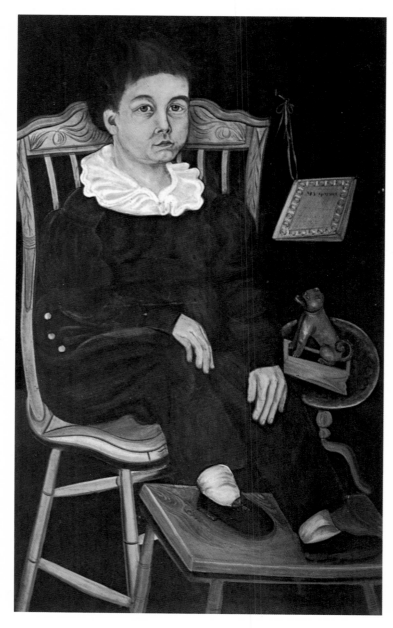

Asahel Powers. *Charles Mortimer French*, c. 1832.
Oil on wood, 36 x 21¾ inches.
New York State Historical Association, Cooperstown.

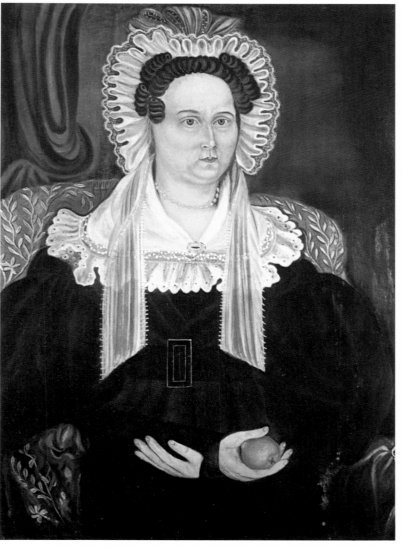

Asahel Powers. *Mrs. Jacob Farrar (Achsah Fisk)*, c. 1834–35.
Oil on canvas, 34½ x 25½ inches.
Collection of Bertram K. and Nina Fletcher Little.

husband's voluntary military service in Springfield, Vermont, covering three months during the summer of 1812. In these applications she stated, among other pertinent facts, that her husband, Asahel, Jr., had died in Olney, Richland County, Illinois, on February 20, 1845. Olney was then a small town in the southeast part of the state, some thirty miles from the border of Indiana. A letter of certification was filed with the pension application from two local citizens, stating that they had known both Asahel, Jr., and his wife in Olney from four years before his death in 1845. These documents prove that Asahel, Jr., and his family migrated to Illinois, arriving there in 1841.

During the first half of the nineteenth century many New Englanders traveled west to seek new opportunities and a more prosperous way of life. The Powers family was evidently among them. A brother of Asahel, Jr., George Powers, also settled in Olney. But what happened to Asahel L., the artist? Did he accompany his parents, or did he remain in Vermont, or go elsewhere after 1839? A letter to the clerk of the Richland County probate court quickly answered these questions.

No estate papers are on file in Olney for Asahel, Jr. However, Asahel L. died there intestate at the age of thirty on August 20, 1843. A partial list of personal property included notes due his estate in the sum of $84.83. Real estate, designated by four lot numbers, was valued between $100.00 and $300.00 per lot. Rent was due from "Mrs. Powers" (his mother?) and others on a house, office, store, and blacksmith shop, some of these buildings being in need of repair. The administrator collected small payments for a cow at $3.00, palings, a book, and a "glass frame" (hotbed?) at 25¢. It was a meager estate, and does not connote prosperity. No listing of household goods was filed, probably indicating that Asahel lived with his parents, and no painting equipment was designated or subsequently disposed of by the administrator. Up to the present time no Illinois portraits signed by, or attributed to, Asahel L. have been found.

After the above information came to light a very significant group of about twenty portraits, signed and dated in 1839 or 1840, began to emerge. All were discovered and researched by Mrs. Charles M. Burdick, Jr., of Plattsburgh, New York, and because of them it is now possible to establish when Powers left Vermont and started west. These likenesses, most of them still owned by descendants, originated in Clinton and Franklin counties, New York. Several of the sitters had moved there from Vermont, and this suggests one reason why Asahel obtained so many commissions in northern New York State. According to the 1840 census, there were also several Powers families living in Clinton County. An uncle, Major Powers, had left Springfield, Vermont, and purchased land in the Schuyler Falls-Peru area as early as 1814. Later he acquired more property adjacent to the Arnolds and Weavers, both of which families Asahel painted in 1840.

During this New York State period the artist's signature evolved into its final form. He dropped the final s from his surname and signed the backs of his canvases *A. L. Power*, with the date and the words *Painted by* or *Painter*. One of his rare advertisements appeared in the *Plattsburgh Republican* on November 7, 1840: "A. L. Power/ Portrait Painter/ Room at John Nichols' Hotel." In the same issue the editor inserted an enthusiastic note of commendation: "If you want your Portrait taken, call on Mr. Power, at Nichol's Hotel. We have seen some of his work; and were particularly struck with his skill in transfering the 'human face divine' to canvas. . . . We say again, to the citizens generally, call on Mr. Power—examine his work, and patronize him if you can—he deserves it."

Also in Clinton County remains the only known proof that Asahel was married. This evidence consists of a document, dated Plattsburgh, December 25, 1844, naming Elizabeth M. Powers, widow of Asahel L. Powers, administratrix, and directing her to return an inventory to the surrogate's office within three months, listing all "goods, chattels and credits" of the deceased. Asahel L. had died one year and four months before his widow's appointment, and his uncle, George Powers, had been named administrator in Olney. This suggests that for some unknown reason Elizabeth Powers had not accompanied her husband to Illinois but had remained behind in Plattsburgh. The inventory that she was directed to make is unfortunately not filed with the other estate papers in the surrogate's office.

In the final group of New York portraits we observe Powers's work at what he probably considered the height of his artistic achievement. His technique had by now become quite proficient, but he had lost much of the crisp and lively quality of his earlier years. Nevertheless, his renditions did not become stereotyped, and his sitters were always depicted with imagination and verve. The landscape and still-life painter Daniel Folger Bigelow, born in Peru, New York, in 1823, received his first art instruction from Powers, and later wrote that he owed his "delicacy of coloring and treatment to this artist's influence." Now, after nearly 150 years, we may credit Asahel Powers with having made a memorable contribution to his profession during the short ten years of his painting career.

NINA FLETCHER LITTLE

This chapter is based on the exhibition catalogue *Asahel Powers—Painter of Vermont Faces* by Nina Fletcher Little. Williamsburg, Va.: Colonial Williamsburg, 1973; reprinted in *Antiques*, vol. 104, no. 5 (November 1973), pp. 846–53.

Further Reading

Late Eighteenth Century and Early Nineteenth Century Portraits by the Vermont Artists Horace Bundy, Zedekiah Belknap, Asahel Powers, Aaron Dean Fletcher (exhibition catalogue). Springfield, Vt.: Miller Art Center, 1958.

LIPMAN, JEAN. "Asahel Powers, Painter." *Antiques*, vol. 73, no. 6 (June 1959), pp. 558–59.

JONES, KAREN M. "Museum Accessions." *Antiques*, vol. 110, no. 5 (November 1976), p. 914. Illustrates portrait of John Martin of Vermont, painted in 1833 by Powers.

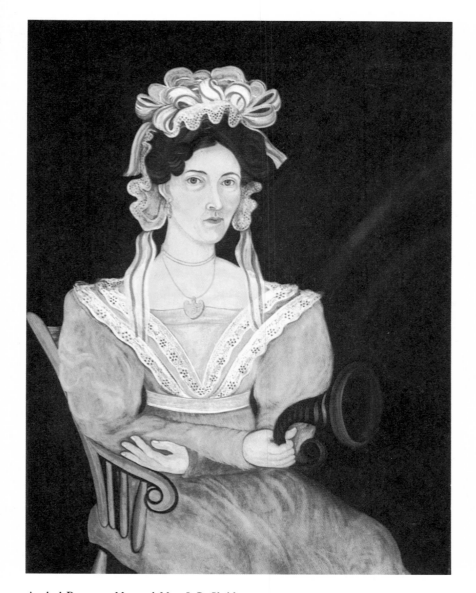
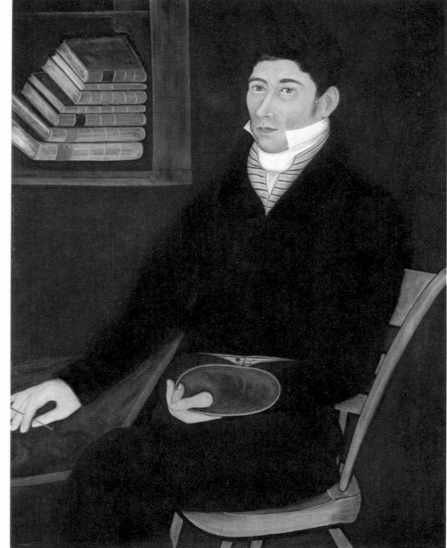

Asahel Powers. *Mr. and Mrs. J. B. Sheldon*, c. 1833–34.
Oil on wood, 41⅛ x 30¾ and 41 x 30¾ inches.
National Gallery of Art, Washington, D.C.;
Gift of Edgar William and Bernice Chrysler Garbisch.

Paul A. Seifert

1840–1921

Paul Seifert painted finely designed portraits of Wisconsin farms during a period of about forty years—from the late 1870s to about 1915—but until the original publication of this material in 1950 he was totally unknown, his name nowhere recorded. The discovery of signed farmscapes provided the point of departure for a fascinating art treasure hunt, in this case the treasure being the reconstruction of the painter's life.

One granddaughter recalled Seifert as a kindly and indulgent man, whose early life held some mysterious secret, for he jealously guarded the details of his youth in Germany. "My own personal contact," she wrote, "came when he was an elderly man, mellowed by age. By that time he had long ceased his drinking, his home on the banks of the Wisconsin River had been washed away, the myriads of flowers which made his home a show place were gone."

Another granddaughter, Myrtle Bennett, wrote me a number of revealing letters about the painter's life and her recollections of his personality. In order to keep as closely as possible to firsthand information, I quote from her account:

Paul A. Seifert was born June 11, 1840, in Dresden, Germany. He graduated from Leipsig college. Paul's early life in Germany, as much as we can gather from what he told us and his papers, was a life of wealth. His father was called Dr. Seifert—we have his picture and he was very distinguished looking. Then to further bear out this statement of wealth, sums of money, fine linens and jewelry were sent to my grandfather from his parents.

Because Paul disliked the military training in his country, he ran away and came to America in 1867. At that time, men traveled on rafts on the Wisconsin River bringing logs from the north country. Paul Seifert came down the river on one of the rafts and stopped at a small village called Richland City. Laurence Kraft was the only resident who spoke the German language and my grandfather soon gained his friendship and later married his daughter, Elizabeth Kraft.

At this time, Paul Seifert started his life work; for an occupation he raised flowers, small fruits, and vegetables, but as a hobby, he did the painting you wrote about in your letter, watercolor farm scenes. The natural resources of the country were very abundant at that time so he and his wife and four children lived a simple life in a log cabin.

In later life, he set up a shop near Gotham, where he practiced his art of painting and taxidermy. Besides the watercolor work he did oil painting on glass. These were castle scenes, as he remembered them in his native land. He died in 1921.

My grandfather was a small lean man with dark eyes and hair. He was alert, ambitious, highly sensitive, generous to the point of sacrifice. [His other granddaughter wrote that Paul Seifert was "generous to a fault."]

Many wayfarers received food and lodging at his home among the hills. The very decided change from a life of wealth to the most simple pioneer life must have irritated him at times, although he never showed class distinction for he even made friends with the peaceful Indians camped near his home. My grandmother did sewing for them in exchange for venison.

Paul Seifert liked order in his life and disliked disorder or confusion. His gardens carried this same pattern of order.

You asked if he painted at home or traveled to do his farm scenes. Sometimes he left home for days, walking from one farm to the other with his sketch book. Some sketches were brought home and painted, others, as I understand, were done at the farms. Along with his painting, he set out groves of shade trees at farms he visited, and started small fruit gardens for the farm folk, supplying the plants from his own garden.

The farm scenes were all painted in watercolors. As money was very scarce in those days, not more than $2.50 was paid for the paintings. He did not have a shop until later. These were done at home or on the farms.

His first shop was set up at Gotham, then later moved one and one half miles west of Gotham on this farm where I now live. The little shop, about 20 x 20, was painted a gay red with a white sign adorning the front, bearing the name of *Paul A. Seifert, Taxidermist* in black letters. Here my grandfather practiced many arts. It had two rooms and in one corner of the large room was a window and a table where he did his painting.

To me, as a child, going into his shop was like going into a wonderland, where all his mounted subjects were on display and his colorful paintings hung on the walls.

In the shop he did the glass painting. The sketches were made on drawing board, then the glass 16 x 20 inches was laid over the board and scenes of lofty castles with gold and silver foil windows were painted with oil on the glass. Later on, he painted winter scenes of churches and country churchyards. These sold for $5.00, a small fee considering his work and the making of the frames, but the country people were his customers and could not afford higher prices.

As for my grandfather making any remarks about art or painting, I asked my mother, his daughter, and she told me that he said: "People like my work and I like to paint for them." In this he found satisfaction.

Paul Seifert's simple farm scenes are filled with anecdotal detail—people, animals, the orchards the farmer-painter had laid out—that must have pleased and interested his customers; but, from our critical point of view, they are much more than this. The freshness of vision, the clarity and beauty of the linear and tonal patterns, the energy that characterizes every detail, reveal a vital, individual style.

Seifert's love of order, on which his granddaughter remarks in connection with his flower gardens, also dictated the manner of his painting. The lucidly planned design and clear color combine to

Paul A. Seifert. *Residence of Lemuel Cooper*, 1879.
Watercolor, oil, and tempera on paper, 21½ x 28 inches.
Collection of Howard and Jean Lipman.

Paul A. Seifert. *Wisconsin Farm Scene*, c. 1880. Watercolor, oil, and tempera on cardboard, 15½ x 28 inches.
New York State Historical Association, Cooperstown.

Paul A. Seifert. *Residence of Mr. E. R. Jones*, 1881. Watercolor and tempera on paper, 21½ x 27½ inches.
New York State Historical Association, Cooperstown.

make these farm scenes most remarkable. It is interesting to note that Seifert often used colored paper or cardboard for his scenes—tan or gray or blue—and this basic color determined the dominant tone of the painting in an original and arresting manner.

Seifert painted his own farm (colorplate) on light blue cardboard with foliage a vivid green, buildings gray and white, brown fences, and accents of vermilion, all set against pale blue fields and blue sky illuminated with a gilded sun and gilt-edged clouds. There is an almost identical, slightly smaller, version of this scene, also on blue cardboard, in the collection of the State Historical Society of Wisconsin. Both were acquired from Seifert's daughter, Mrs. Nelson Bennett.

The Jones farm (colorplate) is depicted after an early snowfall, ground and roofs covered with snow while the scrub oaks still retain their tawny foliage. In this painting the gray paper gives a wintry cast to the sky and foreground, while the bright red barn and green firs and orange oaks stand out in vivid contrast. The color scheme is unconventional, a staccato pattern of red, orange, yellow, and green against the soft gray-blue and white of sky and ground.

The Cooper farm scene (colorplate) takes maximum advantage of the tan color of the paper as a unifying tone, a good deal of the foreground remaining unpainted. Yellow-ochre buildings and lemon-yellow fields alternate with the neutral areas of the tan paper, accented by green hills and trees and haystacks in a delicate counterpoint of quiet color. The unidentified *Wisconsin Farm Scene* (colorplate) achieves an opposite effect, robust and rich, through bold contrasts of dark reds and greens with emerald, gold, and white, boldly arranged on the gray cardboard.

One interesting aspect of Seifert's work is the use of metallic paints—gold, silver, copper, and bronze—for details such as the sun, evening clouds, a weathervane, or reflections of sunlight on windows. The painter often used, besides the metallic pigments, a combination of transparent watercolor, oil, and tempera, giving an interesting textural variety to the surface. Such mixed mediums, often found in folk painting, would not have been used by a conventional artist of the period. Other examples of Seifert's unacademic approach are the naïve manner in which he portrayed people and animals in exact profile, and his practice of picturing the sky as ending in an arch, just as children do.

Some late castle scenes and churchyard pictures, judging from the examples I have seen, do not seem as stylized, or to be comparable in quality with the earlier farm scenes. They show a loose, rapid manner that indicates that these paintings were turned out in quantity for popular sale, and the fine design and precise drawing of the earlier paintings are lost. That is also true, to a lesser degree, of the late farm scenes. These are considerably smaller—both in actual size and in creative vision—and the drawing and coloring are heavier.

The series of large farm scenes Paul Seifert painted in the last quarter of the nineteenth century are, in my opinion, as outstanding in the field of primitive watercolors as are Edward Hicks's *Peaceable Kingdoms* in that of oil painting. Each of these highly talented folk artists was able to develop an infinite variety of design within a single compositional theme.

JEAN LIPMAN

This chapter is based on "Paul Seifert" by Jean Lipman in *Primitive Painters in America. 1750–1950*, Jean Lipman and Alice Winchester, eds., 1950; reprint ed., Freeport, N.Y.: Books for Libraries Press, 1971, pp. 149–56.

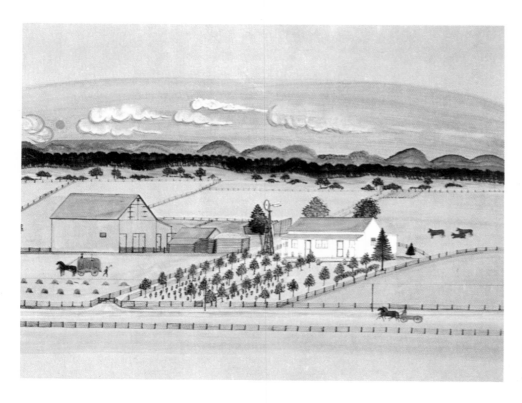

Paul A. Seifert. *Seifert Farm*, c. 1880.
Watercolor, oil, and tempera on cardboard, 20½ x 28 inches.
Collection of Howard and Jean Lipman.

Samuel A. Shute. *Woman with Two Canaries*, c. 1830–32. Watercolor, gouache, pencil, gilt decoupage, bronze paint, and collage on paper, 25 x 20 inches. Collection of Mr. and Mrs. Stephen Score.

Ruth W. and Samuel A. Shute
1803–? 1803–1836

Folk art experts and collectors have known the signatures of R. W. and S. A. Shute and puzzled over them for more than a generation. The first pictures—a pair of oil portraits with the Shute signatures—were found in 1937 by Edith Gregor Halpert, a pioneer in the rediscovery of American folk art. Ten years later another signed painting—this time a watercolor—was acquired by Colonel Edgar William and Bernice Chrysler Garbisch (it now belongs to the Metropolitan Museum of Art). One by one, other portraits in a similar style, or with the mysterious double signature, came to light in museums and private collections.

Efforts to identify the artists and to document their output were frustrated by conflicting characteristics within the potentially attributable pictures and by the scarcity of signed examples. All that was known of the two painters was that they had been active in the 1830s, as evidenced by the eight portraits on which their double signature appeared, dating between February 18, 1832, and March 25, 1833. Four were oils and four were watercolors, and most read: *Painted by R. W. and S. A. Shute.* However, two of the watercolors were signed with a significant variation: *Drawn by R. W. Shute/ and/Painted by S. A. Shute.* (A third portrait with an identical signature was found after the original publication of this research.)

Curiosity about the identities of R. W. and S. A. Shute and the nature of their relationship inspired continuing speculation. Edith Halpert first hypothesized that they were brothers, or possibly father and son. In 1961 the artists were identified as sisters by a hand-written note affixed to the back of a signed watercolor, purportedly the recollection of a descendant of the sitter. This theory was generally accepted until the early seventies, when it was suggested that the Shutes might be a married couple. Yet another possibility was raised in a 1978 article by Bert and Gail Savage, who proposed that "Mrs. R. W. Shute was a woman traveling with her husband (not a painter) and a child, S. A. Shute," who was probably her daughter.

In the forty-odd years since their rediscovery the only concrete evidence about the Shutes appeared in *The New-York Historical Society's Dictionary of Artists in America* (1957), which contains a single reference to: "Shute, Mrs. R. W. Portrait painter active in New Hampshire and Vermont (?), 1834–1836. She was at Concord (N.H.) in 1836." There is no mention of S. A. Shute.

I saw my first Shute, a watercolor, in 1974 in the collection of a friend. Three years later I acquired an anonymous pastel portrait of an unknown boy. Studying it, I was reminded of an anonymous pastel that belongs to the New-York Historical Society. I was surprised to learn that Mary Black, the curator of painting and sculpture there, had ascribed the work to the Shutes, an attribution that others found controversial. Comparing the watercolor and pastels, it struck me that all three could have been done by the same hand. The similarity of the pencil drawing on the faces and hands suggested a relationship, but most compelling was the identical treatment of the eyes. These were a distinctive almond shape with an unusual exaggeration of the inner corners and dark outlines around the irises. The resemblance was intriguing because, with the exception of Mary Black's attribution, no pastels had previously been associated with these artists.

I began to locate more examples in pastel. In each the characteristic pose and arm gestures, as well as details of lace, seemed related to known Shute watercolors, although the pastels were more sophisticated and showed greater skill in the rendering of the hands, suggesting a slightly later date. I expanded my search in an effort to locate, photograph, and compare every picture that might be by the Shutes. The portrait that established the transitional link between the watercolors and the pastels hung in the Abby Aldrich Rockefeller Folk Art Center in Williamsburg: *Man Holding His Lapel* was painted with the familiar monochromatic striped background of three of the signed watercolors, but the figure was drawn with pastels.

Now convinced that the pastels could be safely assigned to the Shutes, I turned to another puzzling problem. There were a few watercolors, Shute-like in feeling, that were, however, regarded by many as the work of yet another artist. My research had uncovered about fifteen of this type, obviously by the same hand, and as early as any known portraits by the Shutes; three are pictured here: *Woman with Two Canaries* (colorplate) and *Dr. and Mrs. Charles Chandler* (illustrations). They had the same large format as the typical Shutes, with figures that filled and often overflowed the paper, and they were executed with the Shutes' characteristic combination of mediums, including pencil, gouache, gold and silver paint, applied metal foil jewelry, and paper collage. But they were strikingly different from the others in their flat, unshaded faces, barely outlined in pencil, and their large glovelike hands. It was difficult to see how these pictures could be by the Shutes, whose signed work was typified by small distinctive hands and faces with heavy pencil shading.

The signatures on paintings dated February 18 and March 9,

1832, seemed to hold the answer. Both read, *Drawn by R. W. Shute/ and/Painted by S. A. Shute*, the only occasions where the contribution of each artist was specified. Realizing that R. W. had been responsible for the drawing in a typical Shute, it occurred to me that the key to the fifteen disparate watercolors was that they were drawn by someone else. Further comparison indicated that this "someone else" was S. A. Shute, working alone. It was now possible to see that in the earliest pictures (none of which is signed), each of the artists had actually been working separately. R. W.'s drawing was readily identified because it appeared in the later work, but S. A.'s drawing remained unrecognized because it never appeared in any of the later signed examples. The Chandler portraits and the unidentified *Woman with Two Canaries* are typical of the watercolors that may be attributed to S. A. Shute alone, and a comparison of these with two of R. W.'s earliest portraits, *Man Holding a Quill* and *Woman in a Blue Dress* (illustrations), reveals the individual differences in style that merged when the artists collaborated.

R. W.'s drawing of faces and hands, as well as her preference for the full-front pose of the figure, are easily recognized in jointly produced works such as the Burnham portraits, *Woman in Black with Brown Ribbon*, or *Girl Holding Blossom and Basket of Roses* (colorplates). However, the hand of S. A. is more difficult to detect. In fact, were it not for the appearance of *Woman with Two Canaries* (sold at auction in 1977 by a Massachusetts schoolteacher who bought it years ago at a church auction for thirty-five cents), the S. A. style might not have been identified with certainty, since this is the only painting in which S. A.'s drawing appears in conjunction with the striped background apparently unique to the Shutes. However, the linear abstraction of the figure also links this S. A. example to the joint work of the Shutes, as can be seen by comparing it with *Girl Holding Blossom and Basket of Roses*. The two paintings show strong similarities in the color and configuration of the dresses, the unusual negative spaces between the sleeves and bodices, and the position of the arms—but in each painting the face, hand, and lace collar are drawn by a different Shute.

While trying to make sense of the apparent contradictions in their style, I began a search for the identities of the two artists. Using census and vital records, I systematically located all the Shutes of New England. Shute women with the initials S. A. were abundant, but R.'s of either sex were extremely rare, and none could be linked to any of the S. A.'s.

A casual glance through *The History of Weare, New Hampshire, 1835–1888* produced the first real clue. Here a Dr. Samuel A. Shute was mentioned three times, although not in a context suggesting a painter. On April 19, 1828, he was included at a meeting of Freemasons who had assembled to organize a new Masonic Lodge. The second citation was no more helpful: "In 1827 the 4th of July was celebrated in East Weare. Dr. Samuel A. Shute delivered the oration. There was a toastmaster, many toasts, and the old meeting house was packed with an immense audience." The third listed him as a physician in Weare in 1827, with a footnote saying that he had "died on his return from Montreal." To believe that a doctor

and a Freemason who delivered a July 4th oration was also the painter S. A. Shute required considerable imagination—even wishful thinking—but given the scarcity of male S. A. Shutes, I filed him away as a possibility.

The only R. W. appeared in the New Hampshire vital records. Ruth W. Shute, who listed her residence as Weare, had married Alpha Tarbell on March 25, 1840. It seemed an extraordinary coincidence that the only pair of people with the right initials were both associated with the small town of Weare. Samuel A. Shute had died, but when? Might Ruth W. Shute be his widow? I located the original Tarbell marriage record in the archives of the Unitarian Church in Concord, New Hampshire, and found that she was indeed *Mrs.* Ruth W. Shute. For her to be Samuel A. Shute's widow, his death would have had to occur before 1840.

Another search through the New Hampshire vital records revealed that Dr. Samuel A. Shute had died in Champlain, New York, in 1836 at the age of thirty-two, and had been buried in Concord. So far, everything fit.

Meanwhile, I continued to puzzle over the meaning of the footnote: "died on his return from Montreal." Shute paintings had been noted only as far west as Vermont. A breakthrough came when I learned of a Shute cemetery in Champlain, New York, a village close by the Canadian border, thirty miles south of Montreal. William and Abigail Shute had settled in Champlain in 1800, at that time a "howling wilderness of wolves." Their gravestones were there alongside those of a large number of their children.

Perhaps this was the reason for Dr. Shute's visit to Champlain. Possibly he was not returning from Montreal, as the Weare historian had surmised, but had gone to stay with relatives who could provide both a temporary residence and a ready source of portrait patrons among their friends. If this were the case, how was I to establish that this Dr. Shute was indeed the painter I was seeking?

Then I found an advertisement in the *Plattsburgh Republican* that located Mrs. Shute nineteen miles south of Champlain:

PORTRATE PAINTING

Mrs. Shute would inform the Ladies and Gentlemen of Plattsburgh that she has taken a room at John M'kee's Hotel, where she will remain for a short time. All who may employ her may rest assured that a correct LIKENESS of the original will be obtained.
Ladies and Gentlemen are requested to call and examine the paintings.
Price from $5.00 to $10.00
Miniatures from $5.00 to $8.00
May 24, 1834.

And in the same issue of the paper was a review of Mrs. Shute's work:

Portrait Painting—We have examined several Portraits, at the Phoenix Hotel, executed by Mrs. Shute. So far as we are capable of judging, Mrs. S. is extremely happy in her designs and coloring, and in transferring the "human face devine" to canvas. Those who wish to "see themselves as others see them" will do well to improve the opportunity offered by the stay of Mrs. S. in our village.

Samuel A. Shute. *Dr. and Mrs. Charles Chandler (Mary Carroll Rickard)*, 1829. Watercolor, pencil, gouache, gilt foil decoupage, and collage on paper, each 23½ x 19¼ inches. Clayville Rural Life Center and Museum of Sangamon State University, Pleasant Plains, Illinois.

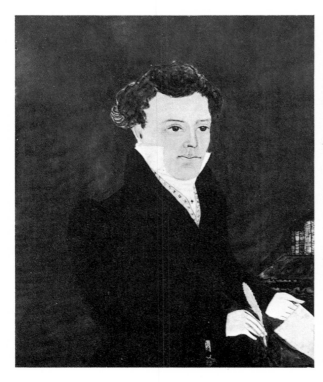
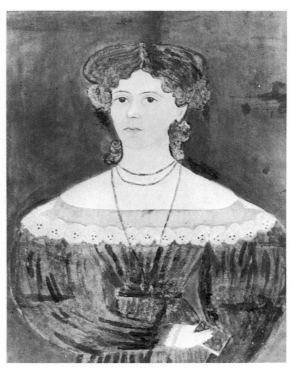

Ruth W. Shute. *Man Holding a Quill*, c. 1827–28. Watercolor, pencil, and silver and gilt foil decoupage on paper, 23 x 18½ inches. Private collection.

Ruth W. Shute. *Woman in a Blue Dress*, c. 1827–28. Watercolor and pencil on paper, 22 x 17⅛ inches. Private collection.

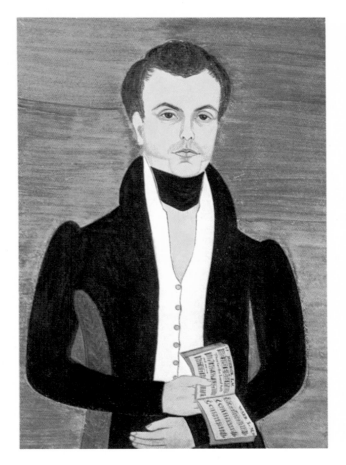

Ruth W. and Samuel A. Shute. *Josiah C. and Abigail S. Burnham*, c. 1832–33.
Watercolor, pencil, gouache, and gilt foil decoupage on paper, 13¾ x 9½ and 13½ x 9¼ inches.
Private collection.

The discovery of twelve oil paintings by Mrs. Shute, all dating from 1834–35, placed her in areas around Plattsburgh, New York, and St. Albans, Vermont (less than thirty-five miles from Champlain), during the eighteen months preceding Dr. Samuel A. Shute's death in 1836, suggesting that he was ill and being cared for in his family home while she was earning their living on painting trips to nearby towns. There no longer seemed any doubt that the Shutes from Weare were also the artists in Champlain.

Undeniable proof came with the discovery of an advertisement in the *New Hampshire Patriot* that brought me full circle back to Samuel A. Shute's death certificate, which had noted his burial in Concord:

PORTRAIT PAINTING
Mrs. Shute would inform the Ladies and Gentlemen of Concord, that she has established herself in the above business, in rooms over Mr. Samuel Evan's store, where she will be happy to attend to all who may favor her with their patronage.
Concord, April 7, 1836.

Mrs. Shute had brought her husband's body back for burial, and she was painting once again.

It is now possible to piece together a rudimentary biography. The Shutes were a young couple, perhaps newly married, when they began to paint. During part of 1827–28, they resided in Weare, New Hampshire, where Dr. Shute briefly practiced medicine and was noted as a Freemason. Mrs. Shute's return to the Concord area—following her husband's death, and four years later when she remarried—suggests that her origins were here, perhaps in nearby Weare, where her family may have provided a home base for the artists from time to time.

The first dated picture places the Shutes thirty miles south of Weare in Lowell, Massachusetts, on November 9, 1828. During the next four years they worked in the greater Boston area at distances as far as Sutton, Massachusetts, and Scituate, Rhode Island, where Dr. Shute painted the Chandlers sometime after their marriage on May 1, 1829.

Unfortunately little has come to light regarding the Shutes' early period, roughly 1827 to 1831, during which husband and wife

worked separately. Of the twenty-five pictures which may be assigned to this period, all are watercolors and include the mixed media associated with these artists. Fifteen are by S. A., ten by R. W. Even in the beginning some involvement by both artists can be detected in almost every portrait. Not only did they borrow ideas, but they frequently seem to have painted on each other's pictures.

The success of their early experimentation eventually led the Shutes to work together. This collaboration marks their second period and dates from sometime in 1831 until mid-1833. Most of the Shutes' finest work is found among the watercolors produced during this brief period (including the only four watercolors on which the double signature has been found). Of the four collaborative portraits reproduced here in color, *Girl Holding Blossom and Basket of Roses* appears to be the earliest, *Woman in Black with Brown Ribbon* the latest. The small somber portraits of Josiah C. and Abigail S. Burnham apparently fall somewhere in between. These are part

of an interesting family group, which includes a much larger portrait believed to be of their young son standing in a garden landscape with his dog, and a mourning picture for their small daughter Sarah Elizabeth. This lyrical landscape depicting Abigail Burnham leaning against an obelisk may be unique in the Shutes' careers as portrait painters.

The earliest known pictures on which the Shutes collaborated are the portraits of the Atkinson family of Lowell, Massachusetts, which can be dated by the December 13, 1831, issue of the *Boston Recorder* held by Mr. Atkinson. Two signed watercolors and many unsigned portraits indicate that the artists were in Lowell several months. A signed watercolor locates them slightly north, in Nashua, New Hampshire, the following October; then in nearby Hooksett they painted a portrait inscribed on the reverse: *Dolly Hackett/ Nov. 27, 1832/ Hooksett, N.H./ Painted by S. A. & R. W. Shute/ A. L. 5832.* The mysterious number at the end of the inscrip-

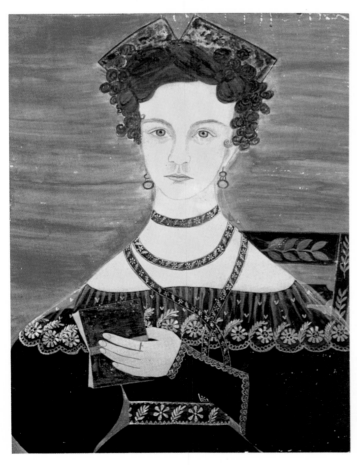

Left
Ruth W. and Samuel A. Shute. *Woman in Black with Brown Ribbon*, c. 1832–33.
Watercolor, pencil, gouache, and gilt foil decoupage on paper, 25⅞ x 19⅞ inches.
Historic Landmarks, Inc., York, Maine.

Right
Ruth W. and Samuel A. Shute. *Girl Holding Blossom and Basket of Roses*, c. 1832.
Watercolor, pencil, and gouache on paper, 24 x 19¼ inches.
The Currier Gallery of Art, Manchester, New Hampshire.

tion proves to be the date repeated in Masonic reckoning, which reaffirms Samuel A. Shute's Masonic affiliation.

By January of 1833 the Shutes were in Peterborough, New Hampshire. At this time a numbering system used only on jointly signed and dated oil portraits appears. So far, only four of these portraits are known—nos. 15, 19, 36, and 37—and by comparing no. 19, dated February 22, with no. 37, dated March 25, it appears that the Shutes completed eighteen oil portraits in thirty-one astonishingly productive days. The thirty-three unlocated oils implied in this numbered sequence, in addition to the one hundred paintings known at the time of this writing, make it clear that the Shutes were far more prolific than previously suspected. The last pictures on which the signature of S. A. Shute has been found are nos. 36 and 37, signed and dated in Milford, New Hampshire.

Within three weeks the Shutes appeared on the opposite side of the state, where they placed this advertisement in the *New Hampshire Argus and Spectator*:

PORTRAIT
PAINTING!
MR. AND MRS. SHUTE
Would inform the Ladies and Gentlemen of Newport, N.H. that they have taken a room at Nettleton's Hotel, where they will remain for a short time.
All who may employ them may rest assured that a correct likeness of the original will be obtained. If not the work may remain on our hands. Prices will be regulated, according to the size of the portrait.
CALL AND EXAMINE THE PAINTINGS
Price from 5 to 10 dollars.
April 15, 1833.

This was found after I had done most of my research and was a particularly exciting discovery: definitive proof that the Shutes were indeed husband and wife.

The community's response to their advertisement kept the Shutes painting in Newport for at least the next eight months. Here important changes took place—S. A. apparently abandoned their joint work in oil, and in September 1833 Mrs. Shute's signature appeared for the first time alone, marking the beginning of a third (and final) working period. Hereafter Mrs. Shute concentrated mainly on oil paintings, and the few works on paper were now pastels, although they included the familiar mixed media of the earlier work. The paintings show a progressively academic orientation, which no doubt pleased Mrs. Shute's increasingly affluent clientele. The hand of S. A. Shute can still be detected in some of the pastels, but by this time the two artists' styles had merged to such a degree that the differences between them can no longer be perceived with certainty. S. A.'s seemingly curtailed activity suggests that a lingering illness may have begun.

Sometime after December 1833, the Shutes left Newport and later appeared in Champlain, where Mrs. Shute painted the portraits of Mr. and Mrs. Elias Dewey, the owners of Dewey's Tavern. Mrs. Shute's advertisement in the *Plattsburgh Republican* and subsequent signed and dated oil paintings document her continued activity in the Champlain area until her return to the Concord area after her husband's death in 1836.

The last known painting by Mrs. Shute is the signed wedding portrait of Sarah Elmira Storrs of Lebanon, New Hampshire, dated 1839. Its discovery makes possible the attribution of several late pastels and oils, proving that Mrs. Shute worked alone for at least three years after her husband's death. In a time when few women had careers of any kind, she was undeterred by society's restrictions and continued to travel and paint. However, the most remarkable facet of her life was the working relationship she had with her husband. Rarely has there been such an uncanny fusion of the creative strengths of two artists. The Shutes were a uniquely cooperative and inspired pair, and together they produced a body of work that was consistently superior to what either was able to accomplish alone.

HELEN KELLOGG

This chapter is based on "Found—Two Lost American Painters" by Helen Kellogg in *Antiques World*, vol. 1, no. 2 (December 1978), pp. 36–47.

As this book goes to press the author has discovered additional facts about the Shutes: Mrs. Shute was born Ruth Whittier on October 28, 1803, in Dover, New Hampshire; she was a cousin of John Greenleaf Whittier. She and Samuel Addison Shute (b. September 24, 1803, in Byfield, Massachusetts) were married in Dover on October 16, 1827. A daughter, born in 1829, was an invalid; their second child died shortly after birth in 1831. After her second marriage, Ruth had two daughters and lived in Kentucky.

Further Reading

SAVAGE, BERT, AND SAVAGE, GAIL. "Mrs. R. W. and S. A. Shute." *Maine Antiques Digest*, August 1978, pp. 1B–3B.

Mary Ann Willson

active 1810–1825

A unique find in the field of American painting was a portfolio of twenty primitive watercolors discovered in 1943 by the Harry Stone Gallery of New York, the only gallery ever devoted entirely to folk painting. The watercolors were executed by one Mary Ann Willson during the first quarter of the nineteenth century. Other than the fact that she worked in Greene County, New York, about 1810–25, little is known of her life and career. Her paintings, with the exception of isolated examples and a contemporary group by Eunice Pinney of Connecticut, are the earliest folk watercolors found to date. They are without exception the most primitive.

A letter written about 1850 by "An Admirer of Art," which accompanied the portfolio of Mary Ann Willson's watercolors, is now in the M. and M. Karolik Collection in the Museum of Fine Arts, Boston. It gives us a firsthand account of the odd menage and partnership of two women pioneers, Miss Willson and a Miss Brundage. An unsigned letter discovered in 1967 (now in the Vedder Library, Bronck House, Coxsackie, New York), and a brief account in Lionel de Lisser's *Picturesque Catskills, Greene County, 1894*, offer exactly the same sparse information as the "Admirer," who most likely authored all three pieces.

The identity of the "Admirer" is not known. Likely candidates are Theodore L. Prevost of Greene County, whom de Lisser credits with Willson's "discovery," or Theodore Cole, son of the painter Thomas Cole and owner of two Willson watercolors published in de Lisser's book.

The letter tells us all we know of the artist's life and might be considered one of the earliest positive criticisms of American folk painting:

The artist, Miss Willson and her friend, Miss Brundage, came from one of the Eastern States and made their home in the Town of Greenville, Greene County, New York. They bought a few acres and built, or formed their house, made of logs, on the land. Where they resided many years.— One was the farmer and cultivated the land by the aid of neighbors, occasionally doing some ploughing for them. This one planted, gathered in, and reaped, while the other made pictures which she sold to the farmers and others as rare and unique "works of art."—Their paints, or colours were of the simplest kind, berries, bricks, and occasional "store paint" made up their wants for these elegant designs.

These two maids left their home in the East with a romantic attachment for each other and which continued until the death of the "farmer maid." The artist was inconsolable, and after a brief time, removed to parts unknown.

The writer of this often visited them, and takes great pleasure in testifying to their great simplicity and originality of character—their unqualified belief that these "picters" were very beautiful, (and original) (they certainly were), boasting how greatly they were in demand. "Why! They go way to Canada and clear to Mobile!" They had not the slightest ideas how ridiculous they were—Their perfect simplicity and honest earnestness made them and their works more interesting:—sui generis without design,—

The writer of this little sketch does not mean to compare these mineral and vegetable compounds of fantastic taste with the more modern artistic works of a Cole, Durand, Huntingdon and others—but simply as the work of a native artist—uneducated of course, but a proof of the unnecessary waste of time under old Masters and Italian travel.

The reader of this will bear in mind that nearly fifty years have passed since these rare exhibits were produced—before "edecation" had taken such rapid strides in the "picter" world—and now, asking no favors for my friends (as friends they were), let all imperfections be buried in their graves and shield these and them from other than kindly criticism—

Nineteenth-century naïve painters were certainly not progenitors of the modern avant-garde, but it was the evident affinities—provocative common interests and attitudes—that largely accounted for the rediscovery and reappraisal of American folk art. Of all the examples that have come to my attention, no folk paintings are so strikingly akin to sophisticated modern art as Willson's artless watercolors.

A much discussed question concerning the style of American folk painting has been that of its abstract and decorative quality. Some critics have insisted that a folk painting was never deliberately decorative, its abstract effect merely an incidental result of the untutored artist's inability to paint realistically. It has always been my belief that this explanation misses a vital point: the folk artist's inability to paint realistically also made way for a compensating *interest in* and *emphasis on* abstract design.

Surely no one will claim that Willson was trying to be realistic and that her futile attempts at realism resulted in an unconsciously abstract style. She undoubtedly realized her technical limitations and, making no attempt at academic realism, felt herself free to develop color and pattern for their own sake. Willson painted George Washington's horse wearing a gaily dotted harness and saddle, and dressed her "marimaid" in something much like a patchwork quilt (colorplates). She boldly followed this decorative style even when her paintings were directly inspired by academic prints, as in the

series based on the parable of the Prodigal Son. Comparing the Willson version of *The Prodigal Son Reclaimed* (colorplate) with its print source (illustration), is like looking at a Picasso version of a Velázquez; the core of aesthetic excitement lies in the revisions of line, color, and design. In this wildly original translation, the row of pointed cedar trees is transformed into a spiked orange design outlined in black. All the formal engraved detail is reduced to flat areas of color or animated with action-painterly brushstrokes.

As a group, Willson's paintings are interesting because of their unusually early date and extremely primitive style, and their surprising kinship with advanced twentieth-century painting. They are the most striking examples that I know of the folk painter's tendency to exploit pure color and design. Her colors, concocted of brick dust, vegetable dyes, and the juices of berries, are different from those commonly used by her contemporaries. They are as primitive as those of the ancient Egyptians, as modern as those of Matisse.

JEAN LIPMAN

This chapter is based on "Miss Willson's Watercolors" by Jean Lipman in *American Collector*, vol. 13, no. 1 (February 1944), pp. 8, 9, 20 (checklist); reprinted in *Primitive Painters in America. 1750–1950*, Jean Lipman and Alice Winchester, eds., 1950; reprint ed., Freeport, N.Y.: Books for Libraries Press, 1971, pp. 50–56.

Further Reading
KARLINS, N. F. "Mary Ann Willson." *Antiques*, vol. 110, no. 5 (November 1976), pp. 1040–45. Includes checklist of known watercolors.

Unknown artist. *The Prodigal Son Returned Home Reclaimed*, c. 1800. Hand-colored engraving and etching, 13¾ x 10¾ inches. Colonial Williamsburg, Virginia.

Mary Ann Willson. *The Prodigal Son Reclaimed*, c. 1815.
Ink and watercolor on paper, 12⁹⁄₁₆ x 10¹⁄₁₆ inches.
National Gallery of Art, Washington, D. C.;
Gift of Edgar William and Bernice Chrysler Garbisch.

The prodigal Son Reclaimed } Father I have Sinned against heaven And in thy Sight
And I am no more worthy to be Called thy Son ——— luke 15 — 21.

(continued)

Mary Ann Willson. *George Washington on a Horse*, c. 1810–25.
Ink and watercolor on paper, 12⁷⁄₈ x 15¹⁵⁄₁₆ inches.
Museum of Art, Rhode Island School of Design,
Providence; Jesse H. Metcalf Fund.

Mary Ann Willson. *Marimaid*, c. 1810–25.
Ink and watercolor on paper, 13 x 15½ inches.
New York State Historical Association, Cooperstown.

20th
Century

Henry Church

1836–1908

Henry Church working on a self-portrait in his studio,
late 1880s. Courtesy of Miriam Church Stem.

The following story relates how I discovered the work of Henry Church some forty years ago:

In 1937 I drove out to see Squaw Rock, a landmark in northern Ohio. I had been told that this high-relief sculpture was commonly believed to have been carved by prehistoric Indians. I contended that the Indians of Ohio had never done any such sculpture and went out with my friend Arthur Feher to investigate the legend.

We soon came to the Squaw Rock Picnic Ground (about twelve miles from Cleveland) where signs told us that we would have to walk. We followed the dark trails leading downward into the deep ravine cut by the Chagrin River and suddenly, through the leafless trees and the early spring mist, we saw the massive fallen cliff called Squaw Rock.

All we could see as we hastened toward it was the life-size figure of an Indian woman surrounded by an enormous snake. But a mo-ment later, standing in front of it, we were able to see the other objects carved on the rock. They were, without any apparent connection to each other, a child in its crib, a mountain lion hanging by its tail, a tomahawk, a skeleton, and a spread eagle which might have been swooping down to rescue the Indian woman from the serpent.

Finally, Arthur spoke: "What do you think?"

"This certainly isn't Indian," I said. "It's the work of some backwoods Rousseau. Whoever made this must have carved other things like it. Let's go look for him. Say, who do you suppose it was?"

Arthur pointed to one of the names carved on the rock. "What about that one?" he said. "*Henry Church 1885.* He might have done it. But maybe he just carved his name on the rock like the others."

We talked to several park workers. None of them knew anything about Squaw Rock, so we set out to get information in Chagrin Falls, the nearest town. We mapped out our strategy on the highway to Chagrin. I was to question the first old resident we could find. We sped into town and cruised until we passed what looked like the oldest inhabitant.

The old man grinned at all my questions and said: "Squaw Rock was carved by a man who lived right here in Chagrin. Anybody here could have told you about him. He was a blacksmith by the name of Henry Church. There's all kinds of stories about him, some true and some false. Some say he carved the squaw by the light of a lantern. On one side he had the Indian girl and the serpent, and on the thirty-foot side, which you can only see from the other side of the river, he began the life story of Abe Lincoln, from Log Cabin to White House. The squaw used to be painted and was a treat to see."

The old man still grinned at us. "That ain't all, though," he said. "Old Hank also carved out his own tombstone and then he preached his own funeral sermon on a gramophone cylinder. He's dead about thirty years now and you'll find him and his tombstone, in the town cemetery, a mile down that road."

The Evergreen Hill Cemetery is a conventional little park, filled with conventional granite stones and landscaped with properly mournful evergreens. But on a small northern slope, we were startled by an archaic, angry lion with green glass eyes. It was Henry Church's tombstone. A closer look revealed a little child and a lamb resting contentedly beside the lion—obviously the Peaceable Kingdom group of the Bible.

Several days later we returned to Chagrin armed with a long list of questions, ready to interview all the residents of the little town, if need be: we were determined to find out all there was to know about Henry Church.

Most of our questions were very ably answered by Mrs. Jessie Sargent, Church's daughter. This keen woman, then in her late seventies, still lived in Chagrin Falls and liked talking about her father. She told us that the real name of Squaw Rock was *The Rape of the Indian Tribes by the White Man*.

"My father planned the rock as part of a sanctuary he was building. He never told us what he had in mind, but it all seemed related to his feeling for the Indians. Further up the river, on a high cliff overlooking the valley, he built a pulpit (the cliff is still called Pulpit Rock), and on certain days he preached sermons from this cliff to the congregated spirits of the thousands of Indians massacred by the settlers. It seems strange to us, but he was a spiritualist and these things had great meaning to him."

She arose. "Would you like to see my father's paintings?"

I looked at Arthur and he looked at me.

"Paintings?" I said. "Did he paint, too?"

"Yes, he painted until the end of his days." Mrs. Sargent led us into the house and we saw *The Monkey Picture*, *Self-Portrait*, and a half dozen others. *The Monkey Picture* and *View of Chagrin* hung in bedrooms and *Self-Portrait* leaned against a basement wall.

"Did he do any other painting?"

"Yes, he painted a great many more. There are a few in the hands of relatives."

"And the rest?" I asked. "Where are they?"

Mrs. Sargent looked at me very calmly. "I burned them," she said. "I burned nearly all of them."

"You burned them?"

"Yes," she said, "I had to. I had them in my house up on the hill and took good care of them for thirty years. Then I lost the house and moved down here. You can see that there is no room for them here. Nobody liked them. Nobody wanted them. I didn't want them to fall into the hands of anybody who wouldn't take care of them. So I did what my father would have done. I destroyed them. All but these few. But I did take good care of them for thirty years."

I had arrived three weeks too late.

From Henry Church's daughter and from many others, we learned a great deal about him. His father, also Henry, had come to Chagrin Falls in 1834 and opened the first blacksmith shop in this new settlement. He and his wife, Clarissa Sanderson Church, had traveled overland by wagon from Deerfield, Massachusetts, to Buffalo, where they loaded their furniture onto the steamboat *Daniel Webster*. The *Daniel Webster* burned wood and tar, and finally began consuming itself. Henry, Sr., is supposed to have put out the fire and saved all lives.

On May 20, 1836, Henry Church, Jr., the painter, was born.

The Churches were ardent abolitionists, and their home was a stop on the Underground Railroad. They also attended circle meetings of local spiritualists whose mysterious rappings and tappings they viewed with a mixture of awe and skepticism. Henry was too frail and sickly to attend school, so his mother taught him, and he was allowed to roam in the surrounding wilderness. His daughter told me that he always regarded these years of separation from other children as decisive.

When Church was thirteen, his father ended this idyllic outdoor life and put him to work in the blacksmith shop as his apprentice. When young Henry took charcoals from his father's forge and drew on the whitewashed walls of the shop, his father whacked him for it. In later years Church always referred to his father as "a practical man and a good provider" and claimed that he inherited his artistic talent from his mother, who drew a little.

Church married Martha Prebble on September 18, 1859. After a brief stay in Parkman, Ohio, they returned to Chagrin Falls, where Church built his home and shop, still standing today. The Churches had two children, Jessie and Henry Austin.

The Civil War drove the town into a patriotic frenzy and out of its population of about 900, 108 men enlisted. But Church, a deeply religious man, bought his way out of the service for four hundred dollars, an arrangement permitted by the government. Many years later he painted a life-size portrait of Abraham Lincoln, with the broken shackles of slavery at his feet, and an equestrian portrait of General Sherman. He presented these portraits to the local chapter of the Grand Army of the Republic, but they immediately put the paintings into their cellar.

A photograph taken in 1870 shows Church in the Silver Coronet Band, which gave benefit concerts at the local "opera house." He played the cornet, the alto horn, and the banjo. He also played a harp and a bass fiddle, both of which he made himself.

His father died in 1878, and Church took to painting, hunting, and sculpture in earnest. He set up a studio and art gallery above his shop, which he eventually rented out to another blacksmith.

It was in this period that Church went to visit Archibald M. Willard, painter of the famous *Spirit of '76*, who had a studio in Cleveland. Willard saw him a few times and sent him off with the address of a paint supply house in New York. This was apparently Henry Church's only contact with another artist.

Church worked secretly on Squaw Rock and quit when only partly through with his conception, because he was discovered. Word traveled through the town, and on the following day the entire population of Chagrin was out in force to see Church's latest. In 1888, he set up a small museum to show his work at Geauga Lake Park, a popular picnic area, and charged ten cents admission (illustration). He had little success in selling his work.

Church's tombstone, finished twenty years before his death, was kept out of the cemetery by the local trustees, who stated that the lion was too ugly for their graveyard. The fight went on for years, and Henry Church finally won when he announced that unless they allowed his memorial into the family plot, he would live forever! This threat overwhelmed the opposition and the lion was installed.

Having won this battle, Henry Church died in his seventy-second year, on April 17, 1908. But his last victory was posthumous.

Henry Church. *Still Life* (detail).

Henry Church. *Still Life*, late 1870s. Oil on paper backed by cloth, 26 x 38 inches.
Collection of Miriam Church Stem.

He left a special list of people who were to attend his funeral. The sermon he delivered on a gramophone cylinder was a scathing denunciation of his enemies, especially the trustees of the cemetery.

When I arrived in Chagrin Falls in 1937, there were only a few fragments left of all Church's work. A vandal had knocked off part of his tombstone, and it looked for a while as though the Chagrin River was going to undermine and destroy Squaw Rock. But his daughter wrote to the park authorities, and after much delay, a new base was built under the rock. The WPA erected a beautiful new sign, telling about the blacksmith artist from Chagrin, and asking Boy Scouts and other young people not to deface the rock or carve initials on it.

In his 1942 book *They Taught Themselves*, Sidney Janis analyzed two of Church's paintings, *Self-Portrait* and *The Monkey Picture* (colorplates):

By its shape [*Self-Portrait*] brings to mind the dying days of the nineteenth century when oval portraits hung in the front parlor. Conventional in

shape, this is no conventional self-portrait, for Church has made some unusual inclusions.

The background of buff-gray-lavender is mistlike, and near the head of the artist the mist rises enough for a group of floating figures to become visible. They are his personal muses, and he has introduced them like a halo about his head. An arrangement of fruits and flowers ties up with them, all being held together by a sharply creased . . . rose-colored ribbon which winds in and about, creating out of them a garland thrown over his shoulders.

The muses are depicted as masculine and feminine, and we notice Painting is connected with the eye, Music with the ear (the harp and cello are faithful recordings of actual instruments which Church, himself, made), and the masculine muses of Sculpture and Smithing with the skull and temple respectively. The muse of Painting has just added the highlight to the eye, the final touch completing the portrait. . . .

In the case of Smithing, we see that Church has given the same importance to this, his trade, as to his fine-art activities. No doubt he felt a strong tie between them and fully realized how his trade had prepared him for sculpture. While he has indicated the mundane nature of the

Henry Church. *The Monkey Picture*, c. 1895–1900. Oil on canvas, 28 x 44 inches.
Collection of Samuel and Angela Rosenberg.

smith's calling—the foot of this muse is seen—he has at the same time exalted it by virtue of the crown placed upon its head. This crown displaces the traditional helmet of Vulcan, which Church in turn has given to Sculpture.

The self-portrait is that of a strong and determined person with pride in his strength. The cap and beard give him the look of a patriarch. For all this imposing aspect of his appearance, his eyes sparkle, and there are suggested smile wrinkles around them, which mark a genial side to his forceful personality. . . .

It does not require great imagination to believe that one of the reasons Church painted *The Monkey Picture* was to ridicule the abundance of staid Victorian fruit still lifes that found their way even to remote sections of the country at the time colored lithography was first in flower.

With great disrespect and no little glee, he has literally turned the tables. The prize fruits assembled here in all their glorious colors, their bloom and lusciousness, are deliberately scattered, trampled upon and tumbled in all directions. Withal, they are tenderly treated as they remain uncrushed in the melee. . . .

We have entered . . . at a crucial moment, the high point of the action. . . . We missed the part where the monkeys escaped from their cage on the lawn, climbed through the window and discovered the table filled with "calendar" fruits. They grabbed for the only banana and the altercation began. The nimbler one got it, but before he was able to devour more than a bite, the fight grew hectic. At the very climax, we enter, and in this split second, the action freezes. . . . It is this moment that the artist has caught, for in the next instant the wreckage would have been complete and the cop out of camera range.

Splashed by a cool dash of lemonade at the height of the excitement, the tiger rug is brought to life, only to suffer a more ignominious fate. For a monkey has anchored himself by firmly coiling his tail about the tiger's throat. . . .

Other humorous twists are the double images, the largest being the profile of the watermelon which is also a face. This fruit is lusciously accented by tear-drop seeds which convey the sensation of dripping juice and whet the palate. Then there are markings on the surface of the canteloupe where the graining resembles ancient script which in part becomes familiar enough to spell out "II. Church, Pixt.—Painter."

The canvas is also signed at the bottom, not as a cryptogram, but plainly so that one may be more directly informed: "H. Church—Painter—Blacksmith."

During the more than forty years since I first saw Henry Church's paintings, I have done some detective work and have found that he seems to have derived his ideas in part from Victorian advertising posters and trade cards of the period 1861–1889. The artist's *Self-Portrait* closely resembles a poster issued by Wolcott's Instant Pain Annihilator in 1865 (illustration). A comparison of the two shows that the heads are surrounded by imaginary beings in the same way, and just as a demon attacks the pain victim's head, so the muse of sculpture aims his chisel at Church's. The fruit knife is placed in the same position and direction as the white collar of the man in the poster. Church has transformed the demons into angels and the sufferer into an image of tranquility.

For *The Monkey Picture*, I believe Church borrowed portions of his imagery from a coconut advertisement showing two monkeys at play, with one pulling the other's tail. As in the Church painting, the monkey on top is holding a banana. The artist improved the design immeasurably and related the mischievous monkeys to a formal Victorian parlor. It was not until the fall of 1978 that I realized how accurately Sidney Janis had read Church's satirical intentions in this painting. While on a magazine assignment to photograph Squaw Rock (it's looking better than ever and has become a

1865 poster advertisement for Wolcott's Instant Pain Annihilator. Courtesy of Sam Rosenberg.

tourist attraction of the Cleveland area), I dropped in on a folk art exhibition at the Cleveland Museum of Art. There I saw Church's *Still Life* (colorplate), lent by his granddaughter, who still lives in Chagrin Falls. Although details of the room and the scene beyond the open door are different, all the elements of the still life are the same as in *The Monkey Picture*. *Still Life* is obviously number I, explaining the roman numeral II on the canteloupe in the companion picture. Side by side, the two present amusing "before" and "after" episodes of this late Victorian farce by the painter-blacksmith of Chagrin Falls, Ohio.

SAM ROSENBERG

This chapter is based on the chapter "Henry Church" by Sam Rosenberg and Sidney Janis in *They Taught Themselves. American Primitive Painters of the 20th Century* by Sidney Janis. New York: Dial, 1942, pp. 99–109.

Further Reading

RHODES, LYNETTE I. *American Folk Art from the Traditional to the Naive* (exhibition catalogue). Cleveland: Cleveland Museum of Art, 1978, pp. 26–27.

CHRISTIAN, BARBARA. "Museum's Folk Art Exhibit Notes Work of Henry Church, Jr." *Chagrin Valley Herald Sun*, January 18, 1979.

Church's Art Museum, Geauga Lake, Ohio, 1888. Courtesy of Miriam Church Stem.

Henry Church. *Self-Portrait*, 1880s.
Oil on canvas, 28½ x 21½ inches.
Collection of Samuel and Angela Rosenberg.

J.O.J. Frost

1852–1928

J. O. J. Frost as a boy.

The Musical Rocks consisted of two piles of assorted stones located on the Frost property which when struck by the expert hammer of their owner, gave forth recognizable tunes. The "art building" was a workshop in the rear of the Frost home at 11 Pond Street.

Mr. Frost began to paint to occupy his mind after the death of his wife in 1919. He was in his late sixties and had had no instruction of any kind. It was not until 1948, twenty years after his death, that an exhibition of some of his pictures at the Institute of Contemporary Art in Boston attracted the first favorable public comment.

A descendant of many old New England families, including the Ornes, Pearces, and Johnsons, Frost grew up as had his family before him in the town of Marblehead. When scarcely sixteen years of age he persuaded his mother to allow him to ship on the fishing vessel *Josephine*, bound for the Grand Banks, at the munificent wage of thirty-five dollars (plus oilskins and boots) for the three-month trip. (See photograph of Frost as a boy, illustration.) Then began the exciting days which young Frost was never to forget and which he re-created so vividly with his paintbrush more than fifty years later. No figment of his imagination were the icebergs, the heavy fogs, the treacherous tides, and the autumn gales—which are still an integral part of the life of a Grand Banks fisherman. On his first trip he passed Sable Island, "the Sailors' Graveyard," halfway to the Banks, and here he began to see for the first time schools of cowfish and blackfish with many whales and porpoises. Frost never forgot what has come to be known as the "great gale of September 6, 1868," but whether his vessels are shown storm-tossed, lying quietly in harbor, or fishing off the Banks, his marine paintings are full of motion, and one senses the sharp tang of the sea.

In 1870 he gave up fishing and married his boyhood sweetheart, Amy Lillibridge, from whose father he learned the restaurant business. Thereafter for much of his life he managed his own restaurant in Marblehead, which became famous for all kinds of seafood. Mrs. Frost specialized in the raising of garden flowers on land that they had reclaimed at the rear of their home, and she arose sometimes as early as four o'clock in the summer to work amidst her famous sweet peas, and beautiful larkspur which grew six feet tall. Even after her death a bouquet of sweet peas would often rest on the piece of burlap covering the colorful landscapes that Frost hopefully carried in a wheelbarrow from door to door. On occasion he exhibited them in a local shop, but sales were meager.

John Orne Johnson Frost was born on January 2, 1852. At the time he painted his first picture in the early 1920s, American folk art as such was still unappreciated by the general public. The citizens of Marblehead, Massachusetts, were not interested in contemporary "primitive" painting, so his efforts did not meet with much enthusiasm when he distributed flyers bearing the following announcement:

Mr. J. O. J. Frost, 11 Pond Street, Marblehead, has opened his new art building containing about 80 paintings, depicting his life on the Grand Banks and in the town of Marblehead. There will be a charge of 25 cents to see these paintings and the famous Musical Rocks.

The proceeds from admissions on Wednesday, August 13, will be devoted to the Marblehead Female Humane Society to assist in its efforts to secure funds for the Home for the Aged.

J. O. J. Frost. *Marblehead Harbor*, c. 1925. Oil on wallboard, 48 x 74 inches.
Marblehead Historical Society, Marblehead, Massachusetts.

However, familiar scenes such as the views of Marblehead and the
harbor, with their descriptive captions, were easily recognized and
thoroughly understood by the children of the town to whom the
artist particularly wished to appeal (see colorplate).

Of paramount concern to Frost was the historical background of
his native town, and he kept scrapbooks of information and clip-
pings about the development of Marblehead. Many of the details of
his pictures he remembered from his youth, when wildlife abound-
ed and fishing was the main industry of the town. He peopled the
streets with his neighbors, showed their homes in minute detail,
and often filled his scenes with long titles because his primary aim
was historical rather than artistic.

He hoped to preserve for the future a pictorial history of Mar-
blehead, and his chronological sequence began with the early days
of semi-wilderness. He inscribed two of his paintings, *when man*

lived in Paradice and did not know it and *the waters were filled with fish
and game*. He re-created the scene when the white men bought the
town from the Indians for eighty dollars in 1684, visualizing the
conference as taking place indoors, by a small open fireplace com-
plete with andirons and crane.

The Revolution made its mark upon the town, and Frost painted
the ranks of blue-coated men marching proudly past the old Town
House headed for Cambridge on June 21, 1775, led by the indomi-
table General John Glover. Frost had heard accounts of the war
from his mother, who had seen Lafayette in 1825 during his second
visit to this country. Also to the honor of General Glover is the
large oil painting, *Washington Crossing the Delaware, Boats Manned
by Marblehead Fishermen* (colorplate). This scene—signed *J. O. J.
Frost, No. 11 Pond St.*—reminds us that it was the hardy sons of
Marblehead in the same "amphibious regiment" who also ferried

J. O. J. Frost. *There Shall Be No More War*, c. 1925. Oil on wallboard, 31½ x 72 inches.
Collection of Bertram K. and Nina Fletcher Little.

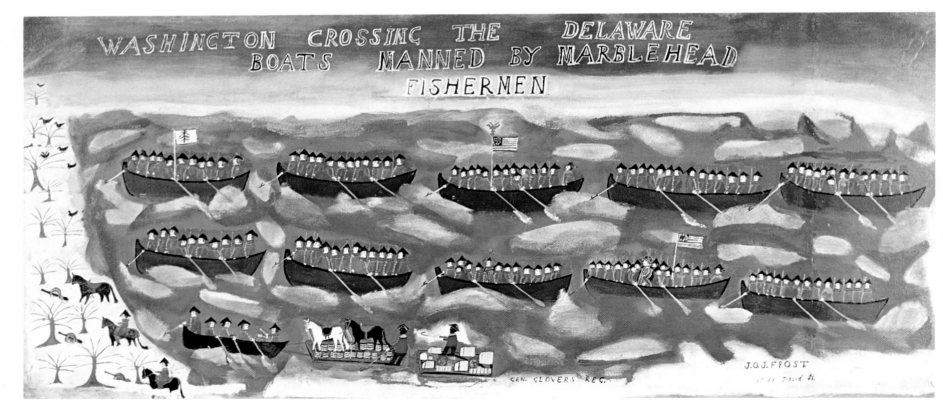

J. O. J. Frost. *Washington Crossing the Delaware, Boats Manned by Marblehead Fishermen*, c. 1925. Oil on wallboard, 32 x 72 inches.
Collection of Bertram K. and Nina Fletcher Little.

Washington's troops across the East River after the battle of Long Island. Lieutenant Joshua Orne was one of the men who crossed the Delaware. He became so numb with cold on the nine-mile march to Trenton after the crossing that he fell and lay nearly covered with snow until accidentally discovered by someone in the rear of the regiment. Frost's younger brother was named for this local hero.

The Civil War had been a long-expected event, and Frost remembered it from his boyhood. His own father, who was over draft age, marched away as a volunteer, leaving behind his wife and five small children. Amos Frost died during an outbreak of fever at the encampment in Hingham, Massachusetts, and then his young family came to know real want. Frost commemorated Marblehead's response to the call for troops by one of his finest scenes, which shows the route from Marblehead to Boston on April 16, 1861 (colorplate). He captioned this picture: *At ½ 7 o'clock. These men left town for Boston. There had been a call for 75,000 men from President Lincoln.* [The local contingent were] *the first to reach Faneuil Hall in the state.* In the sky appears the hopeful prophecy, *There shall be no more War* and at lower left is the signature *J. O. J. Frost.*

The largest group of pictures, however, deals with the sea, and many of them echo the experiences of Frost's boyhood. The schooner *Josephine*, in which he made his first voyage in 1868, formed the subject of one of his first pictures. He also painted the harbor during various periods in its history with its many vessels and schools of fish, and in the foreground the piers and fish flakes (colorplate). Whales and dolphins leap and spout amidst blue waters and sunny skies, surrounded by the off-shore fishing fleet. Other scenes show the old-time vessels in gales, drifting fog, and dark moonlight, while small sketches illustrate examples of the many kinds of fish familiar to the local trade. One of the notable attributes of these pictures is their individuality, despite the frequent repetition of certain motifs, such as the harbor and street scenes. The use of house paints in strong unshaded colors and the detailed compositions (which although crowded are well defined and therefore unconfused) combine to give the panoramas their distinctive vigor and charm.

Frost combined with his other occupations a love of carpentry, and although not an accomplished workman, he executed a number of wood carvings which, like his paintings, achieve interest by their originality. Models and half-models of ships attest to his proficiency in this medium, and small scenes painted on the sides of his own fish carvings are both attractive and unusual. A large painted codfish, measuring almost six feet in length, he cut from a single board fourteen inches wide and over an inch in thickness (illustration). To improve its contour, several small pieces of wood were cut out and applied. This carving was hung from the rafters of his workshop as a decoration, and was found in a shed by later owners of his Pond Street home.

J. O. J. Frost died on November 3, 1928, but it was not until March 1952 that 11 Pond Street passed out of the ownership of the Frost family. During subsequent renovations by the new owners, portions of wallboard were removed in the attic and cellarway, revealing a number of his finest town- and seascapes on the reverse. The scenes had been turned inward when the boarding was reused for later repairs, either by Frost or his son. This discovery led to an exhibition at the Childs Gallery in Boston during May of 1954.

Frost's granddaughter, who lived with her grandparents as a child, said of the family: "They never had much money but they never talked about it, and they never seemed poor. They were quiet people and their chief interest was in befriending their neighbors in a kindly way; by taking Thanksgiving dinners to those less fortunate than themselves, and by assisting others to sell the flowers which they donated from their own garden. My grandfather never considered his work to be of artistic merit, but he wanted it to give pleasure, and above all to keep alive for the younger generation the history of his native town."

An increasing number of those interested in twentieth-century painting have come to know and appreciate the sincerity as well as the decorative quality of Frost's work. And it would surely gratify him to realize that many others are drawn to his pictures by their common affection for the old town of Marblehead.

NINA FLETCHER LITTLE

This chapter is based on "J. O. J. Frost, Painter-Historian of Marblehead" by Nina Fletcher Little in *Art in America*, vol. 43, no. 3 (October 1955), pp. 28–33.

Further Reading

SULLIVAN, JOHN J. "The Discovery of Old John Frost." *The Boston Post Magazine*, June 27, 1954.

"Paintings and Folk Art by J. O. J. Frost of Marblehead from the Collection of the Late Betty and Albert L. Carpenter" (auction catalogue). New York: Parke-Bernet, April 1971.

KATZ, MARTHA B. "J. O. J. Frost: Marblehead Artist." Master's thesis, New York State Historical Association, April 19, 1971.

J. O. J. Frost. *Codfish*, 1920s. Painted wood, 71 inches long. Collection of Bertram K. and Nina Fletcher Little.

Steve Harley

1863–1947

Steve Harley.

Steve Harley grew up on a Michigan farm during a period when uncontrolled lumbering was destroying the wilderness he loved. When he inherited his family farm, he tried to make it successful, but failed. A devotion to nature led him to study taxidermy, and he took a correspondence course in drawing and drafting to equip himself to record the views of nature he admired.

In the early 1920s Harley left Michigan and went to the state of Washington to visit his brother, and during the next few years he traveled from California to Alaska. The Pacific Northwest captured his spirit, and he photographed the forests and lakes in order to enjoy them always. Disappointed in these photographs, he decided to paint pictures of this untouched frontier. Each of his paintings took months to complete in his effort to reproduce every detail under the magnifying glass that aided him in his work. He tried to duplicate exactly the things he loved.

In the early 1930s, penniless, ill, and no longer able to hold a brush, he returned to Scottsville, Michigan, and lived in a shack, subsisting on relief payments from the Michigan Bureau of Old Age Assistance. In November 1947, Steve Harley died.

The three paintings reproduced here (colorplates), all in the Abby Aldrich Rockefeller Folk Art Center, are his only known works. On the back of the canvas of *Wallowa Lake* Steve Harley made a notation: *Painted by S. W. Harley (the Invincible).*

In the only published commentary on Harley's work, which appeared in *Flair* in 1950, Robert Lowry summed up Steve Harley as a painter: "He was not working toward art; he never thought of himself as an artist. He wanted an exact duplication of the things that thrilled his senses. Aiming at undistorted truth, at a fanatically faithful realism, he achieved super realism."

Although Steve Harley died in 1947—well within living memory—the details of his life have yet to be researched and documented. The above biographical sketch was taken from the files at the Abby Aldrich Rockefeller Folk Art Center in Williamsburg, Virginia. It is hoped that it will provide a point of departure for further inquiry into the life of this talented American folk artist.

THE EDITORS

Further Reading

LOWRY, ROBERT. "Steve Harley and the Lost Frontier." *Flair*, June 1950, pp. 12–17.

Steve Harley. *Wallowa Lake*, 1927–28. Oil on canvas, 24 11/16 x 36 1/4 inches.
Abby Aldrich Rockefeller Folk Art Center, Williamsburg, Virginia.

(continued)

Steve Harley. *Upper Reaches of Wind River*, 1927.
Oil on canvas, 20¼ x 33⅜ inches.
Abby Aldrich Rockefeller Folk Art Center, Williamsburg, Virginia.

Steve Harley. *South End of Hood River*, 1927.
Oil on canvas, 20 x 33½ inches.
Abby Aldrich Rockefeller Folk Art Center, Williamsburg, Virginia.

Morris Hirshfield

1872–1946

In 1939, while assembling paintings for the exhibition *Contemporary Unknown American Painters* at the Museum of Modern Art, I met a picture dealer on the street. He told me he had paintings by a Negro artist whose work he believed would fit into this exhibition. This proved to be the work of Horace Pippin, who had previously been shown in the Modern's *Masters of Popular Painting* exhibition and was therefore no longer unknown.

About to leave the dealer's gallery, I peeked at a picture whose face was to the wall. What a shock I received! In the center of this rather square canvas, two round eyes, luminously gleaming in the darkness, were returning my stare! They belonged to a strangely compelling creature which, sitting possessively upon a remarkable couch, immediately took possession of me. This was my introduction to the work of Morris Hirshfield.

The picture was *Angora Cat*. I asked if there were any other paintings by this man, and the dealer, Hudson Walker, turned from the wall two more that stood nearby, remarking that the artist had left them for a few days. He asked what I thought of them. My reply was to borrow two of the three paintings at once for the exhibition, and a moment later I left with the canvases.

At the opening of the *Unknowns* exhibition a short elderly man with reddish-blond hair quietly approached me and said he was Hirshfield. He was happy that his pictures were shown in "such a grand place," and he began at once to tell of his long struggle to achieve the two canvases hung there before us. He had painted only three pictures, and these were his first two.

As will be seen in the psychological development of his work, described in the analyses of his paintings which follow, Hirshfield's difficulties arose from tensions in his home environment; as he informed me at this time, he received little encouragement to paint. He had a wife and three grown children: an unmarried daughter to whom he was especially attached, a son, and a married daughter with two children.

For my 1942 book, *They Taught Themselves*, Hirshfield set down what he considered the essential facts of his life in an essay titled "My Life Biography":

Born in 1872 in a small town of about 1000 inhabitants in Russia-Poland near German border. Mother was German born; father a native of Russia-Poland.

It seems that even in my young days I exhibited artistic tendencies—not in painting—but in wood-carving, for at the tender age of 12 I aroused our little town by producing for myself a unique noise-maker to be used in the Jewish *Purim* festivals at the synagogue.... The furor it created was so great that the Rabbi of that congregation was compelled to go to my father pleading that he hide my work-of-art in order that prayers could be rendered.

Seeing my work so well received and admired, I took courage to go on to even greater efforts. At the age of fourteen I undertook the sculpturing in wood of a piece of work almost six feet high for our local synagogue. It formed the prayer stand in front of the scroll on which the Cantor's prayer-books rested. It consisted of two huge lions holding between them the ten commandments. Below the animals were two prayer books lying flat, and on top of the holy volumes were two birds, one holding in his beak a pear, the other a leaf. Everything was carved in full life-like figures and embossed with a good many more ornamental designs which I do not remember in detail and the whole gilded with gold and other colors of paint....

Unless destroyed by the ravages of recent warfare, it still holds its place of honor in the synagogue for I have been told by kinsfolk recently arrived from my home town that when they left it was still standing....

At the age of eighteen I left Europe and came to America where I found a position as worker in a woman's coat factory. After being in the line several years I became engaged and thus stimulated, went into business with my brother in the manufacturing of women's coats and suits, the firm being known as Hirshfield Brothers. During this period I married.

I stayed in this line for twelve years. While we were making a very nice line of merchandise we could not call it a financial success, so we sold the business and shortly thereafter entered a new field—the manufacturing of boudoir slippers, where I made a huge success, employing over three hundred people. The E. Z. Walk Mfg. Co., as I called it, soon became the biggest manufacturing plant of its kind in N.Y.C.

During all these years, although busy manufacturing, I never quite stifled my strong urge to produce artistically, to paint or carve—although I never quite actually managed to settle down to work on anything. I did turn out several inventions, however, patented in Washington.

After being at the head of the E. Z. Walk Mgf. Co. for fifteen years and enjoying an enviable rating and a well-known name and doing a business of about a million a year, I was suddenly stricken ill and during my long absence the place was so badly managed that on my return I found it impossible to go on. I retired then from active business....

With hands idle for the first time in his life, Morris Hirshfield turned to painting in 1937, at the age of sixty-five. It was two years later that I first saw his work. In 1943 I organized Hirshfield's first one-man exhibition for the Museum of Modern Art, which had, two years earlier, purchased two of his paintings. Recognition from this vanguard museum made Hirshfield a controversial fig-

ure. Like that other great autodidact, Henri Rousseau, he bore the brunt of severe criticism and even ridicule. Rousseau's poetic lyricism was just as misunderstood in his day as was the more challenging archaic imagery of Hirshfield in the 1940s.

Painting was Hirshfield's only recreation. He worked from nine in the morning to seven or eight in the evening, using the bedroom of his Brooklyn home as a studio. He did not paint at an easel but leaned his canvases against the mirror of his dresser. When a new painting was finished and framed, he took it to John I. H. Baur, then curator of painting at the Brooklyn Museum, to be photographed. Baur had given Hirshfield his first encouragement and directed him to the gallery where I discovered his work. In his lifetime, Hirshfield produced seventy-seven paintings, and the Brooklyn Museum has a complete photographic record, with the exception of the first three.

On my last visit with the artist the day before he died, he seemed in reasonably good health. More than anything else he was interested in discussing a canvas he was about to start. The subject was to be Adam and Eve. The following morning, on July 26, 1946, he died suddenly of a heart attack.

Hirshfield's occupational background played an important role in his paintings. We find it in his textures, which remind one of various fabrics, and in his sense of design, which comes from pattern making. He also did large drawings which are really patterns, and sometimes he even cut out a form to serve as a pattern. The continuous line which flows through all of Hirshfield's work is an extension of the rhythmic sensation which accompanies the motor action of cutting around the contours of patterns.

For his first painting Hirshfield removed a picture from his own walls and painstakingly obliterated the earlier composition, saving only the face. He titled the painting *Beach Girl* (colorplate) but spoke of her as his "dream girl." No photos seem to exist of the old painting, so that changes he made cannot be discussed.

When I first saw the painting, I mistook the wavy blue and white area across the top of the picture for cresting sea. But one day, Hirshfield asked me if I thought there were too many clouds in the sky. The two darker forms surrounding the figure, which at first seemed to be formations along the beach, were in fact the sea washing up on either side of the narrow corridor where the girl stands. I was put off further by the rounded edge where the sea met the sky: no evidence here of a flat horizon; Hirshfield's water did not seek its own level, for a straight horizon line would have disrupted the undulations which appear everywhere. Pictorially, then, the poetic takes precedence over mundane laws of physics.

Beach Girl is, in essence, total experience with womanhood: the extremities of a small child, the legs of an adolescent, the face of a young woman, and the torso of a mature one. As we see more of Hirshfield's paintings, we find that eroticism plays a persistent role. Here, what appears to be an innocent girl standing on a beach becomes on an unconscious level something quite opposite. Ambiguous forms enclose the figure on all sides. The soft undulating folds and the striated surfaces around her resemble innards. Within, the figure floats, fetuslike, and the sky in this context suggests uterine waters. Compounding this paradox, the girl androgynously assumes a phallic posture. Needless to say, none of these ideas or images occurred to Hirshfield. Even the Surrealists, who were acutely aware of the power of the unconscious, often found themselves amused by the willful appearance of unsought images in their work.

Textures augment the effectiveness of the composition. They are conceived with a high degree of invention and arouse strong visual and tactile responses. Hirshfield, the former manufacturer of women's apparel, imparted to the fabrics of the girl's garb a special intimacy that came with the understanding of their substance. The folds in her shorts are as supple as silk. The striated texture in her white blouse brings to mind terrycloth. The landscape takes on the character of various textiles; tweed effects in the waves and the patterns in the sand and sky have associations with novelty materials used in women's wear.

The heaviest incrustation of paint surrounds the girl's legs, which by contrast are rendered doubly smooth. Her face, which is also very smoothly painted, is encased in a horseshoe wreath of thick brown braids. The idea of an artist introducing a face from another painting is related to Cubist and Surrealist composite collage pictures. Hirshfield, of course, was unaware of these sophisticated ideas; he was simply painting his dream girl. Here was the face that launched his artistic career.

Nude at the Window (colorplate) was Hirshfield's first attempt at portraying a frontal nude. Like a dazzling apparition, she faces the observer in the buff, a creature with blond hair emerging out of mysterious black depths in a seeming state of somnambulism. Around her, the darkened room assumes the form of a huge vase within which the figure levitates above exquisitely designed golden slippers, themselves suspended. The whole is like a reincarnation in a funerary urn. Although vase and female forms have long been poetically paired, only unwittingly does Hirshfield equate one with the other.

The brilliant red drapes striped with black and yellow are parted, one held aside by hand, the other magically responding even before being touched. Compulsively repeated scallops along the edges of the curtain are momentarily displaced by one foot and are actually interrupted to make room for the hand to grasp. The scallops repeat the breast motif: a semicircle with dot for the nipple. Curvilinear rhythms emanating from the nude are echoed in the surrounding drapes, which seem to cast a magnetic aura about the figure.

The sharp outline of the luminous nude invites the viewer to traverse its every contour, and like a visual caress the observer follows this linear journey as his eye participates in the picture's explicit eroticism. While contemplating these curves, an interesting deviation is disclosed; the artist has painted the hips from different points of view: one faces the observer frontally, while the other is in profile. Unaware of Cubism and its circulating viewpoint, Hirshfield instinctively hit upon one of its most persuasive tenets. Surely he would have corrected this if it had been pointed out to him as an error in conventional draftsmanship. Happily, it wasn't.

Morris Hirshfield. *Beach Girl*, 1937. Oil on canvas, 36¼ x 22¼ inches. The Museum of Modern Art, New York; The Sidney and Harriet Janis Collection.

Morris Hirshfield. *Nude at the Window*, 1941.
Oil on canvas, 54 x 30 inches.
Sidney Janis Collection, New York.

Morris Hirshfield. *Inseparable Friends*, 1941.
Oil on canvas, 60⅛ x 40⅛ inches.
The Museum of Modern Art, New York;
The Sidney and Harriet Janis Collection.

192

At this time the full face offered Hirshfield a puzzling problem: how to portray its most projecting feature. To overcome this, he built up pigment so that the nose stood in low relief, a procedure which to many seemed a prehensile invitation, for after exhibitions, as a result of constant touching, it carried telltale smudges.

Inseparable Friends (colorplate), Hirshfield's largest canvas, presented quite a problem to the artist since the dresser that ordinarily served as his easel was unable to support a work of this size. Instead, he painted it flat on his bed. The idea of two nudes at his bedside, plus the already built-in resistance of his wife to his painting at all (even though he used no models), caused a mini-crisis at home. But Hirshfield persevered; obstacles seemed to aid rather than hinder his efforts.

Hirshfield named this painting *Inseparable Friends*, clearly intending that the title convey the close relationship between the two girls, but no such friendship seems to exist here. The shorter girl has caught the wrist of the other in a gesture of eagerness, but her overture is received indifferently. Turned away, the taller girl concentrates instead upon the mirror image, and despite the artist's intention, it is she and her alter ego that are the inseparables.

But how does Hirshfield handle this reflection? Defying the laws of optics, the reflection is not reversed as normally it would be; instead, it merely duplicates the original, an innocent error that is explained by the artist's unique way of working. Hirshfield made a pattern of the upper half of the central figure; flipping the pattern, he traced this image on the mirror, producing a repeated back-view. The girl facing the mirror, her back to the observer, is confronted illogically by the reflection of a second back. At the same time, the upraised arm at the right has swung to a position where its reflection implausibly finds itself at the far left.

Here, as elsewhere, Hirshfield's religious background is reflected in his work. The mirror frame is blue and white, the colors of Zion's flag. Its shape is that of the shrine in the temple where the Torah rests. The mirror is also shaped like one of the tablets of Moses. The Star of David appears as a stylized motif five times along the arch and five times at the bottom, suggesting the Ten Commandments inscribed on the tablets. On each side are seven candleholders indicating, perhaps, the seven-stemmed candelabra which usually flank the shrine. The scallops across the base of the mirror bring to mind the protective shields that deflect the light of the pink-orange candles of Hanukkah, the effect resembling protected footlights in the theater. This footlight illusion is increased by the light thrown up from below, bathing the mirror image in a blush-pink glow. While a reflected object is commonly painted in tones less vivid than its subject, here the opposite is true.

Further, in the temple, a valance is usually draped across velvet curtains. A valance is also introduced here, although its folds, defying gravity, rise above the three figures, at the same time setting each within a protective niche. Its parallel stripes resemble those of the prayer shawls worn over the shoulders of male worshippers in the synagogue. The gold tassel suspended from the valance is like that attached to the sides of temple curtains and suggests here an unintentional pun in Yiddish: hair falling over the breast of the young girl hides a nipple, and the tassel compensates for it. These male/female symbols—the words for each are so unalike in English—sound alike in Yiddish: *tzitzis*.

The gratifying experiences of Hirshfield's cloak-and-suit background are also present in this picture. The figure and her image are visual references to the dress form of the fashion silhouette of 1910, one of Hirshfield's most active years. In the trade, it is customary for tailors to give a name to the dress form for each size: Sylvia, Minnie, Louise. Here, his model may be Minnie, size thirty-six.

The introduction of slippers may be a reminder of his later business activities; they also function here symbolically—light blue at the feet of innocence and red beneath the more sophisticated girl with the adult hairstyle. But the slippers are all for the same foot, not illogical if we know that, to save space and discourage gift-making, traveling salesmen's samples are not paired. The feet, too, are fashioned the same way, but not for the same reason. Intuitively tied to cultures of the past, Hirshfield showed his nudes standing on the outer edges of their feet, the toes in vertical tiers, very much as they appear in Hittite reliefs of 2000 B.C. This elemental way of seeing is common to many archaic cultures, as is the reduced scale of arms and hands, a typical Hirshfield characteristic. Hirshfield was entirely unaware of these elements or of their influence upon his work. He instinctively selected them from his cultural memory-bank in a process that Jung defined as the workings of the collective unconscious.

In the work of most primitive painters, and of Rousseau and Hirshfield in particular, painted forms remain inviolate; to these artists, overlapping is intolerable. This is very much in evidence in *Zebra Family* (colorplate). Against the sky, each tree and bush occupies its own space, each remains unequivocally distinct and wholly observable as each turns to face the viewer. The same obtains in the foreground; the downward curve of the road at no point allows nature to overlap. As the road widens, the bushes defer to it to a point where, at the lower right, they are all but stunted. Suppressed at the roadside, the foreground flora, by virtue of scale and reduced leafy structure, appear more distant than similar plants in the background, a reversal not uncommon in primitive painting.

The zebras' black-and-white markings and the shaded swirls of the gray road create complex rhythms which contrast with the variations set up by the surrounding landscape. The way in which Hirshfield fits the zebra colt into the space beneath its mother without overlapping is remindful of the benign relationship established in a *Peaceable Kingdom* by Hicks. On this biblical theme, Hicks brings together the wild and the tame, emphasizing their relationship by nesting his animals, each given its own space, without encroachment upon others. Hicks's treatment of background, however, is realistic; Hirshfield artlessly avoids illusionism and naïvely gives maximum identity to figure as well as ground.

Before starting a new work, Hirshfield usually asked me for photographs of the subject he had in mind; these were not to be copied

Morris Hirshfield. *Zebra Family*, 1942.
Oil on canvas, 33½ x 49 inches.
Sidney Janis Gallery, New York.

but merely used as points of departure. In the end, Hirshfield's zebras were quite distinct from the zebra photos I had sent.

Girl with Her Dog (colorplate) exhibits the infinite care with which Hirshfield worked. When it was finished, he wearily pointed to the many-spangled background. "I painted more than one thousand stars," he said. He did not mention the starlike blossoms on the spray of flowers nor did he comment on the starry-eyed girl. Dots like distant suns appear among the stars, setting up rhythmic vibrations which are repeated at the scalloped neckline, the hatband, the girl's belt, and the dog's collar. Contrasting rhythms are set into motion by the stripes of the girl's dress, the flowers in her hand, and the trim of fur around the oddly spotted dog. These rhythms, in turn, add to the dazzle of the constantly changing background constellations. All these visual counterpoints activate what would otherwise be a static pose. Although the girl's arms are amply occupied, they are inordinately foreshortened, barely reaching her waist, another instance of the unconscious archaism which often appears in Hirshfield's art, a disturbing challenge to some, to others a visually refreshing deviation.

Unlike most of Hirshfield's other paintings, equal status is given to each figure. The placement of the dog in front of the girl violates the separate-figure approach seen, for example, in *Zebra Family*. It seems that Hirshfield fashioned his dog so as to fit the width of the composition; to have separated the two figures and retained scale would have resulted in an ungainly format. The anterior position the girl occupies does not in the least diminish her dazzling figure.

The Artist and His Model (colorplate) seems to portray Hirshfield's concept of a working artist, probably French. This immaculately dressed figure wears a blue robe, natty tan shoes, tan pin-striped trousers, and blending tie. Not only is he left-handed, he is dextrous as well, balancing as he does three oversized paintbrushes with his left hand while in the other he holds for all to see his palette of colors.

The nude-pink model, however, captures the viewer's first attention if for no other reason than her sheer scale. Her towering presence and poetic stance give the appearance of an erotic apparition to be beheld by both artist and observer. Immense scale indicates her important role within the picture, a primitive concept of form in which size, regardless of pictorial logic or perspective, is the final measure of importance.

The model stands on what at first glance appears to be an elevated platform but is actually an elaborately designed carpet. Her well-coiffed blond hair falls to her shoulders as she gazes at the viewer. In one hand she holds a precisely draped towel; the other grasps an ornamented golden staff, an unintentional and poetic suggestion of that ancient symbol of womanhood, the distaff.

Although the nude was one of Hirshfield's recurrent subjects, he never used a model. "How could I?" he asked. "If I paint a tiger, can I have a tiger pose for me? And I couldn't very well bring a

nude woman in and paint her. It wouldn't look right." In this and other respects, the reddish-blond and portly Hirshfield is not to be identified with the diminutive artist he introduced in this canvas. However, the painting on the wall above, frame and all, is unmistakably a Hirshfield opus; its appearance in this professional artist's studio obliquely tells us something of the aesthetic judgment of the artist in the painting (and of Hirshfield's own ambitions).

As can be seen from these analyses, occupational, religious, and psychological components are intrinsic to the highly individual substance of Hirshfield's art. His very being was worked significantly into his painting. With many artists, the personal factor is generalized and diffused so that only an abstraction of it is present in their work, but with Hirshfield it was absolutely direct. It is here,

where he did not intend to, that he painted with realism, not the realism of actual appearance but that of the inner life of the artist.

SIDNEY JANIS

This chapter is based on "Morris Hirshfield" in *They Taught Themselves. American Primitive Painters of the 20th Century* by Sidney Janis. New York: Dial, 1942, pp. 14–39.

Further Reading

JANIS, SIDNEY. "The Paintings of Morris Hirshfield," *Bulletin of the Museum of Modern Art*, vol. 10, no. 5–6. (May-June 1943), pp. 12–14.

———. "Morris Hirshfield Dies," *View*, ser. 7, no. 9 (October 1946), p. 14.

SAROYAN, WILLIAM. *Morris Hirshfield*. Introduction by Sidney Janis; critical notes by Oto Bihalji-Merin. Parma: Franco Maria Ricci, 1975 (Italian ed.), 1976 (English ed.).

Morris Hirshfield. *The Artist and His Model*, 1945.
Oil on canvas, 34 x 44 inches. Sidney Janis Gallery, New York.

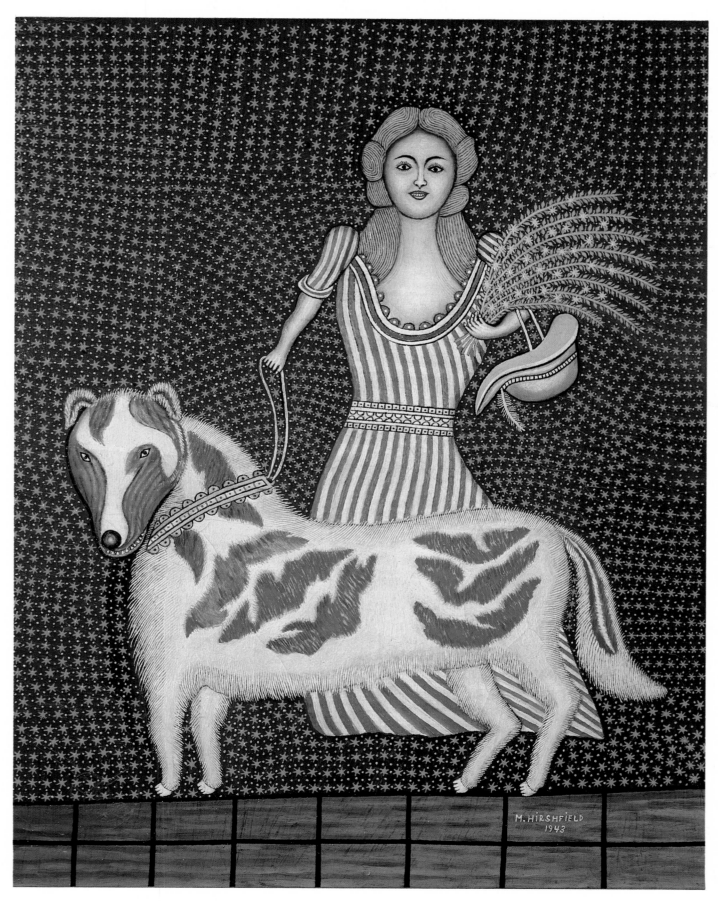

Morris Hirshfield. *Girl with Her Dog*, 1943.
Oil on canvas, 45½ x 35½ inches. Bragaline Collection.

John Kane

1860–1934

John Kane with *Scot's Day at Kennywood*, now in the collection of Norman Kahn.

"Few careers in the long history of art have been more singular than that of John Kane. Everything in it seems to have come from the other side of probability. Search Vasari's *Lives of the Artists* from beginning to end, and you will find in them no more magnificent paradox than this: that an immigrant day-laborer, who had no time to paint, no money to paint, no earthly provocation or encouragement to paint, should emerge, at the age of sixty-seven, as the most significant painter America has produced during the past quarter-century."

So began Frank Crowninshield's foreword to *Sky Hooks* (1938), the autobiography of John Kane as recorded by the late Marie McSwigan during the last years of the painter's life. Told with candor, humor, and much warmth, it is the story of a man of little education who developed a profound wisdom and perception in life and in art. Of his life he wrote, "It is in the main a simple story but like my paintings it contains many details."

Born of Irish parentage in West Calder, Scotland, on August 19, 1860, he was baptized John Cain. Years later a bank clerk in Akron, Ohio, wrote his name as John Kane, and thereafter he adopted this spelling. Kane begins his life's story with his first recollection, that of being punished at school for distracting the class by drawing. When he was ten years old, his father died, leaving a widow and seven children. Kane quit school to work in the coal mines while he was in "the third reader." His mother remarried, and in 1879 he joined his stepfather and older brother, who had preceded the family to America and were working in Braddock, Pennsylvania.

His first job was gandy-dancing, tamping down rocks between the ties of the Baltimore and Ohio Railroad at McKeesport. He then tried his fortune in the coke region of western Pennsylvania, returning to Braddock when he learned that his mother and the remainder of his family would be arriving in the United States. Here he helped dig foundations for an addition to the Edgar Thomson Steel Works and for the Westinghouse plant in East Pittsburgh. He subsequently worked seven days a week at the Bessemer blast furnaces.

Shuttling from job to job in the ever-insecure labor market, sometimes destitute, always poor, John Kane was one of millions of unskilled and semiskilled laborers who literally built the industrial might of the United States. He took great pride in his work, in his physical strength, and in his adopted country. "As a boy in Scotland I had always thought that 'a man's a man,' as our poet Burns tells. If he was good at his work he was a good man."

Between 1884 and 1886 Kane mined coal in Alabama, Tennessee, and Kentucky. His body, tempered by strenuous labor, was spare and muscular. He stood six feet tall and weighed under 180 pounds. He loved to box. In a Tennessee saloon he fought the great Jim Corbett in a draw match of four rounds.

Wanting to be close to his family, Kane returned to Braddock in 1887 and once again mined coal. In 1890 he started to work as a street paver in Pittsburgh and McKeesport. In later years Kane would point in his paintings to streets that "I paved." About this time he began to sketch things that interested him—mills, industrial plants, highways, and surrounding landscapes.

In 1891, while walking along the railroad tracks of the Baltimore and Ohio, Kane was struck by an engine running without lights and lost his left leg. He was thirty-one years old. Not given to self-pity, he learned to wear an artificial leg, and only in his last years were people aware of his disability. Following his release from the hospital, Kane became a watchman for the Baltimore and Ohio at thirty-five dollars a month. There he remained for eight years.

In 1897 Kane married Maggie Halloran at St. Mary's at the Point

John Kane. *Self-Portrait*, 1929. Oil on canvas over composition board, 36⅛ x 27⅛ inches. The Museum of Modern Art, New York; Abby Aldrich Rockefeller Fund.

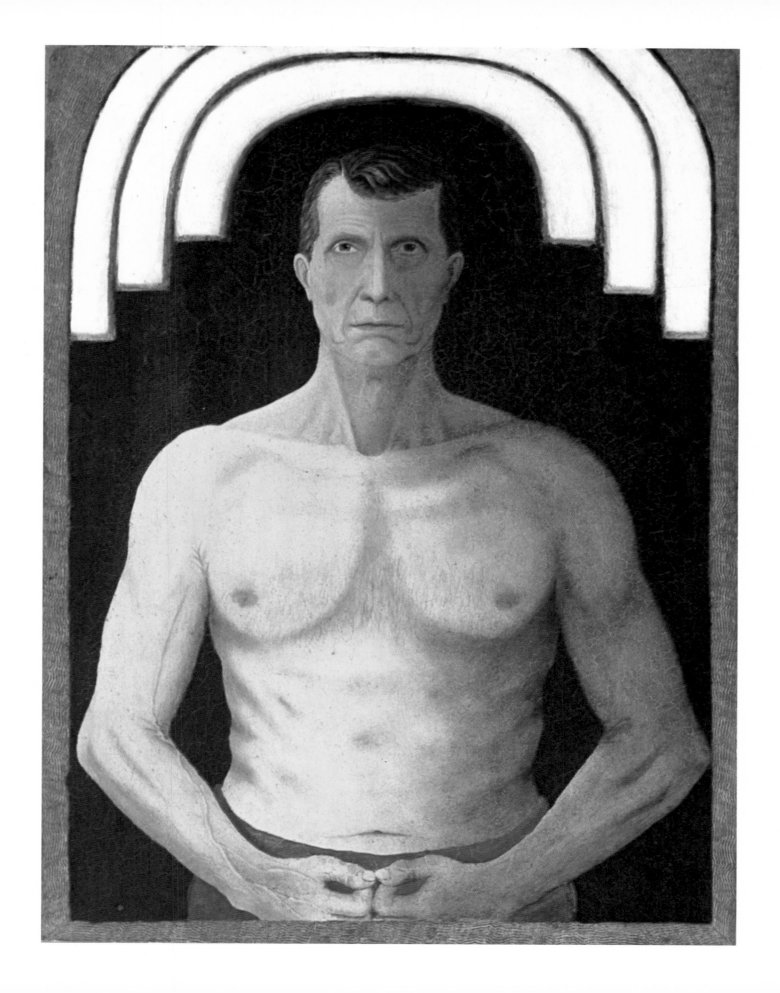

199

in Pittsburgh. "I was still making only thirty-five dollars a month, but she didn't mind that. Not Maggie Halloran. She was willing to be poor with me." After their first child, Mary, was born, Kane found a job painting steel railroad cars. During lunch hours he drew on the side of a car and filled in the colors. Lunch over, the picture disappeared beneath the monotonous, standard railroad car paint. "I had just learned the use of color in my art work." When that job ran out, he turned to enlarging and coloring photographs. Thus he was able to support his growing family, which by this time included a second daughter, Margaret, born in 1901. The birth of his son, John, in 1904, fulfilled his heart's desire, but the child lived only one day. John Kane could face poverty, loss of limb, and the erratic, strenuous life of an itinerant laborer, but the death of a son he had prayed for was the greatest blow of his life. He took to drinking heavily, and his wife, in despair, left him. Except for brief intervals during the following twenty-five years, they were to lead separate lives. He would rejoin his family for several months, then disappear for years.

The depression of 1907 was the bitterest time of Kane's life. For seven weeks he slept on the floor of the Salvation Army building in Pittsburgh. The janitor found Kane a job painting houses in suburban Pittsburgh. Next he worked as a house painter in Charleston, West Virginia, where he tried to enter an art school but could not afford the tuition since he was earning only two dollars a day. He had attempted to enroll at the Carnegie Institute of Technology when its art school was first opened, but the cost of materials and tuition were too high. His search for work took him to Ohio. Just before World War I, an instructor in the Cleveland School of Art made arrangements for him to attend night classes, but by this time Kane was working such long and irregular hours that he had to turn down the offer.

In Youngstown, Ohio, Kane became a carpenter's apprentice to augment his earnings during the winter months, when house painting jobs ceased:

I preferred to paint. But if there was no painting to be done I could fall back on my full-fledged carpenter's card to show. I was never sorry I learned this work. Like outdoor painting, it helped me with my art. It has been said that I am able to apply a technical knowledge to my industrial scenes, my paintings of steel mills, furnaces, pipe factories and of buildings of all sorts. Another man might paint a plant that could never stand up. But not I. I know how that building is erected for I have worked on every part of it, from digging the foundations to the entire structure.

Kane's "pictorial" paintings date from his stay in Akron in 1910. Beaverboard odds and ends that were discarded by the construction crew became an economical surface for the paintings he worked on at night and on Sundays. None of the oils of this period has been recorded.

Following his work in Akron, Kane returned to Pittsburgh, then went to Dauphin County in central Pennsylvania. He was struck by the great beauty of that area, especially the Susquehanna River near Harrisburg, and years later painted some of the scenes from memory. While working as a carpenter at the Cambria Steel Works in Johnstown, Kane did a painting titled *Lincoln's Gettysburg Address*, reproducing the text "word for word and letter for letter against an American Flag as a background."

"Lincoln's words," Kane said in *Sky Hooks*, "I have always considered, contained thoughts among the most beautiful ever expressed in speech or writing.... Abraham Lincoln has always been a hero to me.... I have always thought he was pretty much like myself, strong of body, willing to work and without the advantages that have helped other men. Now Abraham Lincoln has a message for the artist as well as for everyone else. Nothing is denied to well-directed labor. Nothing is obtained without it."

With the United States' entry into World War I, Kane, now fifty-seven, journeyed to Camp Sherman to enlist. "Too old, Dad," was the answer, but he worked at the camp as a carpenter. From there he was sent to Harrisburg to construct a storehouse and, upon its completion, returned to Pittsburgh to make shells for the Westinghouse Company. After the Armistice, Kane did odd jobs and in 1922 obtained work with a construction gang engaged in building the Beechwood Boulevard Bridge. Next he worked in the Homewood streetcar barns as a carpenter until he found what he called "the best job I ever had," painting and decorating to his own taste offices at the Sheet and Tin Plate Works of the National Tube Company. Two years later this plant closed, and he returned to house painting until 1930, when he was seventy, giving this up "only because it was so scarce."

Kane had submitted paintings to the 1925 and 1926 Carnegie International exhibitions, but his works were rejected. However, in 1927 the jury accepted *Scene in the Scottish Highlands*. The sudden emergence of the sixty-seven-year-old laborer as an artist worthy of admission to an International (there were four hundred entries and most of the major painters of the decade were represented) was heralded in the press. He was visited by dealers, newspaper writers, and photographers.

Kane had been painting a house in Ingram when the letter advising him of his acceptance arrived. "For myself, the Carnegie Institute Exhibition was a little matter. I was content. I was proud and glad to have this recognition at last. But ... I have lived too long the life of the poor to attach undue importance to the honors of the art world or to any honors that come from man and not from God."

Shortly after the exhibition opened, Mrs. Kane, who had completely lost contact with her husband for ten years and was living with her younger daughter in Virginia, saw his picture in a New York newspaper. Neither had known whether the other was still alive. She returned to Pittsburgh, and they lived together during the remaining years of his life.

For the next seven years—until his death in 1934—Kane was included in all Carnegie Internationals and exhibited regularly in Pittsburgh and New York. His works were eagerly sought for museum exhibitions and collected by John Dewey, Mrs. John D. Rockefeller, Jr., and G. David Thompson, among others.

The Kanes moved to Ophelia Street in the Oakland section of

John Kane. *The Homestead*, c. 1929.
Oil on canvas, 24 x 27 inches.
The Museum of Modern Art, New York;
Gift of Abby Aldrich Rockefeller.

Below
John Kane. *Larimer Avenue Bridge*, 1932.
Oil on canvas, 32 x 42 inches.
Museum of Art, Carnegie Institute, Pittsburgh.

Pittsburgh in 1931. Both had had streetcar accidents, and, for the first time, Kane felt old and tired. He devoted himself exclusively to painting on the sun porch of the apartment, "John's glory hole," as Mrs. Kane called it. He was a slow painter, working on a picture for months before he felt it was completed. Sometimes he even added to a painting while it was on exhibition.

John Kane died on August 10, 1934. He had tuberculosis, a condition no one seemed to be aware of until his last days. He was buried in Calvary Cemetery in a plot of single graves adjacent to the area reserved for the St. Vincent de Paul Society for the Poor.

One hundred and fifty-six oils by John Kane have been recorded, a procedure complicated by repetition of subjects with only slight variations. Only occasionally did he date his canvases, and never before 1928. He was indifferent to titling paintings, and a single work may have had two or three names. Few drawings have been found, and although he refers to working in pastels, no pictures in this medium have come to light.

Kane found a great need to re-create the world exactly as he saw it. Sam Rosenberg related to me the incident of Kane's leaving his easel site in Calvary Cemetery and trudging down the hillside to a small house in the valley below in order to identify the flowers planted in a window box. Kane has been often criticized for his attention to minutiae in his works—the countless delineated cobblestones in a street, the pains taken with a pictorially unimportant detail of a building—as though that in itself signified a naïve and crude painter. Yet this is the way he saw his surroundings. His many trades had made him aware of the fabrication of things. Once observed, details became an important element in his personal imagery.

No artist equaled John Kane in portraying the industrial scene. Steel mills are organic, monumental structures; railroad tracks have a purposeful yet graceful sweep through his paintings; and houses cluster together as though they had sprung forth from seeds planted in close, orderly rows. Smoke pours from the stacks of factories and river boats, providing a dynamic contrast to the serene green hills. The reflections of bridges in the rivers, as in *The Homestead* (colorplate), provide a contrapuntal pattern.

Kane gives us yet another example of his remarkable innate sense of design in *Larimer Avenue Bridge* (colorplate). It is almost two different paintings; above is a neatly compacted urban scene, its detailing reminiscent of a Vermeer view of Delft; below is a typical Pittsburgh valley road painted broadly, in contrast to the tightly woven upper section. Then there is the bridge itself—of no special interest other than as a unifying element for both halves of the painting, but sturdy enough to support an entire city! The almost surrealist, absolute silence of the streets is offset by the reality of the automobiles and cinder block garages.

Self-Portrait (colorplate) is unquestionably one of the most moving works of its genre. Kane was sixty-nine years old when he painted himself, stripped to the waist, before a mirror. His was an aging but proudly strong body, keenly observed. One senses the layers of muscles and tendons beneath the skin. The veins in his hands and arms are pronounced, and the erect head strains the muscles of his throat. His lips are compressed, the hair carefully combed. The arched ornamental bars at the top of the painting center our attention on his eyes, which belie the realism of the torso and return us to the sensitive artist before the mirror. The formal frontal arrangement of the arms and hands counterbalances the architectural bars above, producing a bold iconlike composition.

John Kane, an unskilled immigrant laborer, gloried in the new industrial scene. He found "beauty everywhere"—in smoke pouring from factory and locomotive stacks, in busy streets and clustered houses. A Whitmanesque evocation of America—its people of varied nationalities and races, ever building, and its countryside, combining nature with the man-made—is the spirit of his art.

LEON ANTHONY ARKUS

This chapter is based on "John Kane. 1860–1934" in *Three Self-Taught Pennsylvania Artists: Hicks, Kane, Pippin* (exhibition catalogue) by Leon Anthony Arkus. Pittsburgh: Museum of Art, Carnegie Institute, 1966, n.p.

Further Reading

KANE, JOHN. *Sky Hooks. The Autobiography of John Kane*, as told to Marie McSwigan; foreword by Frank Crowninshield. Philadelphia: Lippincott, 1938.

JANIS, SIDNEY. "John Kane" in *They Taught Themselves. American Primitive Painters of the 20th Century*. New York: Dial, 1942, pp. 76–98.

ARKUS, LEON ANTHONY, ed. *John Kane, Painter*. Pittsburgh: University of Pittsburgh, 1971. Includes reprint of *Sky Hooks* and an introduction and catalogue raisonné by Arkus.

Olof Krans

1838–1916

Olof Krans. Courtesy of Bishop Hill State Memorial, Bishop Hill, Illinois.

In 1880, a notice appeared in a Swedish newspaper published in west-central Illinois: *OLOF KRANS, vara god skylt-, portratt-, landscaps malare* (Olof Krans, highly-skilled portrait and landscape painter). When Krans placed the ad, the majority of his *portratt* and *landscaps* work lay in the future, but there was no doubt that he was a *vara god skylt* painter. He made his living at a serviceable repertory of decorative and commercial jobs. Most of the time he painted—houses, barns, signs, coffins, flagpoles, fire plugs, duck decoys, even outhouses. He also wallpapered, glazed mirrors, gilded, made stage curtains and scenery, and restored old paintings. In the nineteenth century, this kind of versatility was expected of journeymen painters in rural America. But there was an unexpected streak of art and ambition in Olof Krans, something that made his fellow townsmen choose "Wizard Krans" for their most important jobs. When the Old Colony Bakery and Brewery was converted into a community center in 1894, Krans was commissioned to paint the stage curtain. When the congregations of Bishop Hill, Galva, Orion, Altona, and other towns wanted orna-

mentation for their churches, Krans obliged with false marble and wood grain for some, a star-studded ceiling for another, and an *efterbilda* (reproduction) of Rubens's *Descent from the Cross* for the Swedish Evangelical Lutheran Church of Galva.

Krans was an enthusiastic amateur of other arts. He wrote poetry, gave after-dinner speeches, played the bass horn in the Swede Cornet Band, and had quite a reputation for making snow sculptures.

Olof Krans believed that the community where he grew up, the Bishop Hill Colony in western Illinois, was a momentous historic phenomenon and that it was his duty and privilege to paint a record of its immigration, its eccentricities, and its achievements. This he did, in some of the most striking narrative paintings in American folk art. As a body of work, they are unique. Among scores of utopian communities founded in the nineteenth century, only Bishop Hill has a significant pictorial record of its members.

Like most other utopian colonies, Bishop Hill was created for both economic and religious reasons. It was founded by Swedish dissenters who called themselves Devotionalists for their insistent and literal use of Scripture. Their prophet was Erik Jansson, who had tried for many years to reform what he considered blasphemous practices in the Established Church of Sweden. The Janssonists finally decided that reform was impossible and that their only hope was to found a New Jerusalem in America.

Jansson chose his company well. They were young and strong, more literate and skilled than the Swedish norm, and well supplied with tools and cash. Above all, their faith was strong enough to survive whatever hardships God appointed for them. The journey itself was the first test. They had chosen a stretch of prairie in the black-soil country in western Illinois, forty-five miles east of the Mississippi. After five months on the Atlantic and another month going through the Erie Canal and the Great Lakes, most walked the last one hundred and fifty miles from Chicago. Four hundred arrived at Bishop Hill in September of 1846. They dug caves into the sides of hills, used wood planks to line the caves and extend them beyond the hills, creating "houses" of 18 by 30 feet, whose roofs and walls were covered with turf. Each "house" held twenty-five to thirty damp, cold, and underfed people. Yet during that first winter, which only two hundred and fifty survived, one settler wrote back to Sweden: "... for the land we have taken is large and wide, and is such as none of us realized was to be found in the world, for it is flowing with milk and honey."

The Janssonists accomplished wonders. In the first year they planted more than two thousand acres, built a large house, a flour mill, brickyard, tannery, and shingle factory. In the next fifteen years, they planted over fourteen thousand acres and built an entire town, including a hospital, church, hotel, dairy, dozens of workshops, and, to house the colonists, "Big Brick," the biggest building west of Chicago. They accomplished so much because everyone worked hard, contributing whatever special skills he might have, plus his share of the communal farm work. During the planting and harvesting seasons, everyone worked eighteen hours a day.

The colonists' success—though interpreted as God's affirmation of their beliefs—was very much a result of their ingenuity. *Women Planting Corn* (colorplate) is an excellent example of the way they organized their labor for maximum efficiency. We see a line of women dressed in the colony uniform, each stationed behind a colored knot tied on the string held by the men. First, the men planted their poles. Then the women dug holes with sticks, took a few kernels of corn from their pockets, and planted them. When they had covered the holes with earth, the men moved their poles forward the length of the measuring prong, and the women began digging again. Krans's composition, painted many years after the fact, implies that this line of colonists is but a many-limbed planting machine and that even this earnest communal effort was but a transient phenomenon on the vast face of the earth. All the women are painted with the same face and same dress; their heads are not permitted to interrupt the line of hills, and not one personal gesture disturbs their holy unison.

Olof Krans was born Olof Olsson in 1838, the first son of Erik and Beata Olsson, who lived in the village of Salja, province of Westmanland, in eastern Sweden. The Olssons faced problems common to all peasants in northern Europe—inadequate land, oppressive government, and bitter religious factionalism. Like half a million other nineteenth-century Swedes, they decided to sail for America. At the nearby port of Gavle, they arranged to join a party of eighty who booked passage on an iron ore ship, bound for America and the Janssonist colony of Bishop Hill. As a symbol of their new life Erik Olsson changed their surname to Krans, a name he had used when he served in the Swedish army. When they arrived at Bishop Hill, their children were sent to the colony school, where they were taught the English language and Janssonist principles of religion and conduct. Children were expected to take a share of the daily work, so Olof served as an ox boy. All colonists, young and old, were encouraged to develop useful specialties, so when the twelve-year-old boy showed dexterity and an interest in making things, he was sent to the blacksmith shop and then to the paint shop. There he found his calling.

The years of Olof's adolescence were ominous ones for the colony. In 1850 Erik Jansson was murdered. Although it continued to prosper financially, the colony was plagued with dissension and disaffection. The men who dominated the ruling council, disciplinarians and ascetics all, enacted a series of repressive measures which meant more work and less freedom for everyone. A few years after Jansson's death, they wanted to separate children from their parents. Then they tried to impose celibacy. Perhaps the colony could have survived, but its internal stress happened to coincide with the financial panic of 1857, and no solution could be found. In 1860 the colony was legally dissolved and its property divided.

Most of the colonists who received parcels of land stayed to farm them, but their sons looked elsewhere. The Civil War was just beginning. Olof Krans and twenty-eight other young men from Bishop Hill enlisted in the Illinois Volunteer Infantry. After a year, Krans was mustered out for a leg injury and found himself back in Bishop Hill, clerking in a store. Then he was hired by a photographer to operate a portable photographic gallery. It was a critically formative experience. Years later he painted dozens of portraits from photographs instead of live models.

Krans first encountered a professional artist when he moved to Galesburg in 1865. He was working there as a house painter and decorator, satisfied with his profession but dissatisfied with the limited opportunities in Galesburg. In 1868 he moved to Galva, a small town close to Bishop Hill, where he practiced as an artisan and artist until he retired to nearby Altona in 1894.

He was not only a good workman, he was a good fellow, a man who could be counted on to compose a rhyme for the druggist's sign or a speech for the Fire Department dinner. In 1894, when he was asked to paint *View of Bishop Hill in 1855* as a stage curtain for the new community center, he turned a corner in his career. It was his first opportunity to show himself to the public as an artist and a historian. The curtain, recently restored and put on exhibition in Bishop Hill's Old Colony Church, is an ambitious panorama of the colony at its zenith. Krans remembered it well, but also consulted his friends, his sister, and possibly photographs, doing his conscientious best to be accurate. The directors, highly satisfied, paid him sixty-five dollars and gave him a testimonial dinner and "a beautiful, gold-headed cane, suitably engraved."

Although the curtain was not Krans's first painting, it presaged his change from full-time artisan to artist. Shortly thereafter, he began to paint a series of pictures to commemorate the fiftieth anniversary of the Bishop Hill Colony. First he painted a picture of the dugout houses in which the colonists spent their first winter, and then did five pictures of colonists at work, including *Women Planting Corn*. When the anniversary ceremony was held in 1896, Krans gave the six landscapes plus five portraits to the colony collection of relics and documents. According to the *Galva Standard*, they were "one of the main attractions" of the celebration.

After the anniversary Krans made other forays into the history and lore of the colony, including a popular picture of Nils Helbom, who dressed in a bearskin to frighten a raiding Indian. Undoubtedly the most spectacular work is his painting *The Great Fire of 1872*, enlivened by his own melodramatic recollections.

Although the history pictures were Krans's most important work, they were outnumbered by his *efterbilda*, pictures copied or adapted from illustrations and photographs. Most of his portraits were painted from photographs rather than live models. His *Self-Portrait* of 1908 (colorplate) is a polished presentation of himself as an artist (palette and brushes), as a patriot (Civil War emblems on

Olof Krans. *Women Planting Corn*, 1894–96. Oil on canvas, 25 x 40⅛ inches.
Bishop Hill Memorial, Bishop Hill, Illinois.

Olof Krans. *Self-Portrait*, 1908.
Oil on canvas, 30½ x 24½ inches.
Bishop Hill Heritage Association, Bishop Hill, Illinois.

Olof Krans. *Portrait of Beata Krans*, c. 1900.
Oil on canvas, 29¼ x 23⅛ inches.
Chicago Historical Society.

his lapel), and as a gentleman, barbered and groomed to marmoreal perfection. It is the portrait of a self-satisfied man, with a glint of humor in his eye.

The portrait of Beata Krans in a rocking chair (colorplate) is less imperial but equally splendid. It was based on a photograph taken by an amateur just before the subject's eighty-eighth birthday (illustration). Olof had painted two portraits of his mother before, first as he remembered her at the age of fifty, next from a photograph at the age of eighty-five. (The photograph from which the second version was painted survives, showing a toothless dame with less hair and more humor than her son's painting admits.)

This final portrait of his mother, given to her on her birthday, has an affectionate and valedictory spirit. The border above, the patterns below, the very wrinkles on her face and hands have a brisk and resilient look, quite contradicting the fragility of her years. Her obituary in the *Galva News* (April 1906) confirms the cumulative impression of all three portraits: "Mrs. Krans was a remarkably preserved old lady. She was of a genial and sunny disposition and greatly endeared herself to all who knew her."

Sixty-nine of the portraits Krans copied from photographs now hang in the Old Colony Church, startling the visitor with their flinty scowls and stares. The photographer is often to blame for the bleak effect in such cases. Whose face, after all, would not petrify, having to sit still for the long exposure time required by nineteenth-century cameras? But the painter must be considered here, too. Krans could not be a Salon glamorizer even when he tried. And he never wanted to forget that he was painting a race of obdurate survivors.

Two years before he died in 1916, Olof Krans gave the historical pictures he had in his studio to the Bishop Hill Old Settlers Association. Most were put in the Old Colony Church, some in storage, but many in the side rooms of the building, where they slowly deteriorated. Few visitors came to Bishop Hill in the early twentieth century and Illinois officials chose to ignore the paintings. Now, thanks to the interest of the Swedish government and a more enlightened state policy, both the paintings and the colony buildings are being systematically researched and restored.

Olof Krans's paintings have finally assumed their invaluable double role, as outstanding examples of American folk art and as dramatic historical documents. The bearded artist in the *Self-Portrait*, who holds his palette like a badge, would be satisfied.

ESTHER SPARKS

Further Reading

MORTON, STRATFORD E. "Bishop Hill, an Experiment in Communal Living." *Antiques*, vol. 43, no. 1 (January 1942), pp. 74–77.

JACOBSON, MARGARET E. "Olof Krans" in *Primitive Painters in America. 1750–1950*, Jean Lipman and Alice Winchester, eds., 1950; reprint ed., Freeport, N.Y.: Books for Libraries Press, 1971, pp. 97–105.

ISAKSSON, OLOV. *Bishop Hill, Illinois, A Utopia on the Prairie* (exhibition catalogue). Stockholm: Museum of National Antiquities, 1969.

SPARKS, ESTHER. "Olof Krans, Prairie Painter." *Historic Preservation*, vol. 24, no. 4 (October-December 1972), pp. 8–9.

SWANK, GEORGE. *Painter Krans: O K of Bishop Hill Colony*. Galva, Ill.: Galvaland Press, 1976.

Krans painted the portrait of his mother, Beata Krans, from this 1899 photograph. Courtesy of Mrs. Lora N. Swanson.

Joseph Pickett

1848–1918

Joseph Pickett did not begin to paint until late in life, and although he reportedly produced many pictures, only four are known to have survived. It was not until some years after his death that Pickett's work was "discovered" and included in the pioneering American folk art exhibitions that Holger Cahill organized for the Newark Museum and the Museum of Modern Art in New York in the early 1930s.

The information in this essay was gleaned from many of the older inhabitants of New Hope, Pennsylvania, who knew Pickett well. It is interesting to note that the men remembered him as one who could do anything with tools, a "handy man." The women recalled his picturesque side, his adventurous spirit, his nonconformist ways and habits of dress—and they remembered his paintings.

A man of roving temperament, Pickett for a great many years followed the carnivals. However, his travels took him no great distance, and he returned to New Hope each winter, telling stories about his adventures. At carnivals and fairs he had concessions, sometimes cane racks or knife boards, but most often shooting galleries. He had a flair for this kind of life, was an expansive, gregarious individual, and loved to talk. He was well liked, and he prospered, especially with a rifle range he ran at Neshaminy Falls, a picnic grounds near New Hope to which wealthy Philadelphians drove their carriages for Sunday outings.

By all reports, Pickett was a handsome man. In later years his wide mustache and great shock of hair were completely white, except when he suddenly appeared with them dyed black; then they would gradually whiten again. Although he had never been to the South, his family originally came from there, and he had the grand manner of the Southern gentleman. "Any photo of a Kentucky colonel would do to describe him," said a neighbor—it will have to, for diligent efforts have failed to turn up any photographs of the artist.

Joseph Pickett was born in New Hope in 1848, the youngest of four sons and one of eight children. His father, Edward Pickett, had come to New Hope in 1840 to repair the locks on one of the canals. He remained to build canal boats, and his sons worked with him. Joseph learned carpentry from his father, but he was to spend only a limited time at it. Although he had this early training and did a great deal of manual work all his life, Pickett could not be considered a master craftsman. Still, he was an ingenious man. He built two houses, one on Dark Hollow Hill when he married in the mid-1890s, the other an addition to his general store on Bridge Street. A homemade barber chair, which nobody remembers being shaved in, was found in the back of Pickett's store after his death. This chair was crude but inventively made, with the back and arms hinged to the forelegs so that the back could be pushed forward to give the person sitting in it a lift when getting up. He also made a chest of drawers which a neighbor, May A. Turner, described as "a heavy carpenterlike piece, but elaborately overlaid with jackknife carvings, lozenges, serrated lines, and other crude forms of ornamentation." From her description, the chest sounds very much like the variety of folk art known as "tramp art." At the time, Pickett's efforts at cabinet work were not appreciated, and Mrs. Turner noted, "There seemed something rather pathetic about his striving for beauty of design—and missing it, after so much labor."

At Neshaminy Falls, Pickett met his future wife, Emily. They were both about forty-five years old when they married, which probably accounts for their childlessness. Emily Pickett was a plump, kindly woman who said of her husband's art work: "If Joe wants to paint and does not get paint on the carpet, it's all right with me."

After marriage Pickett settled down, much to the surprise of his neighbors, and opened a modest grocery and general store at 15–17 West Mechanic Street in New Hope, where he remained more than a dozen years, selling everything from live bait to ammunition shells which he himself filled. He also rented out his gun for hunting. On the facade of the building he placed a sign with his name on it—just "Pickett"—and below it, near a window, he painted a landscape with a huge maple tree that looked like the trees in his canvases. This was not Pickett's first attempt at painting, for Mrs. Turner, who was a retired equestrienne formerly with the Barnum & Bailey Circus, remembered that he had decorated his shooting galleries with landscapes and his knife boards and cane racks in "good old circus blue with gay curlicues."

In June 1912, Pickett bought a store on Bridge Street, near the railroad station and the canal, a location that appealed to Mrs. Pickett because there was plenty of room for a flower garden. Pickett built an addition for living quarters. The store, house, and garden, painted from the canal side, are the subject of his last work, *Sunset, Lehigh Canal, New Hope*.

Years later, those who had known Pickett placed his period of painting activity from the late 1890s—after his marriage—until his death in 1918. Some suggested that he painted as a compensation for the quiet life he led after settling down with Emily. For a while

Joseph Pickett. *Manchester Valley,* 1895–1918. Oil on canvas, 45½ x 60⅝ inches.
The Museum of Modern Art, New York; Gift of Abby Aldrich Rockefeller.

he used house paints for his pictures, but later turned to regular artists' supplies—tubes of oil paint and a palette. He worked in the back room of his store, where he used to invite one or two friends to see his work, and he put the finished pictures on display in the store window. He worked on each painting for years, adding color until he got the raised textures that are a striking feature of his self-taught technique.

Reminiscing about her friend Joe Pickett in the New Hope *Gazette* for July 5, 1951, Mrs. Martha R. Janney (then eighty-one) gave this account of his associations with the New Hope artists' colony:

Naturally the artists coming to Delaware Valley became interested in Joe. They laughed at him good naturedly, and thought him a joke. Joe liked it and thought they were funny too. "I can paint like them if I want to," he would say. Taking up his brush he would add: "Now the sky is up here. That's here. Put in a few white clouds. Down here are trees, green, and a creek, a road here—that's red shale. Better put a bridge across this creek." He did. . . . It was lovely. But with a swish of his brush it was gone. He never took his painting seriously. To him it was merely a pastime.

But in 1918, when one of the local artists persuaded Pickett to send a painting to the annual exhibition at the Pennsylvania Academy of the Fine Arts, it received three jury votes, those of William L. Lathrop, Robert Henri, and Robert Spencer.

Pickett died on December 12, 1918, and was buried not far from New Hope in the Hulmeville Cemetery. His widow put his store and effects up for auction. When only a dollar was offered for each of the paintings, Emily Pickett bought them herself and gave *Manchester Valley* to the New Hope High School, where it hung for many years. *Coryell's Ferry, 1776* and *Washington Under the Council Tree, Coryell's Ferry, Pennsylvania* apparently remained in the old store building, which became the Worthington Brothers Garage. It was there that Lloyd Ney, a New Hope artist, saw them in 1925. He bought the pair for fifteen dollars and the following year traded them to R. Moore Price, a local art dealer, for fifty dollars' worth of frames. The introduction of these paintings to the public came about in a circuitous way. According to the records of the Newark Museum, its staff members heard about Pickett in Baltimore from an artist who had just returned from Paris and had heard of the pictures there. She recollected only that they were near New Hope, Pennsylvania, and that their owner's name began with "R." It took considerable detective work to locate Mr. and Mrs. R. Moore Price and their pictures, which they lent to Newark's first folk painting exhibition, *American Primitives*, in 1930.

In his catalogue *American Folk Art. The Art of the Common Man in America*, published by the Museum of Modern Art in 1932, Holger Cahill wrote of Pickett:

It appears that he was entirely self-taught, and that his work is the expression of sheer genius. The only craft he knew was that of carpentry, and from this he may have got the idea of good joinery and sound construction which his work shows so clearly. . . . Late in life he was seized with the ambition to paint the history of his native town, and he knew so little about painting that he had to improvise his technique and even his tools as

he went along. . . . Pickett drew like a child, and often built up his figures in relief, sometimes as high as half an inch above the canvas. . . . For all his technical idiosyncrasies there is in his work a plastic sense, and a craftsmanship of a high order.

Two of Pickett's paintings are devoted to incidents of local history in which George Washington played a prominent role. At the time of the Revolution, New Hope was known as Coryell's Ferry, being the Pennsylvania terminus for a ferry service across the Delaware River operated by the Coryell family. The Coryells' boats came into play in 1776, when the British General Cornwallis tried unsuccessfully to prevent them from carrying Continental troops to safety in Pennsylvania after their defeat in New York and subsequent flight across New Jersey. In *Coryell's Ferry, 1776* (colorplate) a doll-like figure of Washington stands on a hill peering at the New Jersey side through a spyglass while his white horse waits on the road below. Pickett's friend May Turner remembered watching him paint this picture in his store: "He worked over it a long time, changing, adding, and rearranging—we were all privileged to comment and advise." Although he lavished great care on the composition, Pickett obviously didn't worry about historical accuracy. His idyllic scene is hardly the snowy landscape that greeted the Continentals when they bivouacked at Coryell's Ferry in December of 1776. Nor would General Washington and his men have seen the two-story white house at the far left in the foreground, for it was not built until some years later.

According to local folklore, Washington planned his famous Christmas night crossing of the Delaware and surprise attack on the Hessians at Trenton under a chestnut tree that stood at the junction of the York and Trenton roads (in present-day New Hope). Known as the "Washington Tree" or the "Council Tree," this mighty chestnut was twenty-two feet in circumference in 1893, when it was removed in connection with "road improvements." The demise of the famous tree was a much-talked-about event in Pickett's lifetime and perhaps inspired him to paint *Washington Under the Council Tree, Coryell's Ferry, Pennsylvania* (colorplate), as his personal tribute not only to the nation's hero but also to the vanished landmark. The tree is the focal point of Pickett's composition; it fills the canvas and the curves of its branches are echoed in the undulating hilltops, fences, and road. Here, as in *Coryell's Ferry, 1776*, Pickett ignored the facts of history and painted a warm-weather scene, fields green, trees covered with leaves. Martha Janney had memories of this painting: " 'See those leaves?' Joe would say. 'Every one is a perfect chestnut leaf.' And every leaf *was*, points, veins, and all." The trunk is painted with equal care, built up with layer after layer of paint, so that it actually captures the texture of bark. As Mary Black wrote in 1966, the impasto is "so thick that it seems encrusted with history and age"—as was the old Council Tree itself.

Manchester Valley (colorplate) was painted by Pickett to commemorate the coming of the railroad to New Hope in 1891. Some of his friends called it *The School House*, because its most prominent

Joseph Pickett. *Washington Under the Council Tree,*
Coryell's Ferry, Pennsylvania, 1895–1918.
Oil on canvas, 34½ x 36 inches.
The Newark Museum, Newark, New Jersey.

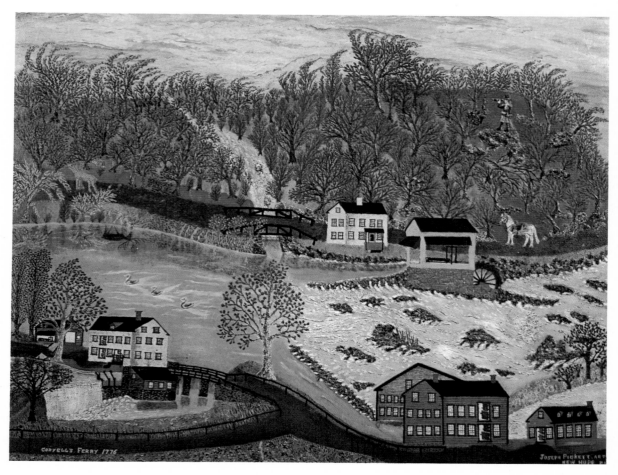

Joseph Pickett. *Coryell's Ferry, 1776,* 1895–1918.
Oil on canvas, 37½ x 48¼ inches.
Whitney Museum of American Art, New York;
Gift of Gertrude Vanderbilt Whitney.

feature is the New Hope High School that stood on a hill just outside town, in the area known locally as Manchester Valley. It was Mrs. Janney's favorite painting; in her 1951 article she recorded this discussion with Pickett, revealing much about his technique, as well as his mental processes:

"What do you think of the flag?" Joe would ask. "Doesn't it need another coat of paint?"

As the paint was already about a quarter of an inch thick, the answer would be "no." And the flag would get another coat of paint anyway.

"Now look at that train," Joe would say. "See—you can read 'Reading Rail Road' right on it."

And you could!

"Joe," I would say, "if you would paint what you see and not what you know, you would get somewhere."

"What do you mean?" asked Joe.

"There is no fence around the schoolhouse."

"Yes, there is," says Joe.

"Let's look."

There was no fence. It had been gone for years.

The topography of the countryside in the painting makes it inevitable that everything follow a cascading movement. The hills, beginning at the upper right, sweep across and down into the ravine at the left. Ingham Creek follows the contours of the land in a series of waterfalls and rapids, and the outline of the banks emphasizes the descent. In a flowing movement, tracks and train also parallel this direction, and buildings and homes throughout the composition adjust themselves to the general movement of the land. The wind creates a countermovement to the topography, as it blows the flag, the clouds, the branches of the trees, and the smoke from the train in the opposite direction.

Formal perspective gives way to a personal perspective, and objects of greater importance to the artist are given greater scale regardless of distance. The school, which is in the background, is largest, while the twin mills in the foreground, although they are actually taller buildings, are reduced. The importance of the schoolhouse is obvious, not only because of its size, but also due to its commanding position near the crest of the hill, where it is topped by a huge belfry and a flag flying at the highest point in the picture.

One of the most striking elements in *Manchester Valley* is the use of textures to give the tactile experience of the materials represented. Sand, shell, and other gritty substances have been mixed with the pigment to gain the desired results. For example, the foundation in the trestle has the feel of cement to the touch, and in the center house near the tracks, concrete, native rock, and brick are all simulated. The bark of the trees is built up to high relief, primarily to give volume, but also the proper texture.

Reflections are introduced under the trestle where tree trunks and concrete piers are seen in the quiet water. The reflection of the bridge itself is omitted, as are all shadows throughout the picture. This omission is particularly striking in the case of the train, which casts no shadow upon the tracks.

Although the engine is in profile, the full circle of its front elevation is seen, adding to the sensation of travel or motion by including the experience of an oncoming view. This doubles the apparent hazard of a shaky train on an unsteady roadbed, leaving the spectator expecting the worst as the train nears the curve over the trestle. On the train are two tiny figures, the only ones in the picture: a fireman and a conductor. They are modeled in half-round relief and are reminiscent of toy figures on a miniature railway. The entire picture resembles a toy village of the Revolutionary period with the fanciful anachronistic interjection of a railroad and a forty-eight-star flag.

Pickett's fresh and vibrant color, his inventive handling of forms and surfaces, and his diverse compositional arrangements are so completely coordinated with the originality of his concepts that his canvases become outstanding achievements.

SIDNEY JANIS

This chapter is based on "Joseph Pickett" in *They Taught Themselves. American Primitive Painters of the 20th Century* by Sidney Janis. New York: Dial, 1942, pp. 110–16.

Further Reading

"Joseph Pickett" in *Masters of Popular Painting. Modern Primitives of Europe and America* (exhibition catalogue). New York: Museum of Modern Art, 1938, pp.100–102, 123–24.

TELLER, WALTER. *Area Code 215. A Private Line in Bucks County.* New York: Atheneum, 1963, pp. 181–90. A brief memoir of Pickett by a local writer.

Horace Pippin

1888–1946

Pippin painting *The Woman at Samaria*, 1940, now in the collection of the Barnes Foundation, Merion, Pennsylvania. Courtesy of Robert Carlen, Carlen Galleries, Philadelphia.

"My opinion of art is that a man should have love for it, because . . . he paints from his heart and mind. To me it seems impossible for another to teach one of Art." In so speaking, Horace Pippin is said to have deeply offended the more sophisticated black painters who came to his first New York exhibition. Mistaking his honesty for the arrogance of a self-taught artist, who unlike them had never received instruction, they thought he had forsaken them, whereas the truth was that they had cut themselves off from their own rich heritage as he never would.

Among the world's self-taught painters, Pippin ranks close to Rousseau. In contrast to the journeymen whose pictures are merely pretty or anecdotal, both artists project a *world*. Thirty or forty of the oils Pippin finished in the last six years of his life manage to convey a vision of the American scene—its history and folk-lore, its exterior splendor and interior pathos. What dozens of artist-intellectuals had tried so desperately and unsuccessfully to do, he achieved convincingly, without trying.

According to an autobiographical statement, Pippin began drawing with pencil and crayon at the age of seven. He was living with his mother in Goshen, New York, where she had gone to find work as a domestic. He was not to return to West Chester, Pennsylvania, where he had been born in 1888, until 1920; hence all his earliest memories, later to be recalled in pictures, were of Goshen.

Like most of his people at that time, Pippin spent the better part of his indoor life in the kitchen. In many black homes the kitchen was the only room. *Domino Players* (colorplate) is one of the strongest of the many pictures he was to paint years later out of his early memories. It is a masterpiece of patterning in subdued colors with the dominoes themselves forming a bridge between the red cap, the polka-dotted blouse, and the intricate reds of the needlework leading into the fiery teeth of the kitchen grate. The decaying plaster, the split shade, the chair with a broken spoke, say all that needs to be said about his people's poverty.

Pippin tells us that his first crayon and watercolor sketches were drawn on muslin squares, the edges of which he frayed to give them the appearance of doilies, and that they depicted scenes from the Bible. Both details are significant. The choice of biblical subjects reflects a lifelong piety and a familiarity with Scripture that often astonished his friends. The lace doily (or antimacassar) was to become as persistent a symbol in Pippin's later work as the classical torso in Chirico's or the jungle in Rousseau's. Whether it represented some unattainable respectability or was seized upon solely for its decorative mosaic, we have no way of knowing. When Pippin reports that the doily pictures were bought by an old lady who later berated him because the pigments washed out in the laundry, we may be sure that he experienced his first aspiration for a stable medium.

His first portrait, Pippin goes on to say, was attempted at the age of fourteen. It apparently aroused enough interest on the part of its subject, the man for whom he worked, to elicit an offer of instruction in draftsmanship. The instruction, Pippin relates, never materialized—for which we may have reason to be grateful. His mother became too ill to do the laundry, and he had to support her, thus terminating his formal education. He went to work first in a coal yard, later in a feed store, and finally (for seven years) as a porter in a hotel.

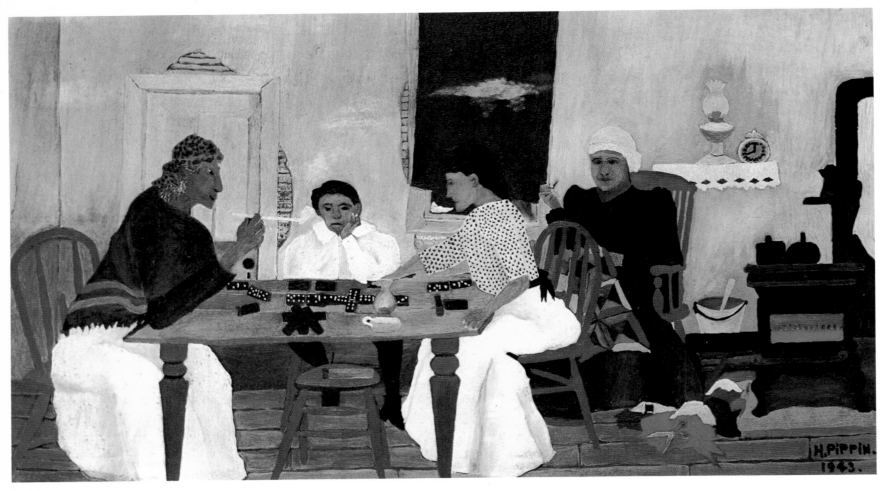

Horace Pippin. *Domino Players*, 1943. Oil on composition board, 12¾ x 22 inches.
The Phillips Collection, Washington, D.C.

Between 1911, when his mother died, and 1917, when he enlisted in the army, Pippin worked in New Jersey as a furniture packer and then as an employee of the American Brakeshoe Company. Between July and December of the latter year, he received his training as an infantryman at Fort Dix, New Jersey, and Camp Wadsworth, South Carolina. Then, from the time he landed in Brest on December 27, 1917, until Christmas Day of the following year, when he was evacuated from the same port on a hospital ship, there ensued the only part of Pippin's life that he documented exhaustively. In four overlapping accounts of his war experience, there is no slightest hint that Pippin was horrified by war, resented his role in it, or ever felt a twinge of guilt or self-pity. His war diaries show a pinpointing of detail, an acuteness of memory for the commonplace, which we can easily relate to Pippin's later descriptions in paint. One account is illustrated by drawings in pencil and crayon, presumably executed in France, and is the earliest work surviving from the artist's hand.

The drawings reveal at once what the narrative, with its clichés and its traditional patriotism, manages most effectively to conceal.

The war had been a shattering experience for Horace Pippin. He would not have admitted it, but the drawings, and to a far greater degree the war paintings that were to follow, cannot be denied. He had seen the desolation of the earth, the ruin of cities, the inhumanity of man. The Book said that all men were brothers, and Horace Pippin believed this as firmly as he believed anything. Then what was the meaning of this Thing they had sent him into, this suffering and this killing? There would be only one way to get at the paradox. But his right arm, the only instrument he had to let out what was fighting inside him, had been paralyzed by a sniper's bullet.

He moved back to West Chester, the place of his birth. He took to wife a motherly widow with a son. He attended church and the local American Legion meetings. He did a little light work.

Nine years later he began with charcoal, scratching a simple design with his left hand on the lid of a cigar box. The surface was too small. There was nothing to hold the shapes. They rubbed off.

Then one day in 1929, watching the white-hot poker as it lay in the potbellied stove, he had a better idea. Holding the handle as

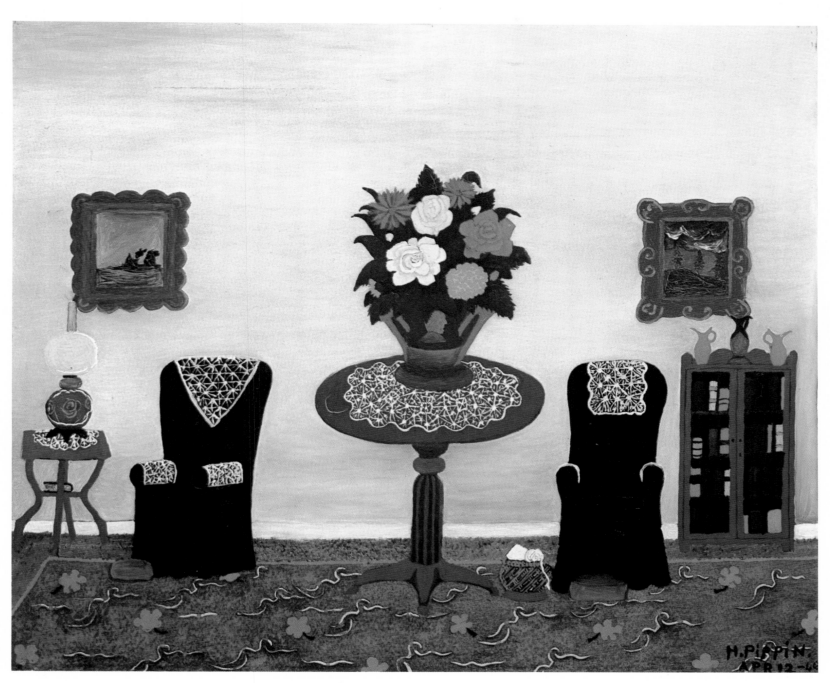

Horace Pippin. *Victorian Interior*, 1946. Oil on canvas, 25¼ x 30 inches.
The Metropolitan Museum of Art, New York; The Arthur H. Hearn Fund.

firmly as he could in his stiff right hand, and balancing the rod on his knee, he took the extra leaf from the golden oak table, and with his agile left hand maneuvered the panel against the smoking tip of iron. It worked. And this time the design was there to stay. As late as 1941 Pippin was to turn out an occasional burnt-wood panel, sometimes leaving them like this first one, bare of color, sometimes adding spots of primary pigment to the incisions. He considered it his invention, and he was proud of it. And it helped him regain strength in his injured arm.

Pippin once asserted that he worked three years on his first canvas, adding at least a hundred coats of paint in his effort to achieve the desired statement about war—and no doubt to purge his memory of it. No other picture that he painted is so loaded with paint, so crowded with figures and objects and events, so full of a sense of tortured earth and violent movement. That this crowding was deliberate may be seen from the frame itself, which the artist decorated with heavy wood carvings of lethal implements. *The End of the War: Starting Home* was no triumphant march, no happy homecoming (colorplate). The opposing soldiers, as though too far gone to respond to the news more than automatically, come out of their holes in the earth to confront each other, expressionless, like corpses on Judgment Day.

"The time it takes to make a picture depends on the nature of the picture," Pippin wrote. "For instance the picture called *The Ending* [sic] *of the War: Starting Home* which was my first picture. On that picture I couldn't do what I really wanted to do, but my next pictures I am working my thought more perfectly." In this same statement Pippin revealed his method of working:

The pictures which I have already painted come to me in my mind, and if to me it is a worth while picture, I paint it. I go over that picture in my mind several times and when I am ready to paint it I have all the details that I need. I take my time and examine every coat of paint carefully and to be sure that the exact color which I have in mind is satisfactory to me. Then I work my foreground from the background. That throws the background away from the foreground. In other words bringing out my work. . . .

No sunlight, and very little light of any kind, penetrated the "second parlor" in which Pippin worked. But from the center of the ceiling over his easel hung a single unshaded 200-watt bulb. Working for the most part at night, Pippin would paint for as long as seventeen hours at a stretch, holding the wrist of his injured right arm in the fist of his left hand, thus controlling his motion to suit the tiny brushes and brushstrokes which he "advanced from side to side of the canvas" until the proper balance of masses and colors had been achieved. When an object or color didn't "set" in the picture, he would paint over it, building up the color to a thick impasto. "Pictures just come to my mind," he said, "and then I tell my heart to go ahead."

Credit for the "discovery" of Pippin in 1937 is generally accorded to the late Christian Brinton, an Oriental scholar living at that time in Chester County, and moving spirit in the Chester County Art Association. Walking one day along the main street of West Chester with his friend N. C. Wyeth, the illustrator, he saw *Cabin in the Cotton I* in a local shoemaker's window. On June 9, 1937, a small exhibition arranged by Brinton opened at the West Chester Community Center. Ten of Pippin's early oils, including most of the war pictures, and seven burnt-wood panels were included. Holger Cahill was impressed by the pictures and borrowed four of them for *Masters of Popular Painting*, to be held at the Museum of Modern Art in New York the following year.

Many of the pictures were sold, but more important, Pippin found a dealer. Robert Carlen was not only willing to offer the artist a one-man show in his Philadelphia gallery; he was also the kind of dealer who took a personal interest in the artist's work, encouraging him, helping him secure equipment and commissions, "talking him up" endlessly and contagiously.

When Pippin's show opened at Carlen's in January 1940, twenty-three oils were included, and the catalogue carried an introduction by Albert C. Barnes of the Barnes Foundation in Merion. Dr. Barnes had already bought several Pippins at a preview, and in his commentary he states: "It is probably not too much to say that he is the first important Negro painter to appear on the American scene and that his work shares with that of John Kane the distinction of being the most individual and unadulterated painting authentically expressive of the American spirit that has been produced during our generation."

Dr. Barnes invited Pippin to Merion to see his collection and to attend lectures at the Foundation. Pippin's "exposure" to modern painting has been variously reported, and opinions conflict regarding the influence the pictures exerted or failed to exert on his subsequent work. That he dozed through most of the lectures is well attested. What cannot be denied is that Pippin did acquire about this time a freedom in the use of color and a consequent liberation in design that were to extend his range and intensify his art.

Two more one-man exhibitions, one at the Carlen Galleries in March of 1941, the second at the Arts Club of Chicago in May-June of the same year, summed up the transitional phase of Pippin's career. The latter show included the first of the *Victorian Interiors*, which may have been suggested in part by the artist's recent visits to the self-consciously "antique" parlors of the great suburban estates. But there is also a memory of Goshen, of how the white man's well-stuffed drawing room must have looked to the furtive gaze of the black laundress's son. And finally, of course, there is the poetic metamorphosis of the vulgar into something magical and stupendously symmetrical, something that never was nor could be. For the next five years the artist would play variations on this theme (see colorplate).

Three of Pippin's best pictures were painted about a legendary hero of his childhood, John Brown. He told Robert Carlen repeatedly that his grandmother had witnessed the hanging of that fanatical white abolitionist, who had staged an armed attack on Harper's Ferry in 1859. *John Brown Going to His Hanging* (colorplate) shows exactly the scene which had so often been described to him. The procession is passing the white farmhouses set against

Horace Pippin. *The End of the War: Starting Home*, 1930.
Oil on canvas, 25 x 32 inches.
Philadelphia Museum of Art.

Horace Pippin. *Holy Mountain II*, 1944.
Oil on canvas, 23 x 30 inches.
Private collection.

the Blue Ridge Mountains. How accurately Pippin's grandmother must have remembered the occasion is shown by the authenticity of every detail: the almost leafless December trees, the spectators along the route with scarves around their necks and hands in pockets, the barred window (the jail?) in the background, and Brown himself with his arms bound to his sides riding his own coffin on a wagon drawn by a pair of white horses. Some of the Southern whites watch curiously; some chat indifferently. But the dominant figure is the single black slave (very likely Pippin's grandmother) who confronts the viewer with an expression at once fearless and accusing.

In the *Holy Mountain* series which was to follow, Pippin perfected a most individual way of painting leaves—an opaque dark green, almost black, over an emerald wash, causing them to glisten magically. Whether Pippin got the inspiration for these pictures from one of the celebrated *Peaceable Kingdoms* of Edward Hicks—Robert Carlen had examples of the latter in his gallery from time to time—or whether, as he said himself, the scene was rendered direct from the Bible, is of less importance than the fact that the artist treated the subject in his own idiom.

It would be easy to interpret the four *Holy Mountain* pictures as racial parables—the black child gamboling among the carnivorous beasts, the black Isaiah presiding over the peaceful assemblage out of which a white goat and lion stare sullenly (see colorplate). Too easy. Horace Pippin had seen modern war at its most grisly, had been the first to paint the horrors of it convincingly. When the United States was plunged into World War II, Pippin, who had belatedly received the Purple Heart, could not face it without some hope for the future. The *Holy Mountain* was his affirmation that wars would one day cease to exist.

"My dear friends, . . ." he wrote in explanation. "It is the holy mountain my Holy Mountain. . . . There is trouble every place you Go today. Then one thinks of peace yes, there will be—peace, so I look at Isaiah xi 6–9 and there I found that there will be peace. I went over it 4 or 5 times in my mind. Every time I read it I got a new thought on it. So I went to work. . . ."

While working on his fourth *Holy Mountain*, Pippin died of a stroke on July 6, 1946. The Second World War was over now, and in this last version of a favorite subject he may have wished to state a different message. The landscape is stripped of verdure; a blasted tree stands alone, and the bald mountain is split by an ugly fissure. There is no place for tanks to maneuver, nothing on which to drop bombs. The three animals are unaccompanied by human figures. Are we indulging in speculation to believe that Pippin intended this last picture as a warning?

If there is any conclusion, other than wonder and thankfulness, to be drawn from the phenomenon of Pippin's artistic maturity, it is that the wellsprings of art, in America as elsewhere, run much deeper than any of the "schools" or incestuous fashions would indicate. "Folk and popular art is significant for us," wrote Holger Cahill in 1938, "because, in our fear that contemporary civilization has almost abandoned its form-creating function in favor of the sterile mathematics of machine-form, we are startled and reassured to find this rich creativeness still alive in the unpretentious activities and avocations of the common man."

The miracle in Pippin's case is not that he began to paint with the direct vision of a child, but that he *continued to* long after he had ceased in any strict sense to be a "primitive." Despite all the additional, and in his case uncorrupting, exposure to contemporary sophisticated art and the acquisition of a knowing technique, Horace Pippin remained true to his vision.

SELDEN RODMAN

This chapter is based on *Horace Pippin, a Negro Painter in America* by Selden Rodman. New York: Quadrangle, 1947. Includes "My Life's Story" by Horace Pippin.

Further Reading

MILLER, DOROTHY C. "Horace Pippin" in *Masters of Popular Painting. Modern Primitives of Europe and America* (exhibition catalogue). New York: Museum of Modern Art, 1938, pp. 125–26.

JANIS, SIDNEY. "Horace Pippin" in *They Taught Themselves. American Primitive Painters of the 20th Century*. New York: Dial, 1942, pp. 187–91.

ARKUS, LEON ANTHONY. "Horace Pippin. 1888–1946" in *Three Self-Taught Pennsylvania Artists: Hicks, Kane, Pippin* (exhibition catalogue). Pittsburgh: Museum of Art, Carnegie Institute, 1966. n.p.

RODMAN, SELDEN, AND CLEAVER, CAROLE. *Horace Pippin, the Artist as a Black American*. New York: Doubleday, 1972.

Horace Pippin (exhibition catalogue). Washington: Phillips Collection, 1976. Includes an essay by Romare Bearden.

Horace Pippin. *John Brown Going to His Hanging*, c. 1942. Oil on canvas, 24 x 30 inches.
The Pennsylvania Academy of the Fine Arts, Philadelphia.

American Folk Art
Six Decades of Discovery

The "discovery" of American folk art began in the 1920s, marked by an exhibition held in 1924 at the Whitney Studio Club—the predecessor of the Whitney Museum—founded by Gertrude Vanderbilt Whitney. This catalogued show, organized by Juliana Force, director of the Studio Club, selected by Henry E. Schnakenberg, and photographed by Charles Sheeler, was simply titled *Early American Art*. However, it presented one of the most varied exhibitions of American folk painting and sculpture to be shown in an art museum until *The Flowering of American Folk Art. 1776–1876* at the Whitney fifty years later. In 1924 it was primarily contemporary artists who were interested in folk art. Lenders included, besides Sheeler, the painters Alexander Brook, Yasuo Kuniyoshi, Peggy Bacon, and Charles Demuth; sculptors Robert Laurent, William Zorach, and Elie Nadelman were also collecting.

Shortly after the 1924 show, the term folk art began to be used, but the terminology varied: this diverse body of work was discussed by art historians as primitive, provincial, vernacular, pioneer, non-academic, or naïve. Today "folk art" seems to be widely, if not universally, accepted. Alice Winchester, in her introduction to *The Flowering of American Folk Art*, said that "it seems more suitable if we think of it as referring not to the artistic expression of a folk but simply to the unpretentious art of 'the folks.'"

The first generation of pioneer enthusiasts was responsible for the early collections, exhibitions, and publications that would establish folk art as a major chapter in the history of American art. Exhibitions were held in museums and dealers' galleries in New York, Boston, Cambridge, Buffalo, and Detroit. The most important of these early shows was *American Folk Art. The Art of the Common Man in America, 1750–1900*, held in 1932 at the Museum of Modern Art in New York. It was directed by Holger Cahill, whose catalogue text has never been surpassed as a basic appraisal of folk art. Before this landmark exhibition Cahill had organized *American Primitives* (1930–31) and *American Folk Sculpture* (1931–32) for the Newark Museum. In 1930 the Harvard Society for Contemporary Art in Cambridge held an exhibition of American folk painting, organized and catalogued by Lincoln Kirstein. (All important catalogues, articles, and books referred to here are listed with other key publications in the Editors' Bookshelf.)

The early books on folk painting that I would select for special attention are, in chronological sequence: Clara Endicott Sears, *Some American Primitives*, 1941; my *American Primitive Painting*, 1942; Alice Ford, *Pictorial Folk Art. New England to California*,

1949; *Primitive Painters in America. 1750–1950*, coedited by Alice Winchester and myself, 1950. Many key articles were published in this early period, most notably by Nina Fletcher Little, researcher, collector, and lecturer. *Antiques* magazine, edited by Alice Winchester, and *Art in America*, which I edited, were especially interested in this field.

The first folk art collections, almost all now in museums, were begun as private projects. Juliana Force was an adventuresome early collector. The first great collection was begun in the 1920s by Mrs. John D. Rockefeller, Jr., with the help of Edith Gregor Halpert, director of the Downtown Gallery in New York. It is now at the Abby Aldrich Rockefeller Folk Art Center in Williamsburg, Virginia. Some time later the remarkable J. Stuart Halladay and Herrel George Thomas collection was added to the Rockefeller group. Other major collections were formed, successively, by myself and my husband, by Nina F. and Bertram K. Little, and by Edgar William and Bernice Chrysler Garbisch, who collected paintings only. Our collection was acquired by Stephen C. Clark in 1950 for the New York State Historical Association in Cooperstown, and important parts of the Garbisch collection have been given to the National Gallery and the Metropolitan Museum. The Littles' collection is still in their two eighteenth-century houses in Essex and Brookline, Massachusetts. The Garbisch collection remains the most remarkable assemblage of folk painting to have been made. It has not been, nor is it likely ever to be, superseded, although its importance has been sadly diminished by the recent series of Parke-Bernet auctions which sold off most of the watercolors and drawings, including many major examples.

Electra Havemeyer Webb was an avid and brilliant collector of folk art in all categories; her collections are installed in the Shelburne Museum which she and her husband, J. Watson Webb, founded at Shelburne, Vermont. Henry F. du Pont formed one of the greatest collections of our time, including many masterpieces of folk art, and then made his home, with its dozens of period rooms, into the Henry Francis du Pont Winterthur Museum in Winterthur, Delaware. Henry Ford's extensive collection, now in the Henry Ford Museum in Dearborn, Michigan, features folk art also. Maxim Karolik's collections, given to the Museum of Fine Arts, Boston, include some of the outstanding folk painters. Elie Nadelman's collection was housed in a private folk art museum adjacent to his home at Riverdale-on-Hudson; many of his choicest pieces are now owned by the New-York Historical Society; a few

others, which we acquired for our collection, are now in Cooperstown. Our collection was also augmented by some items from the Horace W. Davis collection, which we acquired in its entirety for the sake of adding several paintings we considered masterpieces, and we auctioned the rest in a special sale at Parke-Bernet.

In talking about the early collectors, one must not forget the role played by the pioneering dealers: Isabel Carlton Wilde, Valentine Dudensing, Harry Shaw Newman, and, most important, Harry Stone, whose gallery handled folk paintings only, and Edith Gregor Halpert, owner of the Downtown Gallery, which became a gallery of contemporary American art and folk art, equally featured, with the name eventually changed to the Downtown Gallery and American Folk Art Gallery.

My early years of collecting folk paintings and writing about them, publishing rediscovery articles by various authors in *Art in America*, and even occasionally lecturing, were, I find in retrospect, among the most enjoyable and exciting of my life. The thirties and forties were the years when folk paintings were just beginning to emerge from the category of antiques, and they were often not much respected by the dealers, unless they were very early—meaning eighteenth century. But they were being found in quantity in local attics, and available in large numbers in the antiques shops that dotted the main country roads. All of our vacations were antiquing trips in those years. We spent our days driving, mostly in New England and Pennsylvania, with a few trips in New York State, averaging at least a dozen shops a day, spending nights in "tourist homes" where a pleasant guest room and breakfast usually cost one or two dollars a person.

Among the purchases I now recall with most amusement was the oil painting we titled *Winter Sunday in Norway, Maine.* It hung, in 1941, in a barn antiques shop in Norway, had a small tear, but looked wonderful. We cannily asked the price of several things we *weren't* interested in, then the winter scene—of people coming to church on foot and in a sleigh. (This painting has since been featured in many books and articles, and was reproduced for one of the U.S. Christmas stamps.) The shop owner said, "Well, I figured I'd better get fifty cents for that frame so if you want the picture, you can have it for that." We had the painting cleaned and relined, an unusual extravagance for a primitive painting in those days. One of the other items I particularly remember was the wonderful overmantel panel that we acquired from Elie Nadelman in the 1940s. It is actually a fireboard, the much reproduced and exhibited *Bears and Beeves.* Mr. Nadelman had formed a great folk art collection, but at the time I met him, he was totally impoverished. I had made an appointment to visit him at his mansion on the Hudson, to talk about folk art for my current book-in-work, and to see his collection. I arrived by taxi in a violent storm, was greeted by Mr. Nadelman, tall, piercing black eyes, shabby dark suit, who in the first lightning-flash glimpse in the doorway of his great house looked to me like Heathcliff in *Wuthering Heights.* The house had been stripped of almost all the furniture and rugs and—storm or unpaid electric bills, I never knew—was lit only by a few candles. Mr. Nadelman showed me the folk art, we talked about it, and he

asked if I'd like to see his sculptures. We climbed to the attic, where several dozen pieces were covered with sheets, which he removed one by one for me to look—still by candlelight. They were all there—the greatest of the now famous Nadelman sculptures—all unsold. It was a splendid—and a bit eerie—day.

This account sounds as if we clever collectors acquired everything we *should* have in this early time. Not so. We found many great things, but many that we didn't buy stand out in my mind. This was mostly a question of price; in the beginning five hundred or even fifty dollars seemed impossibly high, no matter how much we thought of the paintings. We turned down what is, I think, the greatest Hicks *Peaceable Kingdom,* now in the Williamsburg collection (you can see it in this book), when the dealer asked five hundred dollars. We thought he was literally crazy, and left hastily with the snapshot of the painting he had given us "to consider." *What* a price to ask! Recently, *Peaceable Kingdoms* have been sold for sums between a hundred and fifty and two hundred thousand dollars, seemingly to no one's surprise.

One painting for which we did pay the extravagant price of fifty dollars was *York Springs Graveyard.* We had decided that we badly needed a genre scene with people in it, so we kept asking antiques dealers for "a primitive scene with lots of people." The graveyard picture, for sale in one of the most distinguished antiques shops, was just what we had in mind, but it was fifty dollars. My husband said, "We're really sorry," and I said, "Let's just walk around the block and think about it," which, as we walked, I altered to, "We've really got to do it." We did, but ended our vacation right there and drove home. Fifty dollars was a large item in our budget in those days, which had a lot to do with a very tight selection. We weren't a bit casual about buying.

We acquired many of our best paintings from the Harry Stone Gallery in New York. Stone's appreciation of folk painting, sufficient to chance his livelihood on it alone; his remarkable eye for quality; and his confidence in pricing his prime examples far above the going rate, without being concerned about waiting for prices to catch up to his expectations, were all astonishing. Our first purchase, in 1938, was *Darkytown,* an extraordinary oil painting on glass, for which we paid half of the asking price of two hundred dollars plus an eighteenth-century overmantel panel—now one of the stars in the Littles' collection. It was ridiculous for us to part with it. We also flunked in our decisions at the Stone Gallery a number of times. We turned down the marvelous little *Meditation by the Sea,* snapped up by Maxim Karolik, because it seemed not "primitive" enough. Harry offered us the entire portfolio of twenty watercolors by Mary Ann Willson for five hundred dollars—much too extravagant—and we chose one. We turned down the greatest steamboat painting by Jurgan Frederick Huge, the *Bunkerhill,* because of the wild Harry Stone price, also five hundred dollars—despite the fact that our collection had no example in this category at all and we were searching for one. I've since had the *Bunkerhill* reproduced in color in three of my books, including this one, and in a portfolio of sixteen folk-painting masterpieces.

We also had the opportunity to acquire all the then known wa-

tercolors by Eunice Pinney from one Boston dealer, for seventy-five dollars each; that time we chose five, and ruefully saw the rest acquired later for much higher prices by other competing—we did compete—collectors. But now that just about all these treasures are in museum collections, available to the public and for loan exhibitions, we really have no regrets.

A new stage in the study of folk art could be placed in the decades of the fifties and sixties, when publications, exhibitions, and organized research flourished, bringing folk art to the attention of a wider public than ever before. This was the time when many of the great private collections were "going public," as gifts to established museums or as the cores of new museums. Mrs. Rockefeller's collection had been given to Williamsburg in the thirties, and in 1957 a separate museum created to house it opened and a catalogue of the collection by Nina Little was published. A number of museums and historical societies became actively interested, not only in adding folk paintings and sculpture to their collections, but also in organizing seminars and student training courses in the folk art field. The New York State Historical Association was especially active under the direction of Louis C. Jones, who organized the first Cooperstown seminars and a program of graduate study; a number of important articles and exhibitions have resulted. In 1962 the Museum of American Folk Art was founded in New York City with Mary Black (formerly of Williamsburg, now of the New-York Historical Society) as an early director. Through its exhibitions, publications, and other activities this museum has exerted a strong influence on a whole new generation of collectors, many of whom are showing folk art in their homes along with contemporary art. A few collectors, like Mrs. Jacob Kaplan and Mrs. Rockefeller, had done this before, but they were exceptional.

Mary Black, who has published much important research on folk painters, became coauthor, with me, of *American Folk Painting* (1966). This book included a chapter on contemporary folk artists, a part of the history that has become increasingly important. Sidney Janis had led the way in 1942 with *They Taught Themselves*, but it was not until much later that twentiety-century folk artists were frequently exhibited and published. The outstanding exception, of course, was Grandma Moses, whose work represents the personal achievement of a remarkable woman rather than a body of significant art. Her dramatic success has led to a disastrous production of deliberately quaint "remembrance" paintings in recent years; there have been some, but not many, genuinely creative folk artists since the end of the nineteenth century. *Twentieth-Century American Folk Art and Artists* by Herbert W. Hemphill, Jr.—the outstanding collector of contemporary folk art—is the most recent and comprehensive book on this subject.

A half century of collecting, research, and evolving appreciation climaxed in the 1974 exhibition which Alice Winchester and I organized at the Whitney Museum. *The Flowering of American Folk Art. 1776–1876* was a visual anthology of the best of American folk art—as we saw it—in every category, from painting and sculpture to many varieties of utilitarian objects. The exhibition was received by a vastly expanded audience which had developed a new interest in American art and antiques of all kinds. Interest expanded geographically as well. In connection with the bicentennial celebration, several states in the South and the Midwest sponsored folk art exhibitions that resulted in discoveries in areas previously thought to have little in the way of folk art. Dealers and collectors all over the country began looking at local art and artifacts with new eyes. Suddenly, it seems, folk art is everywhere!

By the 1970s the convictions of the advanced group of artists and museum people who first "discovered" American folk art seemed to be vindicated and accepted. It was more than a quaint relic of the past, it was *art,* and an important branch of American art, at that. To some critics, in fact, it represented a far more vital and original strain of the American visual tradition than the eclectic efforts of many nineteenth-century academic painters and sculptors.

As we neared the end of the decade, a curious new attitude toward this seemingly established category of American art surfaced, bringing back the retardataire concept of folk arts as historical artifacts. Some students of American culture believe that the "art" in folk art is of minor importance. Kenneth L. Ames, teaching associate at the Winterthur Museum, takes this position in his introduction to the 1977 Winterthur exhibition catalogue *Beyond Necessity.* "The differences between objects considered folk art and those with no loftier designation than just 'things,' " he writes, "have been exaggerated." He believes that "the art approach has other drawbacks," and states: "It is legitimate to ask if this discussion of cultural and aesthetic biases is necessary. Do these things really matter?" My answer is emphatically "Yes, they do!" Mr. Ames appears sorry to conclude that "in the value system of many of the people who have been active promoters of folk art, art outranks history." It seems to me that Mr. Ames's approach represents a giant step backward to the antiquated idea that folk art is in the category of archaeology and history rather than art, that it is interesting as an anonymous group activity rather than as the work of highly individual and talented artists. The latter is the point of this book.

For *Primitive Painters in America,* published in 1950, I listed 539 painters, and since that time the careers of many of them have been fully reconstructed, with important bodies of work attributed to them. This book presents thirty-seven of these painters, selected by the editors of this book, as especially worthy of rediscovery.

JEAN LIPMAN

About the Authors

LEON ANTHONY ARKUS has been Director of the Museum of Art, Carnegie Institute, Pittsburgh, since 1968, and in 1971 published the catalogue raisonné of the work of John Kane. He has organized many exhibitions for the Carnegie Institute, among them *Three Self-Taught Pennsylvania Artists: Hicks, Kane, Pippin* in 1966.

TOM ARMSTRONG, Director of the Whitney Museum of American Art since 1974, served as Curator and Associate Director of the Abby Aldrich Rockefeller Folk Art Center, Williamsburg, Virginia, from 1967 to 1971 and as Director of the Pennsylvania Academy of the Fine Arts, Philadelphia, from 1971 to 1973.

MARIANNE E. BALAZS researched the life of Sheldon Peck as an undergraduate student in the Independent Study Program of the Education Department, Whitney Museum of American Art. Her travel for research was supported by a Youthgrant from the National Endowment for the Humanities.

MARY BLACK was Curator and Director of the Abby Aldrich Rockefeller Folk Art Center from 1957 until 1964, when she became Director of the Museum of American Folk Art in New York. Since 1970 she has been Curator of Painting, Sculpture, and the Decorative Arts at the New-York Historical Society. She has organized exhibitions on Edward Hicks, Erastus Salisbury Field, Shaker inspirational drawings, and American primitive watercolors, among many other subjects, and has published numerous books and articles on American folk art, including *American Folk Painting* (with Jean Lipman, 1966).

SIDNEY JANIS, Director of the Sidney Janis Gallery since 1948, has organized several museum exhibitions of twentieth-century American painting, among them *Contemporary Unknown American Painters* (1939) and *The Paintings of Morris Hirshfield* (1943) for The Museum of Modern Art, New York, and *They Taught Themselves* (1941) for the San Francisco Museum of Art. In addition to his book *They Taught Themselves. American Primitive Painters of the 20th Century*, he is the author of *Abstract and Surrealist Art in America* (1944) and coauthor (with Harriet Janis) of *Picasso: The Recent Years, 1939–1946* (1946).

HELEN KELLOGG is a collector of American antiques and folk art. Her successful identification of the Shutes was her first folk art research project.

JEAN LIPMAN was Editor of *Art in America* magazine from 1940 to 1970, and then Editor of Publications at the Whitney Museum of American Art. She is the author of fifteen books and more than a hundred articles on various aspects of American art. She and her husband, Howard, formed a major collection of American folk painting and sculpture, which was acquired in 1950 by the New York State Historical Association in Cooperstown. Her first book in the folk art field was *American Primitive Painting* (1942); with Alice Winchester she published *Primitive Painters in America. 1750–1950* (1950). Her most recent books, accompanied by exhibitions at the Whitney Museum, are *Calder's Circus* (with Nancy Foote, 1972); *The Flowering of American Folk Art. 1776–1876* (with Alice Winchester, 1974); *Calder's Universe* (1976); and *Art About Art* (with Richard Marshall, 1978).

NINA FLETCHER LITTLE began her research and writing on American country arts and architecture in the early 1940s. She has organized exhibitions, with accompanying catalogues, of the works of little-known painters for many museums, including the Museum of Fine Arts, Boston; Worcester Art Museum; Connecticut Historical Society, Hartford; Peabody Museum of Salem; and the Abby Aldrich Rockefeller Folk Art Center. She has published numerous books and articles on New England folk art and artists.

CHRISTINE MATHER is Curator of Spanish Colonial Art, Museum of International Folk Art, Museum of New Mexico, Santa Fe.

ELEANORE PRICE MATHER approaches Edward Hicks from the point of view of her own Quaker heritage; her great-great-uncle Benjamin Price traveled in the ministry with the artist-preacher. For many years she has edited publications for Pendle Hill, a Quaker study center at Wallingford, Pennsylvania. She is currently preparing two books: *Pendle Hill: A Quaker Experiment*, and with Dorothy C. Miller the catalogue raisonné of Hicks's *Peaceable Kingdom* paintings.

LUCY B. MITCHELL began her research on James Sanford Ellsworth in 1952. Since that time she has prepared the catalogues and checklists for important Ellsworth exhibitions at the Connecticut Valley Historical Museum, Springfield, Massachusetts (1953), and the Abby Aldrich Rockefeller Folk Art Center (1974).

NANCY C. MULLER published *Paintings and Drawings at the Shelburne Museum* (1976), where she was Assistant to the Director. In addition to her work on Noah North, she has written articles on several Vermont painters, including Aaron Dean Fletcher (*Antiques*, January 1979). She now lives in New London, New Hampshire, where she continues to lecture on and research northern New England folk artists.

JACQUELYN OAK, Registrar of the Museum of Our National Heritage, Lexington, Massachusetts, was formerly Registrar at the Shelburne Museum, Shelburne, Vermont, where she and Nancy C. Muller began their research on Noah North.

SELDEN RODMAN, poet, art critic, and historian, is also an authority on Latin America. His monograph on Horace Pippin was published in 1947, and his many other books include *Conversations with Artists, Genius in the Backlands: Popular Artists of Brazil*, and *The Miracle of Haitian Art*. Two of his plays, *Hustler of the Gods* (coauthored with his wife, Carole Cleaver) and *Saint of the Revolution*, were staged at the Chamizal Theatre in El Paso, Texas, in 1979.

SAM ROSENBERG, who in the 1930s first called attention to the art of Henry Church, has worked as a photographer, stage manager, and writer. He is author of *Naked Is the Best Disguise* (a biography of Arthur Conan Doyle) and *Why Freud Fainted*.

CHRISTINE SKEELES SCHLOSS investigated the Beardsley Limner while a graduate student at Yale University, and during a year as a Smithsonian Fellow at the National Collection of Fine Arts, Washington, D.C. She organized a traveling exhibition, *The Beardsley Limner and Some Contemporaries*, for the Abby Aldrich Rockefeller Folk Art Center in 1972. She received her Ph.D. degree in 1978 and is currently engaged in field research for the National Portrait Gallery in Washington.

DONALD A. SHELLEY served as the first Curator of Paintings and Sculpture at the New-York Historical Society from 1938 until 1949, when he became Curator of the Edgar William and Bernice Chrysler Garbisch Collection of American primitive paintings. In 1952 he went to Dearborn, Michigan, to be Curator at the Henry Ford Museum and Greenfield Village, where he served as Executive Director and President from 1954 to 1976 and is now President Emeritus. He is also currently Consultant at the Historical Society of York County in Pennsylvania. His many publications include *Catalogue of American Portraits* (New-York Historical Society,

1941); *Picturebook of Audubon Birds* (1946); *The Fraktur-Writings or Illuminated Manuscripts of the Pennsylvania Germans* (1961); and *Lewis Miller: Sketches and Chronicles* (1966).

HAROLD S. SNIFFEN, formerly Assistant Director at The Mariners Museum, Newport News, Virginia, is now Curator Emeritus. He cared for the museum's extensive collection of graphics when he was Curator of Prints and Paintings, and developed a special interest in James Bard. He is now preparing a checklist of the works of another American marine painter, Antonio Jacobsen.

ESTHER SPARKS, Associate Curator of Prints and Drawings at the Art Institute of Chicago, has organized many exhibitions, among them *Ernst Damitz* (1977) and *Three New England Watercolor Painters* (1974) for the Art Institute; *Painters and Sculptors in Illinois, 1820–1945* for the Illinois Arts Council; and *Two Hundred Years of American Painting* for the Peoria Museum.

ALICE WINCHESTER, L.H.D., Litt. D., was Editor of *Antiques* from 1939 to 1972. She has written and lectured widely on the decorative arts, folk art, and historic preservation; among her books are *How to Know American Antiques, Living with Antiques, Versatile Yankee: The Art of Jonathan Fisher*, and *Primitive Painters in America. 1750–1950* (with Jean Lipman). She was coauthor (with Jean Lipman) of *The Flowering of American Folk Art. 1776–1876* and Guest Curator of the accompanying exhibition at the Whitney Museum in 1974.

RUTH WOLFE, formerly Executive Editor of *Art in America*, was Editorial Director for the Whitney Museum's *The Flowering of American Folk Art. 1776–1876* (1974) and *Calder's Universe* (1976).

Editors' Bookshelf

The following publications were used during the preparation of this bool and the accompanying exhibition; asterisks denote books with extensive bibliographies. There is a specialized bibliography at the end of each chapter relating to that artist.

ALLEN, EDWARD B. *Early American Wall Painting. 1710–1850.* New Haven: Yale University Press, 1926.

———. "The Quaint Frescoes of New England." *Art in America,* vol. 9, no. 6 (October 1922), pp. 263–74.

American Provincial Paintings from the Collection of J. Stuart Halladay and Herrel George Thomas (exhibition catalogue). New York: Whitney Museum of American Art, 1942.

AMES, KENNETH L. *Beyond Necessity: Art in the Folk Tradition.* Winterthur, Del.: Winterthur Museum, 1977.

ANDERSON, MARNA BRILL. *Selected Masterpieces of New York State Folk Painting* (exhibition catalogue). New York: Museum of American Folk Art, 1977.

ANDREWS, EDWARD DEMING, AND ANDREWS, FAITH. *Visions of the Heavenly Sphere. A Study in Shaker Religious Art.* Checklist by Susan Terdiman. Charlottesville, Va.: University of Virginia Press for Winterthur Museum, 1969.

ANDREWS, RUTH, ed. *How to Know American Folk Art: Eleven Experts Discuss Many Aspects of the Field.* New York: Dutton, 1977.

*BELKNAP, WALDRON PHOENIX, JR. *American Colonial Painting: Materials for a History.* Cambridge, Mass.: Harvard University Press, Belknap Press, 1959.

*BLACK, MARY, AND LIPMAN, JEAN. *American Folk Painting.* New York: Clarkson N. Potter, 1966.

*BOYD, E. *Popular Arts of Spanish New Mexico.* Santa Fe: Museum of New Mexico Press, 1974.

BRADSHAW, ELINOR ROBINSON. "American Folk Art in the Collection of The Newark Museum." *The Museum New Series,* vol. 19, nos. 3 and 4 (Summer–Fall 1967).

CAHILL, HOLGER. *American Folk Art. The Art of the Common Man in America, 1750–1900* (exhibition catalogue). New York: Museum of Modern Art, 1932.

[CAHILL, HOLGER.] *American Primitives* (exhibition catalogue). Newark, N. J.: Newark Museum, 1930.

*CHRISTENSEN, ERWIN O. *The Index of American Design.* Introduction by Holger Cahill. New York: Macmillan, 1950.

*DEWHURST, C. KURT; MACDOWELL, BETTY; AND MACDOWELL, MARSHA. *Artists in Aprons. Folk Art by American Women* (exhibition catalogue). New York: Dutton with Museum of American Folk Art, 1979.

DREPPERD, CARL W. *American Pioneer Arts and Artists.* Springfield, Mass.: Pond-Ekberg, 1942.

DRESSER, LOUISA. *XVIIth Century Painting in New England* (exhibition catalogue). Worcester, Mass.: Worcester Art Museum, 1935.

Early American Art (exhibition catalogue). New York: Whitney Studio Club, 1924.

*EBERT, JOHN, AND EBERT, KATHERINE. *American Folk Painters.* New York: Scribner's, 1975.

Exhibition of American Folk Painting in Connection with the Massachusetts Tercentenary Celebration. Cambridge, Mass.: Harvard Society for Contemporary Art, 1930.

Folk Art in America: A Living Tradition (exhibition catalogue). Atlanta: High Museum of Art, 1974.

FORD, ALICE. *Pictorial Folk Art. New England to California.* New York: Studio Publications, 1949.

FRENCH, HENRY W. *Art and Artists in Connecticut.* Boston: Lee & Shepard, 1879.

GARBISCH, EDGAR WILLIAM, AND GARBISCH, BERNICE CHRYSLER (with nine other authors). "American Primitive Painting, Collection of Edgar William and Bernice Chrysler Garbisch." *Art in America,* vol. 42, no. 2 (May 1954), special issue.

[GARBISCH.] *American Naïve Painting of the 18th and 19th Centuries: 111 Masterpieces from the Collection of Edgar William and Bernice Chrysler Garbisch* (exhibition catalogue). New York: American Federation of Arts, 1969.

[GARBISCH.] *101 American Primitive Watercolors and Pastels from the Collection of Edgar William and Bernice Chrysler Garbisch* (exhibition catalogue). Washington: National Gallery of Art, 1966.

GOODRICH, LLOYD, AND BLACK, MARY. *What Is American in American Art* (exhibition catalogue). New York: M. Knoedler, 1971.

GROCE, GEORGE C., AND WALLACE, DAVID H. *The New-York Historical Society's Dictionary of Artists in America. 1564–1860.* New Haven: Yale University Press, 1957.

HEMPHILL, HERBERT W., JR., WITH WEISSMAN, JULIA. *Twentieth-Century American Folk Art and Artists.* New York: Dutton, 1974.

JANIS, SIDNEY. *They Taught Themselves. American Primitive Painters of the 20th Century.* Foreword by Alfred H. Barr, Jr. New York: Dial, 1942.

JONES, AGNES HALSEY. *Rediscovered Painters of Upstate New York, 1700–1875* (exhibition catalogue). Utica, N. Y.: Munson-Williams-Proctor Institute, 1958.

JONES, AGNES HALSEY, AND JONES, LOUIS C. *New-Found Folk Art of the Young Republic.* Cooperstown: New York State Historical Association, 1960.

[KAROLIK.] *M. and M. Karolik Collection of American Paintings. 1815 to 1865.* Essay by John I. H. Baur. Cambridge, Mass.: Harvard University Press for the Museum of Fine Arts, Boston, 1949.

[KAROLIK.] *M. & M. Karolik Collection of American Water Colors & Drawings 1800–1875* (exhibition catalogue). 2 vols. Boston: Museum of Fine Arts, 1962.

KAUFFMAN, HENRY. *Pennsylvania Dutch American Folk Art*, 1946; rev. ed., New York: Dover, 1964.

*LARKIN, OLIVER W. *Art and Life in America*, 1949; rev. ed., New York: Holt, Rinehart and Winston, 1960.

LIPMAN, JEAN. *American Primitive Painting*, 1942; reprint ed., New York: Dover, 1972.

———. "Collecting American Primitives." *American Collector*, vol. 11, no. 9 (October 1942), pp. 10–11, 17.

———. "A Critical Definition of the American Primitive." *Art in America*, vol. 26, no. 4 (October 1938), pp. 171–77.

LIPMAN, JEAN, ed. *What Is American in American Art.* New York: McGraw-Hill, 1963.

LIPMAN, JEAN, AND FRANC, HELEN M. *Bright Stars: American Painting and Sculpture Since 1776.* New York: Dutton, 1976.

*LIPMAN, JEAN, AND WINCHESTER, ALICE. *The Flowering of American Folk Art. 1776–1876.* New York: Viking with Whitney Museum of American Art, 1974.

LIPMAN, JEAN, AND WINCHESTER, ALICE, eds. *Primitive Painters in America. 1750–1950*, 1950; reprint ed., Freeport, N. Y.: Books for Libraries Press, 1971.

LITTLE, NINA FLETCHER. *The Abby Aldrich Rockefeller Folk Art Collection* (catalogue). Williamsburg, Va.: Colonial Williamsburg, 1957.

———. *American Decorative Wall Painting 1700–1850*, 1952; rev. ed., New York: Dutton, 1972.

———. *Country Art in New England, 1790–1840*, 1960; rev. ed., Sturbridge, Mass.: Old Sturbridge, 1965.

———. *Land and Seascape as Observed by the Folk Artist* (exhibition catalogue). Williamsburg, Va.: Colonial Williamsburg, 1969.

———. "Little-Known Connecticut Artists, 1790–1810." *Connecticut Historical Society Bulletin*, vol. 22, no. 4 (October 1957), special issue.

———. *Paintings by New England Provincial Artists: 1775–1800* (exhibition catalogue). Boston: Museum of Fine Arts, 1976.

Masters of Popular Painting. Modern Primitives of Europe and America (exhibition catalogue). New York: Museum of Modern Art, 1938.

MATHER, CHRISTINE. "The Arts of the Spanish in New Mexico." *Antiques*, vol. 113, no. 2 (February 1978), pp. 422–32.

MULLER, NANCY C. *Paintings and Drawings at the Shelburne Museum.* Shelburne, Vt.: Shelburne Museum, 1976.

RHODES, LYNETTE I. *American Folk Art from the Traditional to the Naive* (exhibition catalogue). Cleveland: Cleveland Museum of Art, 1978.

*RICHARDSON, EDGAR P. *Painting in America. The Story of 450 Years.* New York: Crowell, 1956.

ROBINSON, FREDERICK B. *Somebody's Ancestors, Paintings by Primitive Artists of the Connecticut Valley* (exhibition catalogue). Springfield, Mass.: Museum of Fine Arts, 1942.

SAVAGE, GAIL; SAVAGE, NORBERT H.; AND SPARKS, ESTHER. *Three New England Watercolor Painters* (exhibition catalogue; J. Evans, Joseph H. Davis, J. A. Davis). Chicago: Art Institute, 1974.

SEARS, CLARA ENDICOTT. *Some American Primitives. A Study of New England Faces and Folk Portraits.* Boston: Houghton Mifflin, 1941.

SHELLEY, DONALD A. *The Fraktur-Writings or Illuminated Manuscripts of the Pennsylvania Germans.* Allentown: Pennsylvania German Folklore Society, 1961.

SHERMAN, FREDERIC F. *Early American Painting.* New York and London: Century, 1932.

[TILLOU.] *Nineteenth-Century Folk Painting: Our Spirited National Heritage* (selections from the collection of Mr. and Mrs. Peter Tillou; exhibition catalogue). Storrs: University of Connecticut, William Benton Museum of Art, 1973.

[TILLOU.] *Where Liberty Dwells: 19th-Century Art by the American People. Works of Art from the Collection of Mr. and Mrs. Peter Tillou* (exhibition catalogue). [Privately published, 1976.]

"What Is American Folk Art? A Symposium." *Antiques*, vol. 57, no. 5 (May 1950), pp. 355–62.

WINCHESTER, ALICE. "Maxim Karolik and His Collections." *Art in America*, vol. 45, no. 3 (Fall 1957), pp. 34–41.

WOODWARD, RICHARD B. *American Folk Painting from the Collection of Mr. and Mrs. William E. Wiltshire III* (exhibition catalogue). Introduction by Mary Black. Richmond: Virginia Museum, 1977.

Colorplates

Index

PHOTO CREDITS

Douglas Armsden, 169 left; Will Brown, 90 top, 109; Barney Burstein, 164; Del Cargill, 20; Richard Cheek, 23, 24 left, 151; Geoffrey Clements, 16, 104 top, 108, 110, 116, 168, 194, 197, 211; Cradoc Bagshaw Photographic Services, 49, 50; Bill Finney, 169 right; Michael Fredericks, 144 right; E. L. Hawes, 167 top; Hayman Studio of Commercial Photography, 121, 125, 126; Fred G. Hill, 79; Richard Hurley, 36; Jane Iseley, 106 right; William H. Jackson, 48, 51; Richard Margolis, 131; Richard Merrill, 25, 37 left, 38, 140, 157 right, 183, 184; Elmer R. Pearson, 203; Eric Pollitzer, 192 left, 196; Charles Rachum Studios, 113 top, 115; Sam Rosenberg, 179, 181; Elton Schnellbacher, 201 bottom; Schopplein Studio, 144 left; David Stansbury, 73 right; Joseph Szaszfai, 14; Charles Uht, 17 left; Arthur Vitols, 72 left, 147 right, 161 top, 163; Richard D. Warner, 85.